The Invention of Art History in Ancient Greece

The ancient Greeks developed their own very specific ethos of art appreciation, advocating a rational involvement with art. This book explores why the ancient Greeks started to write art history and how the writing of art history transformed the social functions of art in the Greek world. It looks at the invention of the genre of portraiture, and the social uses to which portraits were put in the city state. Later chapters explore how artists sought to enhance their status by writing theoretical treatises and producing works of art intended for purely aesthetic contemplation, which ultimately gave rise to the writing of art history and to the development of art collecting. The study, which is illustrated throughout and draws on contemporary perspectives in the sociology of art, will prompt the student of classical art to rethink fundamental assumptions about Greek art and its cultural and social implications.

JEREMY TANNER is Lecturer in Greek and Roman Art at the Institute of Archaeology, University College London. He is the author of *The Sociology of Art: A Reader* (2003).

THE INVENTION OF ART HISTORY IN ANCIENT GREECE

Religion, society and artistic rationalisation

JEREMY TANNER

CAMBRIDGE
UNIVERSITY PRESS

CAMBRIDGE UNIVERSITY PRESS
Cambridge, New York, Melbourne, Madrid, Cape Town, Singapore, São Paulo

CAMBRIDGE UNIVERSITY PRESS
The Edinburgh Building, Cambridge CB2 2RU, UK

Published in the United States of America by Cambridge University Press, New York

www.cambridge.org
Information on this title: www.cambridge.org/9780521846141

First published 2006

Printed in the United Kingdom at the University Press, Cambridge

A catalogue record for this book is available from the British Library

ISBN-13 978-0-521-84614-1 hardback
ISBN-10 0-521-84614-5 hardback

Midwest $99 6/15/06

To my father

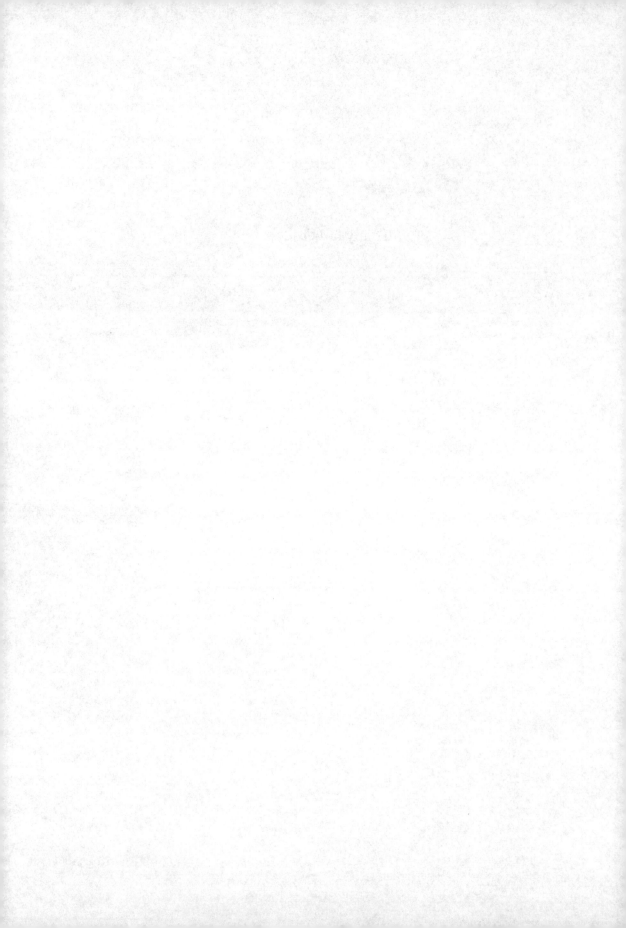

CONTENTS

ILLUSTRATIONS

ACKNOWLEDGEMENTS

I have incurred a great many debts in the course of doing the research for this book and preparing it for publication. Anthony Snodgrass and Geoffrey Hawthorn were generous with their time, unerringly perceptive in their criticisms and always enthusiastic and encouraging as supervisors of my PhD thesis. Gordon Fyfe and Robin Osborne not only contributed greatly to the improvement of the book by their stimulating thoughts and suggestions on the occasion of the examination of the thesis, but since then have also gone far beyond their duty as examiners in providing advice and practical help in seeing the project through to publication.

Mary Beard, Harold Bershady, Richard Brilliant, Paul Cartledge, Robin Cormack, Barbara Graziosi, Keith Hopkins, Christopher Kelly, David Konstan, Michael Koortbojian, Victor Lidz, Paul Millett, Ariadne Staples and Rosalind Thomas have all at one time or another commented on substantial parts of my text, which is much the better for their insights and criticisms. Jas Elsner and Peter Stewart have read the entire text more than once. In addition to improving the substance and clarity of my arguments, they have been unfailingly supportive as friends and colleagues in Cambridge and London.

My students at the Institute of Archaeology, particularly those who have taken the course 'Magic, Religion and Reason in Greek Art and Architecture', have been a constant source of stimulation; so also have my colleagues in the Institute of Archaeology, and the wider classical art history community in London. Cyprian Broodbank has not only contributed much to the development of my thought in innumerable discussions over the twelve years we have both been at the Institute of Archaeology but also made the intellectual journey represented by that period a lot more fun. I am grateful to Peter Ucko for generous grants of research leave, which allowed the completion of this book, and to Stephen Shennan, not least for Peter Ucko's patience at the time of the last research-assessment exercise.

A number of institutions have provided financial support without which my research would not have been possible, and it is a pleasure to be able, finally, to

acknowledge my gratitude to them here. The Thouron Foundation and the Department of Sociology at the University of Pennsylvania generously supported three years of study as a graduate student in Philadelphia. My postgraduate work at Cambridge was funded by the British Academy, the Cambridge Faculty of Classics, and a Research fellowship at Queens' College. The British Academy, the Cambridge Faculty of Classics, the Dean's Travel Fund of University College London, and the Institute of Archaeology made possible visits to Germany, Greece and Italy.

This book is based on my PhD dissertation of the same title, submitted at the University of Cambridge in 1996. Elements of the text have already appeared in rather different versions, as acknowledged in the notes and reference list.

ABBREVIATIONS

Abbreviations in references to primary sources and standard works of reference for classical studies follow *The Oxford Classical Dictionary*, 3rd edition, 1996, ed. Simon Hornblower and Antony Spawforth, Clarendon Press, Oxford. The following abbreviations are also used:

IGB E. Loewy, *Inschriften griechischer Bildhauer*. Leipzig, B. G. Teubner, 1985.

IVP M. Fränkel (ed.), *Die Inschriften von Pergamum*. Altertümer von Pergamon VIII. 2 vols. Berlin, W. Spemann, 1890.

SQ J. Overbeck, *Die antiken Schriftquellen zur Geschichte der bildenden Künste bie den Griechen*. Leipzig, Wilhelm Engemann, 1868.

INTRODUCTION: ART AND SOCIETY IN CLASSICAL ART HISTORY

GREEK ART, THE IDEA OF FREEDOM, AND THE CREATION OF MODERN HIGH CULTURE

On 6 May 1884 a party celebrated the opening of the Cambridge Museum of Classical and General Archaeology.[1] The guests included not only leading lights in classics, but also a wide range of members of the social, political and cultural elite of late nineteenth-century Britain, amongst them the American Ambassador and the Prince of Wales, the painters Sir Frederick Leighton (President of the Royal Academy) and Lawrence Alma-Tadema, and the directors of both the National Gallery and the National Portrait Gallery. At this time, classics enjoyed a prestige unequalled before, or since. Classical education in reformed public schools and the universities had provided a unifying culture for the new functionally differentiated economic, political and cultural elites who displaced the old landed ruling class, which had dominated Britain until the industrial revolution.[2] Moreover, there was a particularly close alignment in the interests of classicists and contemporary painters. Sidney Colvin, the Slade Professor of Art and the primary instigator of the creation of the collection of casts after classical sculptures which formed the core of the new museum, was also the leading critical advocate of the classical revival in late nineteenth-century British painting.[3] The familiarity, amongst a classically educated social elite, of the subjects drawn from classical antiquity, together with a concept of the Greeks as the first people freely to explore beauty for its own sake, both promoted a new formalism amongst English painters and enhanced the image of the painter as autonomous creator and culture hero.[4]

These ideas are encoded in a series of paintings by Alma-Tadema, which suggest a strong sense of identity between the self-image of artists and connoisseurs in the late nineteenth century and their imagined forebears in classical antiquity. *Pheidias Showing the Frieze of the Parthenon to his Friends* (figure 1.1) depicts a Leightonesque Pheidias standing on the scaffolding in front of the

[1] Beard (1993). [2] Bowen (1989). [3] E. Morris (1997) 61. [4] E. Morris (1997).

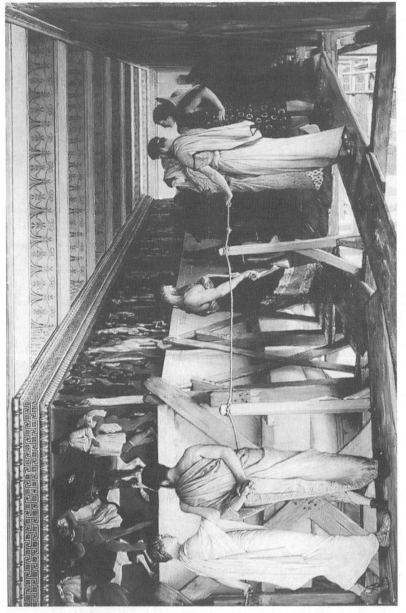

Figure 1.1 L. Alma Tadema. *Pheidias Showing the Frieze of the Parthenon to his Friends.* 1868. Photo: Birmingham Museums and Art Gallery.

frieze, dazzling in polychrome, which he explicates to a small gathering of admirers. The setting – including the ropes, keeping the visitors at a suitable distance – evokes a relationship between work of art, artist and audience, closer to a work of art in a modern gallery, or indeed the Parthenon sculptures in the British Museum, than to the way they might normally have been viewed in antiquity.[5] The placing of Pheidias at the centre of the composition – a position normally occupied by the hero in academic history painting – claims the role of the artist as autocratic creator, source and origin of his œuvre, for both classical and contemporary artists.[6] *Un Amateur Romain* (figure 1.2) shows a group of four classically draped men and women disposed around a silver statue of a young girl, in a Pompeian-style atrium house with elaborate marble columns and gilded capitals. The painting was interpreted by contemporary viewers in terms of the Roman art writer Pliny the Elder's criticisms of collectors who could not distinguish between the material and the aesthetic value of works of art. The gaze of the owner of the statue, reclining on his couch, is turned towards the two ladies, monitoring their reaction to his statue and implying a more profound interest in the impression the collector makes on his social peers than in the work of art itself. The painting thus at one and the same time criticises the pretensions of middle-class Victorian patrons with more money than taste and invites the audience 'to share the pleasure of ridiculing ancient Roman philistinism' and cultural pretension.[7] Alma-Tadema's paintings engage a series of key concepts in the modern institution of art as high culture and project them back onto classical antiquity: the heroic status of the artist as creator, the autonomy of art, and norms of cultivated connoisseurship on the part of authentic art lovers – all concepts which, as we shall see, still centrally inform the dominant paradigm in classical art history writing. The history of classical art played a central role in the formulation of these concepts and their institutionalisation in modern high culture, most notably through the writings of J. J. Winckelmann (1717–68).

Winckelmann, notwithstanding debts to Vasari and ancient art writers such as Pliny, is the inventor of modern western art history writing. He synthesised into a compelling paradigm strands of art writing and antiquarian investigation which had previously been separate.[8] Prior to Winckelmann, classical (Greek and Roman) art had been seen as a unitary ideal. Winckelmann, drawing on analogies with ancient rhetorical theory, gave the academic concept of an individual painter's *maniera* a historical and collective reference. Detailed

[5] Cf. R. Osborne (1987). [6] Becker (1997) 144–9 (Prettejohn). [7] Prettejohn (1996) 134–6.
[8] Potts (1978), (1982), Einem (1986), Haskell (1991).

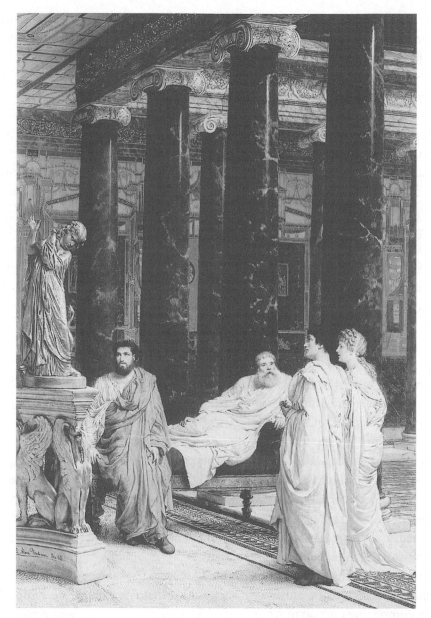

Figure 1.2 L. Alma Tadema. *Un Amateur Romain.* 1868. Photo: Glasgow Museums:
Art Gallery and Museum, Kelvingrove.

analysis of diagnostic features of style such as the conformation of the brow, the
shape of the eye and nose, which were derived initially from the coins and gems
he had catalogued for one of his German patrons, provided the methodological
basis for attributing particular works of sculpture to their proper positions
within his scheme. Winckelmann distinguished four phases. First was a hard

and austere archaic phase. This was followed by a high phase in which artists 'drew nearer to the truth of nature, by which they were taught to throw aside, for flowing outlines, the hardness of the older style' and thereby achieved 'more beauty, loftiness and grandeur'.[9] This high phase gave way to the beautiful, distinguished by a heightened softness and grace, characteristic of artists like Praxiteles who 'hold the same relation to their predecessors that Guido, amongst the moderns, would hold to Raphael'.[10] This in its turn was followed by a period of decadence and imitation. The progressive sequence of development through the four stages is animated by political history: 'when Greece attained its highest degree of refinement and freedom, art also became more unfettered and lofty'.[11] So also, with the suppression of Greek democracy first by the Macedonians, definitively by Rome, 'the loss of freedom, from which art had, as it were, received its life, was necessarily followed by its decline and fall'.[12] Most of the styles of argumentation characteristic of the subsequent tradition of classical art history writing are prefigured in Winckelmann. In addition to the story of decline and fall, grounded in political history, Winckelmann draws analogies between literary style and artistic style: the early style is compared with the prose style of Herodotus' 'phrases disjoined from one another, with no connection',[13] whilst, 'in light of the indisputable association between poetry and art, and the influence of one on the other', the 'subtle grace' of Menander's poetry is held to give us 'an image of the beauties of the works of art that Lysippos and Apelles clothed with grace'.[14] He uses the model of Renaissance art history as a parallel to illuminate the fragmentary record of the classical past. The early style is characterised as 'deficient in that roundness which is produced by light and shade, like the works of the painters who preceded Raphael, and especially the Florentine school, in which the same defect is observable'. Indeed, he sees the parallelism of the sequence of artistic and scientific progress in Florence and Athens as proof of the general validity of his causal model linking artistic progress with freedom.[15] He makes intuitive iconological connections between the inherent qualities of visual style, for example grandeur or grace, and the temper of the culture which produced it.[16]

The importance of Winckelmann's writings lies not only in the systematic nature of his history, and its characteristic analytical tropes, but also in the construction of a culturally specific normative style of relating to works of art. In addition to reconstructing the history of Greek art, Winckelmann also sought to convey 'an intensified appreciation of the beauties of ancient art'.[17]

[9] Winckelmann (1881) VIII.2.1. [10] VIII.2.6. [11] VIII.2.1. [12] X.2.4. [13] VIII.1.3.
[14] IX.3.30; cf. Potts (1994) 99. [15] 1.3.20. [16] Potts (1994) 101–2. [17] Potts (1982) 387.

This he accomplished largely through extended highly subjective 'ekphraseis', or descriptions, of the greatest masterpieces of each style phase, such as the Apollo Belvedere (figure 1.3), which define a normative relationship for the viewer/reader to the work of art:

Among all the works of antiquity which have escaped destruction, the statue of Apollo is the highest ideal of art ... His stature is much loftier than that of man, and his attitude speaks of the greatness with which he is filled. An eternal spring, as in the happy fields of Elysium, clothes with the charms of youth the graceful manliness of ripened years, and plays with softness and tenderness about the proud shape of his limbs. Let thy spirit penetrate into the kingdom of incorporeal beauties, and strive to become a creator of a heavenly nature, in order that thy mind may be filled with beauties that are elevated above nature; for there is nothing mortal here, nothing which human necessities require. Neither blood vessels nor sinews heat and stir this body, but a heavenly essence, diffusing itself like a gentle stream, seems to fill the whole contour of the figure ... In the presence of this miracle of art, I forget all else, and I myself take a lofty position for the purpose of looking on it in a worthy manner. My breast seems to enlarge and swell with reverence, like the breasts of those who were filled with the spirit of prophecy, and I feel myself transported to Delos and into the Lycaean groves, – places which Apollo honoured by his presence – for my image seems to receive life and motion, like the beautiful creation of Pygmalion.[18]

In a similar passage, he evokes the erotic tropes of contemporary pietist hymns and prayers:

What human conception of divinity in sensuous form could be worthier and more enchanting to the imagination than the state of eternal youth and springtime of life, whose recollection even in our later years can gladden us. This corresponds to the idea of the immutability of the divine being, and a beautiful youthful godly physique awakens tenderness and love that can transport the soul into a sweet dream of ecstasy, the state of bliss that is sought in all religions, whether correctly understood or not.[19]

This highly sensual, deeply feelingful, construction of aesthetic response was modelled on the experience of mystic ecstasy that was characteristic of the Protestant cults of eighteenth-century Germany.[20] Winckelmann himself, of course, though he converted to Catholicism in order to advance his career in Rome, was brought up as a boy in the milieu of German Pietism and, even after conversion to Rome, apparently continued to enjoy singing Lutheran hymns in the privacy of his own room.[21]

Although Winckelmann's individual contribution to the history of art cannot be doubted, and was probably strongly inflected by highly personal homoerotic fantasies of subjective and sexual freedom,[22] the most important features of his

[18] XI.3. [19] V.I.I; trans. Potts (1994) 167. [20] Potts (1994) 167; Honour (1968) 60.
[21] I. Morris (1994) 16. [22] Potts (1994) 4.

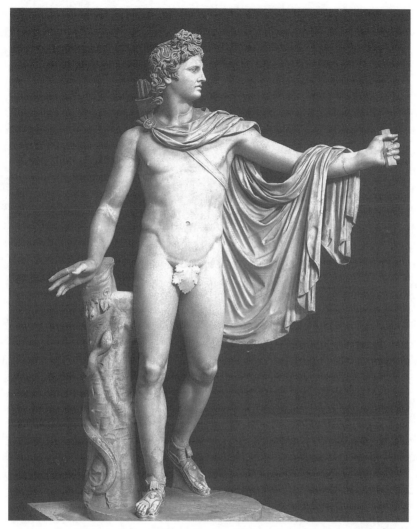

Figure 1.3 Apollo Belvedere. Roman Copy. Original *c.* 330 BC. Vatican Museum.
Photo: Alinari 6502.

work are best understood in terms of profound changes in the institution of art in the eighteenth century, both in its social basis and its cultural framing. These changes encouraged other writers to develop ideas in similar directions to Winckelmann's, in addition to conditioning his subsequent reception. The circumstances under which viewers encountered art underwent marked change during the course of the eighteenth century. In England, the cultural and political revolutions of the seventeenth century had undermined the role of both church and king as major artistic patrons. Art production was increasingly oriented towards collectors from the aristocracy and commercial elite, many of

whose purchases were made at auctions, on the open market, rather than being bespoke commissions.[23] In place of the political and religious contexts for which it had hitherto been created, art was now consumed in collections in country houses, in auctions, or, on the continent, in the salons of the French Academy. These new contexts of consumption and the new, socially much more inclusive, audiences which frequented them motivated the development of new forms of critical writing that were designed to mediate the relationship between the artist and the 'public' or 'society' in general, who had replaced the private patron and God as the primary beneficiaries of the artist's services.[24]

A tradition of critical art writing, commencing with Shaftesbury and the Richardsons in England, and culminating in the aesthetics of Baumgarten, Moritz and Kant in Germany, redefined the nature of art and aesthetics. Building on the beginnings of the development of the concept of the artist as creator in the Renaissance,[25] they conceptualised the work of art not as a skilful imitation of nature, but as a completely self-sufficient and autonomous object, better understood in terms of the contemplative relationship it permitted with its viewer than in terms of the skilful and purposive product of craft technique mastered by its maker on which earlier art criticism had focused.[26] The nature of that experience was articulated in terms drawn from the Methodist and Pietist strands of Protestant culture, which had developed in reaction against the austerity of Calvinism. Pietism emphasised the idea of God as a god of love and benevolence. Just as rational world mastery that was demonstrated in business success served to secure certitude of salvation for Puritans and in secularised form shaped modern conceptions of professional vocations,[27] so charitable and sympathetic feelings towards one's fellow men were conceived of as a mark of God's grace amongst the Pietists, and a premium was laid on experiencing and giving expression to such feelings, as a manifestation of the workings of the grace of God within the heart.[28] Admission to the community of the faithful involved not only a confession of faith but also an account of how God's grace had manifested itself within one, in the form of all the appropriate feelings of Christian love and sympathy: subjective experience became the criterion of personal value.[29] In a secularised form this structure of response survived into and was extended as part of the cult of sensibility celebrated and developed in eighteenth-century novel writing, and satirised in Jane Austen's *Sense and Sensibility*, by which time the movement had passed its peak.[30]

[23] Pears (1988). [24] Honour (1968) 19; Pears (1988) 49; Habermas (1989).
[25] Blunt (1940) 23–38, 72–8; Panofsky (1968) 85–6, 93–5. [26] Abrams (1989a), (1989b).
[27] Weber (1931). [28] Campbell (1987) 99–137. [29] Campbell (1987) 128.
[30] Campbell (1987) 138–60.

The idea of the artist and of the work of art as an object of disinterested love, analogous to the conceptual model of God, had already been intimated in academic art theorists like Bellori.[31] This facilitated the transfer of the sensibility associated with mystical strands of Protestantism – Pietism, Methodism, Quietism – into aesthetic discourse. Karl Philip Moritz, in his essay 'On the Unification of all the Fine Arts ... under the Concept of the Complete in itself', describes the experience of artistic beauty as follows:

it makes us seem to lose ourselves in the beautiful object; and precisely this loss, this forgetfulness of self, is the highest degree of pure and disinterested pleasure which beauty grants us. In that moment we sacrifice our individual confined being to a kind of higher being. Pleasure in the beautiful must come ever closer to disinterested love, if it is to be genuine.[32]

The language echoes that of Quietist mystical experience, described in very similar terms in Moritz's autobiographical novel *Anton Reiser*. A feelingful response lies at the centre of the discourse of the 'art lover' elaborated in eighteenth-century aesthetics. Kant (educated in a Pietist milieu) demanded 'both taste and feeling' as necessary components of an adequate response to a work of fine art, defined as an object which pleases for its own sake, irrespective of ends of utility or morality. Winckelmann wrote a 'Treatise on the Capacity for the Feeling (*Empfindung*) of Beauty in Art' (1763). In this he contrasts the impassivity of 'a certain young Britain of the highest class who was in his carriage and did not even show a sign of life and his presence when I gave him a talk on the beauty of Apollo' with the 'soft heart and responsive senses' which are the sign of the capacity for feeling beauty characteristic of the true art lover.[33] The senses were not, as in strands of Neoplatonic and neo-Stoic thought inherited from classical antiquity, merely means or stepping-stones to higher intellectual ends. Baumgarten, in his essays on aesthetics, characterised poetry and painting in terms of the 'perfection of sensuous cognition', owing its specific value to the exploitation of sensate non-logical capacities of the mind in the pleasurable expansion of human experience.[34] These ways of seeing were cultivated as a set of critical practices which formed an aesthetic ethos, seeking to engender a certain spiritual depth and inner composure or freedom, against the alienating and fragmenting pressures of the instrumental rationality characteristic of the modern social and economic orders, an ethos best exemplified by Schiller's *On the Aesthetic Education of Man* (1795).[35]

[31] Panofsky (1968) 154–77. [32] Abrams (1989b) 166.
[33] Trans. in Irwin (1972) 89–103; quotations 89–90, 92. [34] Abrams (1989b) 174–9.
[35] Hunter (1992).

Although the cult of sensibility as a total way of life fell into disrepute in the nineteenth century, its structure of feeling survived as a normative framework regulating a specific institutional domain, that of art and in particular high-cultural viewing. It can easily be found echoed in contemporary art-writing, for example an article from the French journal *Realities*:

Ignorant or initiated, we are each of us disarmed before that mystery, the masterpiece. Uncertainly searching the canvass, we await the moment of grace when the artist's message will come to us. The silent clamour of Rembrandt, the infinite gentleness of Vermeer, no culture will make these things comprehensible to us if we have not restored the calm, created the expectation, prepared within ourselves the void that is propitious to emotion.[36]

Similarly, in the introduction to a catalogue for an exhibition of his collection of classical antiquities, Georg Ortiz describes how as a young man

I lost my religious faith, studied philosophy and became a Marxist. I was looking for God, for the truth and the absolute. In 1949 I went to Greece and I found my answer. The light was the light of truth and the scale of everything was on the scale of man. And Greek art exuded a spirit which I was much later to perceive as what I believe to be the spiritual birth of man ...

Finding the truth and the absolute in Greek art, Ortiz was converted from Marxism to art collecting, saved from his sense of alienation and spiritually transformed by a relationship with art based primarily on 'feeling'. The catalogue itself is entirely written by Ortiz out of 'love and respect for the objects', in a somewhat effusive style, justified, as against a more scholarly production, by the desire to ensure adequate 'harmony of expression and feeling'.[37]

One of the distinctive features of this aesthetic ethos, and the art-historical consciousness which accompanies it in the modern West, is that it is borne not just by a social elite, but also by the state. The love and respect that were held to be the due of art, together with the historical orientation to art that was developed in the writings of Winckelmann and in national histories of art based on his historiographic model, were intensified by the development in the late eighteenth and nineteenth centuries of national art museums with historical displays, in place of the picturesque or aesthetic displays intended to project the power of princely collectors or to provide *mises-en-scène* for their aristocratic and increasingly bourgeois counterparts.[38] In Britain, France and Germany displays were created which promoted a vision of the respective

[36] Quoted in Bourdieu (1984) 568, n. 63.
[37] Ortiz (1996) no page numbers in introductory section. [38] Ernst (1993).

national schools as legitimate heirs to and continuators of the classical tradition in art[39] and legitimated the power of the state through the civilising gift of culture to its citizens, made in exchange for their identification with and loyalty to the nation state.[40]

The invention of classics, and of classical art history, was intimately tied up with these processes of the construction of modern national high cultures, not only due to the cultural value attributed to classics and classical art, but also through the personnel sponsoring the new ideas and creating the cultural institutions which embodied them. On his appointment in 1789 as professor of the Theory of Fine Arts and *Altertumskunde* at the Berlin Academy of Art, Karl Philip Moritz, whose aesthetic writings I have already mentioned, was responsible for lecturing students on art and antiquities, guiding them in the royal collections and supervising the training of artists in drawing from casts after the antique.[41] Aloys Hirt, the successor to Moritz and from 1810 professor of the 'Theory and History of the Arts of Design' at Berlin University, which also involved lecturing in classical archaeology, played a major role in the development of the Altes Museum project, through which the liberalised Prussian state of the period following the Napoleonic wars sought popular legitimacy as the bearer and mediator of a national cultural patrimony.[42] Political, social, cultural and artistic capital coincided in the small world of classics and classical art history. Parties organised by Eduard Gerhard – founder of what was to become the German Archaeological Institute in Rome and later principal archaeologist at the Altes Museum – to celebrate the foundation of Rome and for the annual Winckelmannfest were attended by the former minister of education, Alexander von Humboldt, and by artists of the stature of Klenze and Schinkel, as well as classical archaeologists.[43] Von Humboldt himself, who was largely responsible for the institutional reforms which engendered the dominance of classics in nineteenth-century German education, had been heavily influenced by his friends the philologist Friedrich August Wolf and the dramatist and philosopher Friedrich Schiller.[44] In Schiller's letters *On the Aesthetic Education of Man* (1795), it is the example of classical antiquity which, alongside art, offers a prospect of harmonious and integrated self-formation against the fragmenting pressures of an increasingly rationalised modern world.

[39] Jenkins (1992), McClellan (1984), Troppenburg (1980). [40] Duncan and Wallach (1980).
[41] Borbein (1979) 104. [42] Borbein (1979) 106–9; Moyano (1990); Marchand (1996) 65–7.
[43] Borbein (1979) 122–4. [44] Bernal (1987) 282–8.

GREEK ART *SANS MIRACLE*: MAX WEBER, TALCOTT PARSONS
AND THE HISTORICAL SOCIOLOGY OF GREEK ART

Primitivists, modernisers and classical art history

In nineteenth-century Britain and Germany the association between art, freedom and national identity as the legacy of ancient Greece to the modern world had powerful ideological and cultural resonances. Given the strength of the institutional supports it rested upon historically and the prestige it once conferred – perhaps still confers – upon the discipline, it is not surprising that the grand narrative of Greek art – the great miracle of Greek art and the discovery of freedom – as a parallel to artistic developments in the modern West has so powerfully shaped paradigms in classical art history. Within a few years of the *History*'s publication in 1764, Winckelmann's vision of Greek art was already being institutionalised as a component of *Altertumswissenschaft* in Heyne's seminars at Göttingen, complete with the paraphernalia of classical casts and a small teaching-collection of antiquities.[45] The archaeological, art-historical and textual scholarship that art history in the style of Winckelmann demanded gave the professional archaeologist, in place of the amateur aristocratic collector or the professional artist, a privileged authority in interpreting and evaluating classical art.[46] Scholarship, as it became increasingly positivistically oriented during the course of the nineteenth century, ceased to claim classical art as exemplary for contemporary art production and eschewed the highly subjective ekphraseis which Winckelmann had used to construct the proper emotive relationship between viewer and work of art. Nevertheless, narrative histories like those of Heinrich Brunn and Karl Ottfried Müller broadly accepted the basic outline of the history of Greek art sketched by Winckelmann.[47] Furthermore, the problems identified by more specialised works of scholarship represented the puzzles of normal science within a paradigm largely set by Winckelmann's classic work: Furtwängler's *Meisterwerke der griechischen Plastik* (1893), for example, gives a rigorous foundation in style analysis and *Kopienkritik* to Winckelmann's history of art, which sometimes rested on rather uncritical and erroneous attribution of Roman copies to specific artists and periods of ancient Greece.[48] The practice of classical art history in Britain and America, as it developed from the second half of the nineteenth century, was largely modelled on German exemplars, giving rise to broadly similar styles of

[45] Connor (1989) 217. [46] Potts (1982). [47] Borbein (1986) 289–92; Marchand (1996) 44–7.
[48] Furtwängler (1893), Marchand (1996) 144–5.

scholarship and parallel institutional developments (cast collections, national archaeological schools in Rome and Athens) through a process of competitive emulation.[49]

This 'Hellenist' paradigm continues to shape the contemporary appropriation of classical art in both scholarly work and presentations oriented to a broader public. An exhibition entitled *The Greek Miracle: Classical Sculpture from the Dawn of Democracy, the Fifth Century BC*, held in Washington and New York in celebration of the 2500th anniversary of the invention of Athenian democracy, provided a vehicle for both the Greek and the American States to project themselves through the classical ideal in a manner analogous to the use of classical art by the European states of the eighteenth and nineteenth centuries in national museums.[50] The preface to the catalogue, by the Greek Prime Minister Constantin Mitsotakis, tells us that the exhibition 'celebrates the birth of humanism in Greece twenty-five centuries ago, [where] the value of the individual was first recognised and that recognition produced the first self-government on earth, the first democracy'. The collaboration between Greece and America in organising the exhibition reflects the 'special roles' the two countries 'play in nurturing the democratic system, the United States providing the political leadership and Greece the spiritual force to ensure that free men live in harmony everywhere'. The themes are echoed in the introduction of the exhibition organiser – 'works of classical art speak to us across the centuries, eliciting timeless homage because of their beauty and grandeur' – and in the scholarly contributions to the catalogue, where the development of naturalism in early fifth-century Greece is described as an emancipation from 'the conceptual idiom of the Orient ... and the magical associations of the East', ensuring an art 'permeated by the individuality of artists'.[51]

Amongst more scholarly work, Martin Roberston's monumental *History of Greek Art* (1975), like Winckelmann's, insistently draws parallels between Renaissance art and Greek art,[52] in the context of a grand narrative placing Greek art 'at the root of the European tradition'.[53] Winckelmann's categories still inform the history of Greek art, which is sometimes seen to prefigure the structure of the modern art world in a concern with creative freedom, historical

[49] I. Morris (1994), Beard (1993), Connor (1989), Dyson (1998).

[50] Buitron-Oliver (1992). [51] Palagia (1992) 23.

[52] E.g. Robertson (1975) 191: the Hestia Giustiniani compared with Piero della Francesca's *Madonna del Parto* in terms of certain formal similarities and an 'aesthetic sympathy'; 412: the linear style of Parrhasios compared with that of early Renaissance masters like Botticelli.

[53] Robertson (1975) xi; cf. 241 tracing back the spatial concepts of Piero della Francesca or Tiepolo to the experimentation on early classical vase paintings; 411: the late fifth and early fourth century as the period when 'painting in the European sense, as against flatly coloured drawing, begins to be practised'; 486: Pausias' flower paintings 'the beginning of a new tradition with a great future in European art'.

self-consciousness and a love for art. The development of naturalism in fifth-century Greece is seen as the birth of art as such. The introduction of the distinction between weight-bearing and free leg, and the ramifications of such distinctions throughout the body, afforded the artist a certain freedom of choice, and consequently, it is argued, 'a fundamentally new significance must have been attributed to him as the form giving subject', leading to 'a relatively autonomous, self-conscious and professional body of artists (*Künstlertum*), much celebrated by the Public'.[54] As in the eighteenth century, it is suggested, art became disembedded from religious and political functions, and became the object of specifically aesthetic critical discourse in a developing public sphere:

Visual art was conceived increasingly as a discipline sui generis, with its own specific problems and possibilities. In contrast to the traditional apprehension of art and its function within the life of the community, there began to develop a public of cultivated experts who discussed questions of Art.[55]

Art was appreciated as a historically evolving phenomenon, in which artists registered their individuality by solving specifically aesthetic problems determined autonomously within the tradition of art itself.[56] Just like Alma-Tadema and his clients, some modern classical art historians identify – as they would like to think – with the Greeks and mock the philistinism of the Romans, evaluating the style of connoisseurship of men like Cicero or Pliny the Elder from within the discourse of art loving that was established in the eighteenth century and is still dominant today. Pliny, one scholar complains (echoing Winckelmann's dismissive criticism of the young English grand-tourist above, p. 9) has 'hardly a spark of feeling or understanding for art'.[57] Cicero, another suggests, did not have 'a great love' for art, nor 'specially sensitive insights' into it.[58]

The Hellenist ideology has not been unchallenged within classics, but such challenges as there have been have had only very limited impact on classical art history.[59] The art-historical sections of Burckhardt's cultural history of Greece (1898–1902) – one of the first important studies to emphasise the unbridgeable gap between Greek culture and society and our own – are a surprisingly anodyne reworking of the conventional account of the development of Greek

[54] Hölscher (1974) 95, 98. [55] Hölscher (1974) 106.
[56] Metzler (1971) 60: 'because of the individuality of the artists, as of their patrons, the development of art in free Greek society naturally led not to the traditionalistic Academicism of the monolithic cultures of the ancient Orient, but instead to an individualistic concern with the solution of self-set problems'. Cf. Hölscher (1974) 101: 'As a consequence of these general conditions, the recognition clearly emerged in the fifth century that artistic form was subject to historical change.' Gombrich (1960) 120 also locates the emergence of art history in the so-called 'Greek revolution' which marks the beginning of the classical period, conventionally 480 BC.
[57] Robertson (1975) xv. [58] Leen (1991) 233. [59] Cf. I. Morris (1994) 37.

art as the triumph of the classical ideal, handed down from Winckelmann.[60] Jane Harrison made great use of visual materials in her Durkheimian studies of Greek religion, *Prolegomena* and *Themis*, but, relying primarily on vase paintings, did not directly challenge the traditional story of the glories of Greek art based around sculpture and wall- or panel-painting.[61] Whilst Harrison used visual materials to draw links between the Greeks and the primitive peoples studied by contemporary anthropologists, the controlling authorities of the Museum of Classical and General Archaeology sought to maintain a proper distance between classical art (the casts) and the collection of ethnographic artifacts which were originally housed with them: first a screen was placed between the classical and the anthropological halves of the museum; ultimately the stone-age choppers and Pacific idols were given their own home.[62] Thereafter, classical art and archaeology at Cambridge took on a conventionally Hellenist guise under the leadership of Charles Waldstein, who had been trained in the German tradition at Heidelberg.[63]

More recently the Paris school of structuralist historians of Greece, led by J-P. Vernant, and English-speaking scholars influenced by them have stressed the 'desperately foreign' character of the Greeks, inverting the Hellenist emphasis on the miracle of the Greek enlightenment by emphasising the extent to which the characteristic modalities of thought amongst classical Greeks, manifested in both myths and social institutions, have more in common with the 'savage mind' of the 'primitive peoples' studied by anthropologists such as Levi-Strauss than with those of modern westerners. The idea, characteristic of Hellenism, that Greeks, at least of a certain class, were 'good chaps basically like us' gives way to an emphasis on the Greeks' 'essential difference'.[64] Within classical art history, the application of structuralist methodology has greatly enhanced the sophistication of iconographic studies of Greek vase-painting. Comparisons of series of representations facilitate the breaking down of images into their constituent components, and the analysis of how those components can be syntactically combined or paradigmatically substituted for each other in specific images in order to produce, in a way analogous to verbal language, particular visual meanings.[65] Such analyses offer access to wide-ranging cultural discourses, for example on the role and cultural conceptualisation of the warrior or the ideology of hunting, in place of the preoccupation with

[60] Haskell (1991) 98; O. Murray (1998). [61] J. E. Harrison (1903), (1912).
[62] Beard (1993) 15–16, (2000). [63] Beard (1999) 130–1.
[64] Finley (1985b) xiii criticising the 'good chaps' assumptions; Cartledge (1993) 4–7 on alterity and difference as the characteristic emphasis of the French school.
[65] Bérard (1983a), (1983b) for the method; Bérard (1989) for a series of examples of the method.

finding the myth or literary text behind the image that is characteristic of more traditional iconography. More recent, post-structuralist, approaches have sought to go beyond the decoding of meaning characteristic of structuralist iconography, to show how visual signs have specific effects, structuring the gender, sexual and political identities of their consumers.[66]

Hellenists, in some quarters still holding the institutional high ground, regard these new perspectives in classical art history with disdain, preferring the 'sturdy scholarship' of nineteenth-century Germany to attempts to 'press [classical art] into anthropological moulds ... or subject it to the service of ideologies bred by modern concerns with race, gender and psychology'.[67] However, the strong opposition between the new classical art history and traditional scholarship obscures what the new shares with the old, namely being dominated by philological models of analysis. The dominance of philology over archaeology is a repeating pattern in the history of classical archaeology.[68] It is linked to the high prestige of philology in comparison with archaeology and to the separation of classical archaeology from mainstream art history and archaeology. Whilst other disciplines became differentiated from each other, on the basis of their specific objects of knowledge and methods of analysis, classics remained fused as a single field, able to resist pressures to differentiation by virtue of its prestige and unified by the ideology of Hellenism.[69] Hellenism and the transfer of philological orientations into archaeology and art history took the place of an engagement with the new theoretical perspectives and methodologies being developed in neighbouring, more disciplinarily specific, social and cultural sciences.[70]

These textual models of analysis have certain shortcomings as a framework for art history: they are not fully adequate to the specific materiality of art; they are over-reliant on an unexplicated concept of 'context'; and – like much theory derived from structuralism – they make it difficult to address in convincing ways the explanation of processes of change, which should be central to *history*.[71] We can see how these difficulties are interrelated from two examples. In 'Eros the

[66] R. Osborne (1994b), (1994c), Stewart (1997). [67] Boardman (1993) 2.
[68] Marchand (1996) 40–51. [69] I. Morris (1994).
[70] Dyson (1989). The extent of the myopia this has entailed is perhaps best exemplified by the extraordinary suggestion of one leading scholar that classical art history has nothing to learn from mainstream art history, since 'other art historians are barely approaching in the last generation the position achieved in classical art history nearly a century ago. Panofsky's iconology was not, to most classical art historians, a new concept at all' – Boardman (1988) 795–6.
[71] These difficulties are generic to post-structuralist art history. On the problematic character of the concept of context, and the difficulties in narrating change, which characterises these strands of the new art history, see Bal and Bryson (1991). For similar problems in the programme of the archaeology of contextual meaning, Tanner (1992) 170–3.

Hunter', Alain Schnapp analyses a series of Attic black-figure vases of the sixth-century BC with scenes of hunting.[72] His careful structural analysis reveals how the vases construct an opposition between two modes of hunting, namely pursuit with dogs and hunting sticks, and trapping with nets. He validates this reading by invoking a similar opposition articulated in fourth-century texts on hunting by Xenophon and Plato. Schnapp is surely correct to suggest that the two media reveal the same underlying cultural codes, but he is unable to address why in the sixth century the code should be materially manifested in a visual medium, on pots for use in the symposium, whilst in the fourth century we encounter it only in philosophical texts, designed for consumption by a very restricted cultural elite. The linguistic model, seeking access to deep underlying cultural codes, effaces the significance of the specific material medium through which such codes are materialised and mobilised in specific institutional contexts, with specific audiences, with correspondingly differing social ramifications and effects.

Deborah Steiner's interesting cultural analysis of the Greek visual imaginary, *Images in Mind*, raises similar issues.[73] Her focus is on the ways in which the visual arts, in particular sculpture, are represented and used in literary texts, and the implications of such uses for how the Greeks conceptualised the significance of statuary within their culture. She also seeks to explore the links between literary tropes or motifs and technical and stylistic innovations in contemporary sculpture. Sometimes the parallels between word and image are contemporary, but often they are not. So, for example, the descriptions of works of art in the Homeric and Hesiodic poems are held to 'anticipate' the interests of early classical sculpture in the close replication of 'visible or living reality', whilst the simulation of breathing in such statues is celebrated in later Hellenistic epigrams.[74] Once again, the temporal gaps in the visual preoccupations of different material media – poems and statues – are left largely unexplained: why should it be only in the fifth century that ideas commonplace in Homeric poetry should be picked up in the visual arts, or, conversely, only in the Hellenistic period that poetry should become much interested in what seem to us to be the most salient features of fifth-century statues?

The major methodological problem with using texts as analogues for images is that there are as likely to be too many as too few potential analogues, and different texts may suggest wholly different, even incompatible, models according to which one might read visual images. In practice, the weight accorded to any text as an indicator of common patterns of thought and practice is linked

[72] Schnapp (1989). [73] Steiner (2001). [74] Steiner (2001) 26–8.

to tacit sociological assumptions about contexts of communication: how those verbal representations circulated, and to what extent they significantly shaped dominant social and cultural practices, and the institutions that gave rise to such practices. Steiner, for example, is never able adequately to resolve the tension between sceptical accounts of images of deities and their efficacy, found in philosophical and dramatic texts, and other evidence which suggests such images were still the object of religious reverence and ritual attention. She simply juxtaposes one account focusing on admiration of Pheidian statuary as 'dead things formed by human labour', objects of purely aesthetic admiration of artists' *technē*,[75] with another centred on their ritual appropriation,[76] offering only the possibility that the former group of statues were merely 'votive', while the latter were 'cult' images, a distinction which, she admits, 'would probably have been lost on the ancient viewer'.[77] Of course, both kinds of readings were possible, but – for a *historical* understanding of art – it is crucial to determine which practices and representations were dominant, in which periods and contexts, in order to determine what concepts and what cultural orientations shape actual processes of art production, dominant identity-forming appropriations of works of art and patterns of artistic change.[78]

To be fair, Steiner's readings do sometimes have such sociological controls, as does some of the best of the new classical art history – but only implicitly. For example, in evaluating, on a purely cultural and visual level, two equally plausible readings of the erotic allure of late fifth-century sculpted representations of Nike, Victory – as representing that which is desirable but which lies forever beyond the viewer's grasp, as opposed to a symbol of the pleasurable enjoyment of the divine favours of the goddess Nike realised in and accessible through military victory – she selects the latter reading on the basis of its greater appropriateness to the rhetorical function of public monuments intended to celebrate victory and motivate citizens to risk their life in its pursuit.[79] Such sociological insights, however, need to be systematically and explicitly incorporated into art-historical approaches if textual analysis, together with image

[75] Steiner (2001) 103–4. [76] Steiner (2001) 105–13.

[77] Steiner (2001) 104. Cf. 99–100 where Steiner argues that the new strategies employed by cult-statue makers in the fifth century, in particular colossal scale and the choice of precious materials like gold and ivory, were 'anticipated' in descriptions and evocations of gods in the Homeric poems. But why is it only in the fifth century that artists chose to *materialise* these particular conceptions in sculptural form, and how consistent is her suggestion that the 'new'-style cult images were objects of purely aesthetic admiration with the very traditionalising representational choices being made in terms of materials, size, and so on?

[78] To suggest a parallel, Marx's *Communist Manifesto* probably circulated as widely in early twentieth-century Britain and Germany as in Russia, but only in the latter was it appropriated and implemented in such a way as to have institutionally formative effects: text analysis alone cannot explain the differences.

[79] Steiner (2001) 238–45.

analysis based on predominantly textual models, is not either to generate the kinds of confusion we have already seen, or to degenerate into philological word/image-play and produce new forms of Hellenist assimilation of past to present.[80] My purpose in this book is bring to classical art history the conceptual tools which will make possible the explicit and systematic exploration of what in most current work is at best tacit background, or, in Hellenist art history, assimilates the ancient to the modern institutional arrangements for the production and reception of art. Only thus will it be possible to develop convincing explanations of why artistic changes occur when and as they do, and to show what the consequences of those changes might have been. Further, it is only through developing generalising concepts and models, applicable to processes of social and cultural change in other cultures, as well as in Greek culture, that one can, through a comparative perspective, identify what is similar in Greek and other (whether modern western or, for example, imperial Chinese) artistic cultures and what is unique to the Greek world.

Sociological perspectives on Greek art

In the remainder of this chapter I wish to sketch a sociological framework for the understanding of Greek art, which will have three purposes: (i) to provide an analytical account of visual art and how it works that pays adequate attention to art as a form of material culture, which is not only shaped by society, but in turn has social effects particular to its specifically aesthetic-expressive character; (ii) to develop a more analytic framework for comparing the social structure and cultural patterning of art institutions in contemporary and past societies, which goes beyond the crude opposition between primitivists and modernisers by doing justice to the real parallels in certain aspects of the development of art institutions in ancient Greece and the modern West, without assimilating one to the other in the way characteristic of the traditional Hellenist paradigm; (iii) to develop a framework which not only *interprets* art, but also seeks to *explain* developments in art and in the institutional frameworks of art production and consumption in the context of long-term social and cultural processes.

[80] Two nice examples of stimulating and creative, but ultimately quite misleading, 'neo-Hellenist' anachronism are: (1) R. Osborne's (1994b) reading of centaur iconography in fifth-century public sculpture as deconstructing the manifest opposition between orderly Greek citizens and their hostile others as objects of proper polemical control, cf. Tanner (1994); (2) Beard and Henderson (2001) 71 reading the aesthetic programme of emulative imitation in Roman 'copies' of Greek statues through the lens of postmodernism. The real insights of the latter (as against traditional approaches in terms of an opposition between imitation and creativity) are translated into a less anachronistic and sociologically more adequate model in chapter 6.

Art as expressive symbolism

Art historians largely take for granted the concept of art as such, and see their role as the interpretative decoding of the work of art, either as autonomous object – in formalism – or as a partially autonomous cultural object seen against the background of a broader social and cultural 'context' in the more contextual variants of art history.[81] Rather than focusing on the hermeneutic interpretation of symbolic *meanings* encoded in an ostensibly autonomous object, sociological approaches seek to explain what art *does* in contexts of social interaction.[82] They suggest that the implicit model of the dominant paradigm in art history is a special case of the social construction of aesthetic experience, linked to the autonomous institutionalisation of art in the high-cultural institutions of the modern West, as sketched in the introduction to this chapter.[83] The key questions for the sociology of art are: how does art contribute to ongoing social processes? What role does it play in the constitution, reproduction and transformation of social relationships, social groups and social structures? And conversely, how does the role of art in social life affect the cultural patterning of art?

Such a functional account of art sees the contemplative relationship to art, as an autonomous object of disinterested aesthetic pleasure, as one particular mode of institutionalisation of a form of symbolism which is constitutive of all interaction systems, namely expressive symbolism.[84] An expressive symbol is any act or object which stands for the feelings or attitude of one person towards another and thus mediates the affective component of interaction. The nature and significance of such symbolism can best be illustrated through its prototypical instance in the context of the mother–infant relationship. When the mother cares for an infant, certain acts which have an instrumental function in meeting the infant's primary needs – for warmth, food, cleansing, and so on – acquire, through processes of symbolic generalisation, a secondary meaning as indications of the disposition or the attitude of the mother towards the child, namely her feelings of caring and love. These expressive meanings are extended to acts which surround the more purely instrumental, for example modes of touching and talking associated with feeding the baby or caring for it. The development of such symbolism is crucial to the socialisation process, since it underpins the development of an attitude of mutual affection between mother

[81] Podro (1982), Baxandall (1985), Bryson (1992). [82] Gell (1998), Witkin (1995).
[83] Witkin (1995), Bourdieu (1996).
[84] This conceptualisation of art was developed in the work of the American sociologist Talcott Parsons: see especially Parsons (1951), (1953). For a full discussion of Parsons' theory in relation to mainstream archaeological and art-historical theory, see Tanner (1992), (2000a), which I summarise here.

and child. This allows the mother, as later other adults who acquire emotional significance for the child, to persuade the child to accept discipline and hard-ship, for example in learning new competencies and behaviours, in order to secure the mother's affection and approval. As social systems become more differentiated, there may develop an increasingly specialised concern with expressive symbolism, manifested in the production of objects with a primarily expressive significance, leading to the emergence of the 'artist' as a specialised role – the bronze statuary, say, differentiated from the producer of objects whose primary function is instrumental, like the armourer (although even here of course armour may have expressive dimensions, perhaps through styl-istic or iconographic elaboration, in addition to its primary functional pur-pose). Ultimately, a sufficiently highly differentiated expressive symbolic system can, as in the modern West, become an autonomous subsystem of a society, with its own constitutive norms and values.

This account of art, as a functionally specific type of cultural symbolism, has more in common with the pragmatist semiotics of Peirce than with the struc-turalist and post-structuralist theories of art modelled on Saussure's account of the radically arbitrary nature of the linguistic sign and highly influential in the more theoretically informed strands of recent classical studies. Expressive symbolism is grounded in the structure and potentialities of the human organ-ism. Its specific effects depend upon the exploitation of capacities for sensuous expression that are built into the human body as a biological organism and that are variably elaborated during the course of processes of socialisation and enculturation. The various components of artistic culture identified by art historians – motifs, compositional patterns, style – accomplish on a much higher level of cultural generalisation the same kind of expressive work per-formed by the mother's body and gestures in her relationship with her infant. That is to say, they construct affective experience on the basis of cultural-level codifications of sensuous form generated in some degree of abstraction from immediate social relationships. These ways of culturally organising affect can then be mobilised in specific social contexts, in order to motivate affective commitment to other systems of cultural representation (for example, religious ideologies) or to the demands placed on individuals in their various social roles, as we shall see in more detail in the case studies in chapters 2–6.

Social structure and cultural rationalisation in ancient Greece

What such abstract accounts of artistic differentiation leave open is how one can explain why the differentiation of art, both as a cultural system and as an

institutional domain, should have taken significantly different courses in different cultures. It is here that another strand of sociological theory can be of some help to us, namely Max Weber's studies of the economic ethics of the world religions. Briefly, Weber argued that the very different paths of economic development taken in late medieval and early modern China, India and Europe – notwithstanding material conditions which were somewhat more favourable to the development of capitalism in India and China – were heavily shaped by the interaction between those material conditions and ways in which the cultural ideals of key social groups influenced their practical behaviour, with unintended consequences for economic development. The most important of Weber's concepts was that of 'rationalisation', by which he meant the subjection of aspects of life to methodical control through processes of calculation or the orientation of the conduct of an aspect of life to systematic reflection.[85] He distinguished between 'theoretical rationalisation' (the systematisation of patterns of ideas into a logically coherent unity), 'formal rationalisation' (the systematic organisation of a domain of life or sphere of action in terms of its own inner logic) and 'substantive rationalisation', which systematically orders action in accordance with certain value premises.[86] Different levels of rationality in actions can be assessed in terms of the number of aspects of action (means, ends, norms and values) which are the objects of choice on the part of the actor following processes of systematic reflection, and the degree to which different domains (the religious, the artistic, the scientific, the economic, and so on) are organised in terms of their own intrinsic inner logics, rather than being subject to external constraints, as when, for example, economic action is constrained by ethical conventions or religious taboos – the Christian prohibition on usury, or the taboos of the Indian caste system.[87] In the case of art, rationalisation processes can be relevant to reflective thought about the means of achieving specific aesthetic-expressive ends (as opposed to the unreflective acceptance of traditionally sanctioned iconography and style) and to the goals and purposes of artistic production and expression. In the Greek case, Polykleitos, in his canon, might be thought to be particularly concerned with the former, and both Plato and the Sophists, in their debates about the functions and purposes of art, with the latter. Such processes of artistic rationalisation are shaped by the social settings within which art is produced and

[85] Weber's use of the concepts of rationality and rationalisation is notoriously complex, and somewhat contested amongst specialists in social theory. In what follows I draw on the expositions of Habermas (1984) 143–272, Schluchter (1981), Kalberg (1994) and especially Kalberg (1980), which provides the clearest introduction. On the religious underpinnings and cultural shaping of rationalisation processes, see Weber (1946a), (1946b).
[86] Kalberg (1980) 1155. [87] Schluchter (1981) 130; Habermas (1984) 168.

consumed, as well as by the value frameworks within which such processes occur, whether relatively concrete values, such as a primacy placed on a particular role model, the hoplite farmer in the classical Greek city state or the scholar official in classical China, or the more abstract value systems characteristic of philosophical and religious systems like Platonism, Stoicism, Confucianism, Taoism, Buddhism, Hinduism or Christianity.

Weber's concepts of rationalisation offer a useful framework for understanding some of the major processes of social and cultural change in ancient Greece, suggesting parallelisms with similar changes in other cultures, whilst insisting on the specific character of the structure and outcome of those processes in ancient Greece.[88] This depended on the particular character of the dominant world-view which emerged in the Greek world, the particular pattern of affinities and antagonisms between that world-view and rationalisation processes in different social and cultural domains, the particular nature of the cultural elites who were the bearers of rationalisation processes, and the social settings in which they found themselves.[89]

Rationalisation was a complex and long-term process in ancient Greek culture and society, although one with certain qualitative transitions, if not the miraculous births of rationality associated with the traditional grand narratives of Greek reason.[90] Already within societies represented in the Homeric poems, the warrior assemblies afforded a model of egalitarian social relations in which resolutions about courses of action were reached on the basis of rational debate rather than magical-religious forms of decision finding. Magical-religious and mythical modes of thought did, of course, still determine many realms of practice, as can be seen from Hesiod's description of the religious conceptions which shaped the activities of the agricultural year, and of the *basilees*, 'kings' or 'chiefs', divinely endowed with a special authority and ability to resolve disputes between men, and correspondingly deferred to like gods by ordinary people as they conducted their business in the agora.[91] One crucial structural factor in the expansion of secular and rational models of discourse was the development of the polis, or citizen state, which may have been characterised by principles of citizen equality as early as the eighth century BC, although throughout the archaic period such principles were contested by an aristocracy which claimed status and authority on the basis of a special relationship to the gods, periodically bolstered through the appropriation of exotic eastern forms of social and

[88] Bremmer (1999). [89] Kalberg (1994) 113–15.
[90] My sketch here relies on Detienne (1996), Vernant (1982), I. Morris (2000), Bryant (1996).
[91] Hes. *Op.*, and *Theog.* 79–93; I. Morris (2000) 165–6; Detienne (1996) 55–67.

cultural capital.[92] A crucial development, tipping the balance definitively in the direction of increasing equality and the promotion of rationalisation, was the 'hoplite reform'. Heavy-armoured infantry fighting in disciplined formation replaced the individual beserking warrior and also the cavalry that was characteristic of the aristocratic Homeric world. Gradually, the broad body of citizens capable of supplying their own armour took on a political role proportionate to their military importance to the security of the polis. The Hesiodic *basilees* lost their role in dispute resolution, which was taken over by courts, themselves constrained by legal codes that were at first created by individual law-givers and sanctioned by religious sources such as the Delphic oracle but later, in the classical period, came under the full control of democratic assemblies, through enacted legislation and popular courts. The hoplite reform and the processes of democratisation also gave rise to new cultural values and norms of social conduct. The individual frenzy of the heroic warrior of the Homeric epics was displaced by a valuation of rational self-control (*sophrosunē*), a necessity in hoplite warfare, where each man and the integrity of the fighting unit (the phalanx) depended on the self-discipline of his neighbour, whose shield protected the first man's exposed right side. The changing power differential between the old aristocracy and the rising hoplite class ultimately undermined the deference towards the former that had been taken for granted. It also promoted an emphasis on mutual respect amongst all citizens. The individualistic self-assertiveness of the old order became misprised as *hubris*, outrage, and was replaced by an emphasis on moderateness and order in all things, *metriotēs* and *kosmiotēs*.

Greek rationality has aptly been characterised as fundamentally 'political'.[93] It was the political sphere that was the first to become separated out as an autonomous domain with its own specific logic and that in some degree dominated other rationalisation processes, in particular artistic ones but also economic and scientific rationalisation.[94] It was the political order that provided the model both for the forms of secular debate that informed the development of Greek philosophy and science, and for the conceptualisation of the cosmic order by such thinkers as Thales and the early Milesian philosophers in the late sixth and early fifth centuries.[95] The dominance of language, *logos*, in Greek thought owes much to this political background, developing out of secular discourse in warrior assemblies. In the classical period these processes of rationalisation were carried much further, with logos/language at their core,

[92] I. Morris (2000). [93] O. Murray (1991).
[94] Finley (1973), Lloyd (1979), (1990); Meier (1990) 218–20. [95] Lloyd (1979), Vernant (1982) 107.

through new cultural elites exploiting the development of literacy: first, the sophists, studying and using language as a tool for the rational control of social relations, above all in the context of democracy; second, scientists and the self-designated 'philosophers', most notably Plato, seeing language as the primary means to knowledge of the true nature of reality, itself conceptualised as a rational order with language-like properties in Plato's theory of the Forms.

These processes of cultural rationalisation stood in an ambiguous relationship to traditional religious culture and traditional educational institutions. Hitherto, a central role in the articulation of Greek moral and religious culture had been played by poetry.[96] The gods, their genealogy and functions were defined in Hesiod's *Theogony*. The mythic history of each city was defined by the great Homeric poems, and, with more local detail, by the poets of the epic cycle, poetry in the epic tradition and, at Athens, tragedy. Ethical codes were articulated in the concrete form of narratives rather than as abstract logically interrelated principles. Even in fifth-century tragedy, where the clash between traditional thought and the developing rationalist culture was dramatised, moral ideals are articulated in aphorisms and proverbs, ethical dilemmas in terms of concrete narrative situations and their unfolding, rather than in terms of the systematic ethics logically elaborated from a simple set of explicit abstract principles such as were later developed by Plato and Aristotle.[97] The relatively low level of intellectual abstraction of this social stock of knowledge was linked to and reinforced by its primary means of transmission in a pre-literate society, namely oral *paideia*. Metre, music and dance, which accompanied the recitation and performance of these poems, ensured this stock of knowledge was not merely known but embodied. Ethical exemplars were not reflected upon, but enacted in poetic performance. The cognitive and the moral were fused with an emotional toning derived from their sensuous expression in music and dance. Moral thought was scarcely distinct from bodily reflex. Life, ideally, took the form of an unreflective but situationally appropriate acting out of this deeply internalised *paideia*.

New religious movements and the intellectuals who were the predecessors of those we now know as philosophers, Pythagoras and Xenophanes for example, had begun to systematise Greek religious ideas during the course of the sixth century. They criticised the traditional polytheistic conception of an enchanted world inhabited by a multitude of gods, and both the ethical conduct associated with them and the magical-ritual practices traditionally understood to secure their goodwill. In its place, they developed a more transcendent conception of

[96] E. A. Havelock (1963) 125. [97] E. A. Havelock (1963) 94–5, 185–90.

the sacred, articulated in terms of certain rational principles which gave order to the universe, and in which humans might participate through methodical practices designed to purify their most rational element, the *psychē* or soul.[98] Such ideas, however, remained restricted to small cultural elites, and it was only in the late fifth century that new forms of education, making significant use of books and literacy, *grammatikē*, began to challenge the traditional monopoly of poetry, choric performance, and physical education – *mousikē* and *gymnastikē* – possibly in part the result of the increasing importance of literacy in the administration of democratic Athens and its empire.[99] A crucial role in this process was played by the sophists, itinerant wise men who charged pupils for an education in *politikē technē*, rational and rationally transmissible techniques for political success. Sophistic studies concentrated on forms of argumentation, logic and the critical analysis of language, in order to understand how persuasive effects were achieved through the medium of language. This knowledge could then be applied in the contexts of debates in the political assemblies and law courts of the polis.[100] Philosophers – the 'lesser Socratics' – also taught for money, but their education, whilst dependent on the same more generalised rationalist culture as that of the sophists, was more directly oriented to wisdom (*sophia*) and the spiritual perfection of the individual than the pragmatic concerns of the sophists.[101] In the course of the fourth century these two strands of the new education received institutional form in Isokrates' school of rhetoric and Plato's Academy, followed by the later philosophical schools – Stoics, Peripatetics, Epicureans. Philosophy and rhetoric were both rooted in the same process of rationalisation, and they hold in common their primary value commitments, above all to reason and education (*logos* and *paideia*). They were used to construct a common value-infused pattern of life, which came to be perceived as entitling its bearers to deference.[102] The same word – *logos* – signifies both speech and reason. Isokrates regarded rhetorical education as a form of philosophical *paideia*.[103] Rhetoric was taught in all the philosophical schools, even in the Academy by Plato's foremost pupil, Aristotle. Mathematics and philosophy formed part of the foundation course for Isokrates' training in rhetoric.[104]

The philosophy of Plato and Aristotle takes for granted the polis, a community of citizen hoplites, as the background to their social and ethical thought, notwithstanding the additional transcendental anchorage of their ideas in commitment to some notion of reason as the ultimate and most highly valued constituent of reality. The defeat of the independent Greek city states by the

[98] Bremmer (1999). [99] Morgan (1999b). [100] De Romilly (1992), Marrou (1956) 46–56.
[101] Marrou (1956) 62. [102] Cf. Shils (1982b). [103] Isoc. *Antid.* 292–4, 304. [104] Marrou (1956) 91.

Macedonian kings Philip and Alexander in the late fourth century, and their subsequent subjection first to the Successor kingdoms and then to Rome, effectively demilitarised the elites of the Greek cities.[105] This severed the functional link between concepts of ethical propriety such as *metriotēs*, *sophrosunē* and *kosmiotēs*, and their original grounds in the norms of conduct and educational practices appropriate to an egalitarian body of citizen hoplites.[106] Whereas Plato and Aristotle had to a greater or lesser degree subordinated education to the heteronomous value of politics, Hellenistic-Roman culture valued education and the word in their own right. Treatises in education are no longer entitled *politika*, but *peri paideias*.[107] *Mousikē* – central to traditional oral *paideia* – was eliminated from the curriculum altogether, whilst athletic and physical education (*gymnastikē*), considered essential to military preparedness in fourth-century educational treatises, had been defunctionalised to the extent that victor statues might be set up not just to winners of competitions but also to those who, whilst not possessed of sufficient athletic prowess actually to win competitions, had sufficiently wealthy fathers to ensure their immortalisation in bronze.[108] The literate education of philosophy and rhetoric dominated the educational system and became a symbol of elite status and identity.[109] *Logos* as reason legitimated elite status and power by grounding them in a lifestyle infused with values linked to concepts of the sacred. *Logos* as speech was a major instrument of power. It allowed civic elites to dominate decision-making processes within their own cities and – through letters, speeches and embassies – to mediate the power of forces which stood over and periodically impinged upon life in the cities – Hellenistic kings and Roman emperors.[110] Than the power of *logos* (λόγου δύναμιν), the first-century BC Greek historian Diodoros of Sicily asserts,[111]

[105] The second-century AD Greek writer Plutarch, in his *Precepts of Statecraft*, argues that military leadership and the glory which can be derived from it have no role to play in contemporary statecraft, unlike in the classical age of Perikles. Brilliance in a public career is the preserve of the orator, participating in public trials and embassies to the emperor. See the excellent discussion of Goldhill (2001a) 7–8.

[106] Whilst much of the vocabulary survives, its meaning is transvalued in an idealistic direction: Panagopoulou (1977). *Eutonia*, literally meaning 'well-strungness', was a term originally applied to the muscle tone and physical vigour of a well-trained athlete, but in the Hellenistic and Roman period it increasingly connotes the fine-tuning or proper tension of the well-trained soul (to which gymnastic metaphors were also applied), abstracted from the physical reference characteristic of the fifth and fourth centuries. Similarly, *eutaxia*, a capacity for maintaining order in the line of battle, is used to refer to the orderliness of the soul in the conflicts of life. See Long and Sedley (1987) I.415–19; Galen *De plac. Hipp. et Plat.* IV.403–4 (Kühn); Stob. II.115.5–17.

[107] Marrou (1956) 100. [108] Morgan (1999a) 13–14; Van Nijf (2001) 327. [109] Morgan (1999a) 22–4.

[110] Cf. Brown (1992) 35–70, most of which is equally applicable to the Hellenistic world and the Roman Principate as to the late empire which Brown discusses.

[111] Diod. Sic. I.2.5–6.

one may not easily find a finer thing. For it is by means of this that the Greeks are superior to the barbarians, the educated (πεπαιδευμένοι) to the uneducated. In addition, it is by means of this [i.e. *logos*] alone that one man may have superiority over the many ...

The ethos of the social and cultural elite, an aristocracy of reason, to which this value system and pattern of education gave rise, is best characterised through a sketch of the primary teachings and ethical practices of Stoicism, the dominant strand of Hellenistic-Roman philosophy.[112] Stoicism conceived the sacred as world-immanent Reason.[113] The universe was a living organism, Nature, with a soul which was Reason itself, *logos*. Reason/*Logos*/God is always knit together with matter in the cosmos. *Logos* gives matter form as one or another element: fire, water, air, earth. The divine Reason that animates the world and directs its natural process of development (φύσις) is both fateful and providential. Man is integrated in the cosmic order by virtue of both his materiality and his essential reason. He is most fully himself, most as he is designed by Nature (Φύσις) to be, when he acts most fully in accordance with the highest standards of human reason.[114] The adequacy of any particular example of human reason, and of human reasoning in general, is demonstrated by its concordance with divine Reason manifested in the structure and processes of Nature. Man, through understanding the processes of Nature, becomes able to adjust his attitudes, dispositions and conduct to a harmonious fit with Nature's providential and inevitable course.[115] If the good life is defined by this state of reasonable, harmonious concordance with the processes of Nature, the Stoic problematic of 'evil' (if it can be called that) is defined as ignorance. Failures of knowledge or reason allow impulses (*hormai*), rooted in our animal nature, to get out of control and thereby disturb the smooth harmonious pattern of life of the reasonable man. Fear of death, which is, for example,

[112] Shaw (1985). My concern here is a general ethos, not the particular details which separated different philosophical schools in the Greek world, or indeed different Stoics. For all their differences, Plato, Aristotle and the Stoic Zeno all believed that man's natural essence was defined by his rationality, and all were committed to one form or another of an ideal of contemplative life through which man might most fully realise his capacity for reason: Long (1974) 110. Even the supposedly materialist Epicureans speak of reason as a charismatic phenomenon by means of which adherents to Epicurus' teachings may be saved from the travails of human ignorance. Competition between the various schools promoted mutual intellectual assimilation as well as differentiation. Stoicism, probably the dominant school, came to form a common point of reference from which adherents of other schools might define the particular details of their beliefs: Lacy (1974), Shaw (1985) 17. Members of the social elite, philosophically educated but not in themselves philosophers, constructed their own eclectic syntheses on the basis of the teachings of masters from a variety of traditions. These ideas became part of the shared cultural horizon of the social elites of the post-classical Greek and Roman worlds, and thereby shaped a common ethos.

[113] My account is drawn from Bultmann (1956) 123–32, 135–45; Gernet and Boulanger (1932) 389–91, 488–97; Long (1974); Sandbach (1975); Solmsen (1963).

[114] Diog. Laert. VII.86–7: Zeno. [115] Diog. Laert. VII.87–8.

manifested in a physical contraction of the *psychē* that produces the symptoms of fear (nausea, paleness, an increased heart rate, and so on), may give rise to an impulse to behave dishonourably in order to escape this object of fear. True reason, however, will tell us that death is morally indifferent since it does not affect our inner being, our rational self, but only our outer body. The disequilibrium which fear had introduced into our psychic state is thus assuaged by reason, and man is, by preserving his inner spiritual harmony, able to adapt rationally to death which is after all part of the process of Nature.

This rational psychic equilibrium was inculcated through philosophical and rhetorical education, and maintained by a range of ethical practices which involved insistent self-monitoring. All conduct must be oriented, by a sense of responsibility for the divine element within, to fit one's higher rational nature.

Do you not wish to recall, whenever you eat, who you are that is eating, and whom you are nourishing? And whenever you engage in sexual relations, to recall who you are who engages in such relations? Likewise in your social intercourse, or in physical exercise or conversations, do you not know that it is God whom you are nourishing and exercising? ... Yet even when God himself is present within you, seeing and hearing everything, are you not ashamed to think and act in these ways, so little aware of your own nature, so estranged from God?[116]

It is only through a life of unremitting acquisition of knowledge of the natural order of things, contemplation upon that knowledge and repeated application of its principles to one's life, only through teaching, training and continual practice, that a man may fully realise the rational nature to which he was born and achieve the Greek equivalent of the state of grace.[117] As Plutarch says:

the best and most divine state of being in us, which we conceive to be rightness of reasoning, the peak of a reasonable nature, and a corresponding disposition of the soul.

τῆς ἀρίστης καὶ θειοτάτης ἕξεως ἐν ἡμῖν, ἣν
ὀρθότητα λόγου καὶ ἀκρότητα λογικῆς φύσεως καὶ
διάθεσιν ὁμολογουμένην ψυχῆς νοοῦμεν.[118]

SUMMARY

The studies that follow explore the relationship between the developments in social structure, cultural change, and artistic rationalisation in ancient Greece, implicitly in comparison with the processes (sketched earlier in this chapter)

[116] Epiktetos, *Diss.* II.8.12–14; cited in Foucault (1988) 168. [117] Sen. *Ep.* 110.8; 90.46.
[118] Plut. *Mor.* 24e.

which led to apparently quite similar outcomes in the modern western world, most noticeably in the invention of the practice of art history writing. Chapters 2 and 3 look at the emergence of 'naturalism' in representations of deities and in portraits of men, a development that has often been held to mark the creation of autonomous art as such, emancipated from the religious stereotyping supposedly characteristic of the art of the Near East and Egypt. I explore the institutional embeddedness of both the production and the consumption of cult images and portrait statues. What did people do with cult statues and what did cult statues do to them? How did the visual language of naturalism shape relationships between men and gods, and to what extent can changes in the institutional contexts of the production and consumption of such imagery help us to explain the development of naturalism? How did the Greeks conceptualise 'portraiture'? Why did they make portraits and how did they use them? What kind of vocabulary did viewers use in the appropriation and evaluation of portraits? How did this shape the forms of the portraits themselves and their effects both in shaping relationships between the state and those portrayed, and in forming the identities of portraits' viewers? Chapter 4 addresses the role, status and agency of visual artists in classical Greece, and in particular how this was transformed by the representational problems and possibilities posed by naturalism. It explores the intersection between the changing relationships between artists, their work and their patrons, and other processes of cultural rationalisation – the development of scientific medicine, of philosophy and rhetoric – which took place in the classical period. It examines how the intersections between these processes both promoted the emergent autonomy of art – including artists' claims to enhanced status – and set rather marked limits to it. Chapter 5 examines the transformation of the legacy of the art writings of classical artists in the context of the new cultural institutions – the Library at Pergamon and the Mouseion of Alexandria – of the Hellenistic Kingdoms, and in particular the invention of the practice of art history writing. It suggests that, although there are marked parallels in the way connoisseurship functions as a marker of social status in ancient and modern high culture, ancient high culture is characterised by a distinctive aesthetic ethos fundamentally shaped by the rationalist emphasis of Greek metaphysics and intellectual culture. In the epilogue I examine how the development of a historical orientation to art shaped artistic agency and affected art production in the Hellenistic-Roman period. Whilst there are important parallels between the invention of art history and the construction of a culture of connoisseurship in ancient Greece and the modern West, both the contents of Greek elite culture and the relationship between the state, dominant elites and high-culture explain the rather different developmental path followed in ancient Greece from that of the modern West.

RETHINKING THE GREEK REVOLUTION: ART AND AURA IN AN AGE OF ENCHANTMENT

THE GREEK REVOLUTION

In the history of Greek art the boundary between the archaic and the classical periods is marked by a profound reorganisation of the languages of visual art, conventionally characterised as the development of 'naturalism'.[1] The most marked of the surface-level characteristics held to comprise naturalism are the 'presentational style'[2] of statues of gods and their iconography. Archaic statues of Apollo, for example, may take the form of a 'kouros' (figure 2.1),[3] sometimes adjusted to hold attributes such as a bow to distinguish the image as a statue of Apollo rather than any other male god or a man (figure 2.2).[4] The form of the statue, based on Egyptian models, is closed. The foot projected forwards symbolises – rather than giving an appearance of – movement, in an otherwise static image. The smiling deity stares forward into space, self-contained, self-sufficient, distanced from the viewer.[5] The fourth-century Apollo Patroos of Euphranor (figure 2.3), by contrast, interacts with the viewer in a way the archaic kouroi refuse to do. His weight on his left leg, he turns on the ball of his right foot. Ripples pass over the cloth of the peplos wrapped around his right leg, caught by its movement. As his torso follows his lower body, swinging gently towards the left, Apollo's head turns towards the right. Catching the viewer's gaze, he looks up, either raising his plectrum as he bursts into song or pouring a libation from a phiale, responding to the viewer's approach with a manifestation of divine power.[6] For statues of goddesses in the archaic period, there were two favoured types, either 'palladia' in the form of armed warriors, a

[1] Gombrich (1960) 99–125; Stewart (1990) 133–6. For a brief preliminary version of some of the arguments developed in this chapter, see Tanner (2001).

[2] Witkin (1995) 54–82.

[3] Vases with statues of Apollo as kouros: *LIMC* Apollon 5–6; archaic statues of Apollo in the form of a kouros: *LIMC* 7–9, 38 (Kouros of the Naxians, Delos).

[4] *LIMC* 432. On the date of the Apollo Piraeus: archaic – Dontas (1986), Mattusch (1988) 75–9; archaistic – Mattusch (1996) 129–40, Palagia (1997). Cf. *LIMC* 332 – Apollo Philesios, Didyma; 390 – Delian Apollo by Tektaios and Angelion.

[5] Stewart (1997) 65–7; Himmelmann (1989) 69–83, esp. 69–70 on 'closedness' as a structural characteristic of kouroi; Steiner (2001) 155.

[6] The right arm is restored from the elbow down. *LIMC* 145; Flashar (1992) 50–60; Knell (1994). See Stewart (1990) fig. 512 for a picture of the original Greek statue after which the Vatican statue is a Roman copy.

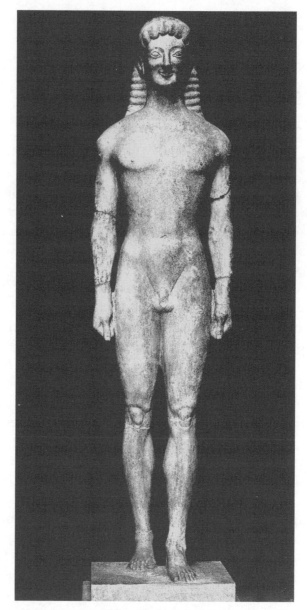

Figure 2.1 Tenea 'Apollo'. Munich, Glyptothek, *c.* 550 BC. After von Reber
and Bayersdorfer, 1898, pl. 457.

type common throughout the eastern Mediterranean world and adopted for
statues of Athena (and sometimes other goddesses[7]) like Endoios' Athena Alea

[7] In the sanctuary of Artemis Orthia, for example, one finds images of a goddess, armed and wearing an
aegis, who could be taken for Athena but for the bow, an attribute of Artemis, and of course the
archaeological context – *LIMC* Artemis no. 538 and p. 743.

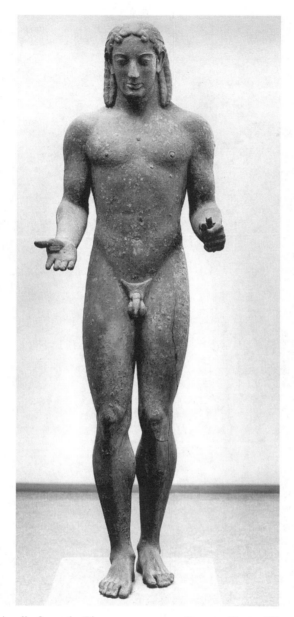

Figure 2.2 Apollo from the Piraeus, *c.* 530–510. Bronze. Photo: Hirmer 654.1835.

from Tegea (figure 2.4), or 'korai' (figure 2.5), based on Egyptian protoypes.
A similar shift in presentational style separates them from their classical succes-
sors like the Velletri Athena (figure 2.6), a copy of Alkamenes' cult statue for the
Hephaisteion (figure 2.7). The closed self-sufficiency of the archaic Athenas is
replaced by a goddess who seems to live and move in the same space as the

33

Figure 2.3 Apollo Patroos, by Euphranor. Roman copy, original *c*. 340–330. Vatican. Photo: Alinari 26936.

viewer. Her weight is divided between her left leg and her right arm, out-stretched to support her on a spear. Her arms reach forward into the viewer's space, embracing that space and by extension the viewer. The play of her drapery again gives us a sense of tangibility. The deep, dark, hollow folds of the free-hanging peplos contrast with the broad, light surfaces of the mantle

34

Figure 2.4 Statuette of Athena Alea from Tegea, *c.* 525–500. Possibly after the cult
statue by Endoios. Photo: DAI, Athens. Neg. NM 6121.

drawn tight from her hips to her lower legs by her flexed right knee. She engages
the viewer with her gaze, and with the libation she pours on his behalf.

Naturalism also comprises a fundamental reorganisation of divine iconogra-
phy, the phenomenal results of which can best be demonstrated by comparing
the representations of goddesses on the friezes of the Siphnian treasury and the
Parthenon. Only attributes or painted inscriptions distinguish the different
goddesses on the friezes of the Siphnian treasury, who have the appearance of
korai, but seated or in action.[8] On the Parthenon frieze, by contrast, one can
immediately distinguish the different goddesses on the basis of characteristic
bodily physiognomies: a 'matronal' Demeter, a 'boyish' Athena, and Aphrodite
'a fuller more fleshy figure'.[9]

[8] Lullies and Hirmer (1957) pl. 44–51; Stewart (1990) figs. 192–6.
[9] Peschlow-Bindokat (1972) 111; Himmelmann (1959); quotation: Younger (1997) 134. Stewart (1990)
 figs. 324–3; Jenkins (1994) figs. 78–80.

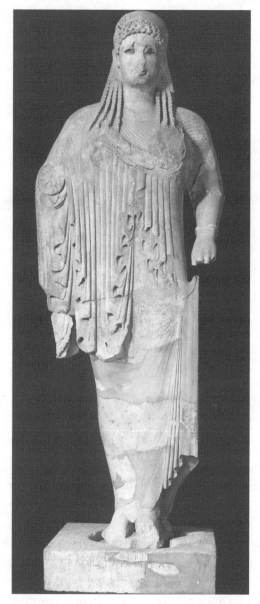

Figure 2.5 Antenor's Kore. Kore 681, from the Athenian Akropolis, *c.* 520 BC. Photo: Alinari 24654.

The emplotment of the story of Greek art in terms of the development of naturalism goes back to ancient art writers, most notably the elder Pliny. In the work of Winckelmann, however, the invention of naturalism and the casting off of the oriental inheritance of Greek art became associated with Enlightenment concepts of political freedom and personal autonomy

36

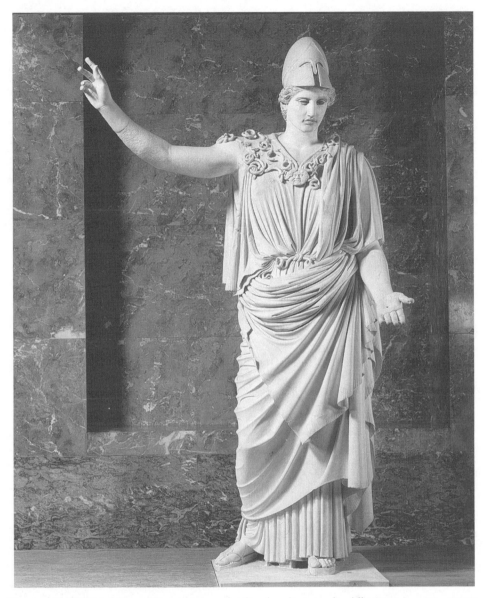

Figure 2.6 Velletri Athena. Roman copy of a Greek cult statue by Alkamenes, *c.* 420–410 BC. Paris 464. Photo: © RMN, Hervé Lewandowski.

held to be implicit in the creation of democracy in classical Greece.[10] Naturalism became a key component in a grand narrative of western identity, associating political freedom or democracy, scientific and philosophical enlightenment or emancipation from traditional religion, and naturalism held to

[10] Potts (1994).

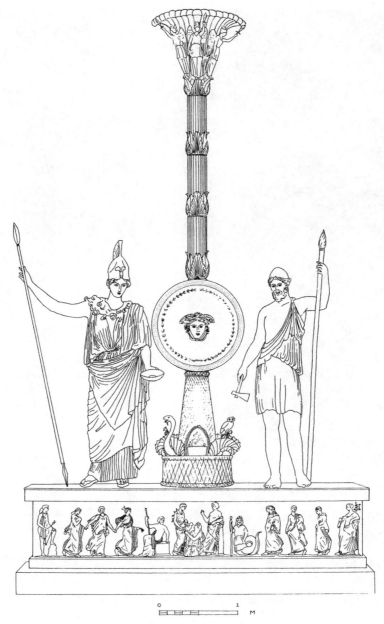

Figure 2.7 Cult group by Alkamenes from the Hephaisteion in Athens: Athena and Hephaistos, *c.* 420–410 BC. Harrison's reconstruction. After E. B. Harrison (1977) 140, illus. 2.

be the natural style of autonomous art. Whilst Gombrich was perhaps the last art historian to present a full-fledged version of this grand narrative of Greek naturalism, the analysis of classical Greek cult statues remains informed by its assumptions. Since naturalism marks the invention of 'art' as

such,[11] classical statues of deities are interpreted according to the protocols developed by Panofsky for Renaissance art. The iconographic content is interpreted either as a form of political propaganda, a 'message', or as an allegory of contemporary scientific and philosophical thought,[12] whilst the style of statues is interpreted as a symptom either of the artist's mentality or of the spirit of the period.[13] Even recent post-structuralist interpretations of classical statues of goddesses present us only with a new (feminist) allegory, this time of Greek patriarchy, in which statues of goddesses – almost exclusively Aphrodite – are decoded as symptoms of cultural attitudes to women in general and the *explanation* of change is largely ignored.[14] What is at best overlooked, more often strongly denied, is the possibility of a specifically religious significance for naturalistic cult statues.[15] Whilst Plato can be taken as an authoritative description of Greek aesthetic experience – to the extent that some see Plato's conception of mimesis and naturalism as two sides in a *mutation mentale* in which art becomes definitively differentiated from religion[16] – accounts of supposedly 'popular' fetishistic manipulations of and responses to cult statues have been relegated to a curious by-way in the history of religion, rather than informing in any substantial way interpretative and explanatory strategies employed in making sense of naturalism in statues of gods.[17]

In this chapter I use the concepts of Parsons and Peirce (see above, pp. 20–1) to develop a new set of interpretative and explanatory strategies. Traditional iconographic approaches have concentrated on either single statues or single deities. I shift the focus of analysis from individual objects and gods to naturalism as a cultural *system*. I characterise naturalism as a stylistic language defined by a particular presentational style mediating interactions between viewer and image, and generating an iconographic system with a particular structure and properties to be further defined in the course of this chapter. On this basis, instead of asking what does this particular statue or this style *mean*,

[11] Gombrich (1960) 120.

[12] Fehr (1979/80); Ridgway (1981) 10; Harrison (1977) 412; Ehrhardt (1997).

[13] Harrison (1977) 413; Pollitt (1972).

[14] Stewart (1997), R. Osborne (1994c), Neumer-Pfau (1985/6), Salomon (1997).

[15] Herington (1955) 36; Ridgway (1981) 10–11; Dietrich (1985) 177; Havelock (1995) 36 a notable exception. Most recent repetition of the traditional view: Steiner (2001) 101–4 on the new fifth-century statues as not objects of ritual, perceived merely as 'graven images ... dead things formed by human labour'. Yet on p. 113 she points out that the statue of Athena Hygieia on the Akropolis, third quarter of the fifth century BC, had a large table placed in front of it for cult offerings, and that the accounts for the statues made by Alkamenes for the Hephaisteion include similar tables as part of the cult equipment. Although she does discuss aniconicism and archaism as visual strategies with religious meaning, she sees no (or negative) religious significance in the development of naturalism, which she does not discuss as a strategy of religious representation.

[16] Vernant (1990a), (1991). [17] Gordon (1979), Faraone (1992), Donohue (1997).

I ask what does naturalism *do* as a functionally differentiated component of Greek religious culture.

In the second section of this chapter (pp. 40–55) I analyse the viewing of cult statues as a ritual process and a performative act, with a variety of 'interpretants' – sensory (visual, auditory, olfactory) and 'energetic' or behavioural as well as verbal and conceptual.[18] In place of the concentration on visual images extracted from any material context and decoded in terms of verbal signifieds, characteristic of traditional iconography and (post-)structuralism, I explore how the interpretative vocabulary at the disposal of viewers, the architectural framing of encounters with cult statues and the manipulation of sensory experience in such encounters predisposed viewers to experience their encounter with cult statues as an interaction with the deities themselves. Such practices engendered a particular structure of expressive responsiveness when viewers processed the 'material resistances' embedded in such images' sensuous artistic substance.[19] This raises the question of how the divergent aesthetic forms of archaic 'schematism' and classical 'naturalism' differentially put to work such a structure of receptiveness and response on the part of viewers, in order to produce specific, structurally quite distinct, expressive effects (pp. 55–92). The final section of the chapter (pp. 92–6) seeks first to uncover the causal mechanisms which acted as a selective pressure for the development of the new expressive system of naturalism, and second to consider the broader functional entailments and historical consequences of the new organisation of affect-production implicit in naturalism.

VIEWING AND RELIGIOUS EXPERIENCE IN ANCIENT GREECE

Image and aura in Greek civic religion

Religion may be understood as consisting in a set of symbols that articulate man's conception of and relation to the 'sacred', that which transcends everyday understanding and experience and is in turn invoked to give meaning at the 'breaking points' that are inherent in the human condition: illness, death, undeserved misfortune.[20] Although the specific content of religious symbols, the way in which they articulate the sacred and the conception of the sacred which they articulate vary greatly across religious traditions, the form of the religious experience has certain properties common to all religions:

[18] On Peirce's concept of 'interpretant', see the excellent discussion of de Lauretis (1983), especially 73–5.
[19] Cf. Jones (1996) 300–1; Tanner (2000a) 292–3, 299–301. [20] O' Dea (1966) 5; Bellah (1970c) 260–4.

The sacred indicates a power which, though it manifests itself in experience, lies beyond it, and the religious experience is an experience of this power. The religious experience is a response to things or events experienced as sacred – that is as a revelation of power eliciting a specific kind of response which combines both intense respect and strong attraction.[21]

Greek civic religion did not conceive the power of the sacred as a monolithic identity utterly transcending the world, like the Judaeo-Christian God of Creation, but as a network of powers 'each with its own dynamic and mode of action, its own sphere and limitations'.[22] Whilst transcending the realm of ordinary human life, these divine figures were immanent in the world and periodically manifested themselves in the mundane world of men. Greek religion was an 'archaic' religion:[23] there were permanent sanctuary sites with cultic equipment and a priest, but the clientele of these sites was transitory and not organised as a specifically religious collectivity. The symbolism of archaic religions takes the form of a 'mythic cosmology' characterised by a very high degree of interpenetration between the sacred world and the world of everyday life. The world is experienced as 'enchanted': 'Not only is every clan and local group defined in terms of the ancestral progenitors and the mythical events of settlement, but virtually every mountain, rock and tree is explained in terms of the actions of mythical beings.'[24] The atmosphere is nicely evoked by the words of Hegesias, a third-century BC historian, on his visit to Athens:

I see the Akropolis and there the mark of the prodigious trident [where Poseidon struck the rock to produce a salt-water spring when competing with Athena to be the patron god of Athens]; I see Eleusis, and I have become a mystic-initiate into its sacred things; there is the Leokorion, here the Theseion [hero shrines]; it is beyond my ability to point them out one by one; for Attica is the possession of the gods and the ancestral heroes, who have taken hold of it as a sacred precinct for themselves.[25]

In the context of such a system of religious symbolism, statues mark the presence of a particular sacred power. Physical control of the statue was tantamount to control of that power. Before the battle of Salamis, Herodotus tells us, the Greek commanders prayed to the gods, the heroes Aias and Telamon, and in particular 'sent a ship to Aigina (a nearby island) for Aiakos and the rest that were of his house'. Aiakos was the son of Zeus by the nymph Aigina, the grandfather of several heroes who had fought at Troy, a powerful figure whom (in the form of his image) the Aiginetans from time to time lent to friends in need. The ship from Aigina carrying (the images of) the Aiakides

[21] O' Dea (1966) 24. [22] Vernant (1983) 328–30. [23] Bellah (1970a).
[24] Bellah (1970a) 27. [25] Strabo IX.1.16.

arrived the next morning to lead the Greek fleet into battle with the Persians, and to victory.[26]

Possession of a cult image, which gave direct access to the power of the sacred, was linked to the sovereignty of the community that possessed the image. In the late sixth century the Aiginetans were subject to the political and legal authority of the polis of Epidauros on the mainland. In an attempt to assert their autonomy, they not only built ships in order to protect themselves, but also sought to enhance their access to the power of the sacred by capturing two statues of Damia and Auxesia, which the Epidaurians had set up on the instructions of the Delphic oracle in order to put their relations with the divine on a better footing during a period of famine. 'These images', reports Herodotus, 'they carried away and established in their own country, in its heartlands, at a place by the name of Oie, which is some twenty stades from the city. Having dedicated the statues in this place, they propitiated them with sacrifices and choruses of mocking women.'[27]

Attempts to gain sovereignty over other states, and the success or failure of such attempts, are expressed in two idioms which run in parallel: the one military, the application of force; the other religious, gaining access to the sacred power of a city through the medium of its cult statue. An Athenian attempt to bring Aigina under their control takes the form of a military expedition and an attempt to remove the images of Damia and Auxesia. Their failure is at once military and religious: a defeat at the hands of the Aiginetans' allies, the Argives, and refusal on the part of the images to budge. Indeed, whilst the Athenians pull at the statues with ropes, divine displeasure is manifested in a sudden earthquake and a thunderstorm; the members of the expeditionary force are struck with madness and kill each other.[28] Kleomenes, the king of Sparta, plays on these assumptions in his defence on a capital charge of having taken a bribe not to capture the city of Argos, following a failed attack on that polis. He told the court that he had quickly gained control of the main Argive sanctuary, the Heraion, at the border of Argos' territory. However,

he did not think it right to make any attempt upon the city before he had consulted the oracle, and learnt whether the god was prepared to give the city over to him or would stand in his way. While he was seeking auspicious omens in the temple of Hera, a flame of fire had flashed forth from the breast of the cult image. Thus he had ascertained the certain truth, that he would not take Argos. For if the flame had shone from the head of the statue, he would have taken the city from top to bottom. But because it shone forth from the chest, what he had already accomplished was all that the goddess wished to happen.

[26] Hdt. v.81; vɪɪɪ.64, 83; Plut. *Them.* 15. [27] Hdt. v.83. [28] Hdt. v.85–6.

Hera refuses the ultimate victory; Kleomenes withdraws his army.[29]

This close connection between the possession of cult statues, command of the power of the sacred and communal autonomy made such statues privileged symbols of civic identity. When the Phokaians abandon their city in Asia Minor to the advancing Persians and sail westwards to found a new community, they take their cult statues with them.[30] Similarly, when facing loss of autonomy to the Thessalians, the Phokians of central Greece prepare to express their loss of identity by immolating themselves and their cult statues on a vast funeral pyre.[31] Cult statues formed a focus for the projection of anxieties about civic identity, anxieties which might be allayed through ritual manipulation. As the long siege of Tyre by Alexander the Great was drawing towards its predictable close, some amongst the Tyrians dreamed that Apollo (whom they had themselves captured from the Geloans and offered cult as the chief deity of their city) 'told them that he was going away to Alexander, for what was going on in the city was not pleasing to him. But the Tyrians, as if they had caught the god like an ordinary human deserter in the very act of crossing over to the enemy, cast ropes over his colossal figure and nailed it down to its base, calling him an Alexandrist',[32] 'by this means, they thought, thwarting the departure of the god from the city'.[33]

This mode of representation and practice is not confined to the archaic period of Greek history nor dissolved by the Greek enlightenment. On the contrary, fetishistic practices are institutional in Greek civic religion until the supression of polytheism by Christianity.[34] When, shortly after the Persian wars, the Argives destroyed Tiryns, they carried off the old cult image of Hera – a small seated image, made of wild-pear wood and supposedly originally dedicated by Peirasos, the son of Argos and founder of the city of Argos – and rededicated it in their own Heraion.[35] This talismanic quality of cult statues was not restricted to primitive xoana inherited from the mythical past. Following his victory at Actium in 31 BC, the Roman emperor Augustus punished those communities which had supported his opponent Anthony, by depriving them of their autonomy and subjecting them to the control of other cities. This was symbolised by the removal of major cult statues either to Rome or to the cities under whose control the miscreant communities were placed. Among the latter was Kalydon,

[29] Hdt. VI.82. [30] Hdt. I.164. [31] Paus. X.1.6–7. [32] Plut. *Alex.* 24.3–4.

[33] Diod. Sic. XVII.41.8; cf. XIII.108. Cf. the Spartans tying down their statue of Enyalios to prevent him from deserting (Paus. III.15.7).

[34] Frischer (1982) 96–108; Merkelbach (1971); Faraone (1992); Freedberg (1989) 33–40; on fetishism, see Ellen (1988).

[35] Paus. II.17.5; V.23.3.

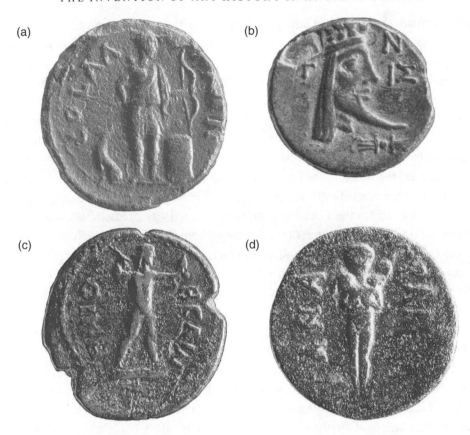

Figure 2.8a Artemis Laphria from Kalydon, by Menaichmos and Soidas, mid fifth century BC. BMC Patrae 38. Date of coin second century AD. Photo: Copyright The British Museum.
2.8b Dionysos of Methymna, coin from Antissa, third century BC. BMC Antissa 1.
Photo: Copyright The British Museum.
2.8c Zeus of Aigion, by Hageladas, *c.* 500 BC, on a coin of the mid second century AD.
BMC Aegium 1. Photo: Copyright The British Museum.
2.8d Hermes Kriophoros (Ram-bearer) from Tanagra, by Kalamis, on coin of the Roman Imperial Period. BM 1975.5–198–1. Photo: Copyright The British Museum.

whose cult statue of Artemis Laphria – a naturalistic chryselephantine statue of Artemis, representing her as a huntress, by the artists Menaichmos and Soidas, datable to the mid fifth century or shortly thereafter (figure 2.8a) – was given to Patras. Nearly two hundred years after the event, the people of Triteia, subjected to Patras by Augustus, and the people of Tegea still remembered with some bitterness the removal of their cult statues to Rome by Augustus.[36]

[36] Paus. VII.18.8–10, 22.6–9; VIII.46 Imhoof-Blumer and Gardner (1885–7) 76, no. 3, pl. Qvi-x for the series of coins.

Viewing as ritual performance

It followed from the status of cult statues as embodiments of the power of the sacred that access to them should be religiously framed, regulated according to religious norms and accomplished through ritual action. The viewing of cult statues often took place at moments of heightened religious significance in the life of an individual or a community, whether festivals or rites of passage, for example when brides dedicated to Aphrodite the *loutrophoroi*, water-carriers, used at their marriage ceremony.[37] The religious calendar determined the times at which one might view a cult statue. Having arrived on the wrong day, Pausanias, the second-century AD periegete, was unable to see the image of Artemis Eurynome at Phigaleia; the sanctuary was only opened on one day each year, during a festival at which both the city as a collectivity and individuals took the opportunity to offer sacrifices to the goddess.[38] However, at the sanctuary of the Mother Dindymene near Thebes, where the cult statue, dedicated by the poet Pindar, had been made by two fifth-century Theban artists, Aristomedes and Sokrates, Pausanias reports: 'On one day each year, and no more, they have it as established custom to open the shrine. And by good fortune it was the very day that I arrived, and I saw the cult image, of Pentelic marble, just like the throne.'[39] Similarly, the distance at which one might view or interact with the image was determined by one's ritual status. Only a female temple servant, qualified by ritual abstinence from sexual intercourse with men, and a virgin priestess were allowed inside the temple of Aphrodite at Sikyon and hence in intimate proximity with the statue of the goddess made by the fifth-century artist Kanachos: 'For all others it is established that they should gaze upon the goddess from the entrance and address her in prayer from the same place.'[40]

As Pausanias' statement suggests, one did not simply contemplate the statue in a state of detached aesthetic disinterestedness. On the contrary, one interacted with the statue, engaging with the sacred through ritual performance. Correspondingly, the viewer-worshipper had a profound interest in the outcome of the interaction. Cult statues in temples were privileged settings for praying to a deity 'face to face – *kat' omma*'.[41] Further actions – feeding, clothing and crowning statues – all served to blur what is to us the proper distinction between the statue as inanimate matter and the god.[42] When

[37] Elsner (1992), Kahil (1993). [38] Paus. VIII.41.5–7. [39] Paus. IX.25.3.
[40] Paus. II.10.4–5. Clerc (1915) 28: ritual restriction of access in the viewing of cult statues; Steiner (2001) 87–8.
[41] Literally 'eye to eye' – Eur. *Andr.* 1117; Corbett (1970) 151.
[42] Gordon (1979); Freedberg (1989) 83–4, 91; Gladigow (1985/6); Paus. VII.25.9.

sacrifices were made to deities, they were entitled to a share of the innards (*splankhna*) roasted on the altar and shared amongst the participants in the sacrifice. The share of the god might be placed on the upturned hand of the statue or on his knees.[43] Oracular consultation of a god might take the form of an encounter with the statue, with which the consultor interacts as if with the god, having first made a ritual offering in order to be in an appropriate condition in which to draw near to the god and gain access to the sacred. Pausanias tells of such an oracle, of Hermes, at Pharai:

> There lies in front of the cult image a hearth, likewise of stone; and to this hearth bronze lamps are attached with lead. And so, anyone who wishes to consult the god comes in the evening and, after burning incense at the hearth and having filled the lamps with oil and lit them, places a local coin, called a bronze-piece, on the altar to the right of the image and, addressing himself to the ear of the god,[44] asks whatsoever question he has. After that, he leaves the agora with his ears blocked. Once he gets outside, he removes his hands from his ears, and whatever sound he should happen to hear, he takes to be the oracular response.[45]

Religious considerations arising out of such ritual interactions with the deity, rather than specifically aesthetic concerns, informed the construction and preparation of the setting in which the cult statue was viewed.[46] The Roman architect Vitruvius, writing under the emperor Augustus but drawing upon a Hellenistic tradition of architectural manuals, advises his readers that:

> altars should look to the east and should always be placed lower than the cult images that would be in the temple. In this way those who supplicate and sacrifice may gaze up towards the divinity, at the different heights that are appropriate for each person's god.[47]

Temples and statues housed in the cella should be constructed looking westwards,

> so that those who come to the altar to perform animal sacrifice or make other offerings look in the direction of the eastern sky and the cult image, which will be in the temple. And in the same way, those undertaking vows may at the same time gaze on the temple and the eastern sky, and the cult images themselves may seem to rise up and look attentively towards those making supplications and sacrifices.[48]

The visibility of the cult statue through the door of the cella was maximised in order to facilitate ritual interactions of the instructively banal forms that Vitruvius records:

[43] Ar. *Av.* 518–20, *Eccl.* 778–83; *RE* XVIII.1 617.
[44] Note the shift from image to god, a shift of attitude realised at the leap into the religious province of meaning as the consultor approaches the god through ritual. For the concept of 'provinces of meaning' in the analysis of the structure of different modes of consciousness, see Schutz (1962).
[45] Paus. VII.22.2–4; Vernant (1983) 158. [46] Burkert (1985) 85–92. [47] Vitr. IV.9. [48] Vitr. IV.5.

If the buildings of the gods are located by public roads, they should be set up in such a way that passers-by can turn their gaze aside and pay their respects in full view.[49]

Such salutations might include, for instance, blowing the god a kiss.[50] Crowning statues, or draping them with clothes and garlands, was so routine that a statue might be rendered all but invisible by the worshippers' offerings which enveloped it.[51]

As ritual action engaged kinaesthetic sensitivities in the construction of the viewing experience, the manipulation of light, smell and sound engaged other sensory modes in orchestrating a multisensory viewing experience which goes far beyond the narrowly cognitive evocations of iconographic analyses.[52] During the course of the classical period, the interiors of temples were increasingly designed in such a way as to enhance the sense of aura associated with the cult statue. Elaborately sculpted architectural frames, the manipulation of light and dark through the use of windows, doors sometimes placed on the side of the cella as well as at its entry, polished floors or reflective pools of liquid in front of statues, all functioned to give a sensible anchor to the distinctively sacred quality of the viewing space, and to bring out the gleam and glance of statues sculpted in materials like marble, gold and ivory, engendering the kind of radiant glow held to be characteristic of gods.[53] On festive occasions, as the doors of the temple were opened, statues might be the focus for the performance of dances and the singing of hymns. These engaged the ear not only with narratives of the *aretai* in which the god had manifested his or her power, but also with rhythms and tones distinct not only to the sphere of the sacred but also to the particular qualities of the gods being evoked.[54] The viewing context was also marked by the distinctive odours of the sacred. Gods could be recognised not only by their extraordinary beauty but also by their exceptionally pleasing fragrance or *euodia*.[55] Correspondingly a primary vehicle for the mediation of relationships between the divine and the human worlds was the burning of

[49] Vitr. IV.5. [50] Minucius Felix, *Octavius* II.4; Men. *Dys.* 10.

[51] Paus. III.26.1; Men. *Dys.* 50. In Aristophanes' *Thesmophoriazusai* (450) the garland-seller bitterly complains that she has nearly been put out of business by the atheist Euripides' persuading people that the gods do not exist; notwithstanding, she still sells twenty votive garlands a day.

[52] See C. Classen (1990) for an account of how artifacts 'employed in dynamic and multi-sensory contexts in their cultures of origin are transformed into static objects of sight' within modern western sensory (museal/art-historical) experience.

[53] Corbett (1970) 154 – Tegea; Beyer (1990) – Parthenon, Bassai; Wolfel (1990) – Olympia; Cooper (1968) – Bassai.

[54] Callim. *Hymn to Delos, passim* but especially 302–15; Philostr. *Imag.* II.1. Bremmer (1981) 201–3; West (1992) 157–9, 178–84, 214–17. Callim. *Hymn to Apollo*, esp. 1–24 with F. Williams (1978) ad loc. Cf. the hymn performed at the Festival of Adonis, whilst the festival-goers contemplate the artistic tableau representing Adonis in the arms of Aphrodite – Theoc. *Id.* 15.

[55] Detienne (1994) 48; Kötting (1982).

incense and spices.[56] The smoking incense burners, which were a standard item of temple equipment, functioned both to attract the gods and to create the fragrant atmosphere that marked a divine presence.[57] The fragrance of holiness was further enriched by the scent of the flowers in the temple gardens, or of the garlands dedicated in the temple, which greeted viewers as they approached the cult image. On occasion the specific plantings and flowers might evoke both the deities in question and the spheres and modalities of their operation. Poppies, for example, were particularly apposite dedications for Demeter, anemones for Aphrodite and lillies for Hera.[58] A distinctive and 'overwhelming' fragrance was held in particular to mark the epiphany or presence of Aphrodite.[59] Alongside burning incense and perfumes, her temples and sanctuaries were often suffused with the scent of myrtle, redolent of sexual desire by virtue not only of its association with the goddess, but also of its ritual use in the crowns of couples being married, and the euphemistic description of the female pudenda as myrtle.[60] The 'intangible qualities' of divine power were thus transposed into a range of sensory modes which prefigured and shaped the experience of viewing a cult statue, preparing in the viewer a specifically religious quality of expressive and sensory responsiveness.[61]

Word and image: religious vocabulary and aesthetic response

This ritual and sensory framework within which the practice of viewing was performed served to blur the distinction between statue and god. Such a conflation is regularly registered also in verbal discourse,[62] even in such apparently rationalist writers as Thucydides.[63] However, relatively little attention has been given to the role of representations of artistic agency, the structure and cultural derivation of the stock of iconographic knowledge deployed by viewers, and the dominant cultural vocabularies available to viewers for talking about statues. These, I shall argue, are the specific cultural grounds of that verbal conflation. All served to articulate viewing experience

[56] Detienne (1994) 35. [57] Harris (1995) 101, 114.
[58] Goody (1993) 67; A. Lambert (1878). [59] Bergren (1989) 8–9.
[60] Lucian, *Amores* 11; Philostr. *Imag.* II.1; Detienne (1994) 63.
[61] Cf. Kondo (1985) 300–3 on the Japanese tea-ceremony; on the precipitation of worshippers 'into a state of altered consciousness' through techniques which 'break up the ordinary patterns of perception and allow the emergence of other dimensions of experience', see Bellah's article 'The Dynamics of Worship' (1970b).
[62] Gordon (1979) is the now classic article.
[63] Thucydides, for example, has Perikles – discussing the resources at Athens' disposal at the beginning of the Peloponnesian war – speak of 'the gold plates clothing the goddess herself (αὐτῆς τῆς θεοῦ τοῖς περικειμένοις χρυσίοις)' (II.13.5), eliding the distinction between statue and goddess which is the natural reflex of modern translators.

very closely with religious culture whilst marginalising the craftsmen who actually made the statues as a potential point of reference in interpreting and responding to them.

The western concept of the artist as creator is a particularly radical version of broader Judaeo-Christian conceptions of work, in which man stands as master over against the inert matter of the natural world, which, through will and effort, he transforms in accordance with an autonomously conceived and original plan.[64] Both mythic and secular-philosophical representations of work in the classical Greek world invert the Judaeo-Christian pattern. In classical Greece the craftsman was conceived to be secondary both to the project realised in the work he performed and to the natural material he worked on in manufacturing his product. The formal essence of a manufactured object, its *eidos*, was defined by its use or purpose. The craftsman was simply the 'means by which a pre-existent "form" is actualized in matter'.[65] He is not morally responsible for the form or its material instantiation, except in so far as his material product falls short of the norm set by the ideal form, uncorrupted by the descent into matter.[66] The dominant mythic representations of the work of visual artists also functioned strongly to marginalise awareness of autonomous artistic agency. The successful outcome of any process of craft production was attributed as much to the ritually invoked assistance of the gods of craft (Athena and Hephaistos), and the power of phallic images in averting malevolent demons from the kiln or foundry, as to the specific skills of the artists themselves, the *metis*, or practical knowledge, which in any case was held to be an endowment derived from the gods.[67]

How were these representations of work specified in the particular context of the manufacture of statues of gods? Some people recognized that the iconographic forms (*eidea*) of certain cult statues or statue types were the result of innovations on some level on the part of individual artists. Pausanias tells us that Alkamenes, for example, was the first to represent Hekate as triple-faced, whilst Boupalos of Chios was the first man to represent Nike winged.[68] Discursive awareness of such iconographic innovations may well have been restricted to antiquarian litterateurs and art history writers of the Hellenistic period, like Antigonos. Such innovations were certainly not widely conceived to be or responded to as the product of free artistic fantasy.[69] Even where such awareness existed, the forms (*eidea*) of the gods were understood to be pre-given. The innovative artist was merely the first executant through whom the

[64] Weber (1931), Nahm (1947). [65] Vernant (1983) 274. [66] Vernant (1983) 291.
[67] See below, pp. 151–3. [68] Paus. II.30.2; Schol. Ar. *Av.* 573, citing Antigonos of Karystos; *SQ* 315.
[69] Gernet and Boulanger (1932) 239.

particular form was realised. The choice of particular iconographic features – for example the polos and the horn of plenty introduced into the iconography of Tyche or 'Fortune' by Boupalos – is derived by Pausanias from the power and accomplishments of the goddess.[70] The addition of wings – a conventional element of the iconography of Eros – to post-archaic statues of Nemesis is explained by Pausanias in terms of the particular mode in which she manifested her power (*epiphainesthai*) 'as a consequence of love'.[71] According to Herodotus, the 'outward forms (*eidea*)' of the gods were codified by the poets Homer and Hesiod.[72] The Homeric corpus articulated a widely shared stock of knowledge which included 'a vocabulary of divine attributes which signalled areas of special functions for individual gods and also made them instantly recognizable, Athena with Aegis ... Hermes with staff'.[73] Reading the iconographic form of a cult statue consequently required no invocation of artistic intention. On the contrary, it was a commonplace to attribute the expressive power of even so famous a statue as the Zeus at Olympia by Pheidias to the perfect material realisation (through the medium of Pheidias) of a form of Zeus already revealed by Homer, whose poems thereby provided a criterion for assessing the adequacy of the sculptor's achievement.[74]

Correspondingly the aura or authenticity of a statue was thought to derive not from the personal touch of the charismatic artist, but from the status of the statue as mediator and periodic embodiment of the power of the god. Such status was confirmed by signs of divine presence or approval, authorising the form in which the god was made manifest to his or her worshippers. The authenticity of Pheidias' Zeus was signified on the statue's completion by a bolt of lightning which struck the base of the image.[75] The truthfulness of the Black Demeter by Onatas at Phigaleia, as of Parrhasios' painting of Herakles at Lindos, was guaranteed by a story recounting how the deity herself had appeared to Onatas in a dream and shown him the appropriate form.[76] Such stories linked to the consecration of cult statues, and the ritual of consecration itself, served to mark off the statue, as sacred embodiment/manifestation of divine power, from the previously profane material constituents about to be worked into an adequate vessel of the divine by a sculptor.[77]

Generalised conceptions of work and more specific understandings of the origins and significance of the forms of gods minimised the significance of the sculptor as an originator of the visual appearance taken by a cult statue. Correspondingly, the stock of knowledge invoked in interpreting religious art

[70] Paus. IV.30.6. [71] Paus. I.33.7. [72] Hdt. II.53. [73] Dietrich (1986) 101. [74] *SQ* 725–30.
[75] Paus. V.11.9. [76] Paus. VIII.42.7; Ath. XII.543f; Pliny, *HN* XXXV.71.
[77] Bevan (1940) 38–9; Clerc (1915) 33.

and the language used to articulate the experience realised in viewing a cult statue were not specifically aesthetic. At the level of content, viewers needed only to invoke the iconographic knowledge which was effectively embedded in the mythological tradition transmitted above all through poetry. The women of the chorus in Euripides' tragedy *Ion* gaze in wonderment at the sculptures of the exterior of the temple of Apollo at Delphi. They recognise figures on the basis of distinctive attributes – Zeus with his thunderbolt (212–14), Dionysos with his ivy wand (216–17) – and thereby construe a familiar tale:[78]

CHORUS A: See, look over here. The child of Zeus slays the Lerneian hydra with his golden sickle. My dear, look over there with your eyes.

CHORUS B: I see. And someone else alongside him raises up a blazing torch. Yes, is it he whom we celebrate in myth (μυθεύεται) at our looms, the warrior Iolaos, who, undertaking the labours in common with the son of Zeus, suffered alongside him.

Notably absent is any self-conscious articulation of individual response to the aesthetic values of the sculptures. The attitude of these viewers is 'unreflectively receptive'.[79] They make thematic the content of the sculptures in particular in so far as that content is part of a communal tradition – 'Yes, is it he whom we celebrate in myth at our looms, the warrior Iolaos'; 'A: And do you see there, brandishing the gorgon-visaged shield against the giant Enkelados? B: I see Pallas (Athene), my goddess!'

Accounts of responses to statues of gods in the classical period are scarce. Evidence from Homeric poetry and post-classical literature, however, suggests a degree of continuity in the language available and used for the appropriation of images of gods. Post-classical writers repeatedly invoke two terms, *megethos* and *kallos* – grandeur and beauty – when talking about especially impressive cult statues.[80] From the Homeric poems onwards, these two terms are conjoined in particular in descriptions of the appearance of gods, who whilst like men in their form, were distinguished by their more than mortal size and beauty.[81] 'Grandeur' and 'beauty' are important dimensions of the experience of the sacred manifested in divine epiphanies.[82] In the fifth *Homeric Hymn*, Aphrodite reveals herself as a goddess to the Trojan shepherd Anchises by casting off her mortal disguise and assuming her true divine form. Her head reaches to the ceiling of Anchises' hut, 'and immortal beauty shone forth from

[78] Lines 190–219, quotation 190–9. [79] Weber (1968) 608.
[80] E.g. Polyb. IV.77 – an Athena by Hekatodoros and Sostratos at Alpheira; Strabo IX.1.17 – Nemesis at Rhamnous. Pollitt (1974) 191–3, 198–201.
[81] Verdenius (1949).
[82] Richardson (1974) 207–11, 252–4; Pfister (1924); Steiner (2001) 95–104; Gladigow (1990).

her cheeks (κάλλος δὲ παρειάων ἀπέλαμπεν ἄμβροτον)'. The appropriate response to such a manifestation is trembling awe: Anchises 'was stricken with fear and turned his eyes aside, and veiled his beautiful face with his cloak'.[83] Similarly, when Demeter reveals herself to her mortal host Metaneira: 'her head reached up to the roof-beams, and she filled the doorway with a divine light. Then awe and reverence and pale fear (αἰδώς τε σέβας τε ἰδὲ χλωρὸν δέος) took hold of Metaneira.'[84]

In the third century BC, the appearance of a woman 'outstanding in personal beauty and physical stature (κάλλει καὶ μεγέθει σώματος εὐπρεπής)', wearing a crested helmet, could be experienced as an epiphany 'of superhuman majesty (σεμνότερον ἤ κατ' ἄνθρωπον)', engendering such fear in the enemy besieging the city as to put them to flight.[85] To be sure, the semantic range of *kallos* and *megethos* was modified during the Hellenistic period, so that they could be used – like other originally religious concepts such as *charis* – as primarily aesthetic concepts without specifically religious connotations.[86] They continued, however, to be coupled in the specifically religious context of epiphany. At the Asklepion in Pergamon, for example, Serapis and Asklepios 'marvellous in their beauty and magnitude (θαυμαστοὶ τὸ κάλλος καὶ τὸ μέγεθος)' appeared to the orator Aelius Aristeides in a dream in the mid second century AD.[87]

There is no good reason to suppose that this structure of experience, well attested in the archaic and post-classical periods, was not common also to the classical period of Greek history. If so, the simplicity of the linguistic tools available to viewers seeking to articulate a response to a cult statue before the development of a differentiated aesthetic terminology certainly did nothing to undermine the identification of statue and deity. Awe and wonder at the 'beauty' and 'grandeur' of the vision one beheld was an equally appropriate response to both god and statue. This vocabulary of response, far from establishing aesthetic distance, facilitated precipitation into that 'state of altered consciousness' which characterises religious experience at its most intense.[88] Of course, the viewer of the Athena Parthenos would not have dropped to his knees and averted his gaze in fear, like Anchises. (The normal attitude seems to have been to stand with hands raised in prayer.[89]) But this was not because he was viewing a statue rather than a god. It was because viewing a god in a temple was less dangerous than viewing a god unexpectedly in a profane context.[90]

[83] *Hymn. Hom.* 5.171–85. [84] *Hymn. Hom.* 2.187–90, cf. 275–83. [85] Plut. *Arat.* 32.
[86] Pollitt (1974) 191–3, 198–201. [87] Aristid. *Or.* 49.46 – Behr.
[88] Bellah (1970b). [89] Van Straten (1974).
[90] On viewing gods when not ritually prepared, see Frontisi-Ducroux (1975) 110–11; Steiner (2001) 175–81 on the power of deities' gaze and the dangers of visual contact.

The viewer in the temple was properly, that is to say ritually, prepared for an encounter with the sacred. Anchises was not.

Oblique confirmation of the relationship between the absence of differentiated aesthetic language and ease of a more direct religious response is provided by the confusion sometimes engendered when viewers of the Roman period applied specifically aesthetic categories to classical cult statues still housed in their original context. Strabo, invoking the aesthetic norm of *symmetria* – commensurability of parts – finds fault with Pheidias' statue of Zeus at Olympia because 'such is its magnitude that, notwithstanding the great size of the temple, the artist seems to have missed the mark for the proper symmetry: he made the statue seated, but it almost touches the roof with its head, giving rise to the appearance that if Zeus were to stand up straight, he would unroof the temple'.[91] Anchises, I think, would not have thus missed Pheidias' point.

The assumptions which informed this culture of image worship were subject to philosophical attack as early as the sixth century, by the likes of Herakleitos and Xenophanes.[92] There is little reason, however, to suppose that the critique made much headway outside relatively restricted intellectual circles. The cultural network I have sketched was very densely woven, with a strong practical coherence, which was probably highly resistant to philosophical unpicking even if it encountered it, and may indeed have been strengthened both by the increasing elaboration of temple interiors and, as we shall see, by the development of naturalism in the classical period. The kinds of arguments developed by philosophers against image worship depended on new contexts of communication and techniques of thought, above all literacy, abstracted from the contexts of communication and cultural practices characteristic of the bulk of the population in any Greek polis. Atheist intellectuals enjoyed some toleration and could even be the object of considerable amusement and diversion in Greek comedy and tragedy. Sustained attempts to subvert traditional religious culture, however, were repressed, securing the insulation of the socially dominant culture of image worship from the corrosive effects of philosophy, a minority and, in democratic poleis, socially dominated culture. Diogenes Laertios tells how the fourth-century philosopher Stilpon employed the rationalist technique of syllogism to force into his listeners' conscious awareness the latent tension between the two conceptions of cult statues as being in some sense the god/dess and as being made by craftsmen. Normally this tension was circumvented by the practical logic of cult practice and religious representations of divine form

[91] Strabo VIII.3.30.
[92] Kirk, Raven and Schofield (1983) 168–9, 209–10; C. Osborne (1997); also the good discussion of Steiner (2001) 121–5.

which suppressed the relationship between craftsman and cult statue for practical religious purposes. Stilpon sought to demonstrate that Athena Parthenos was not divine:

They say that he once asked someone a question along the following lines, concerning Pheidias' Athena Parthenos, 'Is not the daughter of Zeus, Athena, a goddess?' When his interlocutor replied 'Yes,' he continued, 'But this one is not of Zeus, but of Pheidias.' When this was agreed, he continued, 'So she is not a god.' On account of this he was cited to appear before the Areopagos; he did not disown what he had said, but argued that he had reasoned correctly, for she was not a god, but a goddess; gods were the male divinities. Nevertheless, the Areopagites immediately ordered him to leave the city.[93]

Thus far, I have argued that the viewing of a cult statue was rooted in the ritual enactment of shared understandings of the sacred status of the god/statue. 'Reading' the statue, identifying the god, required the deployment of a stock of knowledge derived from the Homeric poems which were the common patrimony of all Greeks irrespective of social status. The language available to the classical Greeks for appropriating cult statues was a religious language which enabled them to express awe at the *mysterium tremendum* of divine epiphany, the irruption of the sacred into the profane world, not an aesthetic discourse enabling the exploration of individualised, specifically aesthetic meanings on the part of the viewer. Purely cognitive or verbal schemata, suggested by currently popular post-structuralist metaphors of 'texts' and 'reading' played a relatively small role in the construction of responses to cult statues, and the verbal schemas used were themselves grounded in a much wider range of practical and embodied interpretative schemata. These schemata, in the construction of expressive response, drew more on the encultured body than the abstracted intellect or eye of traditional iconography.

If we cannot interpret the Greek revolution as a differentiation of art as a cultural system from religion, how are we to understand it? In the following sections, I shall argue that the Greek revolution was not a differentiation of art from religion but a differentiation of the aesthetic expressive dimension of Greek religion. This differentiation was promoted by and was a response to the development of the Greek form of citizen state and the redefinition of the religious community which was part of the process of state development in archaic and classical Greece.[94] The key differences between archaic statues of deities and classical statues lies not in their iconographic meanings as

[93] Diog. Laert. II.116. See Dover (1988) on the evidence for constraints on intellectual freedom in democratic Athens.

[94] On the religious definition of the polis community, see Polignac (1984), Sourvinou-Inwood (1988b), (1989).

traditionally understood but in the way they appropriate the viewer's body in constructing affective attachment to religious and social orders.

ART AND AURA IN ARCHAIC GREECE: ARISTOCRATIC ELITES AND THE APPROPRIATION OF THE SACRED

In this section, I sketch two strategies by which aristocratic elites within archaic Greek poleis made use of visual imagery to make special claims – both as a group and as competing individuals within that group – of proximity to the sacred. This special relationship to the sacred afforded individuals and families a particular charisma, which they could put at the service of the community as a whole, but in return for which such aristocrats laid claim to special prestige and deference, both as particularly outstanding individuals within that community and as a status group as a whole.[95] The ritual use of images and, increasingly also their visual forms, were means by which aristocratic self-identity was sustained and a sense of subordination engendered in sub-elite viewers. The two strategies overlap chronologically, in part because the institutional development of Greek poleis was an uneven and fitful process within individual states as well as across the world of poleis as a whole, in part because, once established, certain images and modes of representation tended to be modified to fit new institutional and ideological contexts rather than abandoned altogether, on account of the strongly traditionalistic orientation of Greek religious culture.

Circulating images and controlling the sacred: the world of the *agalma*

Both the earliest surviving examples of Greek cult images, like the seventh-century cult group of Apollo, Leto and Artemis from Dreros on Crete,[96] and reputedly the oldest cult images that we know from texts or numismatic reproductions are small, easily portable, often iconically not highly elaborated images. Their embodiment of religious power depended less on their specifically visual features than on the the complex of myth and ritual in which they were embedded.[97] I shall analyse three examples: the Hermes of Aenos in Thrace and the Dionysos of Methymna (see figure 2.8b on p. 44) – both heads attached to Hermaic pillars as bodies – and the Herakles of Erythrai, a slightly more

[95] On the place of charisma in the structure of prestige systems, see Shils (1982a), (1982b).

[96] Stewart (1990) fig. 17.

[97] Vernant (1991) 153–8 and Steiner (2001) 80–5 for an excellent discussion of some of the range of religious evocations of aniconic representations. On early Greek cult images in general, see Romano (1988).

elaborate figure, standing feet together, brandishing club and spear, a warrior-deity type common throughout the eastern Mediterranean. The histories of these images link them to a system of archaic representations of value which was the subject of a classic study by Louis Gernet.[98] Like other *agalmata* they have divine or heroic origin and come into the possession of their owners through miraculous rescue from the sea, usually through the agency of fishermen. They are talismans, endowed with magical properties. As means by which the power of the sacred is mobilised, their control and possession are an object of dispute, generally decided through some form of divine intervention.

The Herakles of Erythrai set out from Phoenician Tyre on a wooden raft. It reached the Ionian sea and there stopped, midway between the harbour of Erythrai and the shore of the island of Chios. Both peoples exerted themselves to land the god on their territory. But he would not budge. Finally, a blind Erythraian fisherman 'saw a dream vision which implied that the women of Erythrai must cut off their hair, and thus the men, having woven a rope from their hair, could drag the raft to shore'.[99]

The olive-wood head of Dionysos of Methymna was caught up in the nets of local fishermen: 'This face had an appearance that hinted towards the divine, but it was strange and not rendered according to the established forms of the Greek gods.' So they threw it back into the water, only to catch it again and again, irrespective of where they disposed of it. Finally, the Methymnians consulted the Pythia as to the identity of the image. 'She bade them worship Dionysos Phallen.' A cult was set up, with sacrifices and prayers and a festival at which the power of the deity was given ritual expression by being carried around in a procession.[100]

The Hermes of Aenos in Thrace, built by Epeios during the siege of Troy but washed away by a flood of the river Scamander, was also caught by fishermen in their nets. First, they tried to chop it up for firewood, but were unable to split it. When they tried to burn it, 'the fire flowed around it'. They threw it back into the sea, only to catch it in their nets again. At last, they realised the image was divine and established a cult for it. Each of the fishermen took it in turn to play host to the image, until ultimately it was installed in the city, on the instructions of an oracle from Apollo.[101]

[98] Gernet (1981a). For representations of the images on coins: Hermes of Aenos – Lacroix (1949) plate I.1–3, fifth- and fourth-century BC coins; Dionysos of Methymna – Lacroix (1949) plate I.11–13 third-century BC coins; Herakles of Erythrai – Lacroix (1949) plate III.2–3.

[99] Paus. VII.5.5–9.

[100] Paus. X.19.3, with Frazer (1897) ad loc.; Euseb. *Praep. evang.* V.36; *IG* XII.2.503; Lacroix (1949) 48–54.

[101] Lacroix (1949) 44–8; Callim. Pap. Ox. IV, no. 661 = Loeb vol. II 133–5 (Iambus 7); Steiner (2001) 83.

These stories point in two directions. First, to a period when cult statues were *agalmata* in the sense explicated by Gernet: objects of respect which circulated through the hands of aristocratic networks and endowed their holders with prestige by virtue of the sacred power they were held to represent. As they circulated they accumulated further social and religious value, subject to continuous reappropriation by the members of the networks through which they passed.[102] This was a period when such elites, like the Eupatridai of Athens, sought both to monopolise weakly developed civic functions – religious, judicial, political and social – and to achieve closure of their status group against outsiders.[103] The intervention of the oracle of Apollo at Delphi and the incorporation of these images into civic cults in which the image had a fixed location may be interpreted in two, not mutually exclusive, fashions: either as an attempt from within the elite to regulate the distribution of charismatic power, analogous to the regulation of office holding with which early Greek law is preoccupied,[104] or to mark the beginning of a new period, in which a monopoly of these privileged symbols of religious power by closed elites was partially eroded, analogous to the largely abortive reforms of Solon in Athens.[105]

Incarnating the sacred: aesthetic form, ritual representation and elite identity in late archaic Greece

At the same time as collective or communal control over cult images, and the power of the sacred they mobilised, was being asserted, aristocrats, both as individuals and as a group, were elaborating more specifically visual strategies in order to reappropriate the charisma of religious power. In place of purely physical control and manipulation of cult images, more culturally elaborated or 'generalised' representational strategies were developed which assimilated both individual aristocrats as priests to statues/gods and indeed the entire status group of the *aristoi* to the gods, whilst creating a strongly *hier*archical social distance from the masses.

[102] Vernant (1983) 360; Gernet (1981a).

[103] Gernet (1981a), (1981b), Forrest (1966) 48–58; Garland (1992) 91; Humphreys (1993); Vernant (1991) 155–8.

[104] R. Osborne (1996) 187–90; S. Lambert (1999), following Humphreys (1983) 35–44 on the genos as an institution created, possibly in the seventh century BC, in order to secure and transmit 'rights of access to hereditary offices', comprising all public offices 'in the pre-Solonian aristocratic state', but reduced to some old priesthoods by the fourth century, with the most offices now allocated by democratic means (election or lot).

[105] Humphreys (1993); Vernant (1991) 156–8 on the transformation of the value of private sacra in the formation of public cult at Gela and Argos.

The Argive sculptor Hageladas made identical statues of Zeus 'as a child' for the cities of Aigion and Ithome.[106] In both cities the priest still kept the presumably small image in his own house. Access to the position of priest, however, came under civic control. At Ithome, the priest was elected annually, in Aigion at less regular intervals. The cult at Aigion was of Zeus as a child. The statue, represented on Roman coins (see figure 2.8c on p. 44) shows Zeus as a boy, beardless.[107] The priesthoood of Zeus was filled by whichever of the boys of the city 'won the prize for beauty (*kallei*)': 'As soon as his beard began to appear, the honour for beauty [the priesthood] transferred to another boy.'[108] The priest was thus assimilated to the god/statue as his facsimile, a living embodiment of the power of the god.[109]

A reproduction of a late archaic statue of Apollo by the artist Kanachos has been identified on the basis of descriptions by Pausanias, coins, and a relief from Miletos where the Apollo stood (figure 2.9).[110] An identical statue of Apollo was made by Kanachos for the sanctuary of Ismenian Apollo at Thebes,[111] and our statuette could conceivably be a copy after either. The statue was rather like the Piraeus Apollo (see figure 2.2 on p. 33): a standard kouros adjusted to hold attributes, a stag or fawn and a bow, or more probably on the statuette and the Ismenian Apollo a laurel branch. The god's hair is tied in fillets, but with long locks, characteristic of Apollo, streaming down his shoulders and over his neck. The priest of the Ismenian Apollo was selected from a noble family on the basis of exceptional personal strength and beauty. He was called the Laurel-bearer (*Daphnephoros*). This was a common cult-title of Apollo himself, who had worn laurel for one year in order to purify himself of the pollution incurred when he slaughtered the python at Delphi. At the Theban festival of the Laurel-bearing (*Daphnephoria*), the priest was assimilated to Apollo by assuming the iconographic markers of the statue/god – the laurel branch and his long streaming hair[112] – as described by the late antique Neoplatonist Proklos:

The procession of the Laurel-bearing is headed by a boy, whose parents are both alive. His nearest kinsman bears the wreathed staff which they call *kopo*. The Laurel-bearer himself follows, grasping the laurel, his hair streaming down; he wears a golden crown; he is clad in a bright-hued garment that reaches to his feet, and he is shod with shoes called

[106] *SQ* 392 and 394; Paus. IV.33.2 and VII.24.4; Lacroix (1949) 227–32, Frazer (1897) ad Paus. IV.33.2 and Stewart (1990) 247–8 for the debate on the chronology of Hageladas.

[107] Imhoof-Blumer and Gardner (1885–7) 84, no. 3, pl. R.xii–xiii for the coins. [108] Paus. VII.24.4.

[109] See Scheid (1986) for a similar analysis of the relationship between the *triumphator* and the statue of Capitoline Jupiter at Rome and between Vesta and the Vestals and their statues.

[110] Paus. VIII.46.3 with Frazer (1897) ad loc., Simon (1957), *LIMC* Apollo 31. The relief is conveniently reproduced in Stewart (1990) fig. 167; for the coins, see Lacroix (1949) 221–6, pl. XVIII.6–13.

[111] Paus. IX.10.2–4. [112] Cf. *Hymn. Hom.* 3.134, 450.

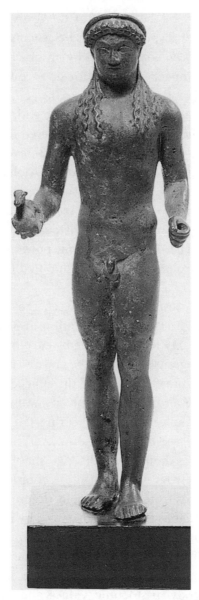

Figure 2.9 Bronze statuette, possibly after the Ismenian Apollo from Thebes, by Kanachos, original *c.* 500 BC. Photo: Copyright The British Museum.

Iphikratides. A choir of virgins follows him holding bows in token of supplication and singing hymns. The procession of the Laurel-bearing is escorted to the sanctuary of the Ismenian and the Galaxian Apollo.[113]

[113] Apud Photius, *Bibliotheca* p. 321 ed. Becker; trans. Frazer (1897) in comment on Paus. VIII.46.3.

Proklos also tells a story of the origins of the festival. The Boiotian city of Thebes was the subject of dispute between Pelasgians, who occupied the city, and Aiolians, who had been commanded by an oracle to leave their own city of Arne. A truce was arranged so that both sides could celebrate a festival of Apollo by cutting laurels and offering them to the god. Polematas, the leader of the Boiotians, after he had made offerings to the god, had a dream in which 'a young man gave him a hoplite panoply and ordered that the Boiotians should offer prayers to Apollo, whilst bearing the laurel, every eighth year'.[114] Two days later, Polematas attacked and defeated the Aiolians. He himself was the first to play the part of the Laurel-bearer and thereby instituted the festival. Once again, we encounter a system of visual metaphor and ritual representation which assimilates members of the local aristocracy to the god as privileged mediators of the sacred. They incarnate a divine power which is at once religious and political, realised through ritual action and tied to the establishment of a sovereign community.

There were similar correspondences between the form of the cult statue, myth, ritual and aristocratic self-representation at Tanagra. Hermes, it was said, had once saved the city from a plague by carrying a ram around the city walls. In return, the Tanagrans honoured the god and commemorated the event at a festival in which the most beautiful of the ephebes was chosen to play the part of the god, carrying a ram around the city walls.[115] The cult statue was made by Kalamis and showed Hermes bearing the ram. It is known from representations on coins (see figure 2.8d on p. 44)[116] and shows Hermes as a kouros with a ram over his shoulders, indistinguishable – except perhaps for an attribute like his wand – from votive self-representations made by aristocrats, such as the Moschophoros from the Acropolis (figure 2.10).[117]

The forms used by Kalamis for the Hermes and by Kanachos for the Apollo were derived from a broader genre of statues, the kouroi, which were used as tomb sculptures or votives for a period of some one hundred and fifty years from the late seventh to the early fifth centuries. Recent studies have explored how these images embody aristocratic values and self-identity.[118] Physical qualities – youthful strength and vigour, grace and splendour of appearance – were conceived by the archaic Greeks as religious values, 'powers of divine origin'.[119] Manly beauty connoted at once closeness to the gods and military

[114] Ibid. [115] Paus. IX.22.I. [116] Imhoof-Blumer and Gardner (1885–7) 115, no. 5, pl. x.xi–xii.
[117] See Himmelmann (1959) 11 on the indistinguishability of god and man in the absence of identifying attributes or inscriptions.
[118] Stewart (1986), Zinserling (1975), cf. Vernant (1991) esp. 35–9. [119] Vernant (1991) 161.

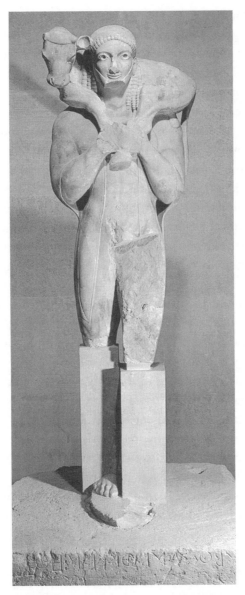

Figure 2.10 Moschophoros (Calf-bearer), dedicated by [Rh]onbos, from the Athenian
Akropolis, *c.* 560 BC. Photo: Alison Frantz Archive, American School
of Classical Studies, Athens: AT 131.

prowess.[120] Whilst perhaps pre-eminently manifest in young adults, these
values could also be embodied by men still in the prime of their life, and the
canonical kouros type is correspondingly adjusted by being given a beard in a

[120] Zinserling (1975) 23.

representation of Dionysos, as also on the Moschophoros from the Athenian Acropolis. Like the gods, kouroi can be as much ageless as specifically young.[121] Korai, the female counterparts of kouroi, are similarly effectively indistinguishable from goddesses except when the latter can be identified on the basis of a specific narrative context,[122] or possess a characterising attribute, like the bow of a bronze statuette of Artemis,[123] or the helmet once worn by Antenor's kore, an Athena (see figure 2.5 on p. 36).[124] Elaborate jewellery signifies membership of an elite status group, ritual haircuts and clothing project them into the sacred sphere, whilst attributes such as the polos and their ageless beauty are equally appropriate to goddess and priestess.[125] Kouros and kore alike have the characteristic archaic smile, a metonym of the aristocratic elite's stylisation of both their lives and their artistic self-representations into *agalmata*, objects in which the gods can take pleasure and delight.[126] *Agalma* and *gelaō* (to smile or laugh) are semantically related, through the intermediate *aglaos* (shining or splendid).[127] The radiant smile of both statues and aristocrats – the *geleontes* or 'smiling ones', as the elites of some archaic communities called themselves – marked them off as *makarioi*, the blessed, distinguished as religiously favoured by the prosperity and fortune which they enjoyed, and assimilated to the gods, also characterised by a life of ease and a joyful smile.[128]

In giving these statues to the gods as votives, archaic aristocrats assimilated themselves to the gods and goddesses on several levels. In consecrating the statues, they also consecrated themselves, entering into a relationship with the deity who was the recipient of the offering and thereby gaining access to the power of the sacred.[129] Their capacity to mediate the power of the sacred, especially as priests and priestesses, and to mobilise it on the behalf of the community of which they were members was of course rooted in their access to the gods.[130] Their privileged access to the gods depended on the possession of

[121] Himmelmann (1989) 79–80 – beard as an *attribute* on otherwise undifferentiated features, and the example of the Dionysos from Naxos. Schneider (1975) 17 on gods as ageless.

[122] For example, the two korai in the pediment of the Siphnian treasury at Delphi identified as Leto and Artemis, by virtue of their proximity to Apollo in the battle for the Tripod – Richter (1968) 67.

[123] Bronze statuette of Artemis, *c*. 515 BC – Richter (1968) figs. 456–9, *LIMC* Artemis 81.

[124] Ridgway (1990). [125] Schneider (1975).

[126] On kouroi as *agalmata*: Karusos (1961), (1972) 93–102; Steiner (2001) 214; on korai: R. Osborne (1994c).

[127] Fowler (1983) 166–7. [128] Yalouris (1986); Schneider (1975) 27. [129] Steiner (2001) 16–17.

[130] Cf. the story of Milon of Croton, an Olympic victor and priest of Hera Lacinia, who functioned as a war and guardian deity with a cult linked with that of Herakles. In a battle against the Sybarites, Milon led the Crotonian army, dressed in the attributes of Herakles (lion skin and club) and wearing his Olympic crowns – Detienne (1994) 43–4, Kurke (1993). The statue of Milon at Olympia was apparently a kouros – Philostr. *VA* IV.28. A similar cultural logic underlies the story of Peisistratos' return to Athens, accompanied by Athena – Connor (1987), Sinos (1993).

symbolic capital at once social and religious, which kouroi and korai both asserted as they were dedicated and realised as they were viewed. Such statues supported fundamentally different relationships to the sacred for viewers who were potential and actual givers and for viewers who were not. For viewers who were givers, the form of the images connoted the life-style and values of their class, the *kaloikagathoi*, 'the beautiful and good'.[131] This lifestyle underwrote their capacity both to give pleasing gifts to the gods and to mobilise the power of the sacred, on behalf of the community, through the exchange of such *agalmata* as votive statues. Viewing such statues of gods and goddesses reaffirmed the aristocrats' sense of being godlike.[132] It grounded their affective investment in the sacred. For the non-aristocratic viewer who is no part of the magic circle constituted by the exchange of *agalmata*, they mark his distance from the sacred. The ordinary viewer can only overcome his partial alienation from the sacred through attachment to a member of the aristocracy as a mediator of the sacred. The detachment of the kouros from the viewer and its similarity to representations of gods engendered appropriate deference on the part of the ordinary viewer towards the aristocratic dedicators of such self-representations as men of a qualitatively different nature.[133]

This system of cultural representation is neatly encapsulated by the story of Kleobis and Biton and their statues dedicated at Delphi (figure 2.11).[134] In the course of a conversation with the Lydian king Kroisos, Solon, the sixth-century Athenian law-giver, tells the story of Kleobis and Biton. Their mother was the priestess of Hera at Argos. When the time came to celebrate her festival, the oxen who were to draw the priestess to the temple were late coming back from work in the fields. So the young men yoked themselves to their mother's chariot and drew her to the temple.

Having done these things, and been seen by the festal assembly, they attained the most excellent conclusion to their lives. And through these men, the god showed how it is better for a human being to die than to live. For while the Argive men gathered round the youths and celebrated them as blessed (ἐμακάριζον) in respect of their strength, so also the Argive women feted the mother, because she had been blessed with such children. Their mother, overjoyed at both their deed and their fame, standing before the cult image of the goddess, prayed for Kleobis and Biton, her sons, that the goddess should give them, who had so

[131] On the origins of the concept of *kalokagathia*, see Donlan (1973).
[132] H. Fränkel (1975) 527–8 on the aristocratic sense of proximity to the gods in the archaic period.
[133] For a brilliant discussion of aristocracies and the creation of social distance, see Mannheim (1956).
[134] An identification recently challenged by Vatin (1977), (1982), who sees them instead as the Dioskouroi, but the dominant consensus retains the traditional identification: cf. Stewart (1986) 56 on the Berkeley epigraphers, (1990) 109; Hurwitt (1985) 200; Pollitt (1985) 100; Jeffreys (1990) 154–6 and 444. For the purposes of my argument it matters only that archaic 'portraits' took the form of kouroi: cf. the gravestone of Dermys and Kittylos (Stewart 1990, fig. 61) and Pausanias VIII.40 (Arrhachion).

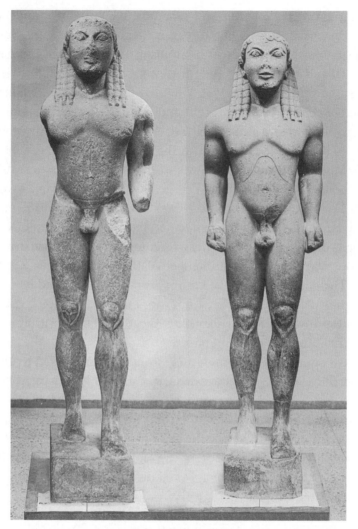

Figure 2.11 Kleobis and Biton, kouroi, *c.* 580 BC; Delphi Museum. Photo: DAI, Athens. Neg. 81.639/40.

greatly honoured her, the greatest good that a man can enjoy. After this prayer, when the young men had sacrificed and partaken of the feast, they lay down to sleep in the temple itself and never rose up again, but here reached the end of their lives. Then the Argives commissioned and set up at Delphi images of them, as being the best of men – ὡς ἀριστῶν γενομένων.[135]

Whereas in the democratic city of the classical period (see chapter 3) portraits were awarded on the basis of achievement in service of the state, here the

[135] Hdt. 1.31.

award of the statues merely recognises the special status of Kleobis and Biton 'as the best of men'. Their strength is celebrated not as the means whereby they contribute to civic goals, but as a marker of their special relationship to the goddess, Hera. They are blessed – *makarioi*. The setting up of the images expresses the deference of the Argives towards two men of a qualitatively different nature from ordinary men, and the form the statues took continued to evoke such deference by virtue of their similarity to representations of gods.

The charismatic power embodied in such imagery was repeatedly put to work in rituals of viewing, in material contexts which further elaborated the religious charisma and claims to religiously inspired deference on the part of individual members and families within an aristocratic elite. We have already seen the talismanic power of mobile images of heroes like those of the Aiakides from Aigina. The living descendants of Aiakos in the late archaic period were a dominant patriliny in Aiginetan society, a number of whose members were celebrated as athletic victors in odes by Pindar.[136] Pindar's fifth Nemean ode, written for the victory of Pythias of Aigina in 483 BC, seems to have been performed at the approach to the heroon of Aiakos in the city of Aigina. The heroon itself was decorated with relief sculptures which narrated the *aretai* of Aiakos, son of Zeus and the eponymous nymph Aigina, and in particular how he had mobilised his special relationship with the gods on Aigina's behalf.[137] As the chorus approaches the Aiakeion, they celebrate the achievements of the Aiakid ancestors of Pythias, to whom he has brought further lustre (*agallei*), passing seamlessly from mythic progenitors to Pythias' more immediate predecessors, including his maternal uncle, Euthymenes, also a Nemean victor. The ode ends with Pindar's instruction to the chorus and Pythias to conclude by singing the fame of Themistios, the grandfather of Pythias and himself an athletic victor, whose statue (an *agalma*, as Pindar referred to such images at the beginning of the poem) they have come to crown with garlands and the victor's fillets of Pythias, returning to its source the special kudos which Pythias has inherited, demonstrated in athletic victory, and embodies for the future.[138]

Similar effects, accumulating symbolic capital on the part of elite families and inculcating deference amongst their dependants and notional fellow citizens, were realised in the elaboration of family tomb-groups.[139] Archaic cemeteries

[136] Nagy (1989) 14–15. [137] Paus. II.29.7–9.

[138] Mullen (1982) 143–64, followed by Steiner (2001) 259–64. Cf. *Nemeans* 3 and 8 for the Aiakeion as a focus ritual celebration of elite prowess.

[139] Steiner (2001) 12–13.

were visually very similar to sanctuaries, in terms of their buildings (*naiskoi*), and sculptural decoration (kouroi, korai, sphinxes).[140] Funerary monuments, like votive statues, were *agalmata*.[141] Like sanctuaries, cemeteries and the images within them were the site of elaborate rituals which afforded communal recognition of the privileged status of elite families and their loss on the occasion of the death of one of their members. Indeed, so central to the construction of elite prestige and authority was the role of such rituals, that many of their key components – the visibility of the *ekphora* taking place by daylight, the evocative sounds of the dirge employing hired musicians and singers, the participation of friends and dependants, the enduring objectification of the ritual in elaborate monuments – were subsequently banned as a threat to more democratic institutions and political culture.[142] Statues, simply by virtue of their placement and their size (often, like gods, larger than life[143]), must have dominated the proceedings which took place in a cemetery: the Anavyssos kouros, Kroisos, for example, is 1.94 metres high and surmounted a massive tumulus with a diameter of 28 metres.[144] Funerary monuments were also the focus of specific ritual attention on the occasion of offerings and libations to the dead.[145] Like *epinikia*, funerary laments (*threnoi*) memorialised the life and death of the deceased in terms of vocabulary and concepts – the *kalos thanatos* or 'beautiful death' – that assimilated the dead person to the heroes of epic (notwithstanding the very different style of combat and death entailed by contemporary hoplite warfare) and celebrated the familial lineage which embodied such qualities.[146] Funerary practice thus provided a powerful ritual frame for the viewing of kouroi and korai. This frame was perpetuated in the inscriptions which ornamented the base of such images, and guided the viewing even of the solitary passer-by.[147] Archaic funerary epigrams draw upon the same cultural values as epinician praise poetry, modulated in register and tone to be appropriate to a memorial dirge. The epigram on the base of the Anavyssos kouros projects the dead Kroisos into a mythic realm of heroic warfare, as it commands the passing viewer's grief at this loss:[148]

> Halt and show pity beside the marker of dead Kroisos,
> Whom raging Ares once destroyed in the front rank of battle.

[140] Karusos (1961) 29–32. [141] Karusos (1961) 29–32; (1972) 93–102; Pind. *Nem.* 10.47.
[142] At Athens, possibly – and probably unsuccessfully – under Solon, definitively after Kleisthenes' reforms; Cf. Stein-Hölkeskamp (1987) 117 for similar laws in Iulis on Keos and Delphi in the fifth century; Humphreys (1993).
[143] Himmelmann (1989) 74–7. [144] Himmelmann (1989) 74–7.
[145] Rohde (1965) 162–74; Kurtz and Boardman (1970) 148. [146] Alexiou (1974), Day (1989).
[147] Day (1989). [148] Day (1989).

As the viewer reads aloud the inscription, he performs the ritual lament, verbally enacting and acoustically experiencing the sense of deference that the statue inculcates visually, through eye and body, by its size, elevation, and artistic forms.[149]

ART AND AURA IN CLASSICAL GREECE: NATURALISM, RITUAL INTERACTION AND AESTHETIC EXPERIENCE

Conceptualising 'naturalism': a pragmatist approach

Any understanding, and consequently any explanation, of naturalism necessarily depends on how one characterises 'naturalism'. The concept of naturalism has been so thoroughly criticised in recent history, anthropology and philosophy of art that the very use of the concept may seem deeply problematic.[150] The burden of the critique has been that the concept of naturalism privileges as natural, and hence in some sense universalistically human and normative, the culturally arbitrary tradition of representation characteristic of western art. The essentialist account of naturalism, elaborated in the gestalt psychology of Gombrich and the perceptual psychology of Deregowski, holds that western traditions of bodily and spatial representation correspond to universal human perceptual experience and are therefore less dependent on conventional knowledge of viewers in order to be understood.[151] Critics of this position have drawn heavily on the assumptions of the linguistic turn in contemporary social thought, whether its structuralist or Wittgensteinian variants. Both Wittgenstein's account of incommensurable language games and Saussure's theory of the radically arbitrary relationship between signifier and signified in the diacritical sign stressed not only the strongly conventional character of systems of cultural representation, but also the extent to which our perceptual access to any external world is linguistically mediated. Since visual representations, however naturalistic, necessarily involve 'a formal element that is not identical with the form in nature',[152] and since our sense of the world against which we match visual representations is 'already clothed in our systems of representation',[153] our feeling that something is a natural representational mode means nothing more than that it is the conventional or familiar mode within our

[149] On early Greek reading practices, out loud rather than silent, see Svenbro (1988), (1990).

[150] In what follows I summarise the arguments of: Bryson (1983), Layton (1977), Mitchell (1986b on Goodmann), (1986c on Gombrich).

[151] Gombrich (1960), (1982), Deregowski (1989). [152] Layton (1977) 24, quoting Boas.

[153] Mitchell (1986a) 38; Layton (1977).

culture. All systems of visual representation involve stylistic conventions which schematise the culturally preconstructed world of perceptual experience in order to represent it. Western 'monothetic elaboration' of minimal iconic schemata on the basis of a single viewpoint 'appears naturalistic only to those for whom it embodies sought after and expected elements of visual information' (i.e. western depth cues).[154] Conversely, the systems of split representation that are characteristic of Northwest-coast American Indian art and other modes of 'synthetic elaboration' of iconic forms, whilst immediately understandable to their own producers as coherently organised representations of particular objects in the world, cannot be interpreted as a meaningfully structured whole by untrained western eyes.[155] Styles simply 'differ in the degree and kind of visual information' they document from a represented object, depending on which 'distinctive features' are 'felt best to characterise that object'.[156]

Whilst the conventionalist critique of essentialist theories of naturalism is both intellectually persuasive and ethically appealing, it is to some degree caught up in the assumptions of the essentialism that it inverts, and it generates its own corresponding set of problems and anomalies, those of cultural essentialism or historicism. First, like the essentialists, the conventionalists articulate the debate in very strongly cognitivist terms: what kind of 'knowledge' does one need to interpret certain kinds of images or what kind of information do different stylistic modes include in their representation of objects? This excludes any account of the properly expressive functions of naturalism in western and other artistic traditions, in so far as the concept of naturalism is recognised as having any validity at all. Secondly, strong versions of conventionalism entail a historicist relativism which, whilst it has created significant intellectual space in which anthropologists of art have been able to analyse the art styles of indigenous cultures in their own terms, has made the comparison of styles, particularly through time in the explanation of change, extremely difficult in so far as it is (by definition) difficult to justify an appropriate metalanguage that can impartially analyse the distinctive properties of incommensurable styles, except in the aesthetically rather impoverished terms of bits of information (i.e. non-stylistic elements of images). Consequently, in so far as any attempt is made to explain naturalism as a distinctive style which can claim in some sense to be more naturalistic than other styles, its distinctiveness is characterised in terms of informational density, and the explanation is couched in purely cognitive terms. Norman Bryson explains the shift from schematic stereotype to

[154] Layton (1977) 38. [155] Layton (1977) 38. [156] Layton (1977) 42–5.

Renaissance naturalism in terms of a shift from a society in which domination is exercised openly, through naked force and symbols which do not seek to veil their arbitrariness, to the gentle violence of bourgeois culture.[157] Naturalism is then a medium of false consciousness, clothing arbitrary cultural domination in the appearance of naturalness.

In place of the unresolved debate between essentialists and conventionalists, I wish to use Parsons' action theory and Peirce's semiotics to develop a critical realist account of naturalism. Parsons recognises the mutual implication of the body and culture in the production of social action, as respectively the conditioning basis and informing control of action. This complements Peirce's conception of signs in terms of a spectrum from (or variable combinations of) the causally motivated index, through the icon related to its signified by resemblance, to the arbitrary 'symbol'. Both assume not only that the world against which we 'match' an image is 'already clothed in our systems of representation', but also that our systems of cultural representation are already embedded in and elaborated on the basis of naturally given sensory and behavioural systems. These behavioural and sensory systems are adjusted to exigencies of our existence in the world and subject to universally given maturational processes.[158] By analytically distinguishing these two bases of artistic expression and representation we can begin to explore the different balances between the natural and the cultural in any given sign system, and also the different modalities of the relationship. More elaborate cultural schematisation does not necessarily mean a reduced role for natural signs, or vice versa. On the contrary, as we shall see, what is distinctive about naturalism is the development of a cultural language of artistic representation which is able to put to work naturally emergent perceptual discriminations and behavioural dispositions in particular culturally organised ways for historically distinctive social and cultural purposes.[159] The advantage of such an analytic characterisation of naturalism is that it does not preclude differential kinds of naturalism in different traditions – for example in Chinese art as opposed to Greek art – but on the contrary permits the comparison of stylistic systems in terms of the way they deploy universally given body-related and behavioural schemata (of facial expression, facial maturation and bodily maturation for example), in constructing iconographic schemata designed to accomplish certain kinds of affective work.

[157] Bryson (1983) 133–62; Mitchell (1986c) 90. [158] Lidz and Lidz (1976).
[159] My formulation of this problem owes much to the stimulation of Robert Witkin's (1995) comparable attempt to integrate social theory, perceptual psychology and the study of style, if on the basis of rather different presuppositions about the nature of art as a cultural system, as I discuss in Tanner (2000a).

A style may be conceptualised as a set of rules for the construction or generation of motifs, and for the organisation or composition of those motifs into larger expressive wholes, from iconographic types to pictures or images. Compositional schemata regulate not only the way individual elements within a picture are related to each other, but also the way the elements and the whole are related to their implied viewer (presentational style).[160] Briefly, I shall argue that the naturalistic style of classical Greek religious iconography differs from the archaic 'schematic' style both in its structure and in its behavioural and semiotic foundations. The expressive code of classical naturalism is more 'generalised' than that of archaic schematism and more differentiated, which is to say it is 'capable of comprising a more extensive range of particularised meanings and a more differentiated system of meanings'.[161] It is more differentiated in so far as it allows distinctions to be drawn between humans and gods, and between personalities of different gods, in a way which the schematism of archaic kouroi and korai does not easily permit. It is more generalised in so far as the codes of naturalism do not so closely determine the particular presentational form of the work of art in which the underlying code is realised. The same iconographic type can be adjusted to show the god pouring a libation in response to the viewer's prayer or sacrifice, in conversation with other gods, or, in a votive relief, touching the votary in order to heal him. In both iconography and presentational style, this involves the generation of visual forms that *indexically engage behavioural potentialities* and repertoires of viewers that were either excluded or only *symbolically* alluded to in archaic schematism. The behavioural potentialities and repertoires engaged are, however, regulated in terms of the constitutive codes of Greek polytheistic religion. These innovations fundamentally change the way in which visual forms gear with the personality structures of viewers and both change the social structure of and considerably intensify the affective motivational work accomplished in rituals of viewing.

Artistic differentiation and the Greek revolution: the structure and foundations of iconographic codes

My definition of style shifts the focus of analytic attention from the phenomenal properties of particular images to the underlying codes which generate them, from the particular 'meanings' instantiated in single works of art, to the way in

[160] Tanner (2000a) 296; cf. Layton (1977) 34; Schapiro (1953).
[161] Parsons (1961) 981 on scientific revolutions.

which a set of generative codes conditions the possibilities of affective communication. In the context of an analysis of Greek religious iconography, this means looking at iconography as a system, rather than decoding an individual statue or looking at the iconography of a single deity as has been the convention in classical art history.[162] Such an approach is commonplace in structuralist analyses of religious systems, where deities are conceived as a system of powers composing a semantic field, in which each deity is characterised by specific qualities, modes of intervention and spheres of action, and such characterisations are elaborated in ritual and spatial practices. Artemis, for example, as a virgin goddess who refuses marriage, is primarily cultivated by female adolescents, girls not yet fully 'civilised' by marriage, and her spatial domain is consequently on the margins of the community (mountains and wilderness), whereas Hera, as goddess of marriage is served by young married women and normally occupies a more central position in civic space.[163] Both structuralism and iconography, however, are largely concerned with decoding the signified, translating various practices in a range of sensory modes into the transparent medium of words. Apart from relationships of *logical* homology or contradiction, relatively little concern has been shown for the specificities of the *material medium* through which such codes are given practical substance and the functional entailments of variations in the properties of such media. Similarly, iconography has been largely content to stop the analysis at the point where it becomes possible to recognise the particular textual narrative or actor lying behind the visual image. As codified in Panofsky's programme, iconographic analysis, referring images to texts, is a largely philological discipline, quite separate from the analysis of style.[164] In traditional art history the very familiarity of naturalistic images has made it seem unnecessary to analyse precisely how they produce their 'meaning' – the semiotic effects implicit in their instant recognition – perhaps in part as a result of the incessant allegorisation induced by the

[162] This is not to suggest that such analyses are not a valid exercise, only that they are not the only appropriate level at which analysis can be pitched. On the contrary, such studies show how the more generalised codes with which I am concerned are specified in particular ways depending on the detailed cultic connections of the temple or sanctuary for which a particular cult statue is made – for example, Harrison (1977), Fehr (1979/80). In practice, however, such analyses bracket the broader stylistic conditioning of the generation of the particular iconographic types in which they are interested, and with it the broader religious questions. Feminist scholarship has inherited this focus, and similarly bracketed the religious dimensions of what is going on in making and looking at statues: statues of Aphrodite are analysed in isolation as indications of Greek male attitudes to women as a whole, and the development of iconography as an allegory of the intensification of patriarchy in classical Greece – for example, R. Osborne (1994c), Salomon (1997) – and on its partial erosion in the Hellenistic world Neumer-Pfau (1985/6).

[163] Calame (1997) 17; Vernant (1994) xv. [164] Panofsky (1939).

Renaissance model. Even post-structuralist iconography eschews any serious consideration of the sensory and behavioural grounds of semiosis by virtue of its reduction of all cultural signification to the models of language and text.[165]

I wish to explore this question of the structure and the semiotic grounds of classical Greek iconographic system by looking at the imagery, primarily sculptural, of two pairs of goddesses: Aphrodite and Artemis, who stand in a fundamental opposition to each other, and Demeter and Persephone, who stand in a relationship of mutual complementarity. In each case, I shall explore how classical imagery differs from archaic imagery in the range of connotations it can evoke, and also in the semiotic means it uses to evoke those connotations.[166] In the next section (pp. 84–9) the analysis will be extended to consider questions of presentational style, and how this shaped social interaction with deities represented in the forms of naturalistic iconography. Then (pp. 89–96) this cultural analysis of style and iconography will be re-embedded in the context of the sociology of religion and the account of rituals of viewing developed above, in order to establish precisely how the whole expressive complex functions in the classical period, in particular in its distinctiveness from the same institutional complex in the archaic period.

Whilst a number of korai – like the Lyons kore or a kore from Samos – have been identified as representations of Aphrodite, none has been recognised with any degree of certainty, since the attributes on which the identifications are tentatively based – a dove or bird, a hare, an apple or piece of fruit – while appropriate to Aphrodite are also potentially appropriate attributes of other deities, or indeed as offerings of human worshippers rather than deities.[167] Evidence of the minor arts, however, makes it reasonably clear that Aphrodite could be represented by a kore. In red-figure vase paintings of the classical period, 'old' statues of Aphrodite, in the context of narratives set in mythic times like the rape of the Leukippidai, are represented as korai.[168] It also seems probable that korai flanked by erotes in bronze mirrors (figure 2.12)[169] and

[165] This is the price that art history pays for purchasing off the shelf Lacan's linguistically overdetermined account of the viewer and visuality, rather than developing the potentially much richer, if not so immediately applicable, work of the object-relations theorists.

[166] The exercise could equally be performed on the basis of male deities, where the personality of deities is also increasingly differentiated on the basis of distinctive physiologies and physiognomies, in addition to attributes such as the presence/absence of a beard or a specific iconographic marker characteristic of archaic iconography – see, for example, the physiological differentiation of the heavily muscled and solidly built Poseidon and the rather lighter Apollo on the Parthenon frieze – Lullies and Hirmer (1957) fig. 154; or compare at the centre of the two pediments of the temple of Zeus at Olympia the heavy-bodied, broad-hipped Zeus with the slighter figure of Apollo – Stewart (1990) figs. 264, 270.

[167] *LIMC* Aphrodite 54, 57, 58, 59; Richter (1968) figs. 186–9 for the kore from Samos, 275–81 the Lyons kore.

[168] *LIMC* Aphrodite 38, 42. [169] *LIMC* Aphrodite 89–94.

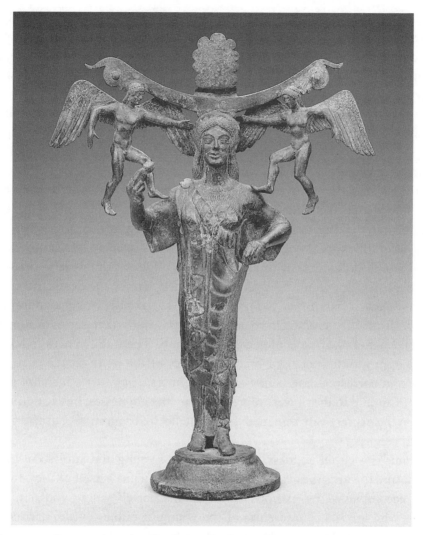

Figure 2.12 Bronze mirror-handle, Aphrodite flanked by Erotes, possibly from Aigina, *c.* 500 BC. Boston Museum of Fine Arts. Henry Lillie Pierce Fund. Photo: Museum of Fine Arts, Boston. All rights reserved.

terracottas in which an Eros sits in the arms of a kore represent Aphrodite.[170] Early representations of Artemis, like the Dreros statuette, are similarly indistinct,[171] except when attributes are added, as in the dedication by Nikandre on Delos, whose hands are drilled to hold a bow and arrow,[172] or the bronze statuette of Artemis in Boston,[173] indistinguishable but for her attribute from

[170] *LIMC* Aphrodite 70. [171] Stewart (1990) fig. 17. [172] *LIMC* Artemis 83; Stewart (1990) figs. 34–5.
[173] Richter (1968) figs. 456–9; *LIMC* Artemis 81.

73

innumerable more anonymous korai – Artemises or other deities or ordinary women – like the peplos kore.[174] Recognition by a viewer of a statue as Aphrodite as opposed to Artemis, or indeed as either (or any other) goddess as opposed to a woman, will have depended (in so far as it was possible at all) either on a distinguishing attribute or on a particular context, a temple of the relevant deity, as opposed to a cemetery. In so far as it was iconographically established, such recognition was primarily intellectual and cognitive, depending on conventional knowledge of arbitrary iconographic codes or symbols that associated particular attributes with particular deities.

In the classical period, by contrast, not only are Aphrodite and Artemis much more immediately distinguishable, but the way in which difference is marked is fundamentally changed. In place of culturally arbitrary iconographic codes which primarily appeal cognitively to the viewer's intellect, physiological and physiognomic differences distinguish the two goddesses, differences which have a double basis, first in the religious codes which defined the distinctive spheres and modalities of action of the two goddesses, secondly in behavioural schemata or dispositions rooted in social role expectations, themselves grounded in universal patterns of physiological maturation. These differences indexically engage appropriate socialised practical senses of the body on the part of the viewer and corresponding behavioural responses, responses which are culturally appropriate to the powers represented by the goddesses, but not grounded solely in the expressively thin medium of intellectual cognition characteristic of arbitrary signs.

Artemis is a virgin goddess, the patroness of young and adolescent girls as they mature towards the active sexuality which Artemis herself refuses. In myth she is accompanied by nymphs, like Artemis herself young and unmarried virgins, who are the counterparts of the young or adolescent unmarried girls who formed the choruses who celebrated the rites of Artemis and were her primary adherents. Not yet fully socialised by the yoke of marriage, adolescent girls were held to be wild, like Artemis, somewhat marginal figures whose appropriate ritual place was on the margins of civic space, under the protection of the virgin huntress.[175] Aphrodite, by contrast, is centrally concerned with active sexuality, sexual pleasure and the arousal of desire. She 'incarnates the immediacy of realised desire'.[176] Sexual allure emanates from the light of her

[174] Or possibly an Athena, as argued recently (2000) in a London seminar by Vincent Brinckmann, on the basis of analysis of the painted decoration of the drapery; Stewart (1990) figs. 147, 149; Richter (1968) figs. 349–51.

[175] Calame (1997) 91–101, 117–19, 142–74; Sourvinou-Inwood (1988a); Kahil (1983).

[176] Loraux (1995) 194; Calame (1997) 123–8.

eyes, and is manifest in a kind of divine glow, which, as described in the Homeric hymn, shines forth from her breasts, 'a wonder to behold'.[177] Even when travelling in disguise 'her marvelous throat, her desirable bosom and her flashing eyes' can give her away to mortals.[178]

Now, whilst attributes like a bow or a dove might symbolically connote these opposed values, naturalism deploys a range of iconic and indexical signs which appeal to the embodied viewer, rather than the mind's eye, in order to give the religious values of the two goddesses practical substance. Artemis is consistently represented as adolescent or younger. This is marked not only by such (relatively) culturally arbitrary features as her clothing – for example, Artemis can wear the short-skirted chiton characteristic also of young girls and a mark of the relative freedom from constraint that they enjoyed before sexual maturity and marriage (figure 2.13)[179] – and hairstyles,[180] but also in physiology and physiognomy. Artemis may be represented as a young girl, with flat or only emergent breasts, as in the small Piraeus Artemis (figure 2.14) or the Artemis from Gabii (see figure 2.13). Aphrodite, by contrast, is represented as a mature woman, full breasted, often wide-hipped, particularly from the fourth century onwards,[181] and a display of her 'desirable bosom' to the viewer may be a central component of the imagery (figure 2.15). Even when Artemis is represented as a relatively mature, full-breasted female, as in the large Piraeus Artemis,[182] there is little chance of confusing her with Aphrodite. First, her physiognomy, generally a rather narrow sharp-featured face, marks her as youthful and nymph-like,[183] whether in opposition to more maternal figures, like her mother on a votive relief from Brauron, characterised by a much heavier body and fuller face (figure 2.16),[184] or to the rather more sensuous fleshy face

[177] Bergren (1989) 9–14. *Hymn. Hom.* 88–9 'And like the moon there was a glow (ἐλάμπετο) around her tender breasts, a wonder to behold'; on the erotic symbolism of the breast in Greek literature, see Gerber (1978).

[178] Loraux (1995) 194, quoting Hom. *Il.* III.396–7.

[179] Sourvinou-Inwood (1988a); Kahil (1983) for illustrations of similarly clad girls participating in the Arkteia in vases from the sanctuary of Artemis at Brauron.

[180] Palagia (1997) 186–90.

[181] The feminisation of representations of Aphrodite takes a particularly marked step forward with Praxiteles' Knidian Aphrodite – Stewart (1990) figs. 503–4; Neumer-Pfau (1985/6), Havelock (1995).

[182] Stewart (1990) figs. 569–70.

[183] Cf. Dontas' description (1982) 25: 'There seems to emanate from her a virginal freshness, luminous and approachable, the purity of a wild-flower; viewed in profile, her visage resembles almost that of a boy, viewed en-face it is rather mild.'

[184] Votive reliefs provide the securest ground for demonstrating that these perceived differences are not just our projections based on preconceptions about the character of the goddesses in question. Comparing statues is a slightly more risky game, in so far as both time and individual artist introduce variability in addition to the variation in appearance dependent on the different nature of the divinities with which I am concerned. The large Piraeus Artemis, a case in point, stands at one extreme of the spectrum of images of Artemis in terms of the heaviness of her bodily build, possibly a defining feature of the work

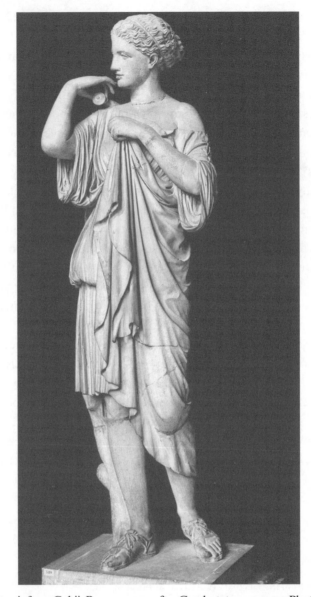

Figure 2.13 Artemis from Gabii. Roman copy, after Greek statue *c.* 340 BC. Photo: Alinari: 22583.

of soft-throated Aphrodite. Secondly, she embodies a very different relation-
ship to her own body than do images of Aphrodite. Where images of Artemis
are typically upright and active, often preparing for or engaged in vigorous
action (figure 2.17), those of Aphrodite eschew any sense of vigorous action,
being characterised more often by a languorous pose (figure 2.18), sinuously

of the sculptor Euphranor to whom some attribute her: Dontas (1982). The distinctive focal points of
the features of each divinity are, however, perfectly clear.

76

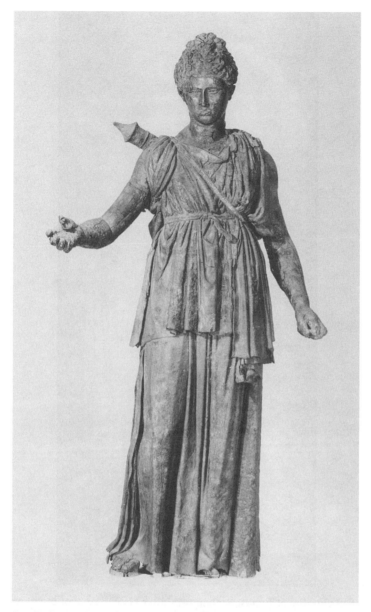

Figure 2.14 Small Piraeus Artemis, *c.* 340–320 BC. Piraeus Museum 4648. Photo: 2nd Ephoreia of Prehistoric and Classical Antiquities, Athens.

reclining on a column in a manner suggesting 'that the goddess would rather be prone than erect', corporeally exemplifying the 'limb-relaxing love' that was the manifestation of her power.[185]

[185] Reeder (1995) 151. Cf. Himmelmann's characterisation of the Parthenon Aphrodite (1959) 11–12. For limb-relaxing love, *lusimelēs*, Hes. *Theog.* 9, 111; Archil. 85; Sappho 40, etc. (LSJ).

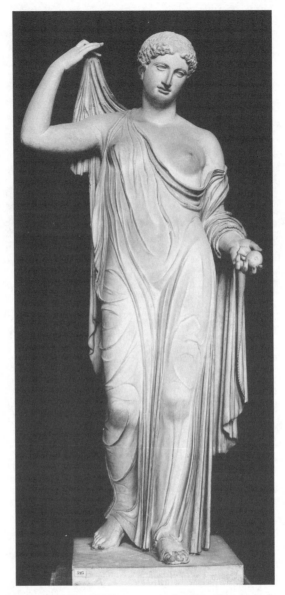

Figure 2.15 Aphrodite of Fréjus, Roman copy after Greek statue of *c.* 410 BC, possibly by Alkamenes. Louvre. Alinari 22752.

A similar picture of aesthetic-expressive differentiation is apparent in the iconographic tradition of representations of Demeter and Kore.[186] Demeter and Kore are often represented together as a pair. Demeter is a mother goddess whose primary function is to guarantee fertility in the contexts of both

[186] Peschlow-Bindokat (1972), whose results I largely follow here.

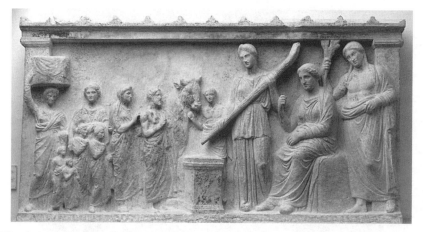

Figure 2.16 Votive relief from Brauron, offerings to Leto and Artemis, second half of fourth century BC. Brauron Museum 1152.

agriculture and human reproduction. She safeguards fecundity for women within the context of civic regulation of sexuality, marriage and the nurturance of children within the family. Demeter's nurturant and maternal role is represented primarily in the context of her relationship with her daughter, Persephone or Kore ('Maiden'), whose rape by Hades, the god of the underworld, and eventual reunion with her mother provide narrative material for the exploration of the mother–daughter relationship, the loss occasioned by marriage, and the continuity of the mother–daughter bond even after marriage.[187] The primary festival of Demeter, the Thesmophoria, was for women only, in particular for *gunaikes*, legally married women or matrons, in the company of their daughters.[188] In archaic sculpture and painting, including early red-figure, Demeter and Kore are represented by identical figure types, korai or their variants, and distinguishable if at all only by attributes.[189] Only in the classical period do the two goddesses acquire distinctive figure types corresponding to their complementary statuses and roles as mother and daughter. On the Eleusis Relief (figure 2.19) not only do Demeter and Persephone have the different hairstyles and clothing conventionally characterising matrons and parthenoi in Greek art,[190] but they are also physiologically distinct. Demeter is represented

[187] Calame (1997) 138–41; Detienne (1994) 80–1; Foley (1996) 119–37.

[188] Vernant (1994) xvi–xvii, xxv; Zeitlin (1982).

[189] Peschlow-Bindokat (1972); *LIMC* Demeter 149, cf. *LIMC* Persephone 17: both enthroned korai, also *LIMC* Demeter 189 – all identified largely on the basis of the sanctuaries in which they were found; *LIMC* Demeter 298 – Metope from Selinus, pair of korai in chariot, identified by some as Demeter and Persephone, by others as Hera and Athena; *LIMC* Demeter 334/40 – late archaic vase paintings – distinctive hair styles and drapery, no physiological distinctions.

[190] The question of the conventional or motivated character of such signs is a nice one, and difficult to make much of analytically without a proper comparative treatment, but see Hodge and Kress (1988) 21–3,

79

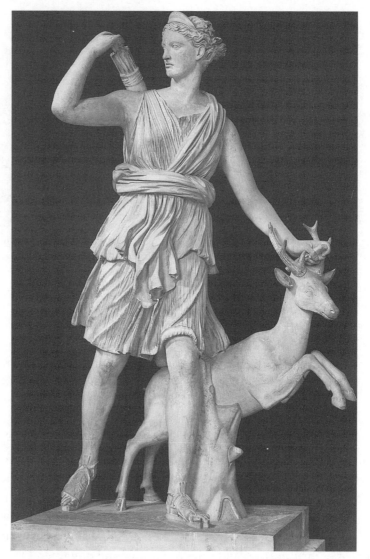

Figure 2.17 Artemis of Versailles. Louvre, MA 589. Roman copy after a fourth-century Greek statue attributed to Leochares. Photo: Alinari 22584.

as heavier bodied, with fuller breasts and a fuller face (fuller cheeks, more flesh under the chin, crease lines on the neck) than the rather slighter figure of Persephone.[191] These distinguishing physiological features become increasingly marked during the course of the fourth century, when Persephone's slight figure

52–9; see Connerton (1989) *passim*, but especially 90–5 for a critique of the linguistic reduction of body to sign.

[191] Cf. Lullies and Hirmer (1957) 58–9 contrasting the 'matronly' figure of Demeter, with that of Persephone 'portrayed as a youthful girlish figure, lighter and more relaxed in posture'.

Figure 2.18 Aphrodite of Daphni. Roman copy after Greek original of late fifth century BC, by Agorakritos. Louvre MA 414. © RMN, Gérard Blot.

is especially emphasised by the very tight wrapping of her himation around her lower body and breasts, in contrast to the free-hanging cloak which frames the more ample physique of Demeter (figure 2.20).[192] Of course, the selection of these particular features is both sociologically and culturally determined, by the social roles represented by the two deities, and the cultural marking of particular dimensions of those roles and their physiological manifestations and

[192] Peschlow-Bindokat (1972), *LIMC* Persephone 45; cf. 70. Note the heads on the Louvre relief are restored, though probably accurately: Persephone also has a slighter face than her mother in other better-preserved reliefs, as also of course on the Eleusis relief; cf. *LIMC* Demeter 412, 413; *LIMC* Persephone 70, 74.

Figure 2.19 Great Eleusis Relief: Demeter, Triptolemos and Persephone, *c.* 420 BC.
Athens, National Museum. Photo: Alinari 24263.

underpinnings. 'Large and bulky breasts', for example, are held by medical writers to be 'good' in mature women, as an indicator of suitability for child-bearing and rearing, whilst from infancy young girls were bound tightly around the breasts in order to ensure the development of a graceful maidenly

Figure 2.20 Votive relief from Eleusis, sacrifice to Demeter and Kore, fourth century BC.
Louvre, MA 752. Photo: after Rizzo Prassitele (1932) plate CLI.

appearance.[193] But they are physiological features that are made available for selection by processes of physical maturation and corporeal changes consequent upon childbirth and child rearing, features that are consequently universal and naturally lend themselves very strongly to marking such distinctions. Moreover, by virtue of being rooted in the physiological experiences of both women and men (through their relations with women), they evoke a sensory recognition and response grounded in the body. Social experience, for example the corporeal discipline of being dressed in certain ways and the relationship to the body which that encourages, amplifies awareness of physiologically given distinctions and embodied responsiveness to them.[194] The distinctive expressive effects of such imagery depend not on culture or biology alone, but on the *interpenetration of cultural and behavioural systems*, which naturalism facilitates.

[193] Hippoc. *Prorrhetikon* II.24; Soranus, *Gyn.* 2.84; Ter. *Eun.* 2.3; with Dean-Jones (1991), Bonfante (1997) 184.
[194] Connerton (1989) 94–5.

The work of creating meaning here, or rather of producing semiotic effects, is predominantly realised through the viewer's sense of the body: from the recognition of different phases of physiological and physiognomical maturation, through the mirroring of different states of muscular tension and repose, to the openly sexual display of some images of Aphrodite. Of course, this body imagery and the responses to which it gave rise were inflected and elaborated by more arbitrary signs – attributes, hair styles – and the cultural preconceptions with which Greek viewers came to the images. Moreover the particular indexical signs used to mark the differences between particular deities are obviously selected on the basis of the pre-existing religious codes, defining the powers and spheres of operation of each deity; a different culture would cut up and put to work the behaviourally given differences differently. Nevertheless, the classical statuary uses indexical signs behaviourally to ground and expand those specifically cultural responses in a way that is radically distinct from archaic Greek art. It is hard to imagine a sexual response to the small Piraeus Artemis, difficult to avoid one to the Aphrodite of Fréjus, irrespective of whether one comes to the imagery loaded with the cultural preconceptions of the Greek viewer, whereas the generation of such diverse responses to two korai with distinctive attributes (bow vs. apple) would depend almost entirely on the work done by the Greek viewer's cultural preconceptions.

Presentational style: the artistic composition of relationships and religious experience

Culture does not generate semiotic effects in isolation, but only through being mobilised in processes of interaction, whether face-to-face interaction or interaction mediated by some form of cultural objectification. Such interaction is largely ignored in iconographic analyses and reduced to the intellectualist model of 'reading' a 'text' in post-structuralism. I have already examined the interactional context of viewers' encounters with cult statues. In this section, I wish to sketch some of the ways in which the presentational style of naturalism transformed the sensory ground of worshipper/viewer–deity interactions.

In the archaic period, the rules for the use and the artistic structure of images kept most viewers at some distance from the sacred, whilst privileging aristocratic elites, whose special status in part depended on their role as mediators of the sacred. The expressive value of aniconic or iconically unelaborate images was realised primarily by ritual 'co-action': the physical manipulations of images – such as dressing the image or carrying it in procession from sanctuary to the boundaries of the polis – in which the power of the deity was mediated to

worshippers on an occasional basis through the intervention of priests possessed of a privileged ritual knowledge and ritual status.[195] Similarly, the presentational style of statues like kouroi and korai functioned more to enforce a sense of religious aura, shared by gods and aristocrats and simply acknowledged by the viewer, than to facilitate interaction between viewer and god in the medium of the image. By contrast, naturalism presents the god to the viewer as one sufficiently similar to the viewer to be a role partner with whom direct ritual interaction might take place. We can see how the structure and flexibility of the presentational code of naturalism facilitated easy interaction with gods in classical votive reliefs, and we can explore some of the experiential entailments of the new sense of accessibility of the gods in accounts of dream visions.

In archaic Greek votive reliefs gods are represented in the absence of worshippers and often frontally face to face with the viewer, or alternatively worshippers are represented (again on their own) in profile, approaching an altar.[196] Classical Greek votive reliefs, by contrast, typically show worshippers represented on a small scale along with deities represented on a larger scale, facing each other in profile, sometimes across an altar, and performing gestures of greeting and libation (see figure 2.20 on p. 83; figure 2.21). In many cases, as in both examples shown here, the iconographic form in which the deity is represented can be shown to be copied or derived from that of the cult statue in question.[197] All these features – shift to profile for gods, difference in scale of worshipper versus god, copying – have been interpreted as indications of the decline of traditional religion and the withdrawal of the gods from the world of men into their own sphere of existence consequent upon the disenchanting illumination of the Greek enlightenment, and correspondingly the emergence of an autonomous art world, in which the value of images derived from their relationship to great artistic masters.[198]

These apparently more direct approaches to the religious and artistic significance of votives – as *symptoms* of religious mentality or tokens of lost cult statues by famous artists – ignore both the role of these reliefs as a medium of interaction and the way in which the artistic language of naturalism constructs the sensory ground for such interaction. The aesthetic form of votive reliefs can be better understood if we think of them as expressive symbols, produced in order to communicate affective meanings such as the attitude or feelings of one

[195] Cf. Witkin (1995) 37–9, 43–50 on coaction.　　[196] Berger (1970) 104–8; Mitropoulou (1977) 86–92.

[197] Eleusis relief: figures derived from Praxitelean cult statues – Rizzo (1932) 100–3, Neumann (1979) 57; Daphni relief and cult statue: Delivorrias (1968), Neumann (1979) 56–7. Other examples: Euphranor's Apollo Patroos – Neumann (1979) 64; Athena Parthenos – Mangold (1993) 25–38.

[198] Hausmann (1960) 34–7, 52–3 – following Himmelmann (1959); Neumann (1979) 53–4, 79–80.

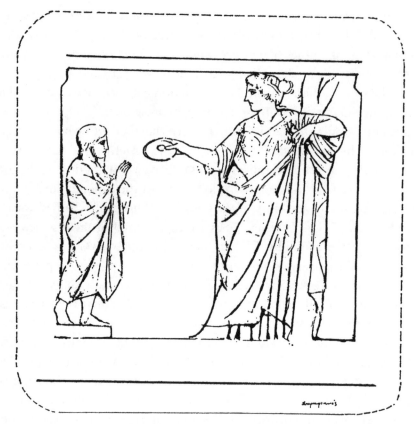

Figure 2.21 Drawing of votive relief, dedicated by the son of Theagenes, from Daphni.
After *Antike Plastik* 8 (1969) 24, fig. 1.

person towards another. As such, their social use and cultural patterning – form, content, style – is organised about the 'attitudinal structure of the relationship' they are used to construct 'and the cathectic interests involved in it'.[199] The pictorial space of the votive relief is one in which cultural elaboration is given to the attitudes of the partners to the exchange relationship set up in the giving of a votive relief and to their feelings about it.[200]

Votives have a sacrificial character. They often not only commemorate a sacrifice by the votary in thanks for or anticipation of benefactions on the part

[199] Parsons (1951) 391.

[200] One might compare the early fifth-century 'workshop' pictures showing Athena present at the workshop but not seen by or interacting with the craftsmen represented. Philipp (1990) contrasts these representations with the easy access of men to the gods in the Homeric poems. But such imagery should be interpreted less as an indicator of global religious change and more in terms of its representational function. The goddess represented is present but not manifest in the workshop. The function of neither vase nor the work being accomplished by the craftsmen represented on the vase is to communicate or to establish a closer relationship with the goddess. On votive reliefs, the function of which is to mediate access to the power of the goddess and her real presence, the deity does interact with the votary.

of the god to whom the votive is given, but they are also themselves a medium of sacrifice. In consecrating a votive relief, the votary gives up to the god the material wealth embodied in the relief and the animal sacrifice it records in return for a reciprocal gift of a higher order, namely access to the power of the sacred.[201] On the completion of this transaction, the votary 'has acquired a religious character which he did not have before'.[202]

Naturalism allows a socially more inclusive and culturally more elaborate construction of the votary–god relationship than had been the case in the archaic period. It is, first of all, naturalism which permits the construction of the relational space for interaction in this form, in contrast to the mutual exclusion of worshippers and deities characteristic of archaic votive reliefs. The small scale of the votary vis-à-vis the god does not simply reflect Greek understanding of the nature of gods as larger than men, an understanding established centuries before the corresponding artistic convention, let alone an increased distance. The significance of the convention is not cognitive, but expressive. It expresses the attitude of the votary towards the god, how he stands and feels in relation to the god to whom he makes his offering. The votary enters into the relationship with the god as a being of an avowedly lesser order. He greets the god with a gesture of pious respect. He claims access to the utilisable power of the sacred not by virtue of an ascribed status which assimilates him to the gods, but by virtue of a ritual performance which demonstrates feelings of dependence upon and an attitude of religious respect towards the god as a power of a higher than human order. As the medium through which these feelings are communicated, the relief sets up a space at once religious and pictorial, a space in which the votary gains access to the sacred and encounters the god. Within this space, the god, turning towards the votary, reciprocates his gift with a libation. He thereby completes the ritual act through which the votary gains access to the power of the sacred and signals his responsiveness to the devotee's ritual performance.

What of the viewer of such votives, rather than the person who has given one? Naturalism, far from permitting a reading of such images of deities on votives as straightforward copies of the cult statue, elides that distinction visually in a way that is parallel to the elision between image and god realised in contemporary discourse.[203] How could one tell whether the image was the cult statue or the god, even supposing that the viewer was – as most were not – inclined to make that distinction? For the visitor to a sanctuary, contemplating the votives before

[201] Gernet and Boulanger (1932) 221–4. On votives and gift-giving, Burkert (1987), Linders (1987); on votive reliefs as gifts, van Straten (1981).
[202] Hübert and Mauss (1964) 9–12. [203] Gordon (1979).

approaching the temple itself, such images prefigured the viewing of the cult statue and promoted confidence on the part of viewers that they too might expect to be religiously transformed by the experience. What joy when on entering the temple they encounter *kat' omma*, face to face, the very deity whose benevolence on behalf of others the viewers have encountered so richly attested by the votive reliefs. Far from reducing the specifically religious aura of the original, such reproductions dramatised and confirmed the authentic power of statue/god, engendering a 'new and compelling aura' of their own.[204]

By virtue of the higher level of abstraction at which the cultural patterning of naturalism is codified, it lent itself not only to institutionalisation as a convention for constructing relationships with gods on votive reliefs, but also to internalisation by worshippers, the product of repeated witnessings of the *aretai* of deities in votive reliefs and viewings of cult statues in ritual circumstances which made the viewer particularly receptive to such internalisation. Once internalised, naturalistic imagery formed the basis for interactions in dream epiphanies. Through such dreams, the viewer/dreamer gained access to the sacred and its utilisable power. The ailing orator Aelius Aristeides reports that while staying in the sanctuary of the healing god Asklepios at Pergamon, he had a dream: 'Athena appeared, having her aegis and the beauty and grandeur in her whole form just as the Athena of Pheidias in Athens (καὶ τὸ κάλλος καὶ τὸ μέγεθος καὶ σύμπαν δὴ σχῆμα οἶα περ ἡ Ἀθήνησιν ἡ Φειδίου).' She encourages him, tells him to bear up and restores his physical strength: 'Thus the goddess appeared to me and encouraged me, and saved me as I lay there on my sick bed, right on the verge of death.'[205] It is a recurrent pattern in Aelius Aristeides' account of his various illnesses, that a god should appear to him in a dream, in the form of his or her statue. The god interacts with Aristeides through word or deed. Serapis, for example,

seated in the form (*schema*) of one of his statues, holding some kind of surgeon's knife, made an incision around my face, somehow even under the gum itself, removing defilement, and purifying it and restoring it to its proper state.[206]

Such visions are accompanied by the hallmarks of a profound religious experience. Aelius is infused with a sense of grace and wholeness through contact with the power of the sacred. His identity is transformed and psychic strength restored by this sign of the god's attitude of special benevolence towards him:[207]

[204] Freedberg (1989) 126. [205] Aristid. *Or.* XLVIII.41–3. [206] Aristid. *Or.* XLIX.47.
[207] Aristid. *Or.* XLIX.47; XLVIII.18–23.

At this moment the god, in the same posture in which he is portrayed in his statue (ἔχων ἤδη τὸ ἑαυτοῦ σχῆμα ἐν ᾧσπερ ἔστηκεν) indicated with a nod of his head that we should go. All the others had departed and I was turning to leave, when the god indicated to me with his hand that I was to stay. And I was overjoyed by this honour, and at how greatly I was marked out for distinction above all the others, and I shouted out 'the one', meaning of course the god. And he said 'It is you.' These words, lord Asklepios, meant more to me than human life itself; every disease is less than this, every grace less than this. This gave me both the ability to live and the will to live. And now that I have said these things, may I enjoy no less honour from the god than before.[208]

Aelius Aristeides is, of course, writing a good deal later than the classical period with which I am primarily concerned. The burden of my argument, however, has been to suggest a high level of continuity in the relationship between art and religious experience between the fifth century and the Christian revolution of late antiquity. There is evidence to suggest, moreover, that Aelius Aristeides is less unusual in the kind of religious experiences he has than in his capacity to articulate them in so compelling a literary form that they have survived until today. The appearance to people in dreams of gods in the same form as they assumed in their cult statues is well attested epigraphically in the classical period and even represented on votive reliefs, particularly, though not exclusively, in the context of the practice of incubation in the cult of the healing-god Asklepios.[209]

Naturalism, semiosis, and the construction of expressive-aesthetic identity

I am now in a position to define more precisely how the artistic language of naturalism functioned in the broader context of the ritual performance of viewing cult statues, and in particular how it differed in the effects it produced from archaic schematism. Naturalism differs from the archaic style not by virtue of the accumulation of perceptual data as schemata are corrected against reality, nor by the addition of connotative social codes to established icono- graphic schemata. On the contrary, the Greek revolution involves a fundamen- tal change in the structure of the language of art. This change affects the internal structure of the language of art, engendering a more differentiated iconographic system and a presentational style which is more flexible and affords a more immediate sense of relationship between viewer and image. The development of naturalism also affects the expressive and semiotic foundations of the language of art, shifting the balance from a predominance of symbolic codes which

[208] Aristid. *Or.* L.50–1. [209] See Van Straten (1976), Clerc (1915) 53–4.

89

appeal to the eye and intellect to a predominance of indexical and iconic codes which engage bodies socialised into role expectations and behavioural schemata, themselves grounded in biologically given patterns of physiological maturation. Whilst grounded in social roles and the maturation of behavioural systems, the development of these iconographic schemata was also controlled by pre-given religious codes, which guided the creation of iconographic schemata expressively appropriate to the specific qualities, modes of intervention and spheres of action held to characterise the manifestation of the power of a particular deity. Far from representing the emancipation of art from religion, naturalism lends practical substance to religious codes, both in providing the sensuous ground for the construction of interactional relationships with gods and in articulating a motivationally intense experience of the nature of the deity in question and the manifestation of its power. It is this intense *expressive* effect, rather than the primarily cognitive truth effect or 'effect of the real', that is the special characteristic of naturalism in art.[210]

Art here is not just a 'reflection' of social roles or religious ideas. It is the cultural means by which attachment to both religious codes and the role expectations codified therein was produced during the ritual process of viewing and the interaction with the deity which such viewing entailed.[211] Rituals of viewing took place at motivationally significant moments in a viewer's life, whether defined in terms of the life-cycle of the whole community at festivals like the Thesmophoria, rites of passage like marriage, or occasional solitary visits to a sanctuary to pray and make offering to a god or goddess for assistance with some particular problem an individual faced. The festival, the rite of passage or the individual problem already defined the visit to the temple, and the viewing of the statue, in terms of specific motivational relevances. The ritual process of viewing – approaching the temple past scores of votive reliefs, preparatory offerings and the manipulation of sensory experience as one encountered the statue – opened up in the viewer a heightened attitude of responsiveness, an openness to sensory stimuli and a readiness both to internalise the codes objectified in the statue and to project corresponding motivational dispositions already embedded in one's personality. It is precisely the abstraction of the ritual of viewing from the acting out of roles that provides a cultural space within which viewers can bring to the surface latent potentialities and transform themselves by intensifying their commitment to certain

[210] It is a good indicator of the intellectualism of structuralist and post-structuralist accounts of naturalism, like Bryson's, that their characterisation of the effect of the real fails to distinguish the semiotic effects of science and art.

[211] Babb (1981), Kondo (1985).

motivational patterns or by reorganising the place of certain motivational patterns within their personality structure, on the basis of controlled projections elicited by the expressive form of the statue.[212]

Imagine a bride and groom coming to the temple of Aphrodite to sacrifice during the course of the marriage ceremonials, and encountering the Aphrodite of Fréjus (see figure 2.15 on p. 78). Far from being simply high-class pornography designed for the gratification of male viewers in a patriarchal society, such an image offered profound motivational meanings to both bride and groom. Drenched in perfumes and crowned in myrtle, the bride, sacrificing to Aphrodite, gained access to and could feel herself as embodying the *charis*, the beauty and sexual desirability that characterised the goddess and also described the attitude of a bride 'giving herself in response to a man's desire in the context of marriage'.[213] The man, in becoming aware of the sexual desire aroused by the image, feels and submits to the power of Aphrodite just as husbands were held to do in recognising the allure of their bride and consummating their marriage.[214] Even the fruit ceases to be a mere symbolic attribute of Aphrodite, but, by virtue of the presentational style, becomes a token of the interaction between viewers and goddess, a sign that she unlocks her powers on their behalf, prefiguring the bride's gift of a quince to the groom in the nuptial chamber.[215]

Aesthetic form renders motivationally attractive the modes of action characteristic of deities (and the roles they represent) by eliciting pleasurable projection by viewers of the corresponding motivations, in part grounded in the stimulation of a pleasurable sensory awareness of relevant behavioural potentialities and schemes of action.[216] Naturalism not only intensifies such affective projections but also constructs them in a far more differentiated way than the archaic style. Statues of Artemis and Demeter, for example, afford women very different models of their own beauty and desirability from statues of Aphrodite; they offer men different grounds for valuing varying forms of female beauty, grounded in different stages in the life-cycle or different roles, and different norms regulating both feminine behaviour and male attitudes to different kinds of women. Such values – at once aesthetic, religious and social – were articulated in the varying types of competition held at Greek festivals in which the beauty of women was evaluated. These included not only the choruses of young girls and adolescents competing in song and dance as they celebrated both the *aretai* and the rites of

[212] Babb (1981), Kondo (1985), Lidz and Lidz (1976) 219–22.
[213] Detienne (1994) 62–3, 87–8, quotation 87. [214] Bergren (1989) 24.
[215] Detienne (1979), Littlewood (1967).
[216] Cf. Lidz (1976) 132 on expressive forms as 'the means by which culture attracts motivational energies of participants to its own basic patterns'.

Artemis or Apollo, but also beauty contests for married women, *gunaikes*, held at festivals of Hera on Lesbos, or, more particularly relevant to the images we have looked at, at the festival to Eleusininan Demeter at Basilis in the Peloponnese, and conceivably during the *Kalligeneia*, the third day of the Thesmophoria at the festival of Demeter at Athens, 'during which the participants prayed for perfect offspring'.[217] Here the bodily form that is valued is not that of the nubile virgin ripe for marriage, or the embodiment of sexuality engendering erotic mutuality in marriage. Rather it is the matronly *gunē*, capable of giving birth to healthy children and standing in a nurturant relationship to both male and female offspring, the same kind of body and behaviour represented and offered as a model in the image of Demeter in the Eleusis Relief. Doubtless it was on the basis of the same kinds of practical and embodied schemata, grounded in their own social roles and religious representations of them rather than in abstract aesthetic theory, that both women and men evaluated the quality of the experience that particular statues offered them and repeatedly returned to particular statues which afforded a pleasurable sense of motivational capacity to embody and perform that role, or alternatively a sense that here with the goddess their own needs for nurturance, for example, might be met.[218]

Causes and consequences: religious culture, political organisation and the social production of art in classical Greece

How can we explain this fundamental reorganisation of the expressive dimension of religious culture, and what were the consequences of these changes? I conclude by looking at the social context of these cultural developments, namely changes in religious organisation in classical Athens and concomitant changes in the social organisation of the production of religious art.[219] The late sixth and the fifth centuries saw progressive democratisation of religious organisation in Athens. Kleisthenes' reforms did not so much directly attack the aristocratic *genē*, which maintained many of their privileges, as progressively displace and marginalise them, undermining the capacity of an aristocratic elite

[217] Calame (1997) 138; Ath. XIII.609. [218] Cf. Morphy (1989) 22.

[219] What follows is an Athenocentric account, notwithstanding that the Greek revolution seems to have been a much more widespread phenomenon. This is in part a function of the concentration of both our literary and our artistic sources on Athens, but a number of other poleis saw democratic revolution in the late sixth and early fifth centuries (I. Morris 2000, 186–90), and the changes in Athens seem to be part of a broader movement towards a 'strong' form of egalitarianism manifested also in other parts of the Greek world (I. Morris 2000, 111–13). Athens may have been particularly important as a centre for the development of the new democratic visual languages by virtue of its major role in artistic patronage in both sculpture and wall-painting from the late archaic period through to the mid fifth century when the new religious iconography was finally codified.

to accumulate prestige through provision of the facilities for collective religious activity and a privileged relationship to the sacred.[220] Cults that were *demotelēs* (at public cost) were created alongside the old *genos* cults dominated by the Eupatrids, and elite euergetism was replaced with compulsory liturgies. Control over the introduction of new cults was assumed by the demos, in assembly, at the expense of the aristocratic Areopagos. The prestige which belonged to *genos* priests as an inherited right was increasingly displaced by the demos voting honours for officials whose performance of ritual duties on behalf of the state had been deemed satisfactory after scrutiny by public boards of treasurers and supervisors appointed by the demos. The priests of the new civic cults were selected democratically, by lot.[221]

This process of democratisation extended to the use and production of religious art. The noble *genos* of the Praxiergidai was traditionally responsible for the care of the old olive-wood statue of Athena Polias on the Acropolis at Athens. Their primary duties were ritually to clean and clothe the statue at two of the major religious festivals of the Athenian year, the *Plynteria* (Washing) and the *Kallynteria* (Beautification). At the latter festival, on Athena's birthday, the goddess was invested with a new peplos every fourth year as a gift from the Athenian people. In the 450s BC the duties and privileges of the Praxiergidai were subjected to civic control. An oracle was sought by the Athenians from Apollo at Delphi to define the ritual duties of the Praxiergidai. These rules were then inscribed on stone by the demos and boule, who also established fines should the Praxiergidai fail to comply with these new public regulations.[222] The peplos given to Athena was woven with representations of myths such as the battle of the gods and giants. Designs for the peplos were submitted to democratic judgement, first by the boule, later by a jury court selected by lot and hence held to be representative of the demos as a whole.[223] Epigraphic evidence – building accounts for the Parthenon including Pheidias' statue of Athena and for the statues in the Hephaisteion – attest a similar pattern for the production of cult statues. A designer (for the temple or statue) would be appointed – probably on the basis of a competition – by the boule, and three members of the boule would be appointed to a commission to work with and supervise the

[220] Rather than the revisionist account of Roussel (1976) and Bourriot (1976), I follow here the modified version of the traditional account of *genē* in the archaic period as an institution created in the archaic period, possibly the seventh century BC, in order to secure and transmit 'rights of access to hereditary offices', of which, following the democratisation of office holding, the hereditary priesthoods were the only surviving privilege in the classical period: S. Lambert (1999), Humphreys (1983). See also Vidal-Naquet (1993) xxxvi and Parker (1996) 56–66 for similar modifications of the revisionist account.

[221] Davies (1981) 107–14, (1988) 379; Garland (1984), (1990), (1992); Parker (1996) 24–6, 56–66, 124–31; R. Osborne (1994a) 146.

[222] Ostwald (1986) 145–8; Garland (1992) 100–2. [223] *Ath. pol.* 49.3 with Rhodes (1981).

artist. The commissioners reported back regularly on progress in the project, which was subject to annual public scrutiny and accounting by the boule and demos.[224] It is perhaps not surprising then that an artistic language oriented more closely to the expressive needs of ordinary people displaced one oriented primarily to the needs of an aristocratic elite.

The development of naturalism depended on a number of factors, variously interwoven into a quite complex causal configuration. First, the motivation for the development of a new artistic language was conditioned by the overthrow of the old aristocratic regime and the discrediting of both the status order associated with it and the expressive languages through which that status hierarchy was manifested. Both funerary cult and monumental funerary commemoration seem to have been legislatively curtailed either by Kleisthenes or shortly thereafter, whilst the state assumed a monopoly on the collective allocation of prestige to the dead in the context of the public funeral.[225] The end of the old expressive order was reflected also in changes of styles of dress and personal ornamentation as members of the elite adjusted their own behaviour to the exigencies of democratic politics and adopted a more demotic style of presentation of self.[226] Secondly, the reorganisation of patronage under the control of the demos and with the very considerable resources of the state laid a premium on artists elaborating new visual forms that appealed to the expressive needs of the population as a whole rather than those of the elite. Existing religious codes defining the nature of particular deities (their spheres of intervention and modes of action), together with the motivational needs of citizens in the context of the roles corresponding to the domains of the relevant deities, acted as selective criteria controlling the discovery of new iconographic types and presentational modes, mediated through the same kinds of practical aesthetic judgements as were made in ritual beauty contests but this time in the context of democratic control over artistic production.

Of course such changes were not accomplished overnight: the selective pressures of social, cultural and psychological environments are necessarily mediated through the material structures of artistic agency in the creation of new forms of expressive symbolism, all of which require time and effort.[227] The disappearance of the kouros as a type and the radical reorganisation of bodily form in early classical statues like the Kritian boy indicate a marked

[224] Burford (1963). [225] Humphreys (1993) 85–8; Karusos (1961) 41.
[226] Thuc. 1.6 with Gomme's (1945) note for the evidence of the vases. Cf. Ps.-Xen. 1.10. See further below, ch. 3, pp. 116–34.
[227] I discuss the social construction of artistic agency in classical Greece in chapter 4.

change of direction.[228] The beginnings of physiological and physiognomic distinctions between deities emerge during the course of the early classical period, but it is not until the classical period that they are fully realised and to some degree codified during the high point of democratic art production, the massive building programme at Athens. The development of artistic technique, including the capacity to mark the kinds of physiological and physiognomic differences and to compose the bodily and gestural presentations which I have discussed, was of course a necessary condition of the realisation of naturalism, but not a sufficient one. Technique *per se* is normally a blunt instrument for explaining change, in so far as technique itself can seldom explain the particular direction of change – the uses to which technique is put – which depends on the expressive purposes of the work of art in question; this brings us back to questions of patronage and the social functions of art. Indeed when art is as deeply socially embedded as in the archaic and classical Greek worlds, the investment of time and effort in technical innovation itself requires explanation, which brings us back to social factors – structure and demands in the artistic 'market' – rather than narrowly artistic ones. This seems particularly to be the case in the role of bronze in the Greek revolution. By the middle of the sixth century the technical level of bronze-casting which Greek sculptors had achieved potentially afforded formidable formal and expressive advantages over marble, which had hitherto dominated monumental sculpture: increased tensile strength, compositional flexibility and freedom of experimentation in statues built up on the basis of a clay model. Rather than driving change, however, these technical potentialities remained artistically unexploited for the next half century. Bronze sculpture copied the forms and genres of marble sculpture, and the latent potentialities of the medium were only exploited as a result of the changed sociological context of art production brought about by democracy.[229] Social pressures drive artistic change; institutionalised cultural codes control it; technique conditions it – at least within the embedded sociological situation of art in archaic societies like ancient Greece.

That said, we should not follow those who suggest that there is no *evolution* from archaic schematism to classical naturalism since the classical forms of the gods are merely the logical consequence of anthropomorphism and the reflection of ideas already established in Homeric poetry.[230] Such a position simply

[228] Fehr (1979) 25–30 and below.

[229] Mattusch (1988) 51–85, 91–4; (1996) 8–9, 21–2 on archaic bronzes; Stewart (1997) 52 on bronze and design.

[230] Bruit-Zaidmann and Schmitt-Pantel (1992) 218. Spivey (1995) 454 – on naturalism and the Greek revolution as the inevitable consequence of 'the nature of anthropomorphic belief', and the eroticism of

ignores the specificity of art as a form of material culture, both in terms of the conditions of material cultural production and the consequences of material cultural production. The Greek revolution depended on the existence of a material tradition of representation and the capacity and motivation of artists to elaborate and transform that tradition by exploiting inherent technical and design potentialities of bronze, and extending them to marble and other media, in order to produce a more differentiated and flexible medium of aesthetic-expressive communication. It is only those material potentialities and their creative realisation by Greek artists which permitted the greatly enhanced transformative power of naturalism as an artistic language when compared with schematism. Naturalism was more transformationally powerful in its construction of affective meanings in so far as it constructed a more differentiated range of affective meanings than archaic schematism, more precisely adjusted to the particular deity represented in an image, and more effectively appropriating the socialised body and motivational interests of viewers in its construction of affective meanings.

These changes had important consequences, even if they are perhaps difficult to disentangle in more than a speculative way. Whilst changes in moral culture may quite directly modify observable patterns of social behaviour, changes in artistic culture function rather more indirectly, mediated through the functioning of the personality and manifested in the organisation and distribution of affect, which is not always easily observable. It is nevertheless worthwhile to think through the entailments of the reorganisation of affect production that I have delineated, and to explore its possible ramifications, particularly in so far as they may help us to understand more fully certain broader institutional processes. The most obvious consequence of the Greek revolution was that motivational energies tied up in the legitimation of elite hierarchy were released for other purposes. Additionally, naturalism built on the upgrading of the ritual status of all citizens in the Kleisthenic reforms by intensifying attachment both to traditional religious culture and to the role structure which it represented. Heightened affective attachment to traditional religious culture perhaps helps to explain the survival and reproduction of that culture throughout the classical period, notwithstanding the attacks on it by philosophers, and indeed the somewhat widening gap between religious culture and everyday experience, which resulted from the increasing urbanisation that itself had promoted the rise of Greek philosophy.[231]

statues of Aphrodite as an entailment which 'naturally ... logically follow[s]' her role as a goddess of erotic love and patroness of sacred prostitution.
[231] Lloyd (1979); Frischer (1982) 1–26.

PORTRAITS AND SOCIETY IN CLASSICAL GREECE

The Greek revolution transformed not only representations of gods, but also those of men. As early as *c.* 470 BC an image of the Athenian statesman Themistokles was created that is often held to be 'the first true portrait of an individual European'[1] (figure 3.1). Whilst having some features which might echo generic imagery of athletes or their divine patron Herakles – namely short hair, the massive cubic structure of the head, and swollen ears – Themistokles displays features which clearly differentiate him from either the god (most notably features of ageing such as the beginnings of crows' feet at the corners of the eye, the cleft between the eyebrows) or such sculptures of athletes as found in archaic stelai or kouroi: the asymmetries of the upper face (arched brows, left eye higher and larger than the right), the hook at the top of the nose, the jutting chin.[2] The portrait of Themistokles is one of a group of early classical images characterised by such humanising and individuating features, setting an individual apart from gods and marking him out as a particular individual man. A portrait of the blind poet Homer, created *c.* 460 BC, is comparably individuated by closed lifeless eyes, alongside a specific selection of features paralleled in other representations of high-status old men in sculptures and vase paintings: loose cheeks, furrowed brow, hair drawn forwards and knotted in braids over the forehead to disguise baldness.[3] A portrait of Pindar, *c.* 450 BC (figure 3.2), shows the poet with knitted brow, carefully groomed hair, impassive mouth, and the locks of the beard knotted under the chin. What individuates the image is not so much any of the specific features (with the possible exception of the rather large ears)[4] as their particular combination. The knitted brow, for example, rather than expressing anger and suffering as it does in the contemporary centaurs of the temple of Zeus at Olympia, creates an impression of intellectual concentration,

[1] Robertson (1975) 187; cf. Gauer (1968) 148; Metzler (1971) 13; Richter (1955) 21.
[2] Krumeich (1997) 72–8; Fittschen (1988) 18; Voutiras (1980) 46–53; Drerup (1961); Himmelmann (1994) 66–9.
[3] Voutiras (1980) 54–62; Richter (1965) 1.47–8; P. Zanker (1995) 14–22. [4] Voutiras (1980) 63.

(a) (b)

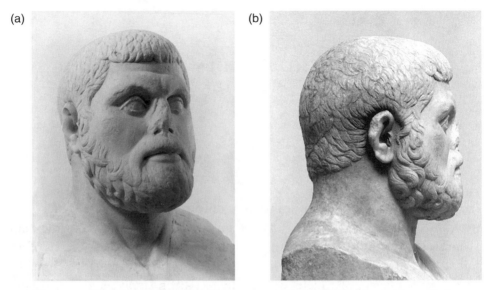

Figure 3.1 Herm of Themistokles, Roman copy after Greek statue, *c.* 470 BC. Ostia.
Photos: (a) DAI, Rome. Neg. 66.2295; (b) DAI, Rome. Neg. 63.2356.

since it is combined with an impassive mouth rather than the open mouth and
flared nostrils of the centaurs. This image of spiritual concentration is then
placed within a specifically aristocratic social milieu by the knotted beard,
which is not otherwise found combined with such features as the knitted brow
and the marked creases under the eyes that are characteristic of Pindar.[5]

Classical art-historical scholarship prior to the last decades of the twentieth
century treated both the category and the purpose of the 'portrait' as largely
unproblematic. Like modern western portraits, Greek portraits were charac-
terised as images of specific historical persons, immediately recognisable as such,
expressing that individual's inner personality.[6] Correspondingly, portraiture
was explained in terms of the development of individualism in Greek culture.
According to the liberal version, the origins of Greek portraiture may be asso-
ciated with the development of 'the concept of and respect for the individual, *an
essential ingredient of our way of life*', institutionally expressed in the develop-
ment of democracy in fifth-century Greece.[7] Marxists tell the same story with a
slightly different emphasis: as the 'feudal' social structures of archaic Greece

[5] Bergemann (1991). See Voutiras (1980) 62–72 for a good discussion of the copies, but before the
identification of the portrait as Pindar rather than Pausanias. Richter/Smith (1984) 176–80.

[6] Fittschen (1988) 2 – discussing Schweitzer's influential studies of the origins of Greek portraiture.

[7] Frel (1981) 1 – my emphases. Cf. Richter (1955) 12: Greek portraits, 'like the characters of Greek drama,
all spring from the same interest in that intricate phenomenon, the human individual'.

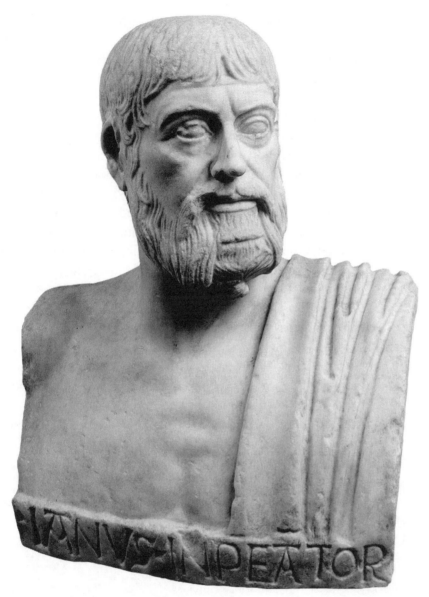

Figure 3.2 Pindar. Roman herm, copy after Greek statue of *c.* 450 BC. Museo Capitolino, Rome. Archivio Fotographico dei Musei Capitolini.

were dissolved by the monetisation of economic life, the bourgeois class of shopkeepers and small manufacturers, the primary builders of Athenian democracy, developed individualistic portraiture as a medium of self-expression.[8] Similarly, the development of a practice whereby the state honoured specific

[8] Metzler (1971) 69–72, 151–3.

individuals with civic portraits, in fourth-century Athens, has generally been interpreted as a symptom of the pathological extension of this culture of individualism: a changing balance of power between the state and its leading citizens eroded the predominantly collective and egalitarian values that were characteristic of fifth-century Athenian democracy.[9]

Within this paradigm, the primary shape taken by research on portraiture was that of identifying portraits, then reading them in terms of what we knew of the character of the specific individual from literary sources and determining when 'true' portraiture began. The same modernising assumptions about the function and meaning of portraits, as vehicles of individual self-expression, informed the categorisation of which images counted as 'true' portraits and constituted the appropriate corpus of objects to study. The images of the Tyrannicides Harmodios and Aristogeiton (figure 3.3), set up in the Athenian agora, have generally been judged not to be true portraits because they are too idealised and not sufficiently individuated.[10] Similar reservations have been expressed about the portrait of Perikles, by Kresilas (figure 3.4) – 'not a true portrait ... any individuality reflects the artist's style rather than the subject's appearance'.[11] Correspondingly, a group of portraits of generals of the same type as the portrait of Perikles, probably dated in the first half of the fourth century BC and representing in one case probably Konon, in another possibly Chabrias (figures 3.5, 3.6), are also adjudged not to be 'true' portraits.[12]

Recent research, however, has questioned the applicability of the modern individualistic conception of portraiture to classical Greece. The concept of verisimilitude seems inappropriate to a culture in which many portraits, like that of Homer, were fictitious and were known to be so.[13] More generally, the validity of any universal standard of realism has been questioned. What counts as 'realistic' is held to be a cultural convention: a portrait can be made to 'any required degree of accuracy'.[14] Since we are in no position to evaluate how

[9] Metzler (1971) 356–7; Dontas (1977) 86; Stewart (1979) 123.
[10] Boardman (1985) 239; Metzler (1971) 13, 17; Richter (1955) 16. [11] Boardman (1985) 206.
[12] For the judgements: Boardman (1985) 239; Metzler (1971) 14; Richter (1955) 16. For the attributions: Konon – Dontas (1977) and most recently Knell (2000) 70–3; Chabrias – Dontas (1977), a plausible guess on the basis of the dates for the best parallels of the head in Attic stelai and our knowledge of which Greeks were objects of biographical interest and hence likely to have their portraits copied by Roman collectors. For variants in the copies of these heads: Pandermalis (1969) 24–33 (Perikles), 34–6 (Berlin–Ephesus), 46–55 (Pastoret), 65–7 (Vatikan 'Themistokles'); Voutiras (1980) 112–21 (Pastoret). See Krumeich (1997) 207–10 on the literary and epigraphic testimonia for the portraits of Konon, Iphikrates and Chabrias.
[13] Cf. Dem. XIX.251–2 on Solon's portrait.
[14] Brilliant (1971) 17; Bryson (1983) 124–7. Cf. Gombrich (1960) 78: 'the correct portrait ... is the end product on a long road through schema and correction. It is not the faithful record of a visual experience but the faithful construction of a relational model.'

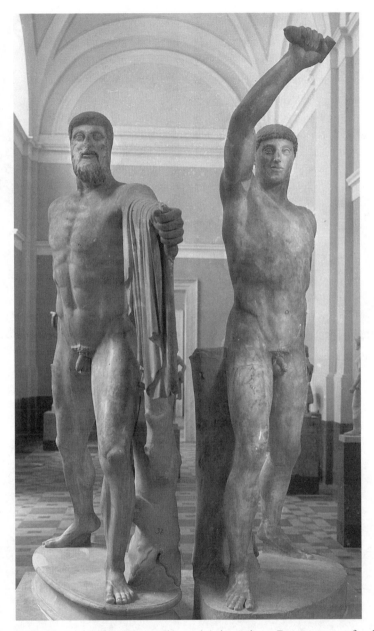

Figure 3.3 The Tyrannicides, Harmodios and Aristogeiton, Roman copy after bronze statues by Kritios and Nesiotes, *c.* 477/76 BC. Naples. Photo: Alinari 44825.

realistic the portraits of Themistokles or Perikles are, it follows that we do better to explore the conventional characteristics of their representations, how iconographic conventions designate the sitter as one or another social category of person with certain typical characteristic features. These conventions are, after

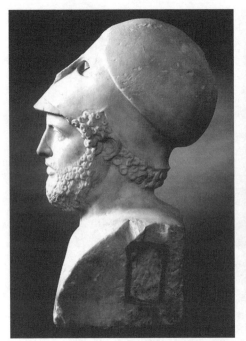
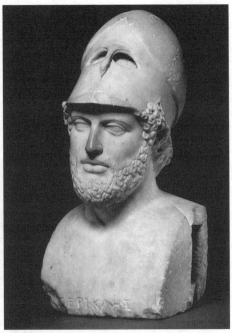

Figure 3.4 Bust of Perikles after statue probably by Kresilas, *c.* 425 BC.
Photo: Copyright British Museum.

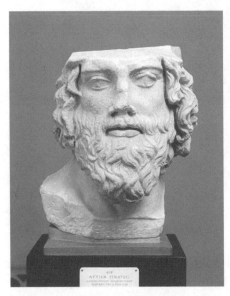
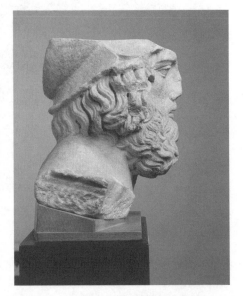

Figure 3.5 Athenian General (the 'Pastoret' head), probably Konon. Roman copy
after Greek statue *c.* 400–375 BC. Copenhagen. Photo: Glyptothek, Copenhagen.

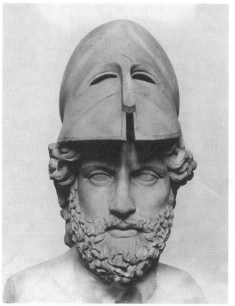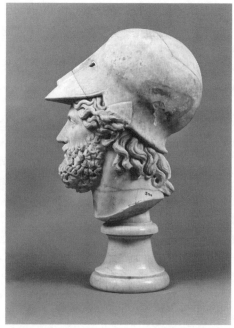

Figure 3.6 Portrait of a general, 'Berlin-Ephesos type', Roman copy after Greek statue of *c*. 390–370 BC. Photo: Berlin, Pergamon Museum.

all, the only evidence that is objectively accessible to the modern scholar for analysis and critical evaluation.[15] Understanding a portrait, then, is not so much a subjective encounter with and exploration of the sitter's individuality, as an objective decoding of a culturally specific iconography, which tells us less about what a specific individual's character 'really was' than how he was classified or evaluated within his society and culture as an examplar of a particular social category or role, such as that of 'intellectual' or 'statesman'. The history of portraiture is the history of the changing social value and cultural meaning attributed to such categories, as codified in visual form.[16]

The critique of the concept of realism, and of the imposition of our own culturally specific standards of what counts as a portrait, has created theoretical space within which it has been possible to conduct these iconographic studies that place images more carefully in their specifically Greek cultural context. It has also to some degree ameliorated our tendency to exclude some images from the corpus through the application of modern western conceptions about how

[15] Brilliant (1971) 17.
[16] See Brilliant (1991) 38–43 for the best account of the theoretical assumptions of such an approach; P. Zanker (1995) for an empirical study informed by such assumptions.

realistic a portrait must be in order to count as a true portrait.[17] Although a welcome recognition of the cultural particularity of Greek art, the assumptions on which this perspective is based have rendered moot the whole issue of the origins of portraiture as such, as an important change in representational practices within Greek art. After all, specific persons had been represented in sculpture during the archaic period, in a range of different types in both relief sculpture (athletes, hoplites – notably the famous stele of Aristion) and, in a still more generic way, as kouroi – Kleobis and Biton, Dermys and Kittylos, the Olympic victor Milon.[18] The development of these types in relief sculpture, as well as the kouros and other free-standing sculptures of archaic Greece like the representations of scribes from the Athenian Akropolis,[19] or the enthroned statues from the sacred way at Miletos,[20] could equally be interpreted according to an iconographic methodology in terms of the changing cultural value attributed to particular social categories of person. Within a narrowly iconographic framework, with such strong culturally relative assumptions about the concepts of portraiture and realism, we simply cannot address the issue of the changes going on in representational practices in classical Greece, changes which implicitly at least are recognised. The portraits of Perikles and the fourth-century generals may explicitly be denied the status of 'true' portraits, but they are readily distinguishable from each other through details of physiognomy in ways in which kouroi are generally not. Furthermore, they are included and discussed in standard handbooks as portraits, where archaic images of specific persons such as Kleobis and Biton or Dermys and Kittylos are not.

Interestingly, what both traditional and more recent iconographic scholarship largely ignore is the Greeks' own cultural classification of modes of figurative representation, and in particular the invention of the category of *eikōn*, or 'likeness'.[21] If there is no question of 'portrait-likeness' in the portrait of Pindar,[22] or those of the Tyrannicides, Perikles and the general portraits, why are they classified as such in contemporary Greek texts, and why did the Greeks invent this new concept and use it to designate precisely these and related

[17] Smith, for example, in his edition of an abridged version of Richter's *Portraits of the Greeks* adds the Tyrannicides to the corpus (Richter/Smith 1984, 9, 124–7) but without any discussion of the significance of this change.

[18] See ch. 2, pp. 60–7; Aristion stele: Stewart (1990) figs. 145–6; on Milon see below p. 135.

[19] Boardman (1978) fig. 164. [20] Stewart (1990) figs. 104, 106–8.

[21] This seems to be an odd by-product of international division of labour. Scholarship on portrait sculpture is overwhelmingly dominated by German archaeologists, whilst most of the work on concepts of figurative representation is by French philologists, neither showing much interest in the work of the other – with the exception of Metzler who does recognise the importance of the new concept: (1971) 153–68.

[22] The judgement of Bergemann (1991) 186, 189.

images?[23] The importance of the textual evidence of the development in the early fifth century of a new concept of figurative representation – the *eikōn*, or 'likeness' – is that it indicates a shift in contemporary Greeks' conception of what they were doing in making an image which could stand for a particular individual. Statues which could stand for individuals were made in the archaic period, such as the images of Kleobis and Biton, Chares of Teichioussa. But they not only took the same form as could be taken by images of gods, without any of the features differentiating them from other individuals or from deities characteristic of classical portraits; they could also be classified like images of gods as *agalmata*.[24] In Herodotus, by contrast, statues of men are classified as *eikones*, whilst those of gods are termed *agalmata*.[25] This distinction remains broadly valid until late antiquity: the same pattern, for example, is found in Pausanias in the second century AD.[26] Sometimes images of men are referred to as *agalmata*, but significantly this occurs primarily where the individuals are being elevated to a quasi-divine status and the images in question have a religious function, notably in Hellenistic ruler cult and the creation of heroising portraits of certain members of the late Roman Republican nobility, some of whom were also the recipients of cult and cultic appellations, by their new Greek subjects.[27] It is only with the dissolution of classical culture in late antiquity that the concept of *eikōn* takes on the sacral quality characteristic of the Byzantine and modern concept of 'icon', acquiring some of the functional characteristics of classical *agalmata*.[28]

'Likeness' in some sense, therefore, became a regulative concept in the production of these images, in a way which bears a family relationship to the modern concept of portraiture and differentiates both modern portraits and classical Greek portraits from archaic kouroi, where the issue of likeness was not, apparently, one of importance.[29] That does not necessarily mean we will readily be able to identify which images would and would not have counted as a

[23] The Tyrannicides, for example, were for the Athenians the archetypal honorific portrait – Dem. xx.70. See Metzler (1971) 157–8 on early uses of the concept *eikōn*.

[24] Karusos (1961), (1972) 91–8, Stewart (1990) 22 for Chares of Teichioussa. See above, pp. 55–7, 65–6 on *agalmata*; Fittschen (1988) 15–17 on archaic statues of specific individuals.

[25] Metzler (1971) 157–9.

[26] Gross (1988) 364. Both could be referred to as *andrias*, the most neutral description of a statue, with no implications for its functional status.

[27] R. R. R. Smith (1988) 15–16; Tanner (2000b) 40–5.

[28] See Said (1987) 328 on Plotinus and the elevation of the philosophical role of the *eikōn* as the background to the Christian conception of icon as transpositions not of sensory appearance but of divine essence, and hence proper objects of religious respect.

[29] On the normative assumption of likeness in portraits, see: Arist. *Poet.* 1454b9, stressing the importance of the artist producing 'the particular appearance, *idea morphē*' of the sitter and enhancing their beauty at the same time; cf. 1448b14–17; Pl. *Criti.* 107d.

portrait for the Greeks on the basis of our own experience of portraiture. First, if, as Gombrich suggests, we are psychologically programmed to recognise individual faces by virtue of their deviation from some norm of typicality, the deviant detail sufficient to ensure for the first time that an image is taken by the viewer as the representation of the appearance of a particular person, that is to say as a portrait, may be quite minimal.[30] Where the boundary between portrait and non-portrait was drawn probably shifted over time: as more portraits were created, so more was required to individuate and differentiate particular subjects. Trying to trace the moment of the origin of the portrait on a purely formal basis, it follows, is a hopeless task. Secondly, even if the common emphasis on the importance of likeness justifies the use of the term 'portrait' for ancient and modern examples, there may be quite significant cultural differences in exactly how 'likeness' was conceived and aesthetically realised, perhaps in part related to the particular social uses to which portraits were put.

Although the category *eikōn* is a fifth-century coinage, the word group with the stem *eik-* or *eisk-* is used from Homer onwards with meanings partly overlapping that of the category *eidolon*.[31] *Eidolon* and its cognates refer to images almost exclusively in terms of surface appearance and self-similarity to a model for which they are a substitute: dream images manufactured by the gods or the *psychē* of the dead, 'apparitions', like the phantom Aeneas fabricated by Apollo in *Iliad* v.449–50 to substitute for the real Aeneas in battle, or the *pyschē-eidolon* of Patroklos which presents itself to Achilles in *Iliad* XXIII.66 and 107. Such *eidola* may then be said by the poet to be like (*eikota*) their original: their viewers mistake them for their original and in a sense they are a reality in their own right, not a mere appearance opposed to real being, as *eidola* become in Platonic philosophy. But the comparison remains on the surface level of manifest appearance, including those values of appearance – beauty, grace, elegance – characteristic of the *kaloikagathoi* of archaic Greece, and held to be the special gifts of the gods.[32]

The word group with the stem *eik-* or *eisk-*, by contrast, necessarily implies a comparison, both likeness and difference, between two terms. The verbs *eikazein* and *eiskein* are used to describe a characteristic trope of archaic (and in certain domains classical) Greek thought which reveals a connection between two objects through some *perceptible* or sensuous connection of resemblance – most notably in Homeric similes where the specific action or nature of a

[30] See Gombrich (1972), Brilliant (1971) 14 on conditions of an image being taken as a portrait.
[31] Fundamental: Rivier (1952), (1956). On *eikōn* vs. *eidolon* Said (1987), with the qualifications of Vernant (1990b).
[32] Vernant (1990b) 233–4.

particular hero is illuminated through a comparison with a god or an animal. Priam, for example, is described as 'likening' (ἔισκω) Odysseus, as he marshals the Greek soldiers, to a ram watching over his flock.[33] Typically, such comparisons move from what is perceptible at a surface level, to some underlying or depth significance, in this case the nature of Odysseus' benevolent authority over his soldiers.[34]

When later Greek thinkers such as Thucydides and Plato draw a radical distinction between being and appearance, such conjectural inference, *eikazein*, also characteristic of divination, for example, is unfavourably contrasted with various forms of apodictic knowledge, *saphōs eidenai*, whether grasped directly by the mind in syllogistic and geometrical demonstration, or directly by eye and mind in experiment and logical inference.[35] However, the concept of *eikazein* as illuminating and evaluative comparison remains in usage in Herodotus and in fifth-century tragedy and comedy. Moreover, the particular mental operation, a kind of practical syllogism, 'by which the intimate nature of an object is seized by means of a relationship which unites it with another object, better known', also underlies classical Greek physiognomic thinking, best attested in the Pseudo-Aristotelian treatise *Physiognomonica*, which has also been shown to have its roots in a tradition of animal–human metaphorical comparisons stretching back to Homer.[36] The lion for example, is described as a perfect instance of the male type amongst animals, in terms which easily pass over into anthropomorphic description, of the leonine man:

sparkling deep-set eyes, moderately large but not excessively round, nor excessively narrow, a good-sized eyebrow, the forehead four-square ... the legs strong and sinewy, his gait vigorous, the whole body well-jointed and muscular, not excessively hard, nor excessively moist. Slow in pace but with a long stride, swinging his shoulders as he walks. Those then are the features of his body. As regards the characteristics of his soul (*psychē*), generous and liberal, magnanimous and fond of victory; gentle, just and affectionate towards those with whom he associates.[37]

The panther is the female antitype to the lion:

a small face, a large mouth, eyes small and inclining to paleness, hollow and rather flat ... the neck is excessively long and slender, the chest narrow ... the whole body poorly articulated and lacking proportion (*symmetria*). Such is the form of the body, and as far as the characteristics of the soul are concerned, small-minded, thievish and, in general, deceitful.[38]

[33] Rivier (1952) 41–63, esp. 50–3; (1956) 46–8 on Hom. *Il.* III.197.
[34] Vernant (1990b) 229–30, following Said (1987). [35] Rivier (1952) 43–4, 48–51.
[36] Sassi (2001) 34–81; quotation Rivier (1952) 50. [37] Arist. [*Phgn.*] 809b14–36.
[38] [*Phgn.*] 809b37–810a9.

Similar analogies inform the interpretation of individual features of the human face:

Those whose lips are thin and slack at the extreme points where the lips join, so that the upper lip overhangs the lower lip at their juncture, are magnanimous; make reference to lions ... Those whose lips are thin and hard, with prominence in the area of the canine teeth, those with such characteristics are noble; make reference to the boar. But those whose lips are thick, the upper hanging forward over the lower, are stupid; make reference to asses and monkeys.[39]

In the light of this background, the concept of *eikōn*, therefore, seems to imply not only an exterior resemblance between subject and image, but also a deeper sense of unity between outer appearance and inner character; this rests on bodily and facial signs which can be interpreted and evaluated on the basis of habits of 'visual association and analogical correspondence' sometimes quite foreign to modern psychological styles of portrait interpretation, notwithstanding the assumptions, at first sight similar, of psycho-physical unity (a necessary assumption on some level of any art of portraiture).[40]

The development of the concept of *eikōn* to describe statues of men represents, therefore, a shift in the function of such images, implicit in the changed regulative norms shaping their production and evaluation. Such a shift in the *function* of images simply cannot be addressed within a purely iconographic framework concentrating on questions of meaning, nor is the new function sufficiently similar to our own conception of portraiture that we can simply project modern interpretative protocols.[41] Consequently, alongside the formal or iconographic approaches of art historians, I wish to develop a more sociological approach, looking at portraiture as an institution.

In the following section I shall look at the institutional arrangements which shaped the practice of honorific portrait giving, how those arrangements structured the ways in which portraits generated meaning, how they shaped the specific visual forms of portraits, in particular in the case of portraits of generals, and in turn the implications of the structure of the institution of portrait exchange for the reproduction of the political sphere in democratic Athens. This particular focus offers a good opportunity for looking at the uses of portraits within a textually well-documented institutional setting. Further, focusing on a group of portraits which are anomalous according to modern western concepts of what a portrait ought to look like may help us better understand why the

[39] [*Phgn.*] 811a18–27. [40] Sassi (2001) 34–81.
[41] I deliberately echo Gombrich's account of the Greek revolution here, although my explanation will be rather different.

Greeks made portraits which look the way they did, and hence the factors that underlay the sociogenesis of this new genre. In the third section of this chapter (pp. 116–34) I shall look at how portraits' core meanings – created culturally through their iconographic forms and sociologically through their exchange within a system of honours – were elaborated and evaluated by viewers in particular contexts of reception, and ask what were the grounds of such viewers' interest in scrutinising the faces and bodies of men who were publicly honoured, or made claims to prestige by setting up a portrait on their own behalf. I conclude (pp. 134–40) by suggesting how this institutional analysis of portraiture can – when added to established art-historical and philological approaches to the figurative and conceptual aspects – help to explain the social and cultural dynamics which shaped the creation and development of a distinctive practice of portraiture in classical Greece.

PORTRAITS AND EXCHANGE IN CLASSICAL ATHENS

In the previous chapters I developed Parsons' account of art as a cultural system which in archaic societies, whilst it has a certain technical autonomy, remains structurally embedded in systems of social relations. The components of art works – including style and form – are organised about 'the attitudinal structure of the relationship' which they are used to construct 'and the cathectic interests involved in it'.[42] I shall argue that we should understand civic portraits in democratic Athens as a particular type of expressive symbolism, namely reward symbolism. Reward symbols express an attitude of approval of one party for the way in which a second party has performed a role, and are correspondingly subject to social rules concerning what counts as adequate performance of a role and hence deserves reward. Such approval is valued in its own right, irrespective of the material value of any symbol of approval.[43] Portraits in democratic Athens, I suggest, were symbols specially produced to mediate such attitudes as elements of a system of reward symbolism. As such, their allocation, use and form were regulated by a number of institutional rules. The entire expressive symbolic system – from the social rules governing the use of portraits to the cultural patterning (form, content and style) of the portraits themselves – was integrated with the emotional interests in each other's attitudes of the givers of the portraits and their recipients.[44]

[42] Parsons (1951) 391; for an earlier version of the arguments developed here, see Tanner (1992).

[43] Parsons (1951) 414.

[44] For a similar approach to portrait exchange as an institution, see Stewart (1979) 115–32. My approach differs in seeing exchange as regulated by norms, grounded in political values, whereas Stewart interprets

The political embedding of portraiture is evident from the procedures which were followed in setting up a civic portrait. First, a petition had to be presented to the boule – a council representative of the demos as a whole which prepared business for meetings of the assembly. In this petition, the person who was requesting the grant of an honorific portrait – or whoever was requesting it on his behalf – formally made the request and laid out the reasons why he deserved to be granted one:

Archon Pytharatos (271/0 BC). Laches, son of Demochares, of (the deme) Leukonoe, requests from the boule and the demos of the Athenians for Demochares, son of Laches, a grant (δωρεά) of a bronze portrait statue in the agora and maintenance in the prytaneion for him and the eldest of his descendants for all time, and the privilege of a front seat at all the public competitions, because he proved himself a benefactor and a good advisor to the demos of the Athenians (εὐεργέτηι καὶ συμβούλωι γεγονότι ἀγαθῶι τῶι δήμωι τῶι ’Αθηναίων) and benefited the demos as follows: he was a good ambassador, framer of legislation and statesman (πολιτευομένωι) ... he went as ambassador to Antipater ... he never did anything adverse to the democracy by word or deed.[45]

The petition would then be presented as a motion before the assembly, debated, and voted upon.[46] If a majority voted in favour of the motion, a decree would be passed incorporating the text of the motion with a postscript along the following lines:

With Good Fortune: it seemed good to the demos to praise Lykourgos, son of Lykophron, of the deme Boutadai, for his virtue and justice, and to set up a bronze portrait statue of him in the agora, excepting any place where the law forbids its erection ...[47]

the exchange of portraits solely in terms of the individual self-interest of the two parties concerned – the elite's desire for statues (assumed not itself to require explanation), the state's need for access to the resources of the elite, and the capacity of the elite to 'exploit' the demos by virtue of the state's fiscal needs. Apart from the theoretical questionableness of utilitarian exchange theory, the advantage of a normative theory is that it allows me to integrate the rules regulating exchange with the cultural patterning of the portraits themselves, unifying sociological and art-historical analysis, whereas Stewart's reading of the portraits themselves remains a formalist and idealist one, as reflections of personality or Zeitgeist, unrelated to his sociology of portrait exchange (136–46).

45 Plut. *Mor.* 851d–f. For a petition by Demochares, asking for an honorific portrait of Demosthenes, see Plut. *Mor.* 850f–851c.

46 Harpocration, s.v. Theorika, mentions speeches by Philinos against Lykourgos' proposals to set up statues of the three great tragedians – Aeschylus, Euripides and Sophocles – in the theatre of Dionysos in the late fourth century BC.

47 Plut. *Mor.* 852e – 307/6 BC. This decree survives also as a fragmentary inscription engraved in marble – *IG* II² 457 = *SIG*³ 326. The epigraphic evidence for the Hellenistic period (after 323 BC) is considerably richer than that for the classical period with which I am concerned – see above all Gauthier (1985) esp. 79–92. This may in itself represent a formalisation of the procedures involved in granting an honorific statue. Consequently, I prefer to rely on the admittedly often anecdotal but at least contemporary fourth-century literary evidence rather than later epigraphic material as the basis of my reconstruction. I draw selectively on the Hellenistic material to supplement the classical evidence where it is clear that the pattern of the practices is the same in both periods. On the difference between classical practices (fourth century) and Hellenistic ones (late fourth and third centuries), in particular the extension of honorific portraits to persons other than generals, see Gauthier (1985) 103–12.

Thereafter, those who objected to the award of a portrait to a particular individual might bring an indictment of illegality or *graphē paranomon*, claiming that the decree contained a false statement since it was not true that the honorand had in word and deed benefited the people. The case arising from such a charge would be heard in one of the popular courts – with a jury of as many as five hundred citizens – which was held to represent the demos acting in a judicial capacity. The orator Lykourgos, for example, brought a prosecution against Kephisodotos as the proposer of a decree to set up a portrait statue honouring Demades for his services on Athens' behalf when he mediated with Philip of Macedon after Athens' defeat at Chaeronea in 338 BC, and with Alexander when he threatened Athens with an army in 335 BC. Lykourgos aimed to 'demonstrate that the decree is illegal (παράνομον) and inexpedient and that the man is unworthy of a reward (δωρεά)', by comparing Demades unfavourably with other benefactors of the demos who had received lesser rewards and questioning whether Demades should really be considered a benefactor at all.[48] In short, the procedure which gave rise to the erection of an honorific portrait statue was the conventional one for the proposal, enactment and scrutiny of decrees in democratic Athens.

The norms which regulated the award of honorific portraits were a specification of Athenian civic values. Honorific portraits were to be awarded only to benefactors of the demos. If a man manifested his good will (εὔνοια) to the demos by performing outstanding services, it was held to be just (δίκαιον) according to the norms of reciprocity which pervaded Greek social life that the demos should respond with a sign of their approval or esteem.[49] Honorific portraits were a gift (δωρεά) which marked the esteem (τιμή) in which the recipient was held and the gratitude (χάρις) that the demos felt towards him. Once given, such tokens of esteem might not be withdrawn by the demos without good reason.[50] The recipient of the portrait was expected to reciprocate the gift with an attitude of gratitude (χάρις) towards the demos, manifested in continued good service on behalf of the demos.[51] Failure on the part of the recipient to manifest the

[48] Lykourgos 14, frs. 1–4. For a brief account of *graphē paranomon* and further references, see MacDowell (1978) 50–2. Other occasions we know of when a *graphē paranomon* was made to prevent or reverse the erection of an honorific portrait statue include a prosecution against the general Iphikrates brought by Harmodios, a descendant of the Tyrannicide, on the grounds that Iphikrates was unworthy of the honour – Arist. *Rh.* 1397b30-1389a1; Dion. Hal. *Lys.* 12; Scolia on Dem. *Meid.* XXI.534.24.

[49] Cf. Dem. *Lept.* XX.71: 'It was not then only by you, Athenians, that Konon was honoured (ἐτιμήθη) for the services that I have described, but many others who rightly felt bound to show gratitude [lit. 'reciprocate with a gift of *charis*'] for the benefits they had received (οἳ δικαιῶς ὧν εὐεργέτηντο χάριν ὤιοντο δεῖν ἀποδιδόναι).'

[50] Dem. *Lept.* XX.71–2, 120.

[51] Aeschin. *In Ctes.* III.177. On *charis* in fourth-century Athens, see Ober (1989) 226–33.

appropriate attitude could be sanctioned by the withdrawal of the positive attitude of the demos, symbolised by the destruction of the portrait statue. Astylos of Kroton, for example, was awarded an honorific portrait by the people of Kroton in recognition of the honour brought to their city by the first of his three Olympic victories. However, as Pausanias tells us: 'when on the occasion of the latter two victories, in order to curry favour with Hieron, the son of Deinomenes [the tyrant of Syracuse], he proclaimed himself as a Syracusan, because of this the people of Kroton condemned his house to be a prison, and pulled down the portrait statue of him, set up beside the temple of Hera Lakinia'.[52]

The placing of such portraits in civic space was also regulated by law. Different kinds of service to the polis might be marked by the placing of portrait statues in different kinds of space. Astydamas, the tragic poet, whose civic role was primarily cultural as opposed to the specifically political roles of orators or generals, received an honorific portrait in the theatre of Dionysos, as opposed to the more specifically political space of the agora.[53] The statues of Aeschylus, Euripides and Sophocles that were erected following the passage of a decree proposed by Lykourgos towards the end of the fourth century were also placed in the theatre of Dionysos.[54] Similarly the forebears of Spartokos, king of the Bosporos, whose primary service to the Athenians was to give merchants who were shipping corn to Athens priority of lading and tax-breaks, were awarded, in addition to portrait statues in the agora, portrait statues to stand in the emporion or commercial marketplace of the Piraeus, Athens' port.[55] Within the agora itself, the demos might determine precisely where the portrait was to be placed, since this allowed further specification of the meaning of the portrait. After the Athenian general Konon and Euagoras, king of Salamis on Cyprus, had defeated the Spartan fleet at the battle of Knidos in 394 BC, thereby freeing Athens from Spartan domination and enabling her to restore her Aegean hegemony, they were awarded by the Athenian demos portraits set up next to the statue of Zeus the Saviour in the agora 'as a memorial of the magnitude of their benefaction'.[56] When Demetrios Poliorketes and Antigonos I expelled the Macedonian governor Demetrios of Phaleron from Athens in 307 BC and restored the 'democracy', they were voted golden statues to stand next to the Tyrannicides, because they too had 'restored to the demos their freedom'.[57] Expressive symbolism is here embedded in a range of socially organized spaces, none of which has specifically aesthetic functions. The meaning of a portrait is tied to the locality in which it is placed.

[52] Paus. VI.13.1; Steiner (2001) 18 for further examples. [53] Diog. Laert. II.43; Suda s.v. Σαυτὴν ἐπαινεῖς.
[54] Plut. *Mor.* 841; Paus. I.21.1. [55] *IG* II/III² 635 – date of the inscription honouring Spartokos 285–284 BC.
[56] Isoc. *Euagoras* IX.57. [57] Diod. Sic. XX.46.

The visual form of the portraits themselves was also regulated by norms derived from civic values. Iconographic choices in making public honorific portraits were probably regulated through the mechanisms of state patronage – commissions were appointed by the demos to see to the commissioning and setting up of such statues[58] – and such choices were certainly read and judged in terms of civic moral culture rather than in terms of specifically aesthetic values (see below). The honorific portrait given to the Athenian general and statesman Chabrias in recognition of his services to the state showed him in the position which he had ordered the troops under his command to adopt as a stratagem to defeat a Spartan hoplite army in 378 BC: kneeling with spear pointed forward at an angle of 45 degrees, or possibly simply standing at ease with shield leant against his knee.[59] Pindar was awarded, perhaps posthumously, an honorific portrait which showed him 'seated with a cloak and lyre, with a diadem and a rolled-up scroll on his knees', that is to say, in a pose that recalled the manner in which he had served Athens and for which he was being honoured, namely an outstanding eulogy of the city.[60] Demochares, an orator who played a prominent role in Athens' resistance to the encroachments of Macedon in the fourth century, was represented in his portrait, placed in the Prytaneion, the symbolic hearth of the city, 'girded in cloak and sword; for it is thus attired that he is said to have spoken before the people on the occasion when Antipater [the Macedonian governor of Greece] demanded the orators' surrender'.[61]

'The stance ... the gestures of arms and hands' are far from being simply 'vehicles for individualistic expression' as Richter argues.[62] On the contrary, their expressive significance is tied to the political context of the symbolic exchange represented by the setting up of an honorific portrait and the norms of civic culture which regulated that exchange.[63] These choices of iconographic form served to define the relationship between the demos and the recipient of

[58] *IG* II/III² 510.4 (after 307), 646.40–3 (295/4).
[59] Diod. Sic. xv.32–3; Corn. Nep. *Chabrias* I.2; Anderson (1963); Buckler (1972).
[60] Ps.-Aeschin. *Epistle* 4, p. 669 – ed. Reiske; Paus. I.8.4; *SQ* 1414–15.
[61] Plut. *Mor.* 847d; *Mor.* 851 for the petition, quoted above on p. 110. [62] Richter (1955) 12–13.
[63] Cf. the story about Gelon, tyrant of Syracuse, in Aelian, *VH* XIII.37: 'Certain factious men were forming a plot against him. Learning about this, Gelon called together the Syracusans into the assembly and himself entered fully armed. He enumerated the good services he had accomplished on their behalf, unveiled the conspiracy, and removed his panoply, saying to them all: "See now I stand before you in my chiton, bereft of arms, and I give myself to you to do with as you wish." And the Syracusans marvelled at his judgement. They handed over the conspirators to him to punish and gave him the office of sole ruler. But Gelon gave the conspirators back to the demos to take vengeance on them. And the Syracusans set up a portrait statue of him in a chiton, unarmed ...' The same assumptions concerning the iconography of portrait statues are implicit in Polyeuktos of Sphettos' attack on the award of a portrait to the orator Demades (apud Apsines, *Rhet.* p. 545 Walz, vol. IX), where he questions what *schema* for a statue could possibly be appropriate for Demades – a statue holding the shield he threw away at Chaironea perhaps – Gauthier (1985) 109–10.

the portrait, as constituted by the giving of the portrait, in terms of civic values. The prestige marked by the giving and objectified in the erection of the portrait was tied to acts of service performed on behalf of the demos by the person represented in the portrait. The best surviving example is the Tyrannicide group showing Harmodios and Aristogeiton in the act of slaying the (absent) 'tyrant' Hipparchos (see figure 3.3 on p. 101).

The strength of these iconographic norms – and the viewing practices tied to them – is suggested by the response of the πρεσβύτεροι, the older and more authoritative elements of the citizenry, to an ostensibly private portrait dedicated by the aristocrat Alkibiades on the Akropolis. In this portrait Alkibiades tried to lay claim to prestige by asserting a special relationship to the goddess Nemea, the eponymous goddess of the Nemean games where Alkibiades had just enjoyed that most aristocratic of triumphs, a victory in the chariot race: 'When Aristophon painted Nemea holding Alkibiades seated in her arms, crowds of people rushed in delight (χαίροντες) to see the picture. But the elder people were displeased at this also, on the grounds that it was tyrannical conduct, not in keeping with the laws (ὡς τυραννικοῖς καὶ παρανόμοις).'[64]

Whilst the idea that the favour of a deity might lie behind worldly success was a quite conventional one in Athens, the iconography of Alkibiades' portrait placed him in a position in which one might more normally find a deity, reclining in the arms of a goddess, a conception only paralleled for mortals in the victory odes of Pindar, commissioned some half a century earlier for aristocrats still maintaining pretensions to the privileged relationship with deities that was characteristic of archaic Greece.[65] Alkibiades' iconographic choices are not evaluated according to specifically aesthetic values but in terms of civic moral culture. Furthermore the protocol according to which judgements of the portraits are made gives priority not to specifically aesthetic reasoning but to the traditionalistic criterion of the moral authority of the elderly, the same criterion by which the elderly enjoyed priority in giving advice to the assembly.[66]

My account thus far has laid great stress on norms and values, in accord with the basic Parsonian conception of social structure as institutionalised normative culture. I do not mean to suggest that either Athenian society or indeed the particular system of reward symbolism represented by civic portraiture was perfectly integrated, or that the normative order was not subject to transgression or contestation. I would, however, argue that the practice of portrait exchange was 'institutionalised'. First, the norms were sufficiently widely

[64] Plut. *Alc.* 16.5; cf. Ath. XII.534. On Alkibiades and *paranomia*, cf. Thuc. VI.15.4, VI.28.2 and De Romilly (1992) 154.
[65] Krumeich (1997) 131–4. [66] Aeschin. *In Tim.* 1.23–4.

recognised that their transgression was perceived as a violation. Secondly, sanctions of varying degrees of severity corresponding to the severity of the offence were mobilised against norm breakers like Alkibiades or Astylos. Even in the limiting case where an autocrat had sufficient control of the means of coercion effectively to compel the demos to give him portraits, the force of the normative order is shown by the expressive explosion which marks the downfall of the autocrat and the reinstatement of the repressed normative order.[67] The Macedonian governor of Athens, Demetrios of Phaleron, is reported to have had hundreds of statues erected by the city in his honour. When he was over-thrown by Antigonos and Demetrios Poliorketes, and the democracy was restored, he was indicted in his absence on a capital charge: 'and when they were not able to lay hold of him bodily, they made the bronze of his portrait statues the object of their venom. Having torn down the portraits from their bases, some they sold, some they threw into the sea, still others they chopped up to recycle as chamberpots.'[68]

Just as the portrait mediates the demos' cathexis of or affective investment in the person whom they wish to honour, and that primary cathexis is generalised to the portrait as sign-object,[69] so the sign-object can serve as a substitute upon which the demos can act out its feelings of hostility towards the primary object – Demetrios – in the case of a violation of the expressive order.[70] Conversely, orators, in their capacity as leaders of the demos, recognised that if the demos were to transgress the norms which regulated the system of honorific rewards, it too ran the risk of material and reputational loss. If, for example, the demos were to withdraw its good attitude as symbolised in a portrait without the honorand having done anything to deserve this punishment, it would both suffer a loss of reputation and render the entire system of rewards 'uncreditable' (ἀπίστους), thereby undermining its capacity to motivate the benefaction and performances that statues rewarded.[71] Both parties to the system exchange maintained an interest in maintaining its integrity.

[67] In less democratic cities things may have worked differently. At Mylasa in Caria, the sons of one Peldemos were punished for illegal action against (*paranomesantas*) the portrait statue of Hekatomnos, the father of the satrap/tyrant of Caria, Mausolus. They were cursed, their property was made public, and they were exiled along with their families – *SIG*³ 167; date 361/0.

[68] Diog. Laert. v.77. [69] Cf. Parsons (1953) 36.

[70] Cf. the events at Erythrai, discussed in *SIG*³ 284.20–31. During an oligarchic revolution the statue of the tyrant-slayer Philitos had his sword removed, apparently since the oligarchs felt the erection of the statue was specifically directed against them. On the restoration of democracy, the boule and demos pass a decree making provision for the restoration of the statue, and instructing the *agoranomos* (official in charge of the agora) to remove recently accumulated dirt and patina, to ensure that the statue is regularly polished to remain *lampros* or glistening, and also determining that the statue be crowned at the beginning of each month and during festivals.

[71] Dem. *Lept.* xx.120 and 124.

EVALUATING PORTRAITS: SOCIAL STRUCTURE, AESTHETIC JUDGEMENT AND THE CIVIC BODY

Viewing is a meaningful activity in its own right. It is a mistake to assume either that Greek viewers came to portraits with the same interests as ours (a personal encounter with a specific individual) or that one can reconstruct the viewer's response simply on the basis of detailed iconographical analysis of the corpus of portraiture.[72] The following paragraphs address a series of questions related to the activity of viewing portraits. How did the settings within which portraits were displayed frame the viewing and appropriation of portraiture? Using what kind of vocabulary and to what social and cultural purposes were the primary meanings objectified in the style and iconography of portraits evaluated and elaborated in primary and secondary contexts of appropriation? Can the particular categories of visual interest we uncover in these viewing practices help us understand some of the iconographic and stylistic features of Greek portraiture, especially those which seem anomalous according to our conventional expectations of what a portrait should look like?

Plato, Aristotle and Xenophon all suggest that the specifics of character can be read from not only the features of the face but also the *schemata* or positions of the body at rest and in movement:

Nobility and free spirit, meanness and servility, temperance and prudence, wanton violence and vulgarity are made manifest in the faces of men, and in the attitudes of their bodies, whether standing still or in movement.[73]

μεγαλοπρεπές τε καὶ ἐλευθέριον καὶ τὸ ταπεινόν τε καὶ ἀνελεύθερον καὶ τὸ σωφρονικόν τε καὶ φρόνιμον καὶ τὸ ὑβριστικόν τε καὶ ἀπειρόκαλον καὶ διὰ τοῦ προσώπου καὶ διὰ τῶν σχημάτων καὶ ἑστώτων καὶ κινουμένων ἀνθρώπων διαφαίνει.

What does this mean in practice?[74] The bodies of the general portraits, including Perikles, are lost. There are, however, some pointers to the kinds of bodies they may have had, and consequently images which we might use as proxies. All the busts of the general portraits have naked shoulders, although there is nothing to confirm that this is more than the convention of the Roman copyists, other than in the case of the British Museum bust of Perikles. This seems to copy the original statue in some detail, preserving not only the leftwards turn and inclination of the head, but also an unevenness of the

[72] Thompson (1990) 24–5 on the fallacy of internalism and for the interpretative methodology followed here. Cf. Richter (1984) 13 for portrait viewing as personal encounter: 'brought face to face with the famous personalities of ancient Greece ... in itself an inspiring experience'.

[73] Xen. *Mem.* III.10.5; cf. Pl. *Leg.* 655; Arist. *Pol.* 1340a.

[74] For a fuller discussion of these issues, see Tanner (2000c.)

shoulders, indicating at least that the statue was ponderated (left weight leg, right free leg) and possibly that it was also naked.[75] The issue of nudity may not seriously affect the meaning of the statues for our purposes – namely their patterns of movement or modes of standing. One highly influential model for ponderation in the late fifth and early fourth centuries was that of the Polykleitan canon, realised first in the Doryphoros (see figure 4.3 on p. 163), and then in variants such as the Diadoumenos and the Westmacott athlete (figure 3.7) and other statues by Polykleitos and his followers. The canonical contrapposto was also recycled in Attic contexts, in a number of figures on the Parthenon frieze as well as on grave monuments such as the stele of Chairedemos and Lykeas from Salamis (figure 3.8). Alternatively, some have wished to see a bronze statuette of a general (figure 3.9), with a post-Polykleitan contrapposto and a turn of the head similar to that of the Perikles bust, as a Roman copy after one of the Attic general portraits dating from the end of the fifth or the early fourth century.[76] Either the Hartford general or Chairedemos and Lykeas could give a fair approximation of the body types of Perikles and the general portraits. It is not so much the specific details of the corporeal style and iconography of the individual statues which concern me here, as the frameworks within which they were interpreted and evaluated, and the grounds of this particular preoccupation with the ordering of bodily form.

One strand of recent writing has particularly stressed the intellectual background of contrapposto in philosophical and medical thought. Polykleitos codified and discussed his canonical systematisation of contrapposto in a treatise which lays great emphasis on the role of number and measurement in sculptural design, echoing, some would argue, the mathematical preoccupations of Pythagorean philosophy.[77] Correspondingly, some suggest that Polykleitan contrapposto should be conceived as an abstract aesthetic-philosophic ideal, and that it was viewed as such in antiquity. 'The untenable equilibrium of the Doryphoros makes visible the cosmic harmony in which the human being (in Herakleitos' thinking the *oppositum coincidens* of the gods) partakes.'[78] 'Works like the Doryphoros were vehicles through which one could contemplate, like a Pythagorean philosopher ... the perfect number, *to eu* of man.'[79]

[75] See Voutiras (1980) 103: nudity; 116 for the Pastoret head also belonging to a nude body, and the assumption that the Copenhagen replica comes from a complete statue; Himmelmann (1990) 87–101 arguing for a clothed portrait; Krumeich (1997) 121–2 – probably naked on the basis of comparanda in funerary art and Parthenon frieze.

[76] Dontas (1977) 89; Krumeich (1994) 121–2 – with earlier literature and the discussion of whether this might be a classicising Mars, rather than copy of a statue of a warrior or general.

[77] See below, chapter 4, pp. 161–70, for a discussion of Polykleitos' canon in the context of the refiguring of the artist's role in classical Greece.

[78] Meyer (1995) 87. [79] Pollitt (1995) 22.

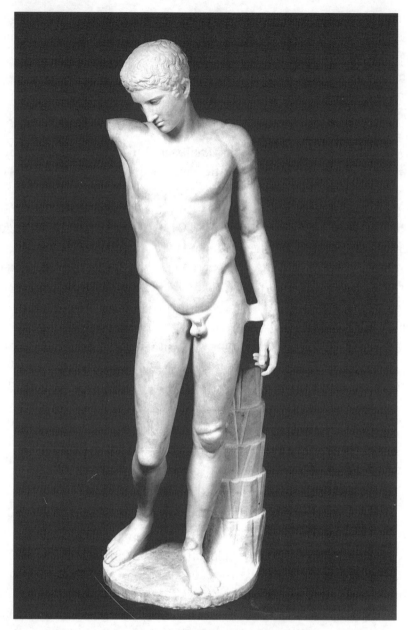

Figure 3.7 Athlete crowning himself. 'The Westmacott boy'. Roman copy after Greek statue *c.* 450–20 BC, probably by Polykleitos. London, British Museum. Photo: Copyright The British Museum.

Others have drawn attention to the extraordinarily high level of medical knowledge displayed in classical contrapposto statues, and their concern to display the functional interrelatedness of parts of the body in a way which exactly parallels the knowledge and the concerns of contemporary medical writers, the

Figure 3.8 Attic funerary stele of Chairedemos and Lykeas, from Salamis, *c.* 410 BC.
Photo: DAI, Athens. Neg. 204.

Hippocratics.[80] It seems unlikely, however, that most viewers, even in a city that was a centre of intellectual activity, like Athens, would have possessed the cultural knowledge necessary to read contrapposto in these specifically philosophical

[80] Leftwich (1987), (1995), Metraux (1995), Tobin (1995).

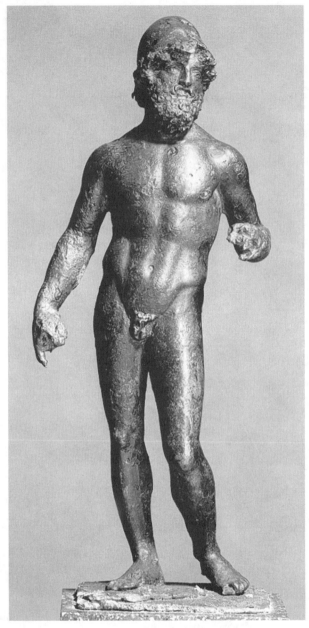

Figure 3.9 Bronze statuette, possibly after a classical statue of a general of the late fifth/early fourth century BC. Wadsworth Athenaeum, Hartford. Gift of J. Pierpoint Morgan. Photo: Museum.

and medical terms. Only in the fourth century did the institutionalisation of the philosophical and rhetorical schools begin to erode the dominance of oral culture and traditional *paideia*, which was still in the second quarter of the fourth century assumed as the primary framework for education by Plato in his *Republic*.[81]

An alternative argument suggests that patterns of bodily movement in classical contrapposto statues should be interpreted using the vocabulary applied to such movements in texts in the first place designed for popular consumption, like tragic and comic drama, supplemented with elite texts where these are broadly consistent with them.[82] On the basis of these texts, Burkhard Fehr outlines an interpretative grid that contrasts 'effortful' or 'heavy' movement, as an indicator of the capacity and readiness to engage in the military and athletic exertions that brought social esteem, with 'light' or 'easy' movement, which was read in classical texts as a symptom of ease, indicative of a person possessed of the material means to enjoy the good life. These patterns of movement were set within a framework of restraints which were indicators of self-control, *sophrosunē*, moderating both the ambition for social prestige and the ostentatious demonstration of wealth. This indicated respect for one's fellow citizens and the egalitarian social order of Athenian democracy.[83] Smaller, less violent movements were held to be characteristic of a man who was 'more orderly and better trained in courage (κοσμιώτερος μὲν ὢν πρός τε ἀνδρίαν μᾶλλον γεγυμνασμένος)' and contrasted with the 'greater and more violent changes of motion' of the man 'who is cowardly and untrained in temperance (δειλὸς δὲ καὶ ἀγύμναστος γεγονὼς πρὸς τὸ σωφρονεῖν)'.[84] Conversely a wide gait and sweeping gestures of the arms might be interpreted as a sign of excessive ambition.[85] Similarly, moderately 'slow and gentle actions' were preferred to actions which were too 'sharp, quick or hard', too 'hybristic', and interpreted as a sign of 'orderliness', *kosmiotēs*.[86] Ideally speed, strength and scope of movement should be harmonised by rhythmic ordering or *taxis*, characterised as *eutaxia*.[87]

This interpretative framework has a number of advantages over medical and philosophical readings. It has a significant overlap with the vocabulary of honorific decrees passed by the Athenian assembly in recognition of benefactors' services, where concepts such as *sophrosunē* and *eutaxia* are highlighted as 'cardinal democratic values' in the late fifth and fourth centuries.[88] The

[81] Robb (1994) 203–5. [82] Fehr (1979). [83] Fehr (1979) 16–23. [84] Pl. *Leg.* 815e–f.
[85] Ar. *Eq.* 77; *Vesp.* 188 – wide gait and excessive ambition. Aeschin. *In Tim.* I.25–7; Dem. XIX.251, 255; Plut. *Phoc.* 4 – restriction of hand movement by placing hand inside cloak as a sign of *sophrosunē*.
[86] Pl. *Plt.* 307a–b. cf. Dem. XXXVII.52.
[87] Fehr (1979) 20–2. Pl. *Leg.* 815e–f; *Plt.* 307a; *Leg.* 653e; *Horoi* 412d. [88] Whitehead (1993).

orientation of portraits towards such an interpretative framework is indicated by the two surviving statue bases for honorific portraits from classical Athens, for Chabrias and Lykourgos. These cue the viewing citizens' everyday knowledge of the distribution of civic honours as the relevant stock of knowledge by framing the main inscription, naming the honourer (the Athenian demos), the honorand and the immediate occasion of the honour with a series of engraved wreaths representing honorific crowns previously granted to the person portrayed. Inside, or immediately adjacent to each crown, is engraved an inscription naming the collectivity – the demos, a deme, a garrison – which had awarded it to the portrayed (figure 3.10).[89]

Similar considerations inform the elaboration of the primary meanings of portraits in such secondary contexts of reception as the law courts. Members of the political elite might draw upon the core meaning of their own portraits – as objectifications of a relationship of benefaction and reward between the demos and themselves, implying mutual *charis* or gratitude – to bolster their defence in legal cases heard before mass juries, who were in effect representatives of the same demos who had set up the statue, and who were assembled in law courts immediately adjacent to the agora where the statues were placed. As Aristotle reports in a discussion of metaphors:

Lykoleon, in his speech on behalf of Chabrias, used the expression 'not even feeling shame at the symbol of his suppliant status, the bronze portrait statue' [for the kneeling position of the statue, see above, p. 113], a metaphor for the present moment, not for all time, but vivid before the listeners' eyes; for when Chabrias is in danger, the statue acts as suppliant on his behalf, the inanimate becomes animate, a memorial of his services to the polis.[90]

Conversely, in a speech prosecuting Demosthenes' associate Timarchos on a charge of homosexual prostitution, Aeschines invokes a well-known statue of Solon in the agora on the island of Salamis. The posture of the portrait of Solon, standing with his arm inside his cloak, is interpreted as a sign of *sophrosunē*, contrasted with the character of Timarchos as revealed by his public infraction of norms of bodily propriety, when 'at a meeting of the popular assembly, he tore off his cloak and leapt around half naked like some all-in wrestler, his body in such a foul and disgraceful condition, the consequence of drunkenness and debauchery, that right-minded men at least veiled their faces, feeling ashamed on behalf of the city, that we should make use of men such as this as our advisors'.[91] As he speaks, Aeschines adopts the pose of Solon's statue, reinforcing his case, and his claim

[89] Burnett and Edmondson (1961); *IG* II² 3207. [90] Arist. *Rh.* 1411b1–12. [91] Aeschin. *In. Tim.* 1.25–6.

Δι[ό]τιμος καὶ οἱ στρατιῶται [οἱ] [οἱ στ]ρατιῶται οἱ ἐπὶ τῶν Φιλίσκος
ἐ[ν Σ]ύρωι οἱ ἐπὶ τῶν νεῶν [ν]εῶν περὶ τὴν ἐν Νάξωι ναυμαχίαν καὶ οἱ στρατιῶται οἱ ἐ[ν ᾽Αβύδωι]
CORONA CORONA CORONA

Figure 3.10 Left-face of base of Chabrias portrait statue, c. 370 BC. After Burnett and Edmondson, in *Hesperia* 30 (1961) 77, fig. 1.

to the ear of the popular jury, by literarily embodying the exemplary conduct and character of the great Athenian law-giver.[92]

The interpretative and evaluative vocabulary identified by Fehr was grounded not in highly specialised intellectual discourses accessible to only a small literate minority, but in social rituals and bodily practices that were a central component of the traditional *paideia* experienced either directly as participants or indirectly as spectators by all members of the citizen body, and which were determined by the exigencies of the political existence of a polis.[93] Many cities, including Athens, organised beauty contests as part of the regular cycle of competitive athletic events that might be held at religious festivals.[94] The most common titles for such competitions are *euandria, euexia* and *eutaxia*, literally 'good-manliness', 'fineness of disposition', and 'good-orderliness'. Such competitions were often team events, contested by the tribes or *phylai* into which the citizenry were divided for purposes of military organisation. Similar kinds of arrangements seem to have been put in place to those used for judging other civic performances, or indeed for supervising and evaluating artistic commissions, namely a panel chosen by lot (like the members of the boule or a court jury) and hence representative of the demos.[95] Athletic competition had military fitness as its goal.[96] Dancing might involve rhythmic movement and 'cheironomy', controlled movement of the hands, in order to enhance agility and dexterity with weapons.[97] Dances with armour and weapons not only enhanced levels of strength, but also *eutaxia* in the battle line and when the battle line is disrupted at the turning-point of a battle.[98] The *euschemosunē* – beauty of bodily form (*schema*) – that such exercise generates is at once a sign of military preparedness and an aesthetic phenomenon that draws the gaze of viewers sensitised by their own experiences and bodily training, evoking the admiration and pleasure of those who behold it. Xenophon describes Ephesos, filled with the soldiers of Agesilaos training for competitions in *aristeia* of the body, as 'a sight worth seeing'.[99] Plutarch tells how the Arkadians 'admire and gaze at' the Thebans as they 'perform their military

[92] Dem. XIX.251–6, with discussion of Catoni (1997) 1033–6 for Demosthenes' attempted deconstruction of the network of meaning elaborated by Aeschines' invocation and mimesis of Solon's statue, implying that Aeschines' hand stays in his mantle not so much when he speaks but when he is on embassies on behalf of Athens, holding the bribes he has taken from Athens' enemy Philip. The implication being, contrary to the dominant cultural logic that Aeschines had sought to invoke, that in Aeschines' case at least, there was no real connection between outer bodily conduct and inner character.

[93] For an earlier discussion of these issues, which I draw on here, see Tanner (2000c).

[94] Crowther (1985), (1991), Reed (1987).

[95] *SEG* 27.261.45–60 – Beroea, second century BC; Crowther (1991) 289.

[96] Plut. *Mor.* 639e; Lucian *Anacharsis*; Xen. *Mem.* III.12.15; Pl. *Resp.* 404; Pritchett (1974) 213.

[97] Pritchett (1974) 213; Ath. XIV.628f; Xen. *Anab.* VI.1.11; Polyb. IV.20.12; Pl. *Leg.* 814.

[98] Pl. *Lach.* 182. [99] Xen. *Hell.* III.4.16.

exercises and wrestle (*pros to hopla gumnazomenous kai palaiontas*)', whilst quartered in Arkadia over the winter.[100]

The classical Greek sense of beauty and of formation of the body in athletic and militarily training are internally related. According to Aristotle:

Beauty differs for each stage of life. For a young man, beauty consists in having a body serviceable for extreme exertion, whether in running or in exercising physical force; to look at, he is pleasing and a source of delight. Because of this, pentathletes are the most beautiful, because they are by nature well equipped for both speed and bodily force. The beauty of man in his prime consists in being fit for the labours of war, pleasant to gaze upon but at the same time formidable.[101]

The *eumorphia* of the ephebe Autolykos, a prize winner in the Panathenaic games, which arouses the desire of his admirer Kallias in Xenophon's *Symposium* is characterised in terms of strength (*rome*), endurance (*karteria*), and manliness (*andreia*).[102]

Athletic and military displays by mature men were merely the culmination of a programme of education and training through which young Athenian citizen males were socialised into a normative relationship to their body. In school, teachers were concerned with *eukosmia* ('good-orderliness') of their pupils, ensuring that they conducted themselves in a manner which was both *eurhythmos* ('well rhythmed') and *euarmostos* ('in a fine state of harmony').[103] Ephebes participated in armed dances (naked but for spear and shield), torch races, and athletic training in the gymnasion, which prepared them for military service.[104] This disciplining of the body was grounded in the political reality that the security and autonomy of any Greek state was directly dependent on the capacity of its citizen hoplites to defend their territory against allcomers, and a corresponding value system in which primacy was laid upon each citizen's obligations to the state. The citizen's body belonged to the state. As the Corinthian ambassadors tell the Spartans, shortly before the outbreak of the Peloponnesian war: the Athenians 'even use their bodies as if they were those of other men, when it is in the service of their city ... to accomplish anything on her behalf'.[105]

[100] Plut. *Mor.* 788a. Cf. Pritchett (1974) 220–1. [101] Arist. *Rh.* 1361b7–12.

[102] Xen. *Symp.* viii.6–8. These were the same qualities as the Greeks, and above all the Athenians, had claimed as their defining characteristic since the Persian wars and Marathon, manifested in the famous armed run at Marathon: Fehr (1979) 29 with references.

[103] Pl. *Prot.* 326b. [104] Fisher (1998).

[105] Thuc. i.70. Cf. Thuc. ii.41: 'In short, I declare that our entire city is an education for Greece, and it seems to me that amongst us each individual man can independently adapt his body to the most various aspects of life, and do so with exceptional grace and versatility.' See Stewart (1997) 80–5 for discussion.

Such training, the traditional paideia of the Greek citizen hoplite, shaped an entire bodily hexis, and with it a disposition to classify and respond to bodies in terms of a common vocabulary and shared value system. The very high degree of institutional integration of art and politics, along with the *practical sensibility* engendered by such patterns of athletic training, predisposed viewers to blur the distinctions between responding to and evaluating the body of an athlete, hoplite or fellow citizen and the body of a statue of an athlete or hoplite set up in civic space to celebrate and memorialise a particular individual's exemplary embodiment of civic virtue. The same evaluative language as was applied to patterns of orderly movement in war – *kosmiotēs, eutaxia* – could be used to describe the orderly, self-controlled movement of well-brought-up youths or model citizens and ponderated sculptures like the Hartford general or Chairedemos and Lykeas (see figures 3.8 and 3.9 on pp. 119–20), with their orderly compositions of a complex pattern of movement.[106] Similarly, the form of the portraits of the Tyrannicides (see figure 3.3 on p. 101) iconographically indexes not only the particular historical ground for which they were awarded the portrait but also, through their style, the composition of the limbs and the modelling of their sinewy musculature – 'the body kept erect (*orthon*) in a state of vigorous tension (*eutonon*), with the limbs extended nearly straight (*euthupherēs*)' – displays the 'fine physique' which indicates the noble soul and courageous character[107] of those who 'use their bodies in service of the city' on behalf of democratic freedom.[108]

The immediate transferral of such vocabulary to works of art might seem inappropriate, a typical form of sociological reductionism; after all a human body is not a work of art. Such criticism, however, presupposes the differentiated art world and critical institutions that are characteristic of the modern world. Greek art was embedded in the institutions of the polis, and in practice we find exactly this conflation between judging bodies and judging works of art being made by Greek writers. Aristotle, for example, in *Politics* book VIII, comments (not entirely favourably) on the introduction of drawing into school curricula that 'drawing also seems to be useful in making us better able to judge the works of *technitai* (δοκεῖ δὲ καὶ γραφικὴ χρήσιμος εἶναι πρὸς τὸ κρίνειν τὰ τῶν τεχνιτῶν ἔργα κάλλιον)'.[109] On the following page, he elaborates the meaning of this practical use of an education in drawing in order to judge

[106] Ar. *Nub.* 961–5 for the description of well-brought-up ephebes in these terms.

[107] The quotation is from Plato's description (*Laws* 815a) of the Pyrrhic dance, performed by the ephebes as part of their civic and military paideia, and involving the acting out of 'the movements which result in aggressive postures (*schemata*) ... imitations of the delivery of every kind of blow' (trans. Saunders – Penguin).

[108] Thuc. 1.70. [109] Arist. *Pol.* 1338a13–24.

the works of *technitai* in contrast with an orientation to drawing that is appropriate to free men:

Similarly the young should study drawing *not* in order to avoid mistakes in their private purchases, or to ensure that they cannot be cheated when buying and selling household chattels, but rather because it makes one observant of bodily beauty; and to seek everywhere for utility (τὸ χρήσιμον) is not at all appropriate for great-souled and liberal-minded men (μεγαλοψύχοις καὶ ἐλευθέροις).[110]

This makes perfect sense in an institutional context where portrait statues were set up as rewards for citizens who had shown themselves as pre-eminent embodiments of civic virtue by their services towards the demos of Athens, and where the vocabulary of criticism and structure of response is not a specialised theoretical one, monopolised by 'circles of cultivated art lovers', but a practical sense shared by all citizens by virtue of a common educational experience.

This scrutinising of the body was part of a developing culture of careful looking linked to the specific social and political structures of classical Greek city states and above all to the processes of democratisation most marked in Athens. It was not just in portraiture that this concern is registered. The same norms of bodily propriety as informed portraiture also informed the social evaluation of conduct of members of the Athenian elite, with consequences of varying gravity. Arrogant aristocrats, swaggering about with wide gait and fast pace might get themselves noticed, but at the potential price of incurring popular hostility if they should ever appear in court. One fourth-century litigant tries to explain away his 'fast walking' as a congenital defect which he could not control and could not be held responsible for, not (as his opponents had suggested) a sign of bad character.[111] Another counters cricitism of his loud voice and fast walk by noting that in fact his actual style of life was 'more measured' (*metrios*) and 'well-ordered' (*eutaktoteron*) than that of his opponent in the case at hand.[112]

Within this broadly sociological context, we can also make sense of the undoubted parallelisms between sculptural and medical representations of the body. In addition to making it possible to simulate in highly plausible ways patterns of posture and movement that had significant social meanings, the *semeia* or signs of health represented by good muscle tone, breathing, veins, and so on were a visual indicator that the bearer was *onesipolis*, useful to the state. The concept of health was endowed with new meanings in the classical period

[110] 1338a41–1338b4. [111] Dem. XXXVII.55–6; Ober (1989) 151. [112] Dem. XLV.77–8; Ober (1989) 221.

as part of a general democratising revaluation of ethical and aesthetic concepts inherited from the aristocratic social order of archaic Greece. These shifts are particularly sharply registered in Simonides' poem to Scopas. In addition to suggesting that the worth of a person be measured not in terms of good fortune attributed to divine favour, but rather in terms of achievement accomplished through effort, Simonides develops a concept of the *hygiēs anēr*, who is characterised by a sense of justice (*dikē*) and benefit to his city (*onesipolis*): εἰδὼς γ' ὀνασίπολιν δίκαν, ὑγίης ἀνήρ. The concept of health acquires psychological and political connotations, referring to health of mind, and in particular 'political sanity'. 'There can be no *hygieia* without a knowledge of what is politically *dikaion*.'[113]

Similar considerations informed the reading of faces and the iconographic patterns selected for portrait faces.[114] Plutarch describes how Perikles developed a specific style of self-presentation as one component in the development of a new, more specifically democratic style of politics, distancing himself from the personalistic claims to influence made by more traditional aristocratic politicians.[115] Where an Alkibiades might seek to accumulate popular influence by conspicuous aristocratic consumption of racing horses for the panhellenic games (and the highly personal charisma manifested in victory and its artistic celebration, see above p. 114) or a Kimon by giving money and clothes to needy citizens in the agora – both forms of what John Davies calls 'property power'[116] – Perikles adopted an impersonal lifestyle. In addition to handing over his property to a manager, he also eschewed participation in the normal round of social intercourse in private symposia and other gatherings, which had been the core of politics in pre-democratic Athens, and which remained a significant setting for the development of ties of family and friendship which could be mobilised in political contexts.[117] This mode of comportment shaped also Perikles' corporeal and facial self-control, which suppressed any indication of affective disturbance, whether joy or sorrow, with a demeanour of gentle serenity or *praotēs*: 'a composure of countenance that never broke down into laughter, a gentleness in his movements, a dignity in the arrangement of his

[113] Simonides 5.19; Bowra (1934), quotation 231. Cf. Steiner (2001) 40–4: ambivalent between the intellectualist and the social reading, ultimately reaching similar conclusions concerning the specific meanings of the Doryphoros, but with no grounds for privileging one reading over the other, nor any explanation of the development of ponderation as one component of naturalism more generally.

[114] For the following, and the development of the iconography of facial expression in general in classical Greek art, Giuliani (1986) 101–62, esp. 129–40 is fundamental, with Hölscher (1988) on the facial expression of the Perikles portrait.

[115] Plut. *Per.* 5–8. [116] Davies (1981) 88–131.

[117] See Connor (1971) 3–32 and 35–84 on family, friendship and traditional politics, 119–37 on Perikles and the new leadership style.

attire subject to no disturbance by any emotion in speaking'.[118] The face of the portrait of Perikles (see figure 3.4 on p. 102) is not so much expressionless as expressing impassivity: complete rational self-mastery within the vicissitudes of life – the antithesis of centaurs in their battles with lapiths in fifth-century architectural sculpture: their faces, racked by snarling grimaces, display the violent mobility of the *hybristikos* (the man given to outrage), a complete lack of control of facial expression.[119] The ideal of *praotēs* remains current into the fourth century, and continues to be characterised largely by similar features: a steady gaze (ἀτρεμὲς τὸ ὄμμα), soft voice (πραεῖα ἡ φωνή) , and measured words.[120] Perikles, and the generals of the fourth century (see figures 3.5, 3.6 on pp. 102–3), display the face of the *metrios* or well-balanced man – calm and controlled in social interaction, free from any personal involvement and wholly subsumed in his civic role. Prestige is thus defined in a way that fitted well with the political culture of Athens. Generals whose portraits were modelled on this type were honoured in terms of their embodiment of a role, that of hoplite, and a set of incorporated social values which ideologically at least (and to some degree in practice) were shared with most other citizens. The somewhat muted individualism of the facial style further serves to emphasise their likeness to other citizens, rather than individual difference. They stand out by being the same as others, only more so.

Scrutiny of faces in order to determine character also seems to have enjoyed heightened importance in the fifth and fourth centuries.[121] As with bodies, so with faces, correct self-presentation became an important component of elite comportment within the political sphere. Demosthenes attacks Aeschines in court by contrasting the latter's *metrios* presentation of self at the beginning of his political career, when as a humble clerk he was grateful to the Athenian demos for any appointment, with his more recent conduct. Now, after his role in an embassy to Philip of Macedon and the creation of a peace with Philip, his personal style had changed. Demosthenes describes how Aeschines struts around the marketplace (the wide gait of an oligarch), his robes reaching to his ankles, 'with supercilious brows' (τὰς ὀφρῦς ἀνέσπακε) and 'puffed out cheeks', features interpreted as an index of inflated self-importance, in other words a lack of regard for his fellow citizens and the demos as a

[118] Plut. *Per.* 5.
[119] Stewart (1997) 194 on the Olympia centaurs; see R. Osborne (1994b) for the significance of the variable treatment of centaurs' facial expression on the Parthenon and at Bassai. On the normative ideal physiognomy of the *metrios* , the 'measured' or 'middling' man, in physiognomic writing, free from the 'marked contrast' to which any emotional imbalance might give rise – Sassi (2001) 50.
[120] Xen. *Symp.* VIII.3; Giuliani (1986) 132–3.
[121] See Malten (1961) 6–21 for the rather limited interest in facial expression in archaic Greek literature.

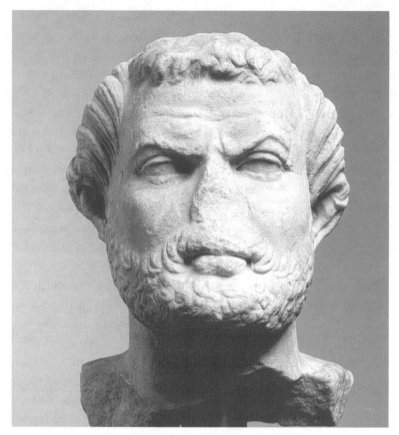

Figure 3.11 Roman portrait bust of Philip of Macedon, after Greek statue of the late fourth century BC. Ny Carlsberg Glyptothek, Copenhagen. Photo: Museum.

whole.[122] Demosthenes invokes a widely recognised pattern of facial expression – raising of the brows into a dynamic arched pattern – interpreted elsewhere as a facial expression such as might be characteristic of someone like a king, who wished to establish a certain dignified social distance from those with whom he interacted – *semnotēs*, 'solemnity'.[123] The pattern was well known, codified iconographically in representations of rulers – tragic kings in fourth-century Italian vase painting, the portrait of Philip of Macedon (figure 3.11) and the so-called Mausolus – and significantly is never found in fourth-century Attic portraits or grave stelai.[124] What better way to suggest Aeschines' putative oligarchic and pro-Macedonian tendencies?

A speech by an unknown sophist in the corpus of Isocrates instructs a young man about to enter into public life, to 'habituate yourself not to appear gloomy

[122] Dem. XIX.314. [123] Isoc. II.34, with Giuliani (1986) 140–4. [124] Giuliani (1986) 140–4.

(σκυθρωπόν) in your countenance, but thoughtful (σύννουν); for the former will make you seem self-willed (αὐθάδης), while on the basis of the latter you will be judged intelligent (φρόνιμος)'.[125] For men of a certain age and cultural authority, however, a somewhat sterner facial expression of intelligence might be appropriate. *Skythropos* is the term used by Aeschines to describe the 'venerable face of the members of the Areopagos', the council of former archons or chief magistrates of Athens,[126] and Demosthenes uses the same term to describe the facial expressions of persons seeking to cultivate the appearance of seriousness and integrity.[127] This positive valuation of an appearance of intelligence and serious reflection as a component of appropriate civic behaviour informs the iconography of the portrait of Plato (figure 3.12).[128] The Roman copies of the head, possibly after a portrait by Silanion set up in *c.* 350 BC by Plato's pupil Mithridates in the Academy where Plato taught, show a figure who in most respects corresponds to the contemporarary representations of male citizens in funerary stelai: short, neatly cut hair, full beard, furrowed forehead. What sets him apart is his slightly hooked nose, an individuating feature, and the heightened emphasis on contracted brows, drawn together and sharply downwards over the nose, creating a line across the bridge of the nose and a double furrow at its root.[129] Like Perikles' portrait in the fifth century, that of Plato was adjusted to the moral contours of the fourth-century polis, making a claim to have something specific to offer in a civic culture which was increasingly ready to recognise the potential contribution of the *phronimos*, the individual capable of managing affairs well by virtue of good reasoning.[130]

The development of the science of physiognomics in classical Greece was another component of this pattern of heightened interest in scrutinising bodies and faces to determine character and more or less synchronous with the

[125] Isoc. I.15; Giuliani (1986) 135. [126] Giuliani (1986) 135; Aeschin. *In Ctes.* III.20.

[127] Giuliani (1986) 135; Dem. XLV.68; LIV.34. [128] Richter (1965) II.164–70.

[129] Following Giuliani (1986) 134–40 and von den Hoff (1994) 29–31 in seeing this iconography as a specific indicator of intellectual activity, if not differentiating intellectuals from others. Cf. P. Zanker (1995) 67–77 on the recurrence of the motif on some funerary stelai, although here the issue is complicated by the quasi-narrative context of such stelai, where the brow contraction may be interpretable as an indicator of grief or sorrow. I rather doubt Zanker's suggestion (1995, 74) that we look at these portraits too closely, so that for contemporary viewers the additional brow contraction would not have been perceived as a significant alteration of the standard citizen image. As I have suggested, both the contemporary textual evidence and the development of physiognomics suggest a very deep interest in facial expression, reinforced by a strong assumption of psycho-physical unity which we no longer share. The setting up of portraits, especially honorific portraits, must have been important occasions and must have given rise to a perhaps more intense scrutiny than in an image-saturated culture like our own, where public statuary and self-presentation is taken as opposed to the true individual personality represented only in the private sphere; this is of course associated with the intimate distance that is characteristic of the bourgeois painted portrait.

[130] Cf. Adkins (1960) 244–9 on Plato as the first person to use *phronimos* to define the *agathos*.

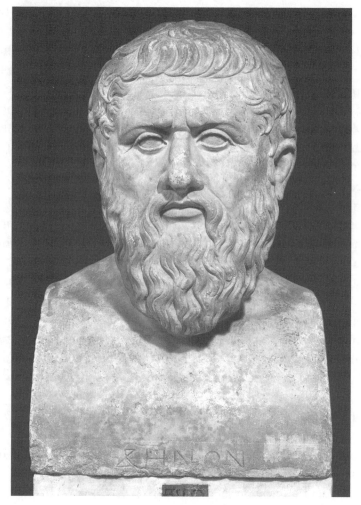

Figure 3.12 Portrait bust of Plato, Roman copy after Greek statue dated *c.* 360 BC. Vatican, Sale delle Muse. Photo: Anderson/Alinari 23856.

development of portraiture.[131] The late-sixth-/early-fifth-century philosopher Pythagoras is attested to have used physiognomical interpretation of the bodies and faces of candidates for education in his school, in order to assess their character and educability.[132] One Zopyros, a travelling sophist of Persian or Syrian extraction, was active at Athens in the later fifth century as a practitioner of physiognomics. He made sufficient impact to be much followed in sophistic

[131] On the origins of physiognomics: Tsouna (1998) for the philosophical context, esp. 181 for the early history; Megow (1963); Sassi (2001) 34–81 on the history and cultural logic of Greek physiognomic writing.
[132] Gell. *NA* 1.9.

circles, the subject of controversy amongst Socrates and his followers, inspiring Phaedo's dialogue *Zopyros*, which is thought to have centred on Zopyros' physiognomical diagnosis of the famously saturnine features of Socrates.[133] Aristophanes makes play on physiognomic practices and assumptions in some of his comedies. The human shape of the eponymous chorus in *Clouds* is explained in terms of clouds' capacity to transmogrify themselves into a form appropriate to whatever they encounter. If they see 'some wild, long-haired, shaggy-looking lecher, like Xenophantos' son, they jest at his mania and turn themselves into centaurs', or into foxes if they catch sight of an embezzler or into deer if a coward.[134] In the *Peace*, Hermes physiognomises the audience, identifying their different trades from their faces.[135] Conceivably such physiognomic skills as those displayed by Zopyros were taught amongst the *technai* which helped one to get on in political life, just as representing character was amongst the foremost skills of the orator, since it was on judgements of the character – as good citizens – of litigants, rather than the legal 'facts' of the case as we might understand it, that success or failure at the hands of popular juries hung.[136] Character was not just personality, the real inner person as we might think, but a form of symbolic capital, which is exactly why it plays also a central role in portraits as a form of prestige symbolism, objectifications of symbolic capital.

It is often difficult to pin down the exact reference of facial descriptions in such texts. The referents and value accents of some words may have shifted over time, and the exact valuation of different expressions and the value accents placed on particular descriptions of facial expression may be somewhat labile, according to context (for example, comedy as opposed to tragedy, where the emphasis is generally on a particular emotional response to a specific event, rather than character). These two problems may be compounded when using, for example, tragic texts (fifth century) alongside rhetorical ones (fourth century).[137] One can argue about details of specific facial expressions without its affecting the basic point: the particular social and political framing of the face in classical Athens and consequently what might have been at issue in certain

[133] *RE* XA 768–9, no. 3; Tsouna (1998) 181; Sassi (2001) 62; Cic. *Tusc.* IV.37.80; *Fat.* V.10–11; Alex. Aphr. de *Fato* 171.14–17.

[134] *Nub.* 340–55. [135] *Pax* 545–9. [136] Ober (1989) 43, 147.

[137] I am not convinced, for example, by Giuliani's (1986, 113–40) evolutionary model of a shift from brow contraction as affect expression to brow contraction as expression of fixed character. They existed alongside each other: the early Pindar portrait shows brow contraction, for example – von den Hoff (1994) 28. The meaning of patterns of brow contraction is to quite a large degree contextually determined: the brow contraction or frown associated with concentration differs from that expressing grief or pain only through very subtle details, and the two may be confused if one looks only at the brow, rather than the entire facial configuration, where the mouth of the concentrating individual is either simply relaxed or pursed rather than grimacing as in expressions of sorrow: Eckman (1979) 196.

modes of facial appearance in classical portraiture. That said, whilst this interest in character, and in particular in exploring character through its facial and bodily manifestations, is an important part of the context within which the practice of portraiture develops, and a distinctive feature of the visual culture of the democratic polis, it does not as such explain it: each is rather a response to the same underlying social process which I shall explore in the final section.

PORTRAITS AND SOCIETY: SOME CAUSES AND CONSEQUENCES OF ARTISTIC CHANGE

How can these considerations of the social uses of portraiture and the social contexts and cultural frameworks within which they were evaluated, and responded to, help us, first, to explain the development of portraiture both as a genre and in terms of some of the specific visual forms in which that genre is realised and, second, to evaluate the social significance of this innovation in the forms and uses of expressive culture? The dominant tradition in art-historical explanation is an iconological one, tracing parallels between different domains of cultural practice in order to make sense of art, generally interpreted as a reflection of ideas. My approach to portraits here has, on the contrary, adopted a structural-functional approach, assuming that portraits as expressive symbolism have particular functional consequences – the production, cultural shaping and distribution of affect – within particular contexts of social relations whose structure I have analysed. Such a framing of the institution of portraiture allows a much more specific explanation of the development of portraiture: this can be grounded in actions of individual and collective agents pursuing their interests and implementing their values within specific structural configurations and with specific sociological consequences, rather than the kinds of global cultural and political changes appealed to in earlier explanations, in which artistic change is seen as an epiphenomenon of more global political or cultural change – for example the birth of portraiture and the rise of ponderation as reflections of the growth of individualism/democracy or reflections of contemporary philosophy.[138]

I have suggested that the nerve of Greek portraiture lay not so much in some kind of free-floating or autonomous concern with identity and the self (as in modern private portraiture) but in a very public domain – the prestige system of the polis. The late sixth and early fifth centuries saw considerable struggle over the terms in which claims to social esteem might be made, and how different

[138] Cf. Pollitt above p. 117.

kinds of esteem might be converted into social and political leadership.[139] Aristocratic elites had demonstrated their superior status through lavish participation in ritual, and in particular such expensive ritual activities as athletics and horse-racing. Prominence and success in such ritual contexts both effected and marked a privileged relationship to the gods, which was also asserted in visual representations such as kouroi, which assimilated men to gods.[140] The conversion of such religiously tinged social charisma into political leadership is well illustrated by the case of Milon of Croton. Milon, a four times Olympic victor whose statue at Olympia took the form of a kouros, was also priest of Hera Lacinia, who functioned as a war and guardian deity with a cult linked with that of Herakles. In a battle against the Sybarites, Milon deploys his religious kudos as priest and Olympic victor on behalf of his city, by leading the Crotonian army into battle dressed in the attributes of Herakles and wearing his Olympic crowns.[141] The late sixth and early fifth centuries see serious criticism of this elitist ideology. Xenophanes attacked both the luxurious lifestyle of contemporary aristocracy and the special honours paid to athletic victors on the grounds that such practices were not beneficial to the city, and therefore not worthy of esteem.[142] By the fourth century, such enacting of the role of a god as Milon had performed seems to have occurred only on the margins of the Greek world, and when it occurred was seen as madness.[143]

A number of athletic victors become the recipients of hero-cult in the same period, some recently dead, others much earlier (even eighth century) winners receiving hero-cult only now for the first time. The concentration of these new foundations in the late sixth/early fifth centuries points towards the instability of status orders during this period of marked political and social-structural change. They could equally well be interpreted as the last 'serious bid for talismanic power by a beleaguered aristocracy' or a civic takeover of the talismanic value of a particular athlete and his (sometimes newly created) statue on behalf of a democratising state.[144] Kleisthenes' reforms in late sixth-century Athens are in certain respects similarly ambivalent: on the one hand, his strategy in the context of factional struggles within the aristocracy was one of traditional aristocratic power-play, seeking to extend his *hetaireia* or personal following; on the other, by incorporating the demos into his *hetaireia* he found

[139] I. Morris (2000) 166–76, esp. 169 on converting prestige into leadership, and on the conflict between elitist aristocracy and the 'middling' ideology which gave rise to democracy.
[140] See above pp. 60–7.
[141] Detienne (1994) 43–4; Kurke (1993); Metzler (1971) 347; Philostr. *VA.* IV.28 for the statue.
[142] Xenophanes frs. 2–3; Bowra (1970a), (1970b).
[143] Diod. XVI.44.2–3; Metzler (1971) 347; Hölscher (1971) 38 for further examples.
[144] Kurke (1993) quotation on 149; Bohringer (1979); Steiner (2001) 8.

himself compelled by the situational logic of his action to transform radically the whole nature of the political game in Athens in instituting democracy.[145] Part of the purpose of this political revolution was to enhance the military effectiveness of the Athenian state, replacing the occasional 'free-booting' conducted by individual members of the aristocratic elite and their personal following, characteristic of attested Athenian military activity in the seventh and sixth centuries, with a more centralised military organisation. This would be based on an official call up of all citizens by the state, to serve in military units dependent not on personal connections and local residence, but on the mixing of citizens from all regions of Attica in ten new arbitrarily constituted tribes.[146] The new specifically political context of the agora provided the setting for specifically political and secular imagery which celebrated the civic and military virtues of the new state. The erection of the portraits of the Tyrannicides – the first and exemplary honorific portraits in classical Athens – represented a radically democratic secular image, a more decisive break than in other cities where, unlike Athens, athletes might receive honorific portraits. The painting of the battle of Marathon in the Stoa Poikile – a new category of image, a history painting – also contained portrait images of some of the leading protagonists on both sides, and this marking out of particular individuals was perceived as a mark of distinction.[147]

These institutional ruptures and the creation of a new secular representational space must lie behind the creation of portraiture, both as a new category of image, the *eikōn*, and as a new type of image, the public honorific portrait.[148] They also changed the social and cultural frame towards which individual members of the elite were oriented in making personal claims to social esteem by setting up images of themselves in sanctuaries, but significantly not at the family tombs in cemeteries, one of the more important settings for kouroi and korai, since severe restrictions were placed on funerary display under the new regime.[149] This is perhaps best exemplified by the portrait of Themistokles (see figure 3.1 on p. 98): whatever the exact connotations of the physiognomic peculiarities of this head, it is perfectly clear that it seeks to differentiate itself quite markedly from the elegance and refinement of the heads of kouroi, in a way not dissimilar from the head of Aristogeiton in the Tyrannicide group, which is one of the closest comparanda. Themistokles notoriously lacked the

[145] Hdt. v.66. [146] Connor (1988) 6–10. [147] Aeschin. *De Leg.*II.186.

[148] Cf. Detienne (1996) 108–15 on Simonides and the secularisation of the role of the poet, in association with extension of the proper subjects of choral lyric from praise of gods to that of men, in particular to 'praise citizens who have risked their lives for the city' (109), notably those who fought at Thermopylae, Marathon and Plataea.

[149] Zinserling (1965), I. Morris (1992) 128–9.

cultural skills and graces characteristic of the old aristocratic *paideia*, prerequisite to success within the elite world of the symposium, and consequently challenged its values, 'saying that he was unable to tune a lyre or handle a harp, but he did know how to take a small city of no reputation and make it great and glorious'.[150] It is surely this social habitus, deliberately distancing himself from the old-style elite and orienting himself to the new democratic social order, that determined the selection of Themistokles' image, rather than 'the character of Themistokles as described by ancient authors – far seeing, fearless, headstrong "an ambitious lover of great deeds"'.[151]

The selective role played by the new evaluative culture, linking prestige with benefit for the polis and respect for egalitarian norms of social interaction, is most clearly demonstrated in the institution of honorific portraiture, for which the preponderance of the evidence from Athens is relatively late by virtue of the extreme democratic character of fifth-century Athens' political culture. Fourth-century Athens, with its changed balance of power between elite and demos, perhaps gives us a better sense of what the picture might have looked like in ordinary poleis (lacking an empire) in the fifth century. But private portraits, such as those of Perikles and Plato, and the complete absence of monarchic *semnotēs* from the sculptural record of classical Athens also seem to have been shaped in their style and iconography by the same selective pressures.

These changes were not a purely Athenian phenomenon, although they perhaps took a particularly radical form at Athens, which is probably the most likely setting for the invention of the portrait, as it is for 'naturalism' in religious art. Democratisation is attested in eight examples of political revolution all concentrated in the period 525–490 BC, and the development of what Ian Morris calls the culture of the middling man, the *metrios*, is characteristic of all of central Greece in the first half of the fifth century.[152] The diffusion of democratic iconography and style from Athens also seems to be associated with democratisation. The construction of the temple of Zeus at Olympia (470–456 BC) followed a democratic revolution which took place as part of the *synoikismos* or unification of the polis of Elis. The iconography of the west pediment, a centauromachy, seems to have been closely modelled on the paintings of the Theseion at Athens. The figure of Theseus echoes Harmodios from the Tyrannicide group in a deliberate appropriation of the iconography of democracy.[153] Similarly, Polykleitos' Doryphoros, the corporeal hexis of which was, as we have seen, taken up in Athenian art of the second half of the fifth century, was created during a period in which Argos had a democratic

[150] Plut. *Them.* 2. [151] Richter (1984) 212. [152] I. Morris (2000) 110–44. [153] Barron (1972).

constitution and was possibly associated with the reorganisation of the Argive *ephebeia*.[154]

The new features of portraiture, ponderation and the more differentiated facial iconography, are oriented to the new democratic political order. Potential for political-military contribution through actions of *aretē*, moderated by a self-control which demonstrated respect for others, and performance in service of the polis became the primary markers of social distinction. This replaced an elitist ideology which claimed distinction by virtue of an aristocratic essence, in part the expression of a privileged relationship to the gods, manifested in styles of artistic expression which distanced the elite from the ordinary people, the demos. The languages of archaic art were ill-equipped to express this new pattern of relationships. The 'emblematic' character of the representation of both standing/striding posture (in kouroi) and movement (for example the *knielauf* as a sign to indicate running) did not permit the representation of self-conscious control; nor did the 'attributive' mimic of the archaic smile of the kouroi.[155] The body and face of the kouros do 'not appear linked to an ego'. On the contrary, they are a surface 'charged' with certain properties and powers of a religious significance – beauty, charm, strength, youthfulness – in which the person represented realises his identity in fullest perfection through complete assimilation to divine appearance. Like the *charis* poured by the gods on their favourites in the *Iliad* and *Odyssey*, the values emanating from the surface of these statues are designed to engender deferential wonder, *thauma idesthai*.[156]

The bodies and faces of classical portraits are oriented to fundamentally new kinds of visual scrutiny and ethical evaluation, in which surface appearance is integrated with depth, an underlying character towards which appearances point. This new model of interpretation or inference is tied to a shift in the balance between symbolic, iconic and indexical components of the iconography. In both archaic iconography and classical there are iconic and symbolic or arbitrary components. The archaic smile, for example, is an icon of a smile, but also depends for its particular cultural meaning on the culturally arbitrary connection of such a smile with the idea of a godlike blessed existence. Brow contraction, and the lines on the face which it entails, are causally determined by a particular momentary configuration of muscular activity in the case of an

[154] Fehr (1979) 36.

[155] See Sourvinou-Inwood (1995) 253 on the emblematic character of representations of movement in archaic Greek art; Giuliani (1986) 105–12 for the bipolar attributive character of facial 'expression' in archaic Greek art, and especially 112 for the impossibility of representing self-control within its conventions.

[156] See above, pp. 65–7, for a discussion of kouroi and the ritual contexts of their viewing, with Vernant (1983) quotation on 330, (1990b) 236–7.

emotional response to a particular event, or by a certain muscle tone which is the result of repeated movements of the same facial muscles, as, for example, in the use of a certain type of brow contraction associated with mental concentration to indicate, by cultural convention, the man of thought, the *phronimos*.[157] Similarly, ponderation in classical statues introduces an indexical character into the icons of standing or moving posture: the posture is causally determined by the particular interrelationships of tensed and relaxed muscles represented, which themselves point towards particular *choices* of conduct or carriage being made by the individual portrayed, and hence (by social convention) to an underlying character.[158] The analogical inferences made by viewers – in interpreting these indexical signs of bodily movement controlled consciously or habitually by an ego in terms of a particular kind of underlying character with certain socially relevant qualities and dispositions (*praotēs*, *sophrosunē*, *phronimos*) – were grounded in shared experience of bodily civic paideia, and in routine scrutinising and evaluation of members of the elite in these terms in such contexts as the assembly, the law courts and the gymnasium. That is to say, it was a practical logic of inference (rooted in an embodied mind not an abstracted intellect), rather than the kind of abstract theoretical analogy from form to concept suggested by the more philosophical readings of ponderation. Just as in the case of the naturalism of classical religious iconography, so here 'naturalism' generates its motifs by drawing on socially marked categories of physiological functioning, whether control of bodily or of facial musculature in particular repertoires of posture, movement and facial expression.

[157] Just as in the case of patterns of bodily movement, so also the patterns of facial expression in classical Greek art are at least in part based in close observation of naturally occurring patterns. Cf., for example, Eckman (1979) 196 for the characteristic patterns of brow contraction in moments of intense concentration, and the slight differences (heightened orbicularis oculi contraction) characteristic of expressions of grief or sadness, emphasised also by differences in other features of the face, particularly the mouth. A wrinkled forehead and brow contraction as characteristic markers of portraits of intellectuals are also found in early Chinese portraiture: Spiro (1990) 61, 168. I certainly would not wish to argue that all facial expressions in classical Greek art have this natural/indexical character, and in some cases the simulation of such expressions is not sufficiently accomplished to ensure differentiation of, for example, brow contraction in mourning and as a sign of concentration out of context. A full study of this problem, making use of the relevant ethological literature, is the prerequisite of a full understanding of the issues. My point is simply to challenge the routine assumption that art is entirely dependent on cultural convention, and to illustrate the shifting balance between the conventional/arbitrary and the natural/indexical entailed by the development of 'naturalism'. One might contrast the scroll or book as a wholly arbitrary indicator of an intellectual role in medieval art, in comparison with the natural basis of brow contraction as a conventional indicator of the intellectual, in which culture puts nature to work for its own purposes.

[158] See Leftwich (1987), (1995) for exhaustive analysis of the Doryphoros' systematic representation of the fundamental principles of mechanical movement in the human body and the knowledge of anatomy which it presupposes.

The practices of portraiture were not only brought into being by the democratic social order; they also served to make and sustain it. The development of an institution of honorific portrait-giving, in the context of a wider reward system, far from being an indication of the decline of the polis and civic values, as traditional art historians have argued, represents a fuller institutionalisation of the normative culture of the democratic polis. The iconography and style of the fourth-century portraits gave a particular cultural shape to the attitudes expressed in the setting up of portraits. In objectifying these feelings and mediating them through an aesthetic form, they shaped the feelings to fit the moral culture of the democratic polis. The recipients of portraits, in accepting these symbolic rewards in order to enhance their own prestige within the civic community, were socialised into a 'language of emotional communication'.[159] They became sensitive to the attitudes of the demos towards them, as expressed in these reward symbols. Demosthenes talks of an honorific portrait as a moral and emotional investment in the city, and a motivation to loyalty towards it, on a par with children living at Athens.[160] The very presence of portraits in public space fed into the political process, creating new forms of symbolic capital, and thus new inequalities in prestige, but inequalities based on the perceived capacity of individuals to be of service to the democratic polis. The everyday appropriation of such imagery by viewers and the pleasure they took in gazing on and evaluating bodies and faces that pointed towards exemplary characters enculturated viewers into the same sets of civic values as underlay both the forms and the institution of portraiture.

[159] Parsons (1964) 27. [160] Dem. *Against Aristokrates* XXIII.136–7.

4

CULTURE, SOCIAL STRUCTURE AND ARTISTIC AGENCY IN CLASSICAL GREECE

It has been suggested that artisans started claiming some distinction, or at least some knowledge of reality and 'truth' during the course of the fourth century. This may well be the case, but the evidence at hand does not suggest to my mind qualities of originality and aesthetic genius such as have been attributed by modern scholarship to the 'big names'. To be sure the level of sculptural competence must have been extremely high, and commissions frequent, but within the parameters of tradition and extended practice. (Brunilde Ridgway, *Fourth-Century Styles in Greek Sculpture*, 1997, p. 267)

The great artist's near god-like status as the creator of things which seemed to be alive (immortalised in what is certainly the most moving and sympathetic hymn of praise to artistic creation in antiquity, the shield of Achilles in *Iliad XVIII*) is further testified to by literally hundreds of later sources, and puts the cream of the artistic profession on a totally different level from the potter or shoe-maker, even the vase-painter or journeyman carver nominally at least their fellow craftsmen. (Andrew Stewart, *Attika: Studies in Athenian Sculpture of the Hellenistic Age*, 1979, pp. 109–10)

As the range of available choices, stylistic, technical or whatever multiplied, so too did opportunities for individual self-expression – and thus individual greatness – increase. Skopas and Praxiteles apart, there are explicit statements of Lysippos to this effect. His aesthetic was clearly revolutionary, and his sense of mission undoubted: with his independent mind, unrivalled creativity, and matchless technique, he represents the acme of artistic autonomy in Greek sculpture. (Andrew Stewart, *Greek Sculpture: an Exploration*, 1990, p. 69).

INTRODUCTION: PRIMITIVISTS, MODERNISERS AND THE PROBLEM OF THE ARTIST IN CLASSICAL ART HISTORY

Ridgway's and Stewart's diametrically opposed views of the role, status and autonomy of the artist in classical Greece represent merely the most recent repetition of a debate whose terms have remained largely unchanged for more than a century. On one side we find 'modernisers', who hold that the role of the artist, the function of art and the social structure of the Greek art world was more similar to the modern western art world than different. On the other side are ranged the 'primitivists', who argue that modern conceptions of artistic autonomy and creativity are an anachronistic imposition on ancient Greek art,

which was a largely anonymous craft, performing traditional functions and oriented to the reproduction of traditional artistic forms rather than the individualistic innovation held to be characteristic of western European art since the Renaissance. The modernisers look back to Winckelmann's neoclassical view of the Greek artist as free and autonomous creator, whilst the primitivists ultimately draw their inspiration from Jacob Burckhardt's alternative account of the Greek artist as mechanical craftsman or *banausos*.[1] More recent contributions have largely been concerned with adducing, or criticising, new evidence for one or other side of the debate, whilst retaining the assumptions within which the debate was set up in the nineteenth century, namely that artistic autonomy is synonymous with, and can only be legitimated in terms of, an ideology of creativity.[2]

The debate, however, is not one which is likely to be settled, at least within its current terms, by empirical evidence, since in practice it is as much an argument about fundamental disciplinary presuppositions, in particular the kinds of art history that classical art historians should write, as it is a strictly empirical discussion about the status of artists in classical antiquity. When so many careers are founded on a monographic study of an individual artist, it is perhaps unsurprising that the authors of such studies are predisposed to see the history of Greek art as a story of 'the modification of tradition by strong artistic personalities'.[3] Conversely, students trained in a strongly formalist tradition of style analysis of sculpture as the 'anonymous product of an impersonal craft', in which stylistic change is 'strictly conditioned by evolutionary laws which are in turn dependent on the unchangeable dictates of the mechanisms of human vision', simply cannot accept any evidence of individuality amongst artists such as might impinge on their artistic production itself.[4] To do so, would subvert the presuppositions on which their work is based.

Because such high disciplinary stakes rest on which side of the question one comes down on, there are strong temptations to ignore or dismiss evidence

[1] See Himmelmann (1979) 127–9 on the origins of the contemporary debate. Coarelli (1980a) reprints Burckhardt's original essay (1887) and the more important recent contributions. For an earlier version of this chapter, focusing on the question of artists' status, and with a fuller discussion of the cultural and structural setting for this, see Tanner (1999). For a discussion of the concepts of 'imagination' and 'creator' in relation to Greek artists, expecially in relation to Schweitzer's influential article of 1925, see Tanner (forthcoming), which criticises the uncritical projection of modern culturally specific concepts of creativity and imagination onto the ancient world. The focus on structures of agency in this chapter seeks to replace the tacit modernising Renaissance analogy of the Greek artist as creator, with an explicit sociological framework more adequate to the specificities of the historical evolution of culture and social structure in ancient Greece, and placing them in a framework where they can be analytically, rather than evaluatively, compared with other instances.

[2] Bianchi Bandinelli (1980), Coarelli (1980b), Lauter (1974), Wesenberg (1985).

[3] Robertson (1975) 605. [4] Carpenter (1960) v–viii.

which is inconvenient to one's own presuppositions. Stewart, for example, concludes his essay with a truly desperate argument:

That the Greeks had no word for 'art' or 'artist' [i.e. as opposed to craft/*technē*] has clearly little or no bearing on the problem at hand, for the appearance of the artist as an autonomous creator well after the codification of Greek aesthetic terminology for art was *simply the result of an historical accident*.[5]

It is hard to credit the existence of a classification system establishing a radical distinction between true artists and mere craftsmen but leaving no trace in language, which is after all the primary medium of cultural classification. Similarly, Ridgway dismisses all the evidence for competitions between artists, and the epigrams in which they celebrate their victories in artistry, by suggesting that such competitions had nothing to do with aesthetics, but were simply a question of price.[6] In both cases, the cost of such arguments is to move certain problems within classical art history outside the bounds of rational discussion or explanation. For Stewart, the development of Greek and later western terminology for describing and classifying visual art is simply an accidental or random event which cannot itself be explained nor used to interpret and explain Greek art. For Ridgeway there is a *hiatus irrationalis* between the social frameworks within which art is produced and aesthetic issues of stylistic development and patterning that involve questions of a totally different order, a kind of mystical and immanent unfolding of underlying potentialities of which artists are the medium rather than the agents.[7]

In this chapter I seek to advance the debate about Greek artists' roles and status by shifting its terms. The argument between primitivists and modernisers may be seen as a particular version of the broader discussion in sociological theory between 'voluntaristic' and 'deterministic' accounts of action,

[5] Stewart (1979) 111. My emphases.

[6] Ridgway (1997) 14: Paionios won 'the commission for the akroteria to the temple of Zeus, not in aesthetic competition amongst artists, but probably by proposing the most economical and feasible model'; 239: sculptors for the Mausoleum selected not 'because of their established fame' as leading artists, but because they had available 'trained manpower and established workshops'.

[7] Similar aporiai have been generated by the introduction of structuralist methodologies. Bérard (1983a, 1983b) draws a distinction between vase painters and other producers of serial imagery (votive reliefs, sarcophagi), whom he refers to as '*imagiers*', artisans 'working to order and deprived of any creative freedom', and true artists, such as Polykleitos, who produced individuated works of art. In part, this is a methodological device, in order to define the corpus of vase images as a synchronic unity, consisting of 'a shared repertoire of stable and constant elements' in which the only changes over time are semantic changes, in the combinations of those preconstituted elements. The semantic dimension is contrasted with the aesthetic dimension of Greek art, where there is a detectable evolution over the same period, and Bérard argues that 'notions of an aesthetic order' play little role in the imagery of serial productions like vases. The polarities are at best unhelpful and collapse on closer inspection: Mattusch (1996) on the serial character of bronze sculpture production; Neer (1995) and (2002) for the individual aesthetic agency of vase painters.

respectively emphasising the autonomy of the individual actor or the constraints of social and cultural structures. Contemporary social theory has been concerned with transcending this dichotomy, by exploring the 'interplay between structure and agency over time'.[8] In the sociology of art, this has involved a shift from reductionist accounts of the social determination of art as a cultural product to a concern with how cultural forms facilitate or constrain cultural agency, and how 'forms of cultural agency are linked to the [social] structures in which they are effective'.[9]

Three concepts will be central to my analysis and require brief clarification: status, role and agency. The concept of status describes the position of an actor within social structure, in particular in so far as this position is ranked as superior or inferior to other positions. Is the position or role of sculptor or painter one which brings the bearer esteem or disesteem? What are the grounds of such evaluations of sculptors and painters as a group, and to what extent are they recognised as a distinctive group – artists – with their own special claim to esteem as such? The concept of role describes patterned expectations about and performances of action by actors interacting with each other. At its most abstract level, the role of artist involves the production of artistic forms which serve to mediate emotional communication on the part of the consumers or viewers of such forms in particular social and cultural contexts. The concept of role addresses questions of the social organisation of production. How do artists interact with clients in the process of the commissioning and production of works of art? What are the norms which guide such interactions, and how are such interactions shaped by the social, cultural and economic resources at the disposal of artist and client?

The concept of agency has been developed in order to try to describe and analyse how actors actively negotiate the social structural and organisational and cultural settings within which they act – on the one hand constrained by each of those environments, on the other hand drawing upon the material and cultural resources in them to change those environments and their relationship as actors to them.[10] All action has an 'iterational' element, dependent on and reproducing inherited patterns or schemata of action. All action has a 'projective' element, configuring action sometimes in an innovative way towards the actors' aspirations for the future. All action has a 'practical-evaluative' element, evaluating the appropriateness of available cultural schemata or patterns of action according to the evolving exigencies of immediate situations. On any

[8] Archer (1995) 64. [9] Brain (1989) 61, (1994).
[10] My discussion here draws in particular on the work of Sewell (1992) and Emirbayer and Mische (1998).

occasion, actors have at their disposal an array of resources for action, cultural schemata, to which they can relate in more iterational, projective or practical-evaluative ways. The balance between these dimensions of agency may depend on the situation actors encounter, the repertoire of schemata at their disposal, and the orientation of actors to those schemata. Problematic situations in which it is impossible simply to implement inherited repertoires of action may create reflective distance from inherited schemata and encourage or permit their transformation or substitution with other schemata available in an actor's environment. The degree of such creative transformation is determined by the kinds of resources available to actors and the degree to which their environment – whether a social environment (role-relations) or a cultural environment (the stock of inherited artistic schemata) – is responsive, and is seen to be to be responsive, to efforts to transform it. Agency consists in the capacity to transpose inherited schemata from one context to another and to transform and elaborate the inherited repertoire of cultural schemata (for example, stylistic and iconographic schemata) or schemata of social interaction (for example, role definitions). Structures (social and cultural) condition such agency, which, in turn, through actors' actions affects those structures, whether reproducing them unchanged or transforming them, hence reproducing or transforming agency itself. A crucial component in artistic agency is the practical technologies of design or image-production used by artists, since it is the way in which these articulate with the social and cultural environments in which artists work that offers opportunities for artists to augment their practical autonomy, redefine their role and enhance their status.[11]

Although they articulate with and condition each other, the relationship between status, role and agency is not neccessarily strictly determinate: you cannot read high levels of agency directly off from high status, for example. In dynastic Egypt, sculptors enjoyed a relatively high social status: they were often depicted as participating in shared activities with the tomb owner, for example in hunts, or in high-status positions (as servants, for example bearing offerings at meals). They also seem to have had a well-developed sense of artistic identity, signing their works, creating self-portraits and sometimes boasting of their special artistic prowess.[12] The social and cultural setting in which they worked, however, prevented such strong self-awareness from eventuating in a strongly transformative orientation towards their inherited artistic repertoire. The structure of the art market and the organisation of production created little space in which individual artistic identity might be explored. Sculptors' workshops were

[11] Brain (1989) 61. [12] Drenkahn (1995) 338–40; Davis (1989) 110–13.

attached to temples or the domestic establishment of state officials, who provided both the materials on which artists worked and the goods in kind with which they were paid.[13] Technical drawings defining the canonical repertoire were controlled by scribe artisans with the title 'Master of Secret Things': the instructions for one funerary statue command the priests to 'execute the very secret things, no one seeing, no one beholding, no one knowing his body'.[14] By virtue of an extraordinarily high division of labour, probably no single individual had mastery of the whole repertoire of forms and the techniques of their production. In relief sculpture, for example, six different stages of production were distinguished, each with their own specialists, from outline draftsmen through modelling-sculptors to painters, each having to follow set rules in order to permit collaboration with his counterparts.[15] By contrast, the humble pot-painter, a by-word in classical Athens for a person of low status, generally controlled the production of the image on a vase from beginning to end, freely improvising in provisional sketches on each vase and very seldom exactly repeating designs, since part of the point of the pot painting seems to have been to provoke discussion and admiration of the pots' innovative representations in the context of the drinking-parties where they were used and viewed.[16] In the case of major works of sculpture and painting, particularly in democratic Athens, public discussion and evaluation of the artist's work played a central role in the organisation of the production process and significantly informed the transformative reconstruction of artists' identities, role and agency (see below).

Shifting the terms of the debate in this way offers a number of advantages. First, it allows us to break out of the dichotomising question of whether Greek artists were (or were held to be) creators or mere craftsmen replicating tradition. Instead, we can ask more interesting and productive questions about the range of factors – social, cultural, technically artistic – that condition artistic agency, their changing interrelations over time, and the sociocultural mechanisms which expand or restrict artistic agency and capacity for innovation and give that capacity a particular shape. Moreover, the aesthetic and material practices of sculpture and painting become a central part of the question of the status and role of the artist, which in turn can no longer be considered a peripheral question to more mainstream object-oriented art history. What it was to be a painter or sculptor in the ancient Greek world – the nature of the role, its cultural meaning or evaluation, and the social status of painters and sculptors – was changing and contested in classical Greece, in association with changes in

[13] Drenkahn (1995) 332–4. [14] Davis (1989) 99. [15] Drenkahn (1995) 336–8.
[16] Dem. *De falsa legatione* 237; Aeschin. II.149; Neer (1995), Corbett (1965).

the material practices of painting and sculpting. This chapter will explore the social and cultural (and technical-artistic) bases of that debate, the expansion of artistic agency during the classical period, and the nature and sources of the limitations placed on that expansion, whilst the final stabilisation of a long-lasting and specifically Greek structure of artistic agency in the post-classical (Hellenistic and Roman) periods will be sketched in chapter 6.

Secondly, a focus on agency offers the possibility of an enhanced understanding of the shifting balance between tradition and originality over time in Greek art. Even in very recent work in classical art history, explanations of cultural innovation and reproduction may have an extraordinarily primitive, undifferentiated character. Ridgway's argument that tradition was always prized above originality in Greek art leads to a one-dimensional account of artistic change, in which the quantity of artistic production is the primary explanatory variable, and rates of change are the only real explanandum.[17] She argues, for example, that the Greek revolution may be explained as a simple function of the quantity of artistic production at the end of the archaic period.[18] In practice, however, the material structure of artistic traditions, concepts of tradition and innovation, and the relative value attributed to tradition or innovation all vary across cultural traditions and over time within cultural traditions.[19] The internal parameters of tradition (and the scope for innovation they allow or demand) may change, as may the artist's relationship to tradition, whether by virtue of social changes – for example in structures of patronal control – or cultural transformations, such as a change in the self-conception of artists. There are many periods of abundant sculptural production in Egyptian dynastic art that did not generate a comparable level of experimentation or so radical a reorganisation of style as characterises early classical Greece. That is not to say that Egyptian art is not innovative, as recent scholars have rightly insisted, only that innovation and flexibility took place in the context of an artistic system which set rather different limits and demands by virtue of differences in the material structure of the language of Egyptian art as

[17] In addition to being theoretically limiting, Ridgway's position is also difficult to sustain empirically. What Lloyd characterises as the self-conscious innovativeness of the Greeks was characteristic of artists as well as poets and philosophers – Lloyd (1987) 56–78; see below, pp. 178–82, 188–90.

[18] Ridgway (1997) 11.

[19] See, for example, Gombrich's classic article (1952) 'The Renaissance conception of artistic progress and its consequences'. Contrary to Ridgway's suggestion (1997) 267 – see epigraph to this chapter – definitions of artistic competence are culturally constructed and consequently subject to change: an avant-garde artist who is not creative would not be competent in so far as the idea of creativity is internal to the role definition of the avant-garde artist. Expectations about acceptable levels of competence changed considerably during the history of Greek art, and almost certainly involved an expectation of a capacity for contextually appropriate innovation in the classical period. This is presumably part of what lay behind Alexanders insistence on Lysippos as his portrait sculptor: Stewart (1997) 207–10.

well as of the organisation of patronage.[20] There is no shortage of Greek sculptural production in the first two centuries of the Roman imperial period, but again not a comparable level of stylistic innovation. Indeed, other classical art historians have explained the development of copying and the relative stasis of Hellenistic and Roman-period Greek art as a function of the sheer quantity of artistic production.[21]

Why is expansion of production associated in some periods with innovation, in others with reproduction? Why in some periods (or genres, or cultures) do we see innovation solely in combination of motifs within traditional rules of style and composition, whilst in others we encounter either the creation of new motifs, according to traditional rules of style and composition, or alternatively even new rules of style or composition regulating the generation and combination of motifs?[22] The Greek revolution, for example, represents a change of a different order from the innovation represented by Polykleitos' canon. In the former case fundamentally new rules of style are created, on the basis of which new motifs are produced and combined. In the latter, new principles of compositional order are established, but within the already existing generative rules of naturalism. Similarly, Greek art in the Roman world of the early and high empire is not static, but the innovations which take place – for example in the development of the repertoire of images used in sarcophagi – are more a question of novel combinations of elements from established iconographic schemata, or their elaboration according to already established compositional principles than a question of the creation of new styles or new rules of combination or composition (see chapter 6).

The challenge is not to find innovation or continuity, since both are by definition always present in every cultural tradition, depending on what cultural level you choose to examine. It is to find ways of meaningfully *comparing* and *explaining variation* in patterns and structures of innovation and continuity. A focus on the construction of artistic agency – in place of the rigid opposition between tradition and originality in which the creativity of the modern western artist functions as an evaluative norm, or even the concept of spectrum between the poles of tradition and innovation advocated by Kubler[23] – may allow us to begin to develop a more nuanced account of the distinctiveness of patterns of innovation in the Greek artistic tradition (compared, for example, with the

[20] See Wilson (1947) on the relationship between system and innovation in Egyptian art; Robins (1997) 29 on the relationship between conformity and innovation in Egyptian art.

[21] Schmidt (1996) 218–19; Pfanner (1989); Bianchi Bandinelli (1978) 11–13.

[22] For a good discussion of the variable structures and processes of artistic innovation, see Layton (1991) 200–11.

[23] Kubler (1963).

traditions of Egypt or China, or early modern Italy) and also of how and why patterns of innovation change over time within that tradition.

The argument falls into four parts. The second section of the chapter (pp. 149–58) sketches aspects of the social status and role of artists in late archaic and classical Greece, concentrating on the broad social structural setting and the cultural presuppositions within which artistic activity took place. The third section (pp. 158–82) explores the interactions between artists and intellectuals, and the rationalisation of artistic agency which took place as part and parcel of the development of naturalism in classical Greek art. In the fourth section (pp. 182–90) I seek to sketch the distinctive character of artistic agency in classical Greece and the social and cultural factors which engendered its particular structure; it can be compared with the structure of agency characteristic of certain strands of Hellenistic-Roman art production discussed in chapter 6. In the remaining two sections (pp. 191–204) I suggest that certain limits were placed on artists' attempts to enhance their status and their practical autonomy by the countervailing ideological commitments of the contemporary intellectual elite and by the material constraints of contemporary social structure.

THE ARTIST AND THE POLIS

Greek artists and the primacy of the political

The classical Greek polis was a community of citizen warriors, providing for themselves through (ideally) self-sufficient agrarian households, and organised on a basis of egalitarian self-governance. A certain primacy of value was accorded to the political sphere, codified in the ideal of the farmer hoplite, ready to serve his state in the deliberations of the democratic assembly or as a warrior in the citizen phalanx.[24] Craftsmen were looked down on in comparison with farmer hoplites. Whilst farmers' work was held to harden the body for warfare and afforded leisure for further training in the gymnasium, 'the banausic crafts' were said to 'spoil the body and mind', compelling 'workers to sit indoors and in some cases spend their day by the fire'. Lacking the leisure for full civic participation, and in the case of sculptors and painters often highly mobile in the search for patronage and consequently absent from their home city, craftsmen were 'bad defenders of their country'.[25] Unlike autarkic peasants, craftsmen were dependent on others for wages.[26] The unfree character of

[24] Bryant (1996) 16–23, 90–7; Finley (1985a) 116.
[25] Xen. *Oik.* IV.2–3; see Burford (1972) 9, 66 on sculptors' mobility. [26] Xen. *Mem.* II.8.3–5.

such work, together with the disesteem it entailed, must have been reinforced by the presence of slaves, working alongside freemen without distinction, in major artistic projects.[27] These values, articulated most strongly in elite texts, seem to have been widely shared, since texts intended for popular consumption, like comedy and oratory, trade on the assumption that men with a background in craft – like the 'new politicians' of the late fifth century – were not to be trusted as political leaders.[28]

The primacy of these political values shaped not just artists' status, but also the organisation of artistic production, and the relationship between artist and client. The major artistic projects were civic: temple sculptures, cult statues, myth-history paintings for public stoas. In a predominantly agrarian society, the cash needed to finance major artistic projects was largely politically generated, through windfalls such as war booty or the more continuous revenue stream provided by an empire for fifth-century Athens. State-sponsored building and artistic commissions were closely controlled through state administrative bodies – normally a commission set up by the boule and/or the assembly to oversee a particular project. At Epidauros, for example, an elected building commission had ultimate responsibility for all elements of the design and sculptural decoration of buildings and represented the community's interest in such projects.[29] In poleis, more or less democratic assemblies commissioned not only honorific portraits (see chapter 3), but also civic paintings, and both the content and nature of such commissions was scrutinised in law courts with juries held to be representative of the people – often to ensure the proper balance in commemorative practices between the community and leading individuals.[30] Both the religious and the civic-commemorative functions of art tied production of art to the temporal framework of civic festivals and particular occasions of memorialisation. Speed of production was an important issue, alongside quality and cost. Rather than waiting on the artist's inspiration, contracts specified dates for the completion of commissions and financial penalties if the contract was broken.[31] Finally, once the work was completed, it was subject to civic scrutiny in the courts. This involved not only a full accounting for expenditures made and materials used, but also evaluation of whether the final product adequately fulfilled the terms of the commission. Here, in particular, tensions could emerge between the political frameworks within which art was commissioned and evaluated and the more purely formal

[27] Randall (1953). [28] Burford (1972) 57; Austin and Vidal Naquet (1977) 14–18.
[29] Burford-Cooper (1969). [30] Plut. *Pel.* 25.2–7.
[31] Plut. *Mor.* 498; Pliny, *HN* xxxv.109; Lauter (1974); see Burford-Cooper (1969) 97 on penalties for sloppy workmanship and delayed completion of contracts.

interests of professional artists. The elaboration of the political sphere in the early fifth century, and of the resources at the disposal of the state (whether directly or through elite-sponsored patronage), tremendously promoted the development of wall paintings, to decorate major civic monuments. Painters took advantage of these new fields to experiment, in particular with representation of space, such as the introduction of landscape elements.[32] Some such innovations, however, did not meet with approval. Mikon was fined 30 minas for painting Greeks smaller than the Persians in his painting of the battle of Marathon in the Stoa Poikile in Athens. What seems to have happened is that his interest in developing perspective clashed with traditional symbolic conventions and patterns of interpretation, where scale of representation was a marker of status: slaves, for example, are conventionally represented as smaller than their masters or mistresses. Painting Greeks in the background smaller, by virtue of perspectival recession, than foreground Persians – barbarians and natural slaves as the Greeks liked to think – lent itself to misunderstanding.[33] Symptomatically, perspective only came to be systematically explored in the context of scene paintings in the theatre, which involved only buildings, no figures, so the same issues of political propriety did not arise.[34]

Representations of the artist in myth and ritual

Throughout the archaic period myth and ritual played a major role in shaping perceptions of artists and probably remained dominant in popular understanding of artistic identity until the end of the fifth century, when the debate about the nature and status of artists was increasingly shaped by sophistic and philosophical thought.[35] Some have argued that the divine patronage of artisans given by the deities Hephaistos and Athena put painters and sculptors on a similar footing in regard to both role and status as the support of Apollo and the Muses placed poets, namely as inspired creators.[36] The primary setting for the cult of Athena and Hephaistos in Athens was the temple of Hephaistos, located on the edge of the agora, alongside the Kerameikos, or potters' quarter.[37] The cult was not only active, but considerably elaborated with state support during the course of the fifth century. In addition to the building of a major new temple, cult statues were commissioned from Alkamenes, the pupil of

[32] Robertson (1975) 240–70.
[33] Harpokration, s.v. Mikon; *EAA* s.v. Mikon; with Himmelmann (1971) 40–2.
[34] Richter (1970) 43–6; Rouveret (1989) 93–106. [35] S. Morris (1992) 215–56, 357–61.
[36] Carandini (1980) esp. 166–7; Philipp (1963) 64–5, (1990) 83–4; Webster (1939) 174.
[37] Travlos (1971) 261–73.

Pheidias (see figures 2.6–7 on pp. 37–8).[38] The festival of Hephaistos, reorganised in the late fifth century, included torch races, bull-lifting (performed by selected ephebes), and in the feasting after the sacrifices special provision was made for distribution of meat to metics, resident aliens, who may have made up a significant proportion of the craftsmen of classical Athens.[39]

There is no doubt that the link with Athena and Hephaistos was important to craftsmen's self-identity, and claims to special status as craftsmen could be articulated in terms of special propinquity to these two deities. Athena herself could be represented as a sculptor, modelling in clay the archetype for a statue to be cast in bronze.[40] Representations of sculptors' and vase-painters' workshops in fifth-century vase paintings show the two deities present as patrons, guiding presences protecting their clients and ensuring the successful outcome of their work. A weaver of the archaic period might boast that 'queenly Pallas Athene' had 'breathed ineffable charm (*charis*)' on his hands, whilst the fifth-century sculptor Arkesilas claimed to be 'well-practised in the arts of Athena'.[41] The social and cultural implications of the patronage of Athena and Hephaistos were, however, significantly different from those following on poetic skill and inspiration. Inspiration by the Muses gave poets access to the truth (*aletheia*), and, in the right contexts, poetic skill was a form of cultural capital that could be turned into political leadership – best exemplified by Solon's poetic criticism of political conflict in archaic Athens and poetic justification of his own package of reforms.[42] The gifts of Athena and Hephaistos were less a matter of inspiration than of manual skill and practical intelligence, *metis*. They did not provide the cultural resources with which visual artists might have constructed a rationally systematised occupational identity – analogous to that of late-classical philosophers, or Vasari's academicians as masters of *disegno*, or the modern artist's vocation as creator – nor could they be converted into high political status. The gifts of Athena and Hephaistos were of a different order from the civic arts, the gifts of Zeus.[43] They were bound to a more traditional cultural order than the emerging philosophical culture which informed the rationalisation of *technai*: 'magical' powers unlocked on an *ad hoc* basis and for instrumental purposes by ritual action and fetishistic practices. As they fired their pots, potters prayed to Athena to 'spread her hand over the kiln' and prevent

[38] E. B. Harrison (1977).

[39] Parke (1977) 170–1; *IG* I², 84; Sokolowski (1969) no. 13; Harpokration s.v. Lampos.

[40] Bluemel (1969) 37, fig. 28.

[41] Ath. II.48b/*SQ* 385: Diog. Laert. IV.45. Cf. the dedication of a group of the Three Graces by the sculptor Bathykles, on the successful completion of a cult statue of Apollo at Amyklai – Paus. III.18.

[42] Detienne (1996), R. Osborne (1996) 217–20.

[43] Pl. *Prt.* 321–2. On *metis*, see Detienne and Vernant (1978).

ill-disposed demons from damaging its contents, whilst phallic figures of Hephaistos might protect the furnaces of bronze-workers from the evil eye.[44] Nothing is made of these connections by those classical artists we do know of – sculptors like Polykleitos and Lysippos, painters like Zeuxis and Parrhasios – who tried to construct a new image of the artist, affording him greater autonomy and higher esteem.

Social change and the negotiation of artistic identity in late archaic and early classical Greece

This framework of social organisation, moral culture and religious representation did not wholly determine the status of artists in the Greek polis. Individual artists actively engaged these frameworks in order to make personal claims to a higher level of prestige as one exceptionally gifted craftsman amongst others, or as a citizen whose occupation should not disqualify him from respectable political status. Such negotiations of a broadly accepted framework, however, should not be confused with more far-reaching attempts to try to redefine the role of the artist and to make claims to individual specifically artistic autonomy, such as we encounter in the later classical period, or in the modern European tradition from the late Middle Ages. Far from seriously contesting established images and evaluations of artists, as some have suggested, such negotiations of the dominant frameworks as we find in the late archaic and early classical periods only served to reproduce them.[45]

Although great weight has been laid on artists' signatures and their dedications of votives, neither of these practices, when seen in their broader context, served to set visual artists apart from other craftsmen as bearers of a privileged identity.[46] Stonemasons might sign a wall they had constructed,[47] and a miner might boast of his exceptional technical skill in the same way as the painter Parrhasios.[48] In practice, artists' inscribed signatures indicate the relative marginality of the artist in the communicative process involved in setting up a work of art and rehearsed in its viewing. When not tucked away in such a manner as to make it invisible to a viewer in the normal viewing position (figure 4.1),[49] the maker's mark of even a top artist like Praxiteles was normally

[44] Pollux VII.108; Brisson and Frontisi-Ducroux (1992); Faraone (1992) 55–6.
[45] See Tanner (1999) for full discussion, summarised in the following paragraphs.
[46] Tanner (1999) 142–7. Siebert (1978) places sculptors' and painters' signatures in the context of the wider practices of signing adopted by Greek craftsmen.
[47] *IG* XII.8.390; Burford (1972) 215. [48] *IG* II², 10051; Burford (1972) 177. [49] *IVO* 162–3, Polykleitos.

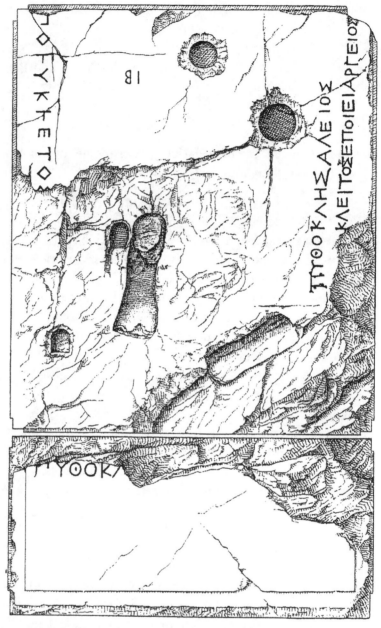

Figure 4.1 Base for statue of the athlete Pythokles, with the signature of Polykleitos.
Late fifth century BC. Black limestone. After *IVO*, p. 282, nos. 162–3.

vanishingly small in comparison with the the names of the dedicants or subjects
of a statue (figure 4.2).[50]

[50] See Tanner (1999) 158–64 for a fuller discussion of the epigraphic framing of the viewing experience, and
the marginalisation of the artist's voice, with further examples.

ΔΗΜΗΤΡΙΚΑΙΚΟΡΕΙ

ΚΛΕΙΟΚΡΑΤΕΙΑ
ΠΟΛΥΕΥΚΤΟΥ
ΤΕΙΘΟΡΑΣΙΟΥ
ΘΥΓΑΤΗΡ
ΣΠΟΥΔΙΟΥΓΥΝΗ

ΓΡΑΞΙΤΕΛΗΣΕΠΟΙΗΣΕΝ

Figure 4.2 Drawing after statue base signed by Praxiteles, *c.* 350 BC.
After *Hesperia* 6 (1937) 340, fig. 6.

Artists' and craftsmen's votives, whether small plaques with representations of their activities or more monumental thank offerings for success in business, particularly conspicuous in late archaic Athens, perhaps represent a more specific assertion of status and self-conscious identity[51] and have been thought to anticipate the supposed artistic freedom of the Greek revolution.[52] These range from small plaques placed in ovens to invoke divine protection for the firing process, and vases showing Nike crowning vase painters in their workshops,[53] to the monumental statue of Nike dedicated in the sanctuary of Apollo at Delos in the middle of the sixth century by the Chiot sculptors Mikkiades and Achermos.[54] Such representations serve not to break out of traditional understandings of the role of artists and the nature of artistry, but only to establish hierarchy amongst other sculptors and vase painters within traditional representational frameworks by laying claim to particular divine favour.[55] The idiom remains a traditional religious one, shared with other craftsmen. On the Athenian Akropolis in the late archaic period, alongside the well-known potters' votives, there stood comparable dedications by a washerwoman, a shipbuilder, a fuller and a tanner.[56]

[51] Guarducci (1980) 88; Carandini (1980) 166–7. The fullest account of this material is in Scheibler (1979). Most recently, see Gill (1991), Vickers and Gill (1994) 93–5; D. Williams (1995).

[52] Hölscher (1974) esp. 95–108; Metzler (1971) esp. 60–3.

[53] Himmelmann (1994) 12, fig. 6 (vase from private collection). [54] Scheibler (1979) 20.

[55] As does Paionios' later epigrammatic appropriation of the Messenians' statue of Nike, in order to celebrate his own victory in a competition for the commission for akroteria for the temple of Zeus at Olympia; cf. Hölscher (1974).

[56] Scheibler (1979) 13; Raubitschek (1949) nos. 58, 196, 342, 376, 383; D. Williams (1995) 151.

The increased affluence of at least the most successful of the growing population of craft producers in sixth-century Athens, amply attested by the Akropolis votives, may have produced a sense of status discrepancy when such craftsmen compared themselves with members of the aristocratic elite. Whilst not contesting their traditional role representations, visual artists and craftsmen adopted two contrasting strategies in order to enhance their status within the framework of dominant aristocratic culture of *kalokagathia*. On the one hand they could ape it. They might adopt aristocratic idioms for making claims to prestige, as the potter and vase painter Nearchos did in dedicating a kore on the Akropolis (see figure 2.5 on p. 36).[57] Further, they might fantasise about participation in the social rituals of aristocratic life. A number of late archaic vases play with the idea of potters taking part in aristocratic symposia, or receiving the kind of literary and musical education which was the cultural monopoly of the elite.[58] On the other hand, excluded from real participation in the social networks and cultural contexts like the symposion and the gymnasia in which traditional aristocratic culture was transmitted, they could transvalue the negative or ambivalent representations of craft in dominantly aristocratic culture into a positive self-image. Touches of realism, for example representing a craftsman with a crippled leg, like his god Hephaistos,[59] have been interpreted as a self-conscious inversion of the normative athletic body of the elite, grounded in a different relationship to the body that was inculcated by the educational and life experiences of disenfranchised artisans, which differed markedly from those of a leisured and politically active aristocratic elite.[60] The former received a practical education on the job in workshops, whilst the literary and athletic education of the aristocracy took place in the socially exclusive settings of the gymnasion and the symposion. Neither strategy pursued by the artisans, however, offered an identity entirely free from contradiction. Identification with kouroi or korai presupposed both an ideology and a body image radically distinct from those of craftsmen's practical experience, as well as participation in networks of social and cultural exchange – of women in marriage, and of religious capital in the form of priesthoods and other religious roles – from which they were excluded.[61] Artisans' realist self-representations were always framed within the dominant aristocratic ideologies of *kalokagathia*, to which

[57] Richter (1968) no. 110.
[58] Mark (1995) 29–31; Frel (1983); Neer (2002) 87–134 for a highly sophisticated account of these representations.
[59] Zimmer (1982) 31, fig. 14 (Berlin, Antikenmuseum F638 + 757 + 829 + 822).
[60] On the Pentaskouphia plaques, Himmelmann (1994) 9–11, fig. 5; Zimmer (1982) 26–32.
[61] Karusos (1961), R. Osborne (1994c).

they were a reaction, and consequently it cannot have been easy to sustain the positive connotations of such realism.[62]

With the elaboration of the institutions and ideology of democracy at Athens during the course of the first half of the fifth century, the sharpness of status differences between elite and demos was eroded. The primacy of political values and the model of the citizen hoplite still precluded a high level of esteem for craft *per se*, but the broader social extension of significant political roles offered craftsmen a source of self-esteem, with some real practical basis, which was a positive alternative to the earlier oppositional or imitative strategies. During the course of the fifth century, representations of banausic activities – whether of craftsmen or shepherds or fishermen – disappear from Attic vase painting.[63] One of the last is highly suggestive of the shifting basis of status identity during this period. A red-figure cup from Boston, dated *c.* 480 BC, shows a seated vase painter, painting a kylix. Leaning against his stool is a stick, whilst on the wall hang the athlete's strygil, oil-flask and sponge – the attributes of the free citizen, who enjoys the leisure for political debate in the agora and for shaping his body in conformity with civic ideals through regular athletic exercise in the palaistra.[64] Significantly, when monumental funerary and votive reliefs reappear at Athens in the later fifth century, and throughout the series which continues in the fourth century, representations of craftsmen or other banausoi occur extremely seldom, and even those few eschew the realistic details which in the archaic period might distinguish the body image of craftsmen from the dominant ideal of the *kaloikagathoi*.[65] A more generalised civic image, of a mature, adult bearded man, draped in a cloak and supported on a stick – in other words dressed appropriately for participation in leisured political activity in the agora, like the tribal heroes represented on the Parthenon frieze – is preferred.[66] The ideal image of the citizen, promulgated in such classic documents as Thucydides' Funeral Speech or on the Parthenon frieze, seems entirely to have swamped class identity, at least in the sphere of public self-representation.[67]

The expansion of civic euergetism in democratic Athens, replacing the personal patronage that was characteristic of the archaic period, afforded further

[62] Compare Himmelmann (1971) – realism as elite hostility, with Himmelmann (1994) 6–15 – realism as artistic self-assertion.

[63] Himmelmann (1994) 17.

[64] Himmelmann (1994) 13, fig. 7 (Boston Museum of Fine Arts 01.8073, *ARV²* 342.19), 28–31; Mark (1995) 31.

[65] Himmelmann (1994) 18 and 28–33. [66] Himmelmann (1994) 18 and 28–33.

[67] Contrast Roman craftsmen, in particular freedmen such as Eurysaces the baker, who characteristically advertise their craft on funerary reliefs, taking pride in the occupation through which they had secured the means to purchase their freedom from their masters; cf. Kampen (1981).

opportunities for visual artists to develop prestigious civic personae. When the early fifth-century painter Polygnotos painted the Sack of Troy in the Stoa Poikile in the Athenian agora, he refused payment and thereby evaded the opprobrium associated with wage dependency. He was celebrated for this action, however, not as a painter or for the high quality of his paintings, but, in accordance with a more general civic ideology, as one who had benefited the city by expending his resources on its behalf. Similarly, when he was awarded hospitality – presumably board and lodging – at public expense by the Amphiktyones whilst working in the sanctuary at Delphi, he was not being honoured as an artist as such, but as a public benefactor.[68] This does not in itself indicate the high occupational status of artists: in some cities even foreign potters might be awarded civic privileges extending as far as citizenship in return for completing public commissions on behalf of the state.[69] It simply demonstrates the extent to which a political value system came to dominate all considerations of social status. Within this political value system, it was extra-ordinarily difficult to place a positive value on manual work, whether artistic or otherwise. The best that could be said of such work was that it was not a disgrace to work if one had to, and that such regrettable necessities should not count against one's political achievements.[70] Symptomatically, when, in a court setting, Demosthenes slanders Aeschines' brother, the well-known pain-ter Philochares, suggesting that here was nothing more than a painter of funerary lekythoi and tympana, Aeschines does not reply by asserting Philochares' relatively high professional ranking as a painter, but by celebrating his high social status, as one who 'habituates the gymnasia', and his political achievements, 'at one time a comrade in arms of Iphikrates, and a general continuously throughout the last three years'.[71]

ART AND CULTURAL RATIONALISATION IN CLASSICAL GREECE

The primary focus of my analysis now shifts away from the broader social structure of the Greek polis that shaped both frameworks of patronage and the moral and religious culture within which craft-occupations were classified and evaluated. I turn instead to more technical questions of artistic design as the 'material substance' out of which a new structure of artistic agency was constructed during the fifth and fourth centuries.[72] Traditionally, the Greek revolution has been seen as marking not only a transformation in the languages

[68] Plut. *Cim.* 4.5–6; Pliny, *HN* xxxv.59.
[69] Burford (1972) 34 – the Ephesians grant citizenship to two Athenian potters, fourth century BC.
[70] Thuc. II.40. [71] Aeschin. II.149; cf. Dem. *De falsa legatione* 237. [72] Cf. Brain (1989) 40.

of art, and their technical foundations, but also in the role of the artist more broadly, and indeed in the whole function of art. According to some it entailed the emergence of the first autonomous or free art world, comparable with the art worlds of the modern West.[73] Art becomes disembedded from its social and religious functions, the modern idea of the artist as free and autonomous creator is born, and art becomes the vehicle of artists' personal expressions of aesthetic philosophy, to be interpreted as such.[74] In practice, such analyses assume a series of homologies between different levels of social and cultural structures and practices: social and political organisation, organisation of artistic production, languages of art, role of the artist, functions of art and organisation of reception of art – all characterised by freedom and structural autonomy.

I want to start from an alternative assumption, namely that societies consist in 'differentiated ensembles of organised practices', in which changes in one set of practices may or may not ramify into and transform other social domains.[75] The creation of homologies – the extension of a higher level of autonomy within the languages of art, first to a higher level of autonomy in the social organisation of art production, and then further to a transformation in the social functions of art from a politically embedded to an autonomous art – is not an automatic process. On the contrary, it depends on the interests of actors, in our case artists, in reorganising social and cultural structures and practices on these various levels, and upon their capacity to do so.[76] Their interest in doing so presupposes a certain level of reflexive self-awareness about the specific characteristics of their particular profession, the inner logic of the representational problems they face and the ways in which they solve them, as well as a degree of self-assertiveness about the intrinsic value of their specific achievements, independent of the social and political uses to which they might be put. As my survey of the way in which late-archaic and early-classical artists made claims to social esteem suggests, neither should be taken for granted. Visual artists' capacity to reorganise environing structures depends on a number of factors. First, they must develop material and cultural resources that permit the reorganisation of these levels of social and cultural practice. Second, they must find some way of overcoming the countervailing interests and efforts of other groups who are committed to already existing arrangements, whether ways of organising artistic production, using and evaluating art, or ways of classifying and esteeming artists.[77]

[73] Hölscher (1974) 95–108; Metzler (1971) 60–3. [74] See further below, pp. 164–5.

[75] Bryant (1996) 400.

[76] Cf. Archer (1988) 172 on the very high levels of social and cultural integration of traditional societies as products of historical processes, rather than an essential characteristic of traditional societies.

[77] For this neofunctionalist formulation of the conditions of structural differentiation, see Colomy (1990).

My argument will involve several steps. First, the development of naturalism created demands and opportunities for artists to transform practices of artistic design in such a way as to enhance the individual artist's importance in determining the particular visual form of a statue or painting, thus enhancing artists' self-awareness. Artists drew upon contemporary scientific and philosophical thought both to reconstruct their design practices and to realign artistic design with the broader culture and society in which it was embedded, seeking in particular to enhance the status and autonomy of artists (pp. 161–71). This process, beginning in the early classical period, was accelerated in the late fifth and early fourth centuries by favourable changes in patterns of patronage and the structure of the art market. It was given a further impulse by developments in sophistic thought which adumbrated a conceptualisation of visual art as a sphere with its own intrinsic value and inner logic detached from religious, political or ethical constraints. This gave rise to strong claims for prestige and autonomy on the part of some leading artists, and even the creation of a small group of works of art which have a self-reflexive character, designed to be read in purely artistic terms as expressions of the specifically aesthetic projects and sensibilities of their producers (pp. 171–82). However, whilst naturalism in certain respects encouraged both the exploration of the inner logic of specifically artistic problems and the appropriation by artists of practices of design which enhanced artistic agency, and it increased the importance of the individual artist in finding solutions to particular artistic problems, such agency was in practice oriented rather towards adjusting the languages of visual art more closely to the changing contours of social life than to the exploration of purely artistic problems or the articulation of individual artistic identity *per se*; it is this which determines the varying balance between iteration and innovation that is characteristic of classical sculptors' and painters' relationship to their artistic inheritance (pp. 182–90). I shall go on to argue that both social and cultural factors set limits to these processes of rationalisation. Elite intellectual and philosophical culture – which was the primary resource on the basis of which artists rationalised their design practices, made claims to autonomy and sought to enhance their cultural esteem – proved to be as much a liability as an asset, partly by virtue of the intrinsic cultural logic of Greek rationalism, partly by virtue of the structurally conditioned hostility of the intellectual elite to visual artists as the primary transmitters of traditional mythic paideia. The rationalisation of design and production practices by artists such as Polykleitos did not extend to a reorganisation of the institutional frameworks within which art was used or the dominant cultural frameworks within which art was interpreted by its viewers and evaluated by those who had commissioned it. Far from being

uniform and unidirectional, different processes of cultural rationalisation – the rationalisation of Greek science (for example, ideas about the human body and optics), of technologies of the word and ideas about argumentation and persuasion, the rationalisation of Greek ethical culture, and the rationalisation of practices of artistic design and ideas about the nature and purposes of visual art – stood in complex relations of affinity and antagonism to each other, changing over time according to particular social and cultural conjunctures. Rationalisation processes were variably promoted or restricted by the structure of the particular social settings in which they were elaborated and by the broader social structure in which they were to differing degrees institutionally embodied.[78]

Naturalism and rationalisation by design

The traditional association of the Greek revolution and the development of naturalism with democracy and even artistic freedom is by no means entirely misleading. In archaic kouroi and korai the basic structure of the statue was codified within the genre, and the individual contribution of artists was limited to variations in the elaboration of ornament or the fineness of the finish within a fundamentally fixed overall design. The development of naturalism – the representation of weight-bearing and free legs and arms, and the ramifications of the muscular tensions generated by these throughout the human body – afforded artists representational problems in which they had to make choices which could fundamentally shape the overall appearance of a statue in a way which was not true of their archaic predecessors. Sculptors drew on the contents, the styles of thought and the cultural technologies – above all writing – of other increasingly intellectually self-conscious disciplines in order to reconstruct their craft. Theoretical reflection and writing, drawing upon the model of contemporary philosophical and scientific thought, was one way in which artists sought to address and think through these new representational problems in a systematic way, and to codify and communicate to each other their solutions.

Recent research has demonstrated a number of striking parallels in the representation of the body in fifth-century sculpture and its representation in Hippocratic medicine.[79] Some individual motifs deployed for the first time in early classical sculpture – the representation of veins, the distinction between prone and supine postures of the arm, the swelling of the abdomen and the

[78] See Kalberg (1980) 1171–3 on questions of affinity, antagonism and sociological anchoring in rationalisation processes.
[79] Leftwich (1987), (1995), Metraux (1995), Tobin (1995).

stretching of the skin over the ribs in breathing, the functioning and mutual response of muscles in repose and in action – are paralleled amongst the preoccupations of the earliest texts of Greek medical writers.[80] Similarly, there are parallels in the general ways in which medical writers and sculptors approach the body, in particular the exploration of the body as an organic whole in which the parts are integrated through functional interrelationships, most systematically in Polykleitos' Doryphoros (figure 4.3).[81]

As I suggested in the last chapter, there is no need to give specifically medical iconographic interpretations to these features, or to suggest that 'sculptors had the duty to create works embodying the new ideas'.[82] Rather, sculptors seem to have appropriated selected features of contemporary medical knowledge for their own particular purposes, specifically in order to produce convincing representations of life and rationally ordered patterns of movement. These needed to be readily distinguishable by viewers from the more disorderly and chaotic patterns of movement held to be characteristic of those, like centaurs or barbarians, not possessed of appropriate levels of self control. Only thus could artists adequately characterise mythic heroes and their opponents in the narratives of architectural sculpture or good citizens in portrait statues.[83] Being able to analyse bodies according to patterns of muscular contraction and extension, exactly as doctors had to be able to do in providing care for athletes, for example, and to represent such forms in sculpture was the means to accomplish this, as is suggested in the dialogue between Socrates and the suggestively named Kleiton in Xenophon's *Memorabilia*. Here Socrates discusses the sculptor's representation of movement in technical medical language, explaining how the effective figuring of 'the limbs compressed or outstretched, the muscles taut or loose' produces a more convincing representation of life and creates pleasure for the beholder.[84]

Medical knowledge provided means through which sculptors might improve from a formal point of view the motifs inherited within their artistic tradition, systematise the relationships of such motifs to each other, and methodically elaborate their sculptural construction of the human body in order to solve the

[80] Metraux (1995).
[81] Leftwich (1995), (1987) 181–2, 212–13: on the use of a highly artificial pattern of oppositions between left- and right-hand sides of the human body – and the interplay of weight-bearing vs. free limbs, extended/contracted muscles – in order to create a persuasive representation of the human body's 'living balance', in which the complex adjustments of the motor apparatus and musculature, in interaction with the effects of gravity on the body, permit human movements such as walking; see Borbein (1996) 71–2 on the methodical character of Polykleitan articulation of the body, with 'clearly defined functional parts, logically interconnected', and a fully systematic treatment of contrapposto.
[82] Metraux (1995) 92. [83] See Tanner (2000c) 198–9; Castriota (1992); Giuliani (1986) 113–44.
[84] Xen. *Mem.* III.10.7; Tobin (1995) 57.

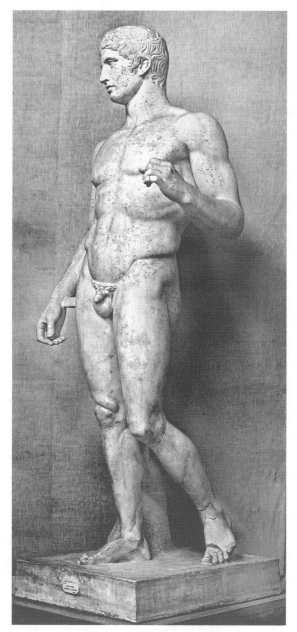

Figure 4.3 Doryphoros. Roman copy after Greek statue by Polykleitos, *c.* 440 BC. Naples.
Photo: DAI, Rome. Neg. 69.635.

artistic problems generated by naturalism and to produce works of art which adequately fulfilled their social purposes.[85] This creative transposition of cultural schemes that were developed in one domain (medicine) into another domain (visual art) where they could be used to solve problems specific to that second domain was facilitated by the rather informal institutional organisation of the intellectual world in fifth-century Greece.[86] The contexts in which intellectuals elaborated and communicated their ideas to each other, and a wider public, were relatively open to each other during the fifth century, in part because doctors communicated their knowledge and recruited patients (and followers) through public lectures and demonstrations of their skills on such occasions as religious festivals, when sculptors, many of whose commissions were votives for sanctuaries, may be expected to have been present.[87] Doctors and sculptors seem to have moved in the same circles as other intellectuals, like the sophists, and to have been classified alongside them as practitioners and teachers of rationally transmissable *technai*.[88]

In addition to being heavily indebted to contemporary medical advances, Polykleitos' Doryphoros also betrays an enthusiasm for measurement and number, which were preoccupations, even obsessions, of fifth-century intellectual culture.[89] Several fragments from Polykleitos' treatise, 'The Canon' – probably written to accompany the Doryphoros, which embodied canonical principles (as did other Polykleitan statues like the Diadoumenos) – betray this interest:[90] 'beauty consists in the commensurability not of the constituent elements (*stoicheiōn*) but of the individual parts (*moriōn*), namely of finger to finger, and of all the fingers to the metacarpus and the wrist, and of these to the forearm, and of the forearm to the upper arm, and of everything to everything, just as it is written in the canon of Polykleitos'.[91] The exact significance of number in Polykleitan sculpture, and of the treatise itself, remains a matter of dispute.[92] For some, the role of number simply continues traditions of sculptural practice already characteristic of archaic Greece (and ancient Egypt), where the design of the statue was sketched out on a grid, with each element

[85] On rationalisation as the elaboration and improvement of traditional symbol systems often 'from a purely formal point of view', involving the systematisation of thought motifs, and the 'methodical construction' of their interrelationships, see Habermas (1984) 175.

[86] On agency and transposition of schemes, see Sewell (1992) 19. Egyptian doctors, and especially morticians, knew as much about the structure and functioning of the human body as Greek doctors. But neither the social purposes of art production in Egypt nor the social organisation of art production and medical practice encouraged or permitted similar kinds of cultural transfer.

[87] Metraux (1995) 20. [88] Metraux (1995) ix–xi. [89] Heinimann (1975), Schneider (1989) 173–81.

[90] The fragments are most conveniently collected, with translation and full discussion in Leftwich (1987) 80–96, with the addition of Stewart (1998) 273–5 for another recently identified fragment.

[91] *De plac. Hipp. et Plat.* v.448 (Kühn) = *SQ* 959.

[92] Robertson (1975) 328–9; Pollitt (1964), (1974) 14–21; Lauter (1974) 9.

placed on the grid according to a predetermined system of proportions. Correspondingly the treatise is held to be simply a workshop manual, as suggested by the very practical concerns of some fragments:[93] 'the arts first mould the shapeless and formless parts, then, after that, all the parts in the figures are articulated in full; because of this, the sculptor Polykleitos said the work is hardest when the clay is at the nail.'[94] Others, see the treatise as a sophisticated work of theoretical aesthetics, informed by Pythagorean number metaphysics, which was embodied in the statue as a philosophical statement concerning the numerical principles that informed both the human body and nature more generally.[95] They emphasise fragments characterised by more abstract forms of expression, which might echo Pythagorean philosophical ideas: 'The excellent arises gradually through many numbers (τὸ γὰρ εὖ παρὰ μικρὸν διὰ πολλῶν ἀριθμῶν γίγνεσθαι).'[96] It is doubtful whether even the Doryphoros could have held such abstract philosophical meanings for more than a handful of viewers.[97] Further, the treatise concerns general rules of design, not just the Doryphoros; some have even questioned whether the Doryphoros is the statue intended as the exemplification of the treatise. Canonical design informed not only the Doryphoros, but also a whole series of later statues produced by Polykleitos and/or his pupils – the Diadoumenos, the Capitoline Amazon, the Westmacott Athlete (see figure 3.7 on p. 118).

That said, the minimalist view of Polykeitos' treatise as simply a practical manual may underestimate the extent to which the development of more complex mathematical procedures transformed both the nature of artistic design and its relationship with elite intellectual culture. Number had played a role in archaic sculpture. Statues were sketched out, in their four primary aspects, onto the stone-block, using a grid twenty-one squares in height, onto which any specific body-part could be mapped according to a set of conventional rules of placement: the distance from the crown to the brows was one unit, from the brow to the chin two units, and so on.[98] Naturalistic representation – in particular the development of multiple aspects and contrapposto – must have rendered such archaic design systems obsolete. The relatively simple systems of number and proportion used in the design of a kouros, or any similarly static and four-square archaic statue, will not have been easy to implement on statues with contrapposto, in which some limbs and muscles are stretched out whilst others are compressed, and in which elements (raised hips vs. lowered ones, raised arms and hands) will not always fall in the same

[93] Ridgway (1981) 202. [94] Plut. *Mor.* 636 c. [95] Leftwich (1987) 313–35; Pollitt (1995) 22.
[96] Philo Mechanicus IV.1. 49–50; DK (7th edn.) 40.b.2; Pollitt (1974) 15–21, esp. 21.
[97] Fehr (1979) 31–5; Tanner (2000c) 183–6; see above, pp. 116–28. [98] Berger (1990) 159–60.

position on the grid.[99] Similarly, the development of sculptures with multiple aspects rendered the sculptor's design task much more complex – whether building up models in clay for bronze sculptures, working from clay prototypes to stone statues or sculpting the marble block directly – since it deprived the sculptor of the stable fixed reference points of the planar sketches of frontal and profile views on the block of the statue, as well as of the relative independence with which each face of the statue might be designed and worked. Already at Olympia there is evidence for blocks and drill holes used to fix multiple cords to the statue being worked on – in place of the single free-hanging plumb line which sufficed for most archaic sculpture – in order to ensure correct transference of the design from models to the marble block.[100] Polykleitos' interest in number may in part have been directed towards solving these and similar problems of design.

Exactly how we should envision Polykleitos' interest in number's transformation of the practical procedures of artistic design is not clear, and – given the nature of the evidence (a fragmentary text and Roman copies of the original statues which vary in their key measurements) – probably irrecoverable. Nevertheless, a couple of hypothetical reconstructions of Polykleitan design procedures are both suggestive and plausible, in light of what we know about fifth-century Greek mathematics, and the possibilities and limitations afforded by the tools and materials available to classical sculptors. Gordon and Cunningham have argued that the starting point of Polykleitan design was not arithmetic but geometric proportionality.[101] Using the principle of the golden section – where two component elements of a line are related to each other in such a way that the shorter section is in the same proportion to the longer as the longer is to the whole line – it was possible to design a figure as a series of golden rectangles, each component related to every other as elements in an accumulating geometric progression, starting with the smallest repeatedly occurring module, based on the nail of the index finger according to Gordon and Cunningham. The advantage of this method is that whatever the scale of the statue, different elements – such as nail length, distance between the eyes, or overall size of the statue – always remain in a constant proportional relationship to each other, so that all the measurement points required in the design of a statue can be quickly and easily established on the basis of a single numeric measurement. This can then be proportionally reduced or amplified through the use of callipers and suitably marked string or measuring rod to apply the measurements to the clay model or marble block. The basic canonical figure

[99] Berger (1990) 160–1. [100] Bluemel (1969) 34–53. [101] Gordon and Cunningham (1962).

thus established is upright and frontal. The same measuring points and system of proportions, however, can be used to control the animation of the figure into the postures of such statues as the Doryphoros or the Diadoumenos. Centre lines plotted through the golden rectangles articulate the relationship between various flexed components of the body, preserving the proportional relationship between parts, whilst permitting the complete range of skeletal movements and muscular flexion and extension to be represented. The basic framework for the design of a statue, or of a relief based on the same underlying pose, can be constructed in the first place by the originating artist, and then transmitted to others, on the basis of relatively simple diagrams, stating the underlying proportional relationships, without the need for elaborate scale drawings either in the design and transmission of the original canon, or in the planning of the complex foreshortenings required to animate the canon into a mobile and naturalistic sculpture fully or partially in the round.[102]

More recently, Berger has developed a similar argument, again linking Polykleitos' mathematical interests with the complexity of the task of maintaining proportional relationships between body parts in a ponderated statue. Berger suggests that the development of three sets of measuring rods – one for the proportions of the unponderated figure (like a kouros), one for the actual height of the ponderated figure and one corresponding to the maximum ponderation gradient – would have sufficed to construct the design of a properly proportional statue, whether in the form of a clay model, to be cast in bronze, or a marble figure.[103] Multiplying in this way the number of measurements (*polloi arithmoi*) that a sculptor would need to make in order to produce a satisfactory composition by properly relating all parts to each other guaranteed an exact solution to the problem: the correlation (*kairos*) of symmetries and numbers that represented *to eu*, perfection.[104]

Given the fragmentary character of the remains of Polykleitos' text, and the fact that the statue survives only in copies, it is unlikely that shall we ever be able to reconstruct the exact design procedures of Polykleitos with any certainty. Nevertheless, Cunningham and Gordon's and Berger's reconstructions of both the Polykleitan process of design and the method of its cultural transmission derive some measure of plausibility from their correspondence with the methods used by architects in the archaic and classical periods, having been shaped

[102] Gordon and Cunningham (1962) 136, with note 25 on the role of geometric working diagrams in Greek sculptural design. For a broadly similar approach, working with the Doryphoros rather than the Diadoumenos, see Tobin (1975).

[103] Berger (1990) 160–4.

[104] See Stewart (1990) 161 for this interpretation of kairos; Pfister (1938) for a full account of the varying meanings of the concept in different times and contexts in classical Greece.

by the same material limitations in the reproduction of technical drawings. Architects had written treatises which discussed problems of engineering involved in the erection of monumental temples and summarised the principles of design – specific measurements of key components and mathematically expressed sets of proportions primarily, rather than scale drawings which were beyond the capabilities of ancient book production – as early as the sixth century.[105] Since some sculptors were also practising architects, it is not surprising that both similar principles of design and methods for transmitting it should have been extended from architecture to sculpture in the context of the new artistic problems presented by naturalism.[106]

The Polykleitan canon, we may conclude, was an innovative response to the problems of design generated by naturalism. It is neither a straightforwardly metaphysical or aesthetic-philosophical treatise, as modernisers wish to suggest, nor simply a practical workshop manual as minimalist primitivists would have it, but a treatise which draws upon developments in contemporary Greek intellectual culture to transform the practice of design on the basis of the developing culture of rationalism. The rationalisation of design, whilst depending on a more abstract (mathematical and medical) conceptualisation of the body represented in statuary, is actually mediated through the intellectual and practical operations – measuring and counting, the application of measuring strings and plumb lines or measuring rods – by which the sculptor intervenes in the material stuff – for example the clay model or the marble block – out of which he produces his statue. The preoccupation with the clay at the nail, for example, may be related to the importance of establishing accurately the basic module out of which the other components of the statue may be elaborated and a primary measuring point which is a reference mark for laying out the design.[107] The practical and the rational dimensions of Polykleitos' treatise are two sides of the same coin, by which he sought to reconstruct and rationalise the material form of artistic agency.

Polykleitos' canon began a process whereby sculptural design might be realigned in its relationship to elite intellectual culture more broadly, in addition to reorganising the practice of design internal to the traditions of art work. The treatise represented a marked step forward in the rationalisation of the cognitive/intellectual basis of Greek art. First, the objectification of workshop procedures in writing made them an object of sustainable reflection and further

[105] Coulton (1983).

[106] See Pollitt (1995) 20 for the model of architectural treatises and the tradition of sculptor architects, starting with Theodoros and Rhoikos in the sixth century.

[107] Stewart (1978a) 126; Mattusch (1988) 159–61.

development on the model of the *technai* – like medicine, music, architecture and city-planning – which were the subject of theoretical writing in the middle of the fifth century[108] – even if there is little evidence to suggest that this potential was realised to any significant degree until the fourth century. Secondly, formulating the problem of design as something which could be approached and solved in exact mathematical terms was at least implicitly – perhaps explicitly if we had the full text – claiming a scientific status for art.[109] Precision – *akribeia* – was a central criterion according to which scientific *technai* based in real knowledge (*epistemē*) might be distinguished from 'things without reason' – *alogon pragmata* – domains like medicine or rhetoric, held by some to be founded on nothing more substantial than opinion (*doxa*) and guesswork.[110] Alongside syllogistic argument, mathematical operations were particularly favoured as indicators of technical rationality, in particular in so far as they relied purely on intellect rather than being contaminated by possibly misleading sensory experience. Sokrates' suggestion that rhetoric was not a *technē*, because, like cooking, it relied purely on experience and completely ignored the intellectual precision afforded by mathematics and number (*ouden diarithmesamenē*), could hardly be applied to Polykleitan sculptural design, reliant as it was on *polloi arithmoi*.[111]

A similar interaction between artistic interests and contemporary intellectual concerns is also apparent in fifth-century painting, even if the almost total loss of substantial material evidence for the character of fifth-century wall painting permits no more than an outline sketch. The development of wall painting as a major medium for civic commemorative history paintings seems to have encouraged the promotion of more complex forms of spatial representation, including foreshortening of individual figures, and the development of elements of perspective.[112] The philosopher Demokritos of Abdera is known to have written works 'On Painting' (*peri zographias*), 'On Colours' (*peri chroon*), and on linear perspective (*aktinographiē*), in part under the influence of scene paintings and a commentary on them by the painter

[108] Metzler (1971) 68.

[109] See Schneider (1989) 270–4 on the importance of defining problems in terms which permitted exact and mathematic solution in the Greek technical literature.

[110] On the use of the term *akribeia* and its Latin counterpart *diligentia* in art critical contexts, see Pollitt (1974) 117–25, 351–7. In Plato's *Philebus, technai* are ranked according to their level of *akribeia*.

[111] On rhetoric as οὐδὲν διαριθμησάμενη, see Pl. *Grg.* 501a, 463b with Schneider (1989) 157. The concern with intellectual demonstrability and the mathematisation of the world was, of course, by no means Plato's innovation. In Aristophanes' *Clouds* (200–5), the Phrontisterion is decorated with images of geometry. Pythagorean philosophers like Philolaos in the middle of the fifth century and Archytas in the early fourth had sought even to organise social action according to mathematical principles: Archytas DK 47B3, Pl. *Grg.* 508a; cf. Eur. *Phoen.* 528–48 – with the excellent discussion of Schneider (1989) 173–81, esp. 176. For Archytas' mathematisation of mechanics: Diog. Laert. VIII.83.

[112] Hölscher (1973) 212–13; Robertson (1975) 240–71; Moreno (1979a) 633–63.

Agatharchos.[113] Given the loss of fifth-century painting, the practical application of contemporary ideas in optics in fifth-century art is perhaps best attested in contemporary architecture, for example the refinements of the Parthenon and the perspectival adjustments made to the positioning of the doors and windows of the *pinakothekē* in the Propylaia, in order to ensure that they *appeared* (at the cost of actual symmetry) to be identically placed at the midpoint between the columns of the fronting colonnade.[114] As with sculpture, so with painting and architecture, there was a relatively free transposition of ideas and practices from the developing sciences of cognition to the visual *technai* (and back again, from Agatharchos' scene painting to Anaxagoras' optics), appropriating the cognitive schemata of contemporary science to their own particular purposes – facilitated by similarly open contexts of communication. In the late fifth and early fourth centuries, mathematics – both number and geometry – and optical science seem to have played an increasing role in the formal systematisation of pictorial design. The use of light and shade, previously used only tentatively, seems to have been systematised by Zeuxis, who was credited with the discovery of the '*luminum umbrarumque rationem* – the logic of light and shade': light was depicted as falling from a single source, creating an internally consistent modelling of bodies and space through the use of light and shade, corresponding to the dominant model of our own psychological experience, the light cast by the sun.[115] Both foreshortening and perspective representation lent themselves to mathematical systematisation. Parrhasios is said to have introduced into painting '*symmetrias*', calculated proportional systems for the representation of the human body, and their use was further developed by Euphranor.[116] The closest we can get to an example of how paintings coming out of this context might have looked is perhaps the late fourth-century Stag Hunt mosaic from Pella (figure 4.4). In addition to showing a systematic control of light, shade and foreshortening in order to construct a plausible three-dimensional space, the painting displays a composition constructed on strictly geometrical lines: the diagonals of the picture and a series of concentric circles provide a structure onto which the major components of the figures (joints, eyes, hands and feet) are mapped and articulated with each other.[117]

[113] Diog. Laert. ix.48, Vitr. vii.praef.11; Moreno (1979a) 655–9; Robertson (1975) 414.

[114] Stevens (1946) 87–8.

[115] Quint. xii.10.4; Bruno (1977) 37–40 with examples from classical painted stelai; Rouveret (1989) 13–63; Robertson (1975) 411–13; Moreno (1979a) 667.

[116] Pliny, *HN* xxxv.67, 129; Moreno (1979b) 470; Rouveret (1989) 34.

[117] Moreno (1979b) 488; Rouveret (1989) 245–7; Robertson (1975) 488.

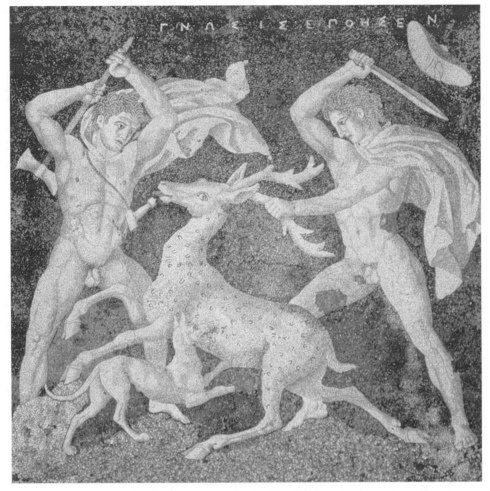

Figure 4.4 Stag-hunt mosaic, Pella. Late fourth century BC. Photo: © Archaeological Receipts Fund.

Refiguring the artist's status and role

Only at the very end of the fifth century and in the fourth century did the opportunities for a radical reorganisation of the relationship between visual art, elite intellectual culture and society – which had been opened up by Polykleitos on the limited level of design – begin to be exploited. Changes in patterns of patronage and the structure of the art market encouraged and enabled artists to extend the rationalisation of art from design practices to broader domains, impinging on the definition of the role of the artist, artists' status and conceptions of the function of art – its place as a particular cultural form within the broader social structure.

In the fifth century Athens, uniquely amongst poleis, had been able to sustain more or less continuously a series of major artistic projects by virtue of the revenues derived from the Athenian empire. In the fourth century, when the empire had been lost and public finances were a perennial problem, no single patron dominated the art market. Although there were occasional major civic projects sponsored by Greek poleis – the temple of Athena Alea at Tegea, for example – civic art tended to be on a smaller scale: honorific portraits and smaller cult statues like Kephisodotos' Ploutos and Eirene, rather than the chryselephantine colossoi of the fifth century.[118] The most important large-scale projects were increasingly sponsored by monarchs on the margins of civic life.[119] In addition, private patronage gained a new importance. Restrictions on funerary expenditure seem to have been relaxed, and fourth-century Athens has bequeathed an extensive series of sculpted grave monuments. New kinds of collectivity, like the philosophical schools, generated further commissions, often, although not exclusively, portraits of their leaders.[120] A wider range of patrons competing for their services enhanced artists' freedom of action in relation to their patrons: the late classical and early Hellenistic period sees a series of anecdotes in which the autonomy of artists in setting their own criteria of performance is asserted against or recognised by kings.[121]

The smaller scale of even civic commissions seems to have promoted the commodification of art, which came to be made speculatively and sold to purchasers as well as commissioned.[122] Praxiteles' Aphrodite of Knidos is said to have been one of a pair of Aphrodites made by Praxiteles. The people of Kos, shocked by the nudity of the one, were unwilling to buy it and chose instead the draped Aphrodite which Praxiteles also had to hand, whilst the naked Aphrodite was bought by the Knidians.[123] A similar picture is presupposed by the stories of Zeuxis giving away his paintings, and by the anecdote which tells how Praxiteles' mistress Phryne discovered which of his works he considered to be the most beautiful.[124] This shift in the pattern of the organisation of production enhanced artists' autonomy in several respects. First, it

[118] Burford-Cooper (1969, 82) points out that the costs of the buildings of even quite major fourth-century programmes, such as that at Epidauros, are very modest compared with the programmes of the fifth century.

[119] Archelaos of Macedon paid Zeuxis 400 minas for painting his palace – Ael. *VH* xiv.17; Bryaxis, Leochares, Timotheos, Scopas and Praxiteles were all employed on Mausolus of Caria's tomb; on Hellenistic kings, see Pollitt (1986) 19–46.

[120] Diog. Laert. iii.25; Frischer (1982).

[121] Ael. *VH* ii.3 Apelles and Alexander; ii.2 Zeuxis and Megabyzos; Pliny, *HN* xxxv.85–6 Apelles and Alexander; Plut. *Mor.* 472 Apelles and Megabyzos; *HN* xxxv.104–5, cf. Gell. *NA* xv. 31 Demetrios and Protogenes.

[122] Lauter (1980), esp. 529–30.　　[123] Pliny, *HN* xxxvi.20.

[124] Pliny, *HN* xxxv.62; Paus. i.20; Ath. xiii.591.

distanced patrons from artists, undermining the closer control they had enjoyed when works were directly commissioned. Second, making art and selling it on a speculative basis both presupposed considerable monetary wealth and augmented it, through higher profits.[125] Kephisodotos the younger, the son of Praxiteles and himself a sculptor, undertook the trierarchic liturgy – equipping an Athenian war galley, for which only the three hundred most wealthy families in Athens were liable – an extraordinary three times in ten years, placing him amongst the handful of most wealthy men we know from classical Athens.[126]

The enhanced affluence of some artists enabled them further to rationalise their art and secure both greater occupational autonomy and higher social esteem. Many painters and sculptors are known to have written on their arts in the fourth century: Melanthios ('On Painting', *peri graphikēs*), Euphranor ('On Symmetry and Colours'), Apelles, the sculptor Silanion, Leonidas (a pupil of Euphranor), Pollis (a bronze statuary), Demophilos, Pamphilos of Sicyon, Protogenes (*peri graphikēs kai schematōn*).[127] Whilst none of these treatises survive, we do have some knowledge of their contents through the art history writing of the Hellenistic and Roman periods, which drew on these artists' treatises as sources.[128] In writing treatises and developing a critical terminology, artists were actively engaged on a project which involved culturally transformative work on an inherited repertoire of cultural patterns and practices, oriented to changing the classical Greek art world on a number of levels – the relation of artists to their work, the communicative functions of art and concomitantly the relation of the art world to the broader society. It seems likely that the writing of classical Greek artists – using old words in new contexts and new ways until they acquired specifically aesthetic meanings – led to a process of conceptual development and abstraction similar to that which Havelock has traced for concepts of wisdom and self in the case of Plato and Greek philosophy.[129] There are certainly traces of such a development, despite the fragmentary evidence. In archaic Greece, religious and aesthetic meaning are undifferentiated in the concept Χάρις (*charis*), a kind of divine power and charisma. Charis is the

[125] Burford-Cooper (1969) 111 discusses the replacement of the system whereby craftsmen were hired by the state on an individual and daily basis, for example in the Akropolis projects at Athens in the fifth century, by a contracting-out system, whereby the contractor was only paid on completion of the work, which of course presupposes a certain amount of capital.

[126] Davies (1971) no. 8334.

[127] Urlichs (1887) 14–16; Vitr. VII.praef.14: Euphranor (cf. Pliny, *HN* XXXV.129); the sculptor Silanion, Leonidas, Pollis, Demophilos (late fifth century, cf. *HN* XXXV.61); Diog. Laert. IV.18 Melanthios; Pliny, *HN* XXXV.79 Apelles; Pamphilos of Sikyon (Suda s.v.), Protogenes (Suda s.v.).

[128] Pollitt (1974) is the standard study, but sociologically naive and ahistorical in his treatment of the terminology as a symptom of 'the Greek mind'.

[129] Preisshofen (1984).

wife of Hephaistos. It is at the same time the capacity to produce beautiful objects, bestowed on craftsmen by Hephaistos and Athena, and the sign of that divine power manifested both in works of art and in people, generally heroes, upon whom gods confer a kind of temporary exaltation or charisma.[130] By the Hellenistic period, it can be used as a secular concept referring to pictorial charm achieved through mastery of line and simplicity of colour, to which Apelles apparently laid particular claim in his volumes about painting.[131] Similarly, in the archaic period, ῥυθμός (*rhythmos*) refers concretely to a mode of personal formation or disposition and character as revealed in patterns of movement or bodily conduct. By the end of the fifth century and in the work of Plato it is used in a slightly more abstract way to refer to any regularly recurring pattern of movement, for example in dance. Finally, in writing on the visual arts – certainly by the Hellenistic period and possibly in earlier sources from which Hellenistic art history writing was derived – it comes to refer to particular forms or shapes of parts of the body in sculpture or architectural elements.[132]

Rather than simply emanating from aesthetic experience, the construction of a critical vocabulary changed artists' relationship to their work. The need to master more complex representational problems generated by the Greek revolution was part of the point of developing these new intellectual tools. This is reflected in a shift in patterns of artistic pedagogy. The dominant model of artistic training in the archaic and early classical periods was based in families. Father transmitted practical knowledge to his son who was trained in the family workshop, and the son's credentials were represented by his patronymic, widely used in signatures of the period.[133] Whilst most sculptors and painters seem to have been the sons of artists and were probably trained initially by their fathers, this traditional mode of training was supplemented in the fourth century by a rationalised and commodified artistic pedagogy, in which mathematics played a central role. This is associated above all with Pamphilos of Sikyon, who, according to Pliny, 'was the first practitioner of painting fully educated in all aspects of learning, above all in arithmetic and geometry, without which he denied art could reach perfection. He taught no pupil for less than a talent, at 500 drachmai per annum, a fee which both Apelles and Melanthios paid to him.'[134] Pheidias and Polykleitos may have taught for money as early as the

[130] See, e.g., Hom. *Od.* vi.234 for the χαριέντα ἔργα of Hephaistos and Athena; Ath. ii.48; Frontisi-Ducroux (1975) 72; Himmelmann (1998) 34–5, 43–5 on the fusion of artistic, material and social/religious in the 'aesthetic' vocabulary of the archaic period.

[131] Dion. Hal. *Isaeus* 4; Pliny, *HN* xxxv.79. [132] Pollitt (1974) 218–28. [133] Burford (1972) 82–7.

[134] *HN* xxxv.76.

fifth century.[135] Zeuxis almost certainly did.[136] Teaching for money in itself was a practice associated with the new learning of the sophists.[137] It seems reasonable to suppose that much of the critical writing on art attested for the fourth century was written for pedagogic purposes, as is explicitly stated to have been the case for Apelles' writings.[138]

Leading artists moved in the same social circles as sophists and philosophers,[139] whose roles in any case were far from distinct in the late fifth and fourth centuries, before Plato developed a specifically philosophical lifestyle, rejecting the world in favour of specialised pursuit of theoretical wisdom.[140] Correspondingly, exchange took place not only on a cultural level but also on a social level, with some visual artists emulating sophists in their public presentation of self. The sophists Hippias and Gorgias took to wearing the purple robes associated with rhapsodes as part of their claim to usurp the traditional pedagogy that was based on Homeric poetry transmitted by the rhapsodes.[141] Empedokles the philosopher not only had his work performed at Olympia by a rhapsode, but also 'liked to walk about with a graceful expression, wearing a purple robe with a golden girdle, a Delphic wreath, shoes of bronze, and a luxuriant growth of hair, and attended by a train of boys'.[142] Similarly, the painter Parrhasios 'was accustomed to wear a purple cloak, and had a white band [or sometimes a golden crown – Ath. 543c] on his head; he leaned upon a staff embossed with golden spirals and tightened the straps of his slippers with golden buckles'.[143] Zeuxis 'amassed such great personal wealth that, in order to make a display of it, he paraded his name at Olympia embroidered in golden letters on the checked pattern of his robes'.[144] In behaving in this way, painters like Zeuxis and Parrhasios were not simply imitating sophists and rhapsodes. They were seeking to redefine the role of visual artist by personifying it in a fundamentally new way.[145]

The sophists took the theoretical rationalisation of Greek culture a step further than the early Greek philosophers and medical writers, extending their enquiries from cosmology and the natural world to human culture. Poetry and

[135] Pl. *Prt.* 311c–d. [136] Pl. *Prt.* 318b–c. [137] De Romilly (1992) 34. [138] Pliny, *HN* xxxv.111.
[139] Xen. *Symp.* iv.63; Pl. *Prt* 318. [140] von den Hoff (1994) 25. [141] Ael. *VH* xii.32; Marrou (1956) 50.
[142] Diog. Laert. viii.73; Guthrie (1965) 132; Lloyd (1987) 101; cf. Arist. *Pol.* 1267b21–8 on Hippodamos of Miletos dressing for distinction.
[143] Ath. xii.543 f. [144] Pliny, *HN* xxxv.62.
[145] See Archer (1995) 191: 'social selves are reconstituted as actors personify roles in particular ways to further their self-defined ends'. For the broader social and cultural context of this process, see Lloyd (1991) especially on the development of intellectual roles in the fifth century (philosophers, sophists, practitioners writing technical treatises), and the crystallisation of the relatively fluid situation of the fifth century into a more stable institutional form with the formation of the rhetorical and philosophical schools during the fourth century. See Xen. *Mem.* 1.4.2–4 on *sophia* as an attribute of poets and artists.

language, along with the visual arts of sculpture and painting, became objects of sustained theoretical debate concerning their function.[146] This represents a more far-reaching interaction between art and intellectual culture than the more specifically scientific exchanges of art with medicine, mathematics and optics. These had simply offered artists the means to reflect upon and systematise the artistic techniques they used to achieve expressive goals which were given by the embedding of art in non-artistic – political and religious – institutions. Sophistic thought took the process of artistic rationalisation a stage further by seeking to define art in terms not only of techniques and media specific to it, but of a specific purpose and cultural value, irreducible to the social and political purposes to which it had traditionally been put. This was part of a broader process of cultural rationalisation and differentiation which was affecting Greek expressive culture more generally. The late fifth and the fourth centuries saw the increasing professionalisation of the arts of acting and music. Individual actors, often professionals not citizen amateurs, became increasingly important and expected plays to become vehicles for their perform-ing star roles. Similarly, the musical component of tragedies became more significant in its own right, with elaborate cadenzas by the flute players, origin-ally merely accompanists for the chorus, becoming increasingly important at the expense of the tragic text itself.[147] This differentiation of the components of tragedy into its constituent parts ultimately culminated in Aristotle's judgement that the true qualities of tragic poetry, as poetry, could be appreciated from reading the text alone, without the necessity of performance: the invention of literature as such.[148]

The evidence for this moment is tantalisingly fragmentary, largely submerged under the social and ethical theories of art that were subsequently developed by Plato and Aristotle, which seem to have won the argument partly by virtue of their good fit with the dominant social functions of art in fourth-century Greece.[149] Parallels between poetry and painting, and the capacity of painting to deceive through illusionary representation had already been sketched in the writing of Simonides and Empedokles earlier in the fifth century.[150] In sophistic thought these ideas are elaborated into an aesthetic theory in which painting and sculpture give pleasure through illusionary deception. Gorgias' *Helen*, an epideictic oration seeking to exculpate the heroine of Troy for running off with

[146] Pl. *Ion.* 532; Xen. *Mem.* III.10. The famous sophist, Hippias of Elis, according to a late source (Philostr. *VS* I.11/495) wrote treatises on statuary (*agalmatapoia*), and painting (*zographia*); Brancacci (1995) 107–11.

[147] Wallace (1995). [148] Arist. *Poet.* 1462a1–12. [149] See below, pp. 191–204.

[150] Brancacci (1995) 106; Empedokles frg. 23, Kirk, Raven and Schofield (1983) no. 356; Simonides ap. Plut. *de Glor. Ath.* 3 = *Mor.* 346f–347 a.

Paris, is, predictably, largely concerned with the persuasive power of speech: what else could Helen have done, subjected to the enchanting compulsions of Paris' seductive words? In the concluding paragraphs, Gorgias further defends Helen on the grounds that she was compelled by erotic desire, inflamed by the sight – the eyes are the primary medium through which Eros operates – of the lovely Paris. The visual has such powerful persuasive force that men may run in fear at the sight of a powerful army; and lastly:

When painters complete out of many colours and objects [or bodies, σῶμα] a single object/ body and form (σχῆμα), they please the sight (τέρπουσι τὴν ὄψιν). The making of figures and the production of statues provides a pleasant disease (νόσον ἡδεῖαν) for the eyes.[151]

In the *Dissoi Logoi*, excellence in painting is defined in terms of the ability to deceive through the production of images 'similar to reality (ὅμοια τοῖς ἀληθινοῖς)', echoing Gorgias' positive account of the role of deceit and illusion in tragedy.[152]

Perhaps the best evidence for the cultural salience of this theory of the persuasive, psychagogic character of visual art, giving pleasure through visual illusion, is that it forms the starting point of both Xenophon's and Plato's attempts to bring art under an ethical and rational rein.[153] But there is also evidence that it informed strands of art production, which made a theme of the specifically aesthetic and seductive powers of art as a value sphere in its own right, autonomous of ethical or other social considerations. Gorgias had drawn a parallel between the seductive and pleasurable aspects of illusionistic painting and the pleasures of erotic love and desire, also mediated through sight and oriented to bodily beauty.[154] Zeuxis' *Helen* quite literally embodied the Gorgianic theory of art. According to the stories told concerning the commissioning and production of the painting, the physical form of the *Helen* was based on individual features of each of the five most beautiful virgins of the city which commissioned the painting.[155] Zeuxis' *Helen*, like its prototype, was celebrated for its seductive charm and concomitantly as an exemplum of the highest level of properly painterly technical virtuosity: asked by a passer-by what people saw in the *Helen*, the painter Nikomachos responded: 'If you had my eyes, you would not ask.'[156]

[151] Gorgias, *Hel.* 18. [152] *Diss. Log.* III.10; Plut. *de Glor. Ath.* 5 = *Mor.* 348b–c.

[153] Plato's attack on the illusionary powers of art utilises all of the psychagogic vocabulary of Gorgias, but inverts the value accent, by placing it within the context of his rationalist metaphysics – see further below. *Psychagogia* and the visual pleasure (*terpsis*) derived from illusionary persuasion (*peithō*) as the starting point of Sokrates' discussions with Kleiton and Parrhasios about the functions of visual art in Xen. *Mem.* III.10 – again closely echoing the language of Gorgian aesthetics; Brancacci (1995) 118–19.

[154] *Hel.* 18; Robert (1992) 405. [155] Cic. *de Inv.* II.2; Robert (1992) 402–4.

[156] Val. Max. III.7 ext. 3; Ael. *VH* XIV.47; Reinach (1921) nos. 214–23.

Some features of the style of certain works of late fifth-century art may also point in the direction of an art oriented to sensuous pleasures of aesthetic illusion in their own right. Carpenter and Pollitt draw attention to the apparently gratuitous and purely 'decorative' use on the Nike Parapet of certain sculptural devices – motion lines, modelling lines, catenaries, illusionary transparency – which had originally been developed to enhance the intelligibility of forms in motion and modelled in the round, in particular in the flattening contexts of architectural sculpture.[157] The ends of the cloth that hang down from the arms and legs of the Nike leading a heifer 'move briskly along the ground instead of collapsing on it', drawing attention to the artificial character of the motion line as a pictorial device.[158] The deployment of the devices, on the one hand, calls attention to their own artfulness in creating persuasive illusions of movement and corporeal substance: both reliefs are virtuoso displays of delicately carved textural variation and dramatic use of the running drill to create swirling patterns of light and shade. On the other hand, in the case of the Sandal-Binder in particular, the effects are extraordinarily sensuously engaging: the series of catenary curves of the cloth draped over the improbably positioned figure draw the viewer into an endlessly pleasurable exploration of the desirable female body, half veiled, half revealed underneath.[159] Here, if anywhere in ancient art, form may be beginning to work its way free of, and even to dominate, content – as, for example, Zeuxis intended with the Centaurs – though, of course, he also was disappointed to find that in practice the subject matter attracted more comment from ordinary viewers than did his specific technical prowess, as we shall see further below.[160]

Like Zeuxis, the fourth-century sculptor Praxiteles made much of the psychagogic, seductive, character of his art. He framed his statue of Eros, dedicated by his mistress Phryne at Thespiai (the site of a major cult of Eros), with the following inscription on its base: 'Taking his own heart for the pattern, Praxiteles portrayed the love he felt, and he gave me to Phryne as the price of myself; and so I no longer cast love philtres with my bow, but by being gazed

[157] Carpenter (1960) 145–50, 156; Pollitt (1972) 115. Stewart (1990) figs. 419–21 for the Nike parapet.

[158] Carpenter (1960) 148.

[159] R. Osborne (1994c, 85–6) for the best account of the *seductive* power of the Sandal-Binder, with a slightly anachronistic reading which sees the image as deconstructing traditional Greek patriarchal representations of Victory. Osborne questions traditional readings on the basis that they separate form from content. Like him, I am unconvinced by Pollitt's reading (1972, 115) of such features as a 'refuge in gesture' arising from the traumas of the Peloponnesian war. However, although the assumption that form and content are linked is a good rule of thumb in ancient art – by virtue of its social embedding – it cannot be a general law of art-historical interpretation: there are, after all, aestheticist movements in art history, such as those of the late nineteenth century, in which form dominates content.

[160] Lucian, *Zeuxis* 7.

upon.'[161] The type (*archetupon*) for the image is, Praxiteles claims, generated by the artist himself (1–2). It is an allegory, giving evidence less of the god's power than of the artist's technical mastery (*diekribosen* – worked with consummate *akribeia*). The autonomous power of the work of art to move a viewer merely by being gazed upon is compared both verbally in the poem and visually in the image to the unseen power of Eros' arrows.

Praxiteles' Eros was one of a series of fourth-century works of art which were self-referential and demanded a formalistic reading in terms of the artist's technical skill, rather than pointing towards an extra-artistic order of meaning, as the rationalisation of art as a province of meaning, separating technical virtuosity from ethical or social criteria, and the self-assertion of artists as the authorial subjects of their own paintings both reached their acme. Zeuxis, again, displayed in Athens a painting representing a family of hippocentaurs: mother, father, and two babies being breast-fed. Centaurs were conventionally represented in the context of mythological narratives, usually violent, articulating Greek conceptions of moral boundaries and the consequences of their transgression.[162] This radically innovative presentation – with no narrative content pointing viewers to a meaning beyond the painting itself – was designed to maximise attention to the formal properties of the painting and Zeuxis' technical skill, as evoked by the second-century AD sophist Lucian in a description of the painting:

As for the other aspects of the painting, such as are not entirely manifest to an amateur like myself, they nevertheless reveal all the power of his *technē* – such things as extreme precison in linear design (τὸ ἀποτεῖναι τὰς γραμμὰς ἐς τὸ εὐθύτατον), accuracy in the mixing of colours (τῶν χρωμάτων ἀκριβῆ τὴν κρᾶσιν), due measure in the application of paint (εὔκαιρον τὴν ἐπιβολὴν ποιήσασθαι), correct use of shading (σκιάσαι ἐς δέον), rational system in the relative proportioning of objects, and balance and harmony in the relation of the parts to the whole (τοῦ μεγέθους τὸν λόγον καὶ τὴν τῶν μερῶν πρὸς τὸ ὅλον ἰσότητα καὶ ἁρμονίαν). The sons of painters best commend these aspects, since it is part of their business to know such things.

The painting itself is as much a description of artistic skill as a representation of centaurs:

The junction (μίξις) and blending (ἁρμογή) of bodies, by means of which the horse part is fused with the woman part and attached to it, is achieved with a gradual transition, without a hint of abruptness, such that the subtle change quite escapes the eye, as it is led from one part to the other.[163]

[161] Ath. 591a. [162] R. Osborne (1994b). [163] Lucian, *Zeuxis* 5–6.

Both *harmogē* and *mixis*, ostensibly used here to describe the anatomy of the hippocentaur, are drawn from the technical terminology of painters.[164] The hippocentaur's body is not just a vehicle of but a metaphor for artistic virtuosity.[165]

The sculptor Lysippos set up outside his workshop a bronze statue of Kairos or 'Opportunity'.[166] It showed Kairos as a winged youth, with hair falling down the front of his face but bald behind, signifying that opportunity once missed cannot be caught again. He balances on tiptoe on a sphere whilst equilibrating a scale on a razor's edge.[167] Conceivably, Lysippos' Kairos could be read as a relatively straightforward cult personification, like Kephisodotos' Eirene and Ploutos (Peace and Wealth). However, both the virtuosity of the statue, a masterpiece of complex casting and delicate balance now sadly preserved only in relief copies (figure 4.5), and its secular location, set up as an education or object-lesson (*didaskalian*) in the entrance way to Lysippos' workshop in Sikyon, suggest an alternative reading. It represented Lysippos' claim to have mastered Kairos and thus to have leapt from the ranks of the craftsmen to that of the intelligentsia. As such, it was both an assertion of autonomy – art about art – and an intervention in the contemporary debate about the rationality of art. In philosophical thought it was sometimes argued that the craftsman was a slave to Kairos, the point in time where human technical action 'meets a natural process developing according to its own rhythm', in contrast to philosophers, who could self-sufficiently dominate time by grasping it through purely intellectual operations of the mind.[168] Lysippos polemically presents himself like a sophist as the master of Kairos. Come to his workshop and artistic success is guaranteed not through chance, the judicious distribution of phallic dolls or the imprecation of the magical powers of Hephaistos and Athena, but through a rational artistic education.[169]

Although the evidence is lacunose and fragmentary, there can be little doubt what is going on here. The formalisation of knowledge, setting it apart from everyday knowledge, and the attribution of importance to the special nature of

[164] Pollitt (1974) 150–1. [165] Rouveret (1989) 157–9.

[166] Poseidippos, *Anth. Pal.* xvi.275; Gow–Page, *HE* Poseidippos 19. [167] Kallistratos, *Eikones* 6.

[168] Vernant (1983) esp. 291–2 citing Pl. *Resp.* 370b, 374c.

[169] See Lloyd (1987) 28 on the Hippocratic treatise 'On the Sacred Disease' (18), where the writer argues that the true doctor, endowed with *epistemē* – scientific understanding – 'could distinguish the right moment (*kairos*) for the application of the remedies. He would not need to resort to purifications and magic and all that kind of charlatanry (*banausiē*).' Cf. Stewart (1978b). The broader message of the Kairos, and perhaps of Lysippos' writings on art were they preserved, may be compared with the treatise *On the Art (of Medicine)* in the Hippokratic corpus, which is centrally concerned with justifying the status of medicine as a true, that is to say 'rational', *technē* against its detractors. Like Lysippos, the author is centrally concerned with the question of whether his *technē* realises its goals by chance, in which case it is not a true *technē*, or through reason. Cf. Xen. *Mem.* iii.10 – Sokrates' defense of artistic *technē*.

Figure 4.5 Roman marble relief after bronze statue of Kairos by Lysippos, original second half of fourth century BC. Source: DAI, Rome. Neg. 1930.236.

the abstract knowledge involved in certain kinds of work are common means by which occupational groups seek to enhance their status and increase their level of autonomy.[170] The sophistic emphasis on an art of illusion, serving no other purpose than sensuous-expressive exploration of subjective response, constitutes the aesthetic as a sphere of value in its own right, independent of everyday social, political and moral constraint. Both of these processes inform the strident boundary marking performed by artists who assert the specifically aesthetic value of their work against popular judgement and the judgements of power.[171] Despite some practical continuities and structural constraints

[170] Freidson (1986a), (1986b); Zolberg (1990) 41.
[171] Moreno (1979a) 670–1; Lucian, *Zeuxis* 7; Plut. ap. Stob. LXIII.34 = *SQ* 1675, Reinach no. 223; see n. 121 above.

given by the place of art as a functionally differentiated strand of cultural tradition within the human action system, for Lysippos and Praxiteles as sculptors, like Zeuxis and Parrhasios as painters, the very sense of what it was to be a visual artist was in important respects quite different from that of archaic sculptors like Mikkiades and Achermos when they dedicated their Nike, or indeed the painter Polygnotos playing the role of civic benefactor.[172]

TRADITION, INNOVATION AND ARTISTIC AGENCY IN CLASSICAL GREECE

How is this changing configuration of the relationship between social structure, culture and artistic activity manifested in the shape and nature of artistic innovation in classical Greece? How did these processes of artistic rationalisation inform artistic agency: patterns of formal invention and artists' relationship to their inherited visual tradition? There is little doubt that visual artists, like many other practitioners of *technai*, in classical Athens were self-consciously innovative – one need only think of Zeuxis' insistence on his *kainotomia*, and his claim to have extended the art of painting to its limits – but alongside the 'fetish for novelty characteristic of late fifth-century Athens',[173] there was also a certain scepticism about innovation for innovation's sake, and a countervailing respect for the past, the ancestral constitution or way of life – *patrios nomos* – that became more accentuated after Athens' defeat in the Peloponnesian war in 404 BC.[174] Naturalism afforded the possibility of innovation, but the social organisation of production channelled that innovation in directions contoured to traditional social values and purposes. Massive augmentation of artistic agency – the cultural capacity for the innovative transformation of an inherited iconographic and stylistic repertoire – was not necessarily inconsistent with continuity in the social functions and purposes of art.

As I have already argued, Greek naturalism comprises a specific structure of artistic agency in which natural bodily schemata, recognised in part on the basis of new forms of medical knowledge, were abstracted as artistic schemata and, using mathematical principles of symmetry and proportion, synthesised into new artistic forms whose compelling character rested in large part on their ground in universal principles of bodily functioning. The early classical period is particularly rich in its coining of 'pathos formulae', archetypal images which draw their meaning from patterns of gestural and physiognomic expression that

[172] For Polygnotos, artistic/cultural self-assertion, and claims to social status, are quite separate; for Praxiteles and Lysippos, they are part of the same social move.
[173] Csapo and Miller (1998) 101. [174] Meier (1990) 188–220.

are characteristic of human beings as a species, and thus predisposed to arouse a strong and immediate empathetic response, even if different cultures differentially permit or inhibit such expressions and give different nuances of cultural meaning to them.[175] These include the gestures of pensiveness (the head inclined, resting the chin on one hand, best exemplified by the famous figure of Penelope), as well as expressions of astonishment and grief (best known from Greek vase painting but probably originally coined as pictorial formulae in the paintings of Polygnotos), in addition to the facial expressions of anger and reflectiveness which we looked at in the context of the development of portraiture (chapter 3).[176] Others, whilst still dependent on knowledge of the functioning of the body, have a more culturally specific character. For example, some of the figures of centaurs and lapiths battling on the west pediment of the temple of Zeus at Olympia, as well as the figures of Herakles on the metopes, draw their form from bodily schemata characteristic of athletes in certain key moments during competitive events, holds in wrestling and the pankration, and postures of release in javelin throwing.[177]

Though differing in their levels of universal transparency, all such signs drew part of their significance and their effect from their presence in everyday life.[178] They appealed to the viewer's body, sensitised by the somatic practices associated with the oral paideia of classical Athens: the mimetic enactment of character through the performance of mythical narratives in choric dances and tragedy, and the athletic and military training, both physical and ethical, received in the gymnasion. The two aspects of oral paideia, *gymnastikē* and *mousikē*, were often closely related through such ritual practices as the Pyrrhic dance, in which postures learnt by ephebes in the gymnasion in order to perform certain blows with sword and spear were codified as part of a highly choreographed dance routine performed by teams organised according to tribal affiliation.[179] The cultural mediation of response was channelled through deeply engrained, unconscious, bodily automatisms, not abstract, distanciated aesthetic reflection.[180] Thus, even as artists were becoming more self-reflective

[175] The term pathos formulae was coined by Warburg – see discussion of Gombrich (1986) 241–53; Eckman (1998) 383–5 on elaboration, inhibition and cultural nuancing of universal patterns of gesture and expression.

[176] Settis (1975), (1997). [177] Raschke (1988). [178] See Settis (1975) 10.

[179] Lonsdale (1993) 143–8, 162–8. On the continuity between dance, tragic performance and visual art in their reliance on bodily schemata as a major medium of expression – Catoni (1997) 1030–6. Correspondingly the tragic poet Aeschylus is attested by ancient sources as an important coiner of new schemata, alongside, as we might more naturally expect, the contemporary painter Polygnotos: Settis (1997) 45–6.

[180] Contrast the abstract intellectual operations which inform high-cultural viewing practices after the invention of art history (chapter 5), and the abstraction of artistic agency from an orientation towards the body and mimetic practices as the grounds of art, in favour of a more self-referential orientation to

about the processes of artistic production, as their agency was enhanced through interactions with philosophy and medicine, the products of that agency militated against comparably high levels of reflectiveness on the part of viewers. On the contrary, naturalism increased the mutual purchase of art and society – in particular institutionalised religious and moral culture – rather than promoting the differentiation of art as a realm with its own constitutive values.

The autonomy of art is linked not just with issues of innovation, but also with the question of the relationship between an artistic tradition and its past. How did the development of the new forms of artistic agency that were characteristic of the classical period inform artists' relationship to their past visual tradition? In Greek art, as in all art, there is much iteration or repetition of a purely practical character, reusing a motif or a compositional pattern which provides a ready-made solution to the routine pictorial problems faced by an artist without any intention that the repetition be perceived as such.[181] This is not to say that classical Greek artists were not on some level historically self-aware, and expected a certain degree of such awareness on the part of their viewers. Rather, that awareness was of a specific and limited kind, shaped by the institutional functions that were performed by art in the classical city, not by the strong historical reflexivity that we encounter developed in some degree in the Hellenistic-Roman period (see chapters 5–6) and most fully in the modern western tradition.

The institutionally most significant form of repetition in classical art is best exemplified by the iconography of the Tyrannicides. I have already examined some of the social and cultural meanings of the statues of Harmodios and Aristogeiton in the context of the institution of honorific portraiture. The characteristic iconography of the Tyrannicides was, however, repeatedly recycled in Attic and related imagery during the following half century.[182] An Attic red-figure cup by the Codros painter, dated *c.* 450–440 BC (figure 4.6), depicting a cycle of the exploits of Theseus, shows the hero first in the form of Aristogeiton dispatching the sow of Krommyon, then, in the posture of Harmodios, delivering the *coup de grâce* to Skiron. The exterior images show Theseus as Tyrannicide from the frontal view, the interior images from the rear.[183] On the east frieze of the Hephaisteion (*c.* 430 BC), Theseus, fighting against the giant Pallantids, is shown in the pose of Aristogeiton; on the west

past, in which artistic culture itself is the primary ground of art production, and a set of abstract intellectual operations is the basis for transforming and recombining inherited elements in the production of new meanings (chapter 6). On the role of bodily automatisms in the mediation of culture and social structure: Bourdieu (1992) 66–79.

[181] Fullerton (2000) 145; Schmidt (1996).

[182] Connor (1970); Taylor (1981) 111–32; Harrison (1972); Barron (1972).

[183] Henle (1973) 80–2; British Museum E84.

Figure 4.6 Attic red-figure cup by the Codros painter; deeds of Theseus; *c*. 450–440 BC. British Museum, GR 1850–3.2–3, vase E84. Photo: Copyright The British Museum.

frieze, fighting against the centaurs, in that of Harmodios (figure 4.7). On the south frieze of the temple of Athena Nike (425–20 BC), possibly copied after the painting of the battle of Marathon in the Stoa Poikile, the polemarch Kallimachos, who died in the battle against the invading Persians, is shown in the Harmodios pose, echoing the speech attributed to Miltiades before the

(a)

(b)

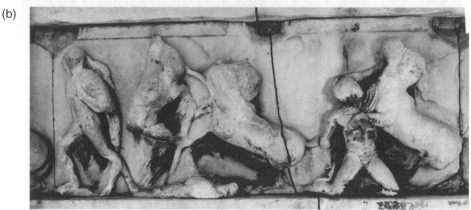

Figure 4.7 a and b Friezes from the Hephaisteion: (a) East frieze – Theseus against the Pallantids; (b) West frieze – Theseus against the centaurs; *c.* 430 BC. Photo: Agora Excavations LXII.4 (Slab 4), XXXVIII.24 (Slab 3). American School of Classical Studies, Athens.

battle, in which he encourages Kallimachos 'to decide whether you will enslave Athens or free her, and thereby leave such a memorial for posterity as was not left even by Harmodios and Aristogeiton'.[184] At first sight, we might wish to see such imagery as signs of the artistic influence of a famous statue by the great artists Kritias and Nesiotes (as copies of the Tyrannicides were to be seen later, in the context of Roman collections, and also other famous works of art quoted for the benefit of connoisseurs, for example in sarcophagus iconography – see chapters 5 and 6). In practice, the mythologic which permitted the transposition of the imagery between different subjects discouraged such abstract art-historicising readings. Rather, the heroic blows on behalf of freedom performed by the Tyrannicides were simply a re-enactment of the emancipatory heroism of

[184] Hdt. VI.109; Harrison (1972); Stewart (1990) fig. 415.

Theseus, as also Kallimachos' heroic self-sacrifice at Marathon. Athenian mythologic conceptualised history as the eternal recurrence of the ever same, the periodic manifestation of essentially unchanging Athenian virtue.[185] Correspondingly, action in support of civic order could be acted out according to the bodily schemata, at once aesthetic and ethical, afforded by the visual arts. Thus, in Aristophanes' *Lysistrata*, the chorus of old men, veterans of Marathon, appeal to the representations of Athenians putting down the horsey Amazons, in Mikon's frescoes in the Stoa Poikile and the Theseion, as a paradigm for evaluating and acting against the hubristic behaviour of the women who had usurped power at Athens, taking their guard by the monument to Harmodios and Aristogeiton, and putting them down with a tyrannicidal blow on the model of the statues.[186] The style and iconography of representations, and their links with the practices of traditional paideia, engendered an aesthetic and ethical order linked in a highly concrete way through perceptible surface to a practical sense, 'the social turned into nature, converted into motor schemes and bodily automatisms', in which reflective thought on the part of the viewer had little or no part to play.[187]

Other examples of repetition do imply a more specifically historical past-orientation to art as such, at the very least a conscious awareness of the historical evolution and period specificity of past visual types and styles. The Daochos monument, erected by Daochos II, tetrarch of Thessaly, between 336 and 332 BC, comprises a series of statues of members of Daochos' family and ancestors over four generations, from his ancestor Aknonios down to his son Sisyphos II. Agelaos and Telemachos, from the generation prior to Daochos himself, are represented emulating models – Polykleitos' Westmacott youth and the Diadoumenos – appropriate to their own acme in the fifth century, whilst the still-living Sisyphos has a ponderation based on Praxitelean models, supported by the herm on which he rests his weight. These choices make sense only if viewers could be expected to have recognised the different period character of the sources being drawn on. The purpose of these choices, however, was linked to the political function of the monument, projecting the *syngenēs ethos*, the

[185] Loraux (1986) 134–6. [186] Ar. *Lys.* 630–5, 672–80.
[187] Bourdieu (1992) 69; cf. Habermas (1984) 46 on mythical thought, Levi Strauss' 'logic of the concrete', operating on the level of the perceptual surface of the world through a 'network of correspondences' generated by analogical schemata of thought, and its contrast with reflective thought. Cf. Thucydides' VI.59 criticism of the irrational, because unreflective, character of the Tyrannicides' action: *alogistos tolma*, 'wholly irrational act of daring', with Taylor (1981) 163–72 for Thucydides' project to rationalise action in contrast to the disastrous mythologic which he saw informing certain aspects of the Athenian conduct of the war as a result of their myth-historical thinking, exemplified by their attitude towards the Tyrannicides.

innate character, of the ruling dynasty of Thessaly; a character preserved over generations, which combined the dynamism and charisma of athletic victors like Agelaos and Telemachos with the self-control and the respect for communal values and laws represented by the figure of Daochos I, his arms enveloped in his cloak.[188]

Similarly, even highly self-conscious innovative transformations on the most specifically artistic formal aspects of the inherited tradition generally manifest some kind of semantic, institutional or socially embedded, motivation. The most important formal problem generated by the development of naturalism was ponderation, the relationship between free leg and weight leg, and how this supported the mass of the body. Polykleitos' Doryphoros represented the canonical mid-fifth-century solution to this problem, solving the formal question in a way that was suitable to the social context of such statuary. Subsequent generations revisit the problem of ponderation in ways which at a technical level explore purely formal questions of alternatives to the solution represented by the Doryphoros.[189] A series of statues of Amazons – possibly produced by Kresilas, Polykleitos and Pheidias c. 430 BC, some dozen years after the Doryphoros – present wounded figures with their weight supported in part outside the body, whether leaning on a spear in the Mattei type or a pillar in the Sciarra type.[190] In the sculpture of Praxiteles in the fourth century these experiments are taken further. The Apollo Sauroktonos (figure 4.8) represents the mighty god slaying the Delphic Python in the guise of a youth languidly leaning against a tree whilst he skewers a sun-bathing lizard with an arrow. The youth is caught in the moment as his weight shifts from right leg to left leg, as he takes aim at the lizard, thus lowering the left hip (although the trailing leg does not yet carry the weight), whilst the right leg, still ostensibly weight-bearing, shows no sign of compression, creating an effect of airy ease of action. The Resting Satyr exaggerates the gentle s-shaped chiasmus of Polykleitan contrapposto, to the extent that the torso is placed not only away from the weight-bearing left leg, but also beyond the free left leg, so that the weight of his body is supported by the tree trunk on which he reclines.[191]

Although these statues and their uses of ponderation can, on one level, be seen as a series of linked reformulations and new solutions of a purely formal problem, on another level, the contexts in which the problem was explored and the specific solutions given were always integrated with the social meaning and functions of the statues in question. The Amazons were dedications at

[188] Fehr (1979) 59–66; Borbein (1995) 451–2, (1997) 1285–7; Stewart (1990) 187, figs. 551–3.
[189] Borbein (1995) 449–53, (1997) 1293–8. [190] Stewart (1990) figs. 388–96. [191] Stewart (1990) fig. 510.

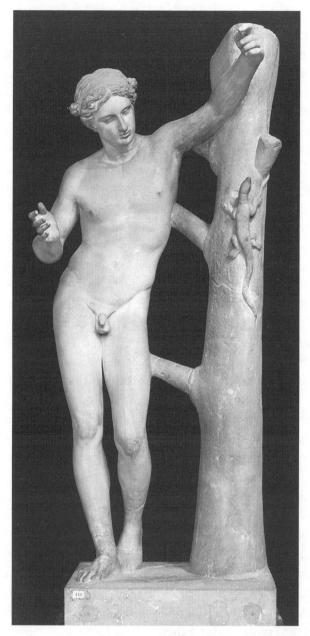

Figure 4.8 Apollo Sauroktonos, Roman copy after statue by Praxiteles; date of original
c. 350 BC. Paris, Louvre. Photo: Alinari 22548.

Ephesos, to where, according to myth, the Amazons had retreated after their
defeat by the Athenians. Their ponderation, showing their capacity for action
and effort, their refusal to accept defeat even in their wounded state are signs of
manly courage (*andreia*) and self-mastery, positive qualities – as one might

expect in a dedication at Ephesos where they had mythic and cultic connections with the sanctuary – which cast still further lustre on their vanquishers.[192] Similarly, each of Praxiteles' Sauroktonos and Satyr exploits the formal potentialities of naturalism and ponderation to bring out a different aspect of each mythical figure from those captured in earlier representations: the consummate ease with which great deeds are accomplished by the gods in the case of the Apollo – comparable to Homer's account of the same deity destroying the Greeks' fortifications on the shore at Troy, like a child knocking over sandcastles;[193] the 'animal inertia' and 'latent sensuality' of the youthful satyr perceived as much as object of desire as insatiate seeker after animal satisfaction.[194] Understanding them and responding to them in their social contexts required of the viewer only knowledge of traditional religious culture and civic *paideia*.

This consistent recuperation of both formal innovation and marked repetition by social context is an important indicator of the limits to processes of artistic rationalisation in classical Greece. The agency of artists was massively enhanced by the rationalisation processes we have examined, permitting higher levels of individual innovation on the part of different artists exploring different formulations of and solutions to the problems of iconographic invention and formal composition. However, both the orientation to the past – whether represented by the repetition of the iconography of the Tyrannicides or by the selection of earlier prototypes in the Daochos monument – and the projective reconfiguration of inherited formulae permitting the development of art in new directions (exemplified by experiments in ponderation) were not determined primarily by specifically aesthetic interests; they rather involved appropriating and recontextualising or innovatively transforming past forms to fit the practical contingencies of the moment.[195] These contingencies, which constrained the intrinsic formal rationalisation of art as such, were mediated through the institutional organisation of the production and reception of art that was characteristic of the democratic polis. As we have seen, some artists did push against and seek to transcend these limits, but, in order to convert such occasional works into a new institutional definition of art, they needed some means of legitimating and implementing their cultural vision.

[192] See Schmaltz (1995) for the reading, though doubting Ephesos as the site of the monument.
[193] *Il.* xv.355–64; Rodenwaldt (1944).
[194] Borbein (1997) 1293–8, esp. 1295, (1995) 449–53; Stewart (1997) 199–202.
[195] Cf. Emirbayer and Mische (1998) 962.

ART AND INTELLECT IN CLASSICAL GREECE

Philosophers' reflections on the status and role of artists

The attempt on the part of fifth-century and fourth-century artists to rationalise their aesthetic practices can be interpreted in part as an attempt to infuse their occupation with a charisma, derived from the definition of the sacred as divine Reason which was being developed in philosophical thought.[196] In the late fifth and early fourth centuries the premises of this new culture were still in the process of construction, and the specification of these premises to define the situation of the various worldly institutional realms still open. Artists' writings, the self-presentation of the likes of Zeuxis and Parrhasios, and the works of art by Zeuxis, Praxiteles and Lysippos discussed above can be interpreted as an attempt to specify the higher-order premises of rationalist culture to the institutional realm of art in such a way as to maximise both the occupational autonomy of visual artists and their cultural esteem.[197] Not being themselves primary bearers of the new culture, and hence in closest possible proximity to the sacred, painters and sculptors were heavily dependent on the new intellectuals, philosophers and sophists, to endorse their claims and provide the kind of charismatic push on which the development of new institutional orders seems to depend,[198] perhaps by sponsoring the most rationalised autonomous examples of the new art, or assisting in the development of new contexts of display and modes of viewing, independent of the civic contexts in which most art continued to be embedded.

There are some indications of philosophical interest in and support for the rationalisation of art in the writings of Anaxagoras and Demokritos, prompted by Agatharchos' perspective constructions in scene painting.[199] Moreover, Xenophon in *Memorabilia* III.10 (dramatic date late fifth century) represents Sokrates as contributing to the rationalisation of painting and sculpture by enhancing artists' levels of self-conscious awareness of the nature, possibilities and effects of their representational practices.[200] As we have seen, this mutual openness between visual artists and practitioners of other rationalising disciplines was particularly marked in sculptural practice, and certain strands of sophistic thought began to develop a concept of visual art that laid emphasis on its autonomous cultural value as a medium of aesthetic pleasure in illusionary

[196] Shils (1982b) esp. 147.
[197] On the way in which cultural patterns formulated in very abstract or generalised terms are 'specified' to fit the structure and functional exigencies of more concrete institutions, see Parsons (1961) especially 977.
[198] Cf. Eisenstadt (1990) esp. 21. [199] Vitr. VII.praef. 11. [200] Preisshofen (1974).

representation, independent of questions of ethical or political value.[201] In the fourth century, however, the increasing codification of philosophy, and its institutionalisation with the foundation of Plato's Academy, gave rise to direct conflicts with artists and their claims to prestige and autonomy.

Although Plato's attack in the *Republic* and earlier dialogues concentrates for the most part on poetry – since it was Homer above all who was the traditional educator of the Greeks – he moves freely between poetry and the visual arts, since both are held to be mimetic or imitative arts, and Plato's argument is intended to hold good for all imitative arts, regardless of medium. Plato's hostility to poetry and painting is in part sociologically determined by an antagonism between two modes of cultural transmission borne by distinct social strata. On the one hand was the new intellectual elite, comprising primarily those sufficiently socially privileged to enjoy the leisure and freedom from necessity of satisfying everyday wants that were prerequisite to consuming their time in intellectual dispute and contemplation. On the other hand was the mass of the citizen body in democratic Athens, possessed of sufficient leisure for occasional participation in civic business, but preoccupied primarily with the satisfaction of their everyday needs through labour-intensive peasant farming or craft manufacture. These latter were committed to traditional religious representations and modes of cultural transmission based in and adapted to the constraints of everyday necessity: a ritual calendar related at least in part to the agricultural year, and to cults – like that of Athena and Hephaistos for artisans – which offered access to powers capable of assisting the adherent in the pragmatic necessities of life on an occasional basis as required.

Plato's attack on mimesis is not, however, a mere rationalisation of that sociological opposition – common to most of the axial age societies – but is independently rooted in a conception of the sacred as divine Reason manifested in the Forms and apprehended only through pure intellect. The implications of such a conception of the sacred, once fully worked out, are almost unavoidably hostile to cultural practices such as the visual arts, which are necessarily tied to sensuous modes of expression. Plato's attack on mimesis has two prongs. First, he discounts the knowledge claims of practitioners of the mimetic arts, on which basis they had claimed autonomy. Secondly, he suggests that the mimetic arts as currently practised are positively deleterious to the integrity of the *psychai* or souls of those who participate in their production or consumption.

From his earliest dialogues Plato had called into question the wisdom traditionally ascribed to poets. In the *Apology* Sokrates argues that poets lack true

[201] See pp. 175–82.

knowledge or wisdom since they are unable to give a rational account of their work and the matters they speak of in their poetry.[202] In the *Ion* it is suggested that the poet's wisdom is an alien, divinely inspired madness taking possession of the poet, who mechanically enacts the poem with no knowledge of the truth or falsity of what he pronounces.[203] In the *Republic* Plato's disapproval of poets and mimetic artists more generally receives full articulation in terms of the systematised metaphysics of the theory of Forms. God, Plato argues, has produced the one true couch that really is, the *eidos*, Form or essence of couch, which exists in nature (ἡ ἐν τῆι φύσει οὖσα). Contrary to what one might infer from most translations, God is not conceived by Plato as a creator analogous to the Judaeo-Christian God, but as a kind of divine principle of Nature, immanent in the world and constrained by the necessity of world-immanent reason, whereby he can make no more than one couch in nature that really is 'couch'.[204] This couch is not 'created', but 'brought naturally into being by the Divinity (ἐφυτεύθησαν ὑπὸ τοῦ θεοῦ)'. God is thought of as the 'planter' (φυτουργόν), 'since it is by Nature that he has made this (the Form of couch)'.[205] He is of Nature and subject to its laws, not the creator of and transcendent to Nature.

The highest level of being, true reality, Plato argues, is this world of Forms, through which Nature constitutes itself and the world. True knowledge is knowledge of this ultimate reality, the world of Forms. Craftsmen, the carpenters who make empirical couches, operate at one remove from true reality. They look towards the Form 'couch' for guidance, but their knowledge concerns not the Form 'couch' as such but the manufacture of particular couches, which are a lower kind of reality than 'the couch itself', that is to say, than the Form 'couch'.[206] Such a particular sensuous empirical couch does not have 'true being'. It is not 'the real, but something which is like the real, but not real itself'.[207] The painter of a couch is 'an imitator' who produces an 'offspring begot at two removes from nature':[208] 'Surely, then, the mimetic *technē* is far away from the truth; and, as seems to be the case, it is for this reason that it is able to accomplish a rendering of everything, namely because it has only a slight grasp of any particular object – and that as a mere phantom – εἴδωλον.'[209] Only the naive, children and stupid adults, are taken in by imitators' representations and knowledge claims, 'encountering a magician (γόητι) and imitator

[202] Pl. *Ap.* 22a–c; cf. Halliwell (1988) 3–4, while offering the best translation currently available, even Halliwell's version is sometimes misleading for our purposes, for example introducing the concept of 'creation' where the Greek text says nothing more than 'made' (*epoiesen*, e.g. 597c).
[203] Keuls (1978a) 135–7; Ferrari (1989) esp. 92–7. [204] *Resp.* 597b–c. [205] *Resp.* 597d.
[206] *Resp.* 596b. [207] *Resp.* 597a. [208] *Resp.* 597e. [209] *Resp.* 598c; cf. 601a.

and being utterly deceived, with the result that the latter seemed all-wise (πάσσοφος)', because the dupe 'was not able himself to discriminate knowledge, ignorance and imitation'.[210] Poets, imitators like painters, represent the products of all kinds of crafts of which they have no true knowledge.[211] The claim of such ignoramuses to be the educators of Greece is, we must conclude, risible.[212] The same conclusion – placing painterly and sophistic image-making at the maximum possible distance from the charismatic centre of reason and knowledge – is reached in the *Sophist*.[213]

Mimetic art, according to Plato, was not merely itself distant from Reason, it was corrosive of it.[214] By virtue of a natural deficiency rooted in human embodiment, we encounter the world through the senses as well as through conceptual reason. Sensuous appearance, unlike pure reason, is often confused. The same stick which out of water appears straight, when partially inserted in water appears bent. 'In making an assault on this disability in our nature, perspective painting (σκιαγραφία) does not shrink from using every sort of magic (γοητείας)', making the flat appear to have depth, a stage painting to seem a house.[215] Measurement, arithmetic and weighing – rational mathematics – allow us mastery over the tyranny of appearances. If we measure both, we can know that a large box in the distance is larger than a nearby small box which appears larger by virtue of its proximity to us. Measurement and calculation is the 'function of the rational element in the soul (τοῦ λογιστικοῦ ἐν ψυχῆι) ... the best part of the soul.'[216] 'The element in conflict with this', which bestows the accent of reality as real on merely apparent variations in the distance of objects painted on flat surfaces with the use of perspectival effects, 'must be one of the base things in us.'[217] Perspectival painting stirs up this irrational element, creates a conflict within the individual as to the nature of the represented reality and thereby threatens the integrity of the soul.

The base, irrational element of the soul is also stirred up by the content of mimetic representations, whether poetic or pictorial. The mythic narratives of Homer and tragedy – and of course the pictorial representations of myths on temples and in sanctuaries – strengthen the base, emotional elements of the soul against the rational controlling element. The representation of others' afflictions – the travails of a Medea or Ajax, both popular themes in classical drama and painting – and the emotive responses to their own experiences of the characters represented in these mythic dramas encourage a 'pathology of identification', which subverts audiences' and viewers' limited capacity for

[210] *Resp.* 598c–d. [211] *Resp.* 598e–600a. [212] *Resp.* 600a–c. [213] Pl. *Soph.* 235–6, 264–8.
[214] *Resp.* 605b; E. A. Havelock (1963) 26; Halliwell (1988) 9; Ferrari (1989) 132–8. [215] *Resp.* 602d.
[216] *Resp.* 602d–603a. [217] *Resp.* 602d–603a.

emotional self-control.[218] The same considerations apply, Plato argues, to other emotions – anger, erotic desire, and so on, *mutatis mutandis*.[219] Tragedy, epic and the traditional mythic narratives of the conflicts and travails of gods and heroes are to be barred from the ideal city. Only hymns celebrating the virtues of gods and eulogies of good men are to remain.

Plato's hostility to the visual arts is unavoidably an embarrassment to conventional art historians whose work is premised on a positive valuation of 'the creative arts'.[220] From a sociological perspective, most of the efforts to discount Plato's testimony are largely misplaced. Keuls and Rouveret suggest that Plato's attack on painting is really only an attack on Pamphilos and the Sikyonian school for integrating painting with more general intellectual education and spuriously claiming scientific knowledge beyond the limits of their own *technē*.[221] But this hardly mitigates the implications of Plato's arguments, which strike at the core of artists' institutional project to enhance their status and secure through claims to reason the autonomy of painting and sculpture as cultural practices.

It is sometimes suggested that Aristotle's somewhat different account of visual art represents a radical repudiation of Plato, and the development of a notion of artistic creativity. Rouveret, for example, argues that Aristotle constructs parallels between poetry and painting no longer, as Plato had done, simply to pillory painting, but to valorise it as an autonomous aesthetic domain, 'passing from the plane of artisanal execution to that of aesthetic and conceptual reflection'.[222] According to Pollitt, Aristotle provides the conceptual basis for a theory of artists as 'human "creators" who by a special wisdom imitate the processes first established by the divine creator of nature'.[223] These arguments, however, depend on very selective reading of Aristotle's accounts both of *technē* and of the the role of visuality in civic culture.

According to Aristotle '*Technē* imitates nature (ἡ τέχνη μιμεῖται τὴν φύσιν).'[224] The products of *technē* differ from those of nature – plants, men and animals – only in so far as the form or *eidos* of a bed, for example, is present in the mind of a craftsman before being used to construct a bed, whereas the final form of a plant is immanent in the seed from which it grows.[225] *Eidos*, essence, substance without matter is the active principle whether immanent in the seed and determining its pattern of growth, or present in the craftsman's

[218] *Resp.* 606a–b. Quotation: E. A. Havelock (1963) 207. [219] *Resp.* 606d.
[220] E.g. Keuls (1978a) *passim*. [221] Keuls (1978a) 141–50; Rouveret (1989) 35.
[222] Rouveret (1989) 132–3. [223] Pollitt (1974) 35–7.
[224] Arist. *Ph.* 194a22. The best secondary account of Aristotle on work and *technē* is that of Vernant (1983) 260–3, 271–8, 293–5.
[225] Arist. *Metaph.* 1034a–b. Cf. Panofsky (1968) 17.

mind and shaping the house (for example) which he, the craftsman, through the agency of the form as the active principle in his soul, 'begets out of' the material with which he works.[226] The *eidos* of the house is no more created or conceived by the craftsman than the *eidos* of an oak tree is created by its seed. *Eidos*, essential form, is unmade. It is given by nature, directly in the case of plants and animals, mediately in the case of artifacts like houses. The *eidos* of a ship's helm is known by its user, the helmsman, who instructs the craftsman accordingly. The latter knows what material is appropriate to the form of helm – namely the kind of wood – and the movements (*kineseōn*) necessary to beget the helm out of the wood.[227] The *eidos* of a helm or a house, knowable only by its users (helmsmen and humans in general in these two cases), is in turn given in nature as prerequisite to meeting man's natural needs for transportation or shelter. The process of production in craft, as in nature, is one of teleology guaranteed by the world-immanent reason that is nature.[228] Craft is not set apart from nature as a specifically human, cultural activity which masters and transforms nature. Rather, craft is embedded within nature and, ideally, conforms with it.[229]

It follows from this understanding of craft that the knowledge or wisdom of craftsmen such as sculptors and carpenters is a partial or limited wisdom, dealing with empirical matters that admit of variation, the particular manner for example, in which the Form 'bed' is variably instantiated in wood, according to the variable grain of the wood and the quality of the tools used in its manufacture. This partial wisdom of technicians like Pheidias, dealing with 'things that admit of variation' is explicitly contrasted by Aristotle with the true wisdom of the wise man, 'consummated knowledge of the most exalted objects ... universals and things that are of neccessity'.[230] This placing of the visual arts and their practitioners well below true intellectuals like philosophers in the hierarchy of reason is in perfect accord with Plato's evaluation of them, and rooted in the same principle of charismatic reason.[231] For Aristotle, as for Plato, the visual arts are far from the realm of truth. Perspective paintings (*skiagraphiai*) are classifed with dreams as false because 'the appearance which results from them is that of something which does not exist'.[232]

[226] *Metaph.* 1032b–1033b, quotation 1033b23–4. [227] Arist. *Ph.* 194b. [228] *Ph.* 199a.
[229] Vernant (1983) esp. 262–3. [230] Arist. *Eth. Nic.* 1140b30–1141a20, cf. 1140a1–b30.
[231] Cf. Keuls (1978a) 119–25. See Pl. *Phlb.* 55e–58a for a hierarchy of manual *technai* rooted in their scientificity defined in terms of the level of arithmetic, weighing and measuring that they require. Without that rational element they would be 'pretty worthless (*phaulon*)', for 'all that would be left for us would be conjecture and to drill the perception by practice and experience'. The emphasis of Aristotle on apodeictic logical knowledge is typically Platonic – cf. *Plt.* 285c–286e, esp. 285e–286a.
[232] Arist. *Metaph.* 1024b23. Cf. Keuls (1978a) 80.

Art and aesthetic experience in classical Greek philosophy

I have already discussed Plato's and Aristotle's accounts of viewing and the formation of the good citizen in undifferentiated civic contexts and their ambivalence about the kinds and contents of conventional civic representations. What, however, of the wise man? The fully wise man, secure in his rationality, was of course immune to those specifically sensuous, affective attractions of the visual arts which constituted a threat to the integrity of the *psyche* of the ordinary man. Could the viewing of sculpture and painting play a positive role in the self-formation of the wise man in the same way as philosophical dialectic and rhetorical mastery of the word (*logos*) did, as components of the new education? Lysippos, Zeuxis and Praxiteles produced works of art which broke with civic frames for viewing and demanded a specifically aesthetic response in terms of the rationalised representational *techne* of the artist. The institutionalisation of such a frame, of art as an autonomous province of meaning, however, required a public prepared to view in those terms, patrons prepared to commission or purchase art produced on that basis, and the development of contexts of appropriation distinct from traditional civic contexts. In brief, it required the legitimation of non-civic autonomous modes of viewing as a practice on a cultural level, as well as the enhanced occupational autonomy of artists on a social level.

Both Plato and Aristotle thematise viewing as such, in some degree independently of the civic and religious contexts in which the kinds of work they consider might conventionally have been viewed, but they do so only in a residual way. The Greek philosophical conception of *logos* as word/reason was intrinsically antipathetic towards the visually sensuous. According to Plato, 'the greatest and most esteemed realities have no corresponding visual image (*eidolon*) made to illustrate them for mankind', requiring instead 'rational definitions (*logon dunaton*)': 'incorporeal realities, which are the most beautiful and the greatest, can be demonstrated clearly only by reason and nothing else'.[233] Pleasures are hierarchised on the basis of their contribution to human learning and their degree of intellectual purity. The pleasure derived from the study of geometry (in which visual images are not subject to sensuous elaboration) ranks relatively highly, though not so highly as the pleasure derived from pure intellection of the Forms, which dispenses with the need for visual figures as illustrations. Amongst the lower pleasures are enjoyment of the purely phenomenal beauty of animals or, worse, paintings,

[233] Pl. *Plt.* 285c–286e. Cf. Keuls (1978a) 121–2.

which are an inadequate source for learning the truth about geometry or proportions.[234] Just as ultimately the only really real true knowledge is of the Forms, 'the knowledge which concerns being, reality and that which is in its nature always entirely unchanging',[235] so 'no other pleasure apart from that of the man of intelligence (τοῦ φρονίμου) is wholly true and pure (καθαρά), but rather an empty sham (ἐσκιαγραφημένη – mere shadow-painting!)'.[236]

Aristotle draws a sharp distinction between the sensory bodily pleasures 'which man has in common with other animals and therefore appears slavish and bestial', such as touch and taste, and pleasures of the soul such as love of honour (*philotimia*) or love of learning (*philomatheia*). Pleasure taken in objects of sight 'like colours and shapes and pictures' are pleasures of the body, but – not being so directly sensuous as touch – do not raise questions of temperance and profligacy in their indulgence.[237] While not so polemical as Plato in his dismissal of lower forms of pleasurable ratiocination as hardly true pleasures or true reason at all, Aristotle can construe the viewing of visual art (independent of its civic functions) in a positive light only as a low, sub-philosophic mode of intellectual learning:

Learning is not only for philosophers the most sweet pleasure but also for other men in a similar way, although they share in this pleasure only in a limited degree. It is for this reason that those who see likenesses enjoy doing so, namely that it happens that, as they look, so at the same time they learn and infer what kind of thing this is and what that. If it should happen that someone has never seen the original before, it is not in so far as it is an imitation (*mimema*) that the likeness produces pleasure, but rather due to the technical finish or the colour or some other such cause.[238]

This somewhat limited account of viewing and visuality is all the more striking when its context is taken into consideration. In the *Poetics* Aristotle sets out to give a rational account of poetry.[239] Just as in the case of other *technai*, so poetry is rooted in nature and man's instinctive disposition for mimesis. Like the 'Forms' of houses or beds, the types (*eidē*) of poetry are given in nature. The history of poetic development takes the form of a teleology, whereby genres such as comedy or tragedy grow to completion along the lines set by their naturally given *eidos*, like a seed growing into a tree. Nature discovers and makes available the appropriate elements – like the iambic metre for tragic dialogue – to poets drawn to higher genres (like tragedy) or lower

[234] Pl. *Resp.* 529d–530b; *Phlb.* 51c2–5, 57a–b. Cf. Keuls (1978a) 122–4. [235] Pl. *Phlb.* 58a.
[236] Pl. *Resp.* 583b, 585d–587b. [237] Arist. *Eth. Nic.* 1117b28–1118a13, 1118a24–6.
[238] Arist. *Poet.* 1448b12–19. Cf. *Rh.* 1371a25–b10; Pl. *Leg.* 667c–669b, esp. 668d–e for comparable rationalist accounts of aesthetic pleasure.
[239] Halliwell (1989).

genres (like comedy) according to their nature (κατὰ τὴν οἰκείαν φύσιν). Tragedy, for example, 'developed little by little as men developed each element that came to light and after going through many transformations it stopped when it had realised its own natural form'.[240] This natural form of tragedy provides a set of dimensions according to which particular tragedies may be criticised and evaluated. For present purposes, two aspects of Aristotle's criticism of tragedy are striking. First, the extensiveness of his *literary-critical* tools; secondly, the consistent slighting of the visual and sensuous dimensions of tragedy. Aristotle's literary-critical tools – building on his sophistic predecessors' analyses of language – are as rich as his tools for the analysis of visual representation are poor. Contrary to Rouveret's suggestion, the few limited passing comparisons of painting to dimensions of tragedy do not represent a valorisation of painting as an autonomous aesthetic domain – indeed the valorisation of tragedy (against Plato) is achieved only by excising its visual and skenographic dimensions; they merely point up the fact that Aristotle and other contemporary intellectuals had not developed (or bothered to appropriate from contemporary artists) a vocabulary for visual analysis of comparable richness to that for literary analysis.

The verbal elements of tragedy are carefully studied. The parts of language – letter, syllable, connecting words, articles, nouns, verbs, inflexion, case and statements – are distinguished and analysed.[241] Poetic diction is discussed – the coining of unusual word forms, and the whole range of literary tropes and metaphors,[242] as is the question of poetic style and elevated language.[243] Although Aristotle recognises that tragedy is conventionally staged, and that the poet must consequently bear in mind the visual effect of entrances and exits,[244] he consistently slights the visual dimension of tragedy:

The visual spectacle (*opsis*) is of course attractive (*psychagogikos*), but it has the least to do with the craft of the playwright and is the least specific to the art of poetry. For *the power of tragedy exists independently of either performance or actors*, and the production of visual effects is more the province of the property man than of the poets.[245]

He accepts the premise of detractors of tragedy that purely verbal forms like epic 'appeal to the cultivated reader/beholder who does not need the help of visual forms (*schematōn*)', whilst tragedy, by means of its visual spectacle 'appeals to meaner minds'. However he argues that the debased visual aspect is not inherent in tragedy as such, which 'fulfils its own special function even

[240] Arist. *Poet.* 1449a13–15. [241] *Poet.* 1456b20–1457a30. [242] *Poet.* 1457a31–1458a17.
[243] *Poet.* 1458a17–1459a16. [244] *Poet.* 1455a21–1455b23, 1459b7–1460b5.
[245] *Poet.* 1450b15–20; cf. 1453b.

without the help of movement (*kineseōs* – i.e. performance) ... *for its quality can be seen from reading it*.[246] Aristotle's legitimation of tragedy for the better sort of person is, in short, tied to a radical transformation in its mode of appropriation. Tragic drama in the democratic city is an example of what Bernstein calls a restricted code.[247] Its complex meanings were articulated on a range of parallel channels – word, music, dance, spectacle.[248] The performance was embedded in the context of a civic ritual – the Dionysiac festivals – and the implicit meanings explored in the mythic dramas were inseparable from its specifically political, particularistically Athenian context.[249] It was from this fusion of the cognitive and the moral – as paradigms articulated according to a logic of the concrete in mythic narratives rather than explicit conceptually elaborated ethics that philosophers such as Aristotle produced – with an emotional toning derived from their sensuous expression in music, dance and visual spectacle that the traditional *paideia*, of which tragedy was one element, derived its cultural force and to which Plato so violently objected.

Aristotle overcomes Plato's objections by disembedding tragedy from its civic and theatrical context. Just as the philosophical schools broke with civic institutions and patterns of cultural transmission, so Aristotle integrates the corpus of tragedy with rationalist culture by constituting it as a text to be read and reflected upon. The relevant stock of knowledge to be invoked by the reader is no longer the set of traditional myths which articulate and explore Athenian civic identity, nor experience derived from participation in the civic, religious and military life of the polis (including its choruses), nor indeed the normative discourses of the democratic polis. It is instead an array of universally communicable critical tools which establish the reader's aesthetic distance from the text, allow him to make explicit the bases upon which the text constructs meaning, and thereby to master it intellectually. Far from being a straightforward counterblast to Plato's account of mimesis, and hence a resource by which visual artists might have sought to legitimate their own claims, Aristotle's *Poetics* brings tragedy, the Dionysiac, under the control of reasonable philosophic discourse, *logos*, by excluding its non-verbal components: music, dance and visual spectacle. Greek rationalism valued the word and expended great effort on its analysis. Owing to its particular nature as a form of material culture, the tragic text was more easily separated from its civic context and inserted in a new context of appropriation than works of visual art like civic portraits or cult statues. By the time a similar break was established between the city and its images, in the art collections of the

[246] *Poet.* 1462a1–12. [247] Bernstein (1971).
[248] On the centrality of the visual in the experience and the thematics of Greek tragedy, see Zeitlin (1994).
[249] Goldhill (1986), (1990).

Hellenistic kings, the institutional project of the visual artists had collapsed, subverted in part by the sociologically and culturally rooted antagonisms of their models and potential allies, the philosophers.

CULTURE, SOCIAL STRUCTURE AND THE LIMITS OF ARTISTIC RATIONALISATION IN CLASSICAL GREECE

The picture I have presented is a complex one. In certain respects, the institutional functions of art in the classical polis promoted artistic rationalisation. The development of naturalism in religious art and portraiture, on one level, augmented artistic agency and the exploration of a series of formal problems of representation with their own specific logic, irreducible to the social context out of which they had emerged – like perspective and ponderation. On another level, whilst encouraging artists in wide-ranging formal explorations of their arts, naturalism discouraged the rationalisation or autonomisation of art as an institution, since it embedded art more deeply in the moral and practical culture of traditional oral paideia, and thus encouraged what was an aesthetically unreflective relationship to visual art on the part of most viewers. This also set certain limits on what might be considered acceptable forms of experimentation (Mikon and perspective) or acceptable solutions to representational problems which could have more than formal entailments within the institutional contexts in which they were consumed.

Similarly, the development of the new intellectual culture played an ambivalent part in the rationalisation of art as an autonomous cultural domain. On the positive side, the ideas being developed by intellectuals in mathematics and medicine provided means (both figurative techniques and such intellectual tools as writing) by which artists were able to rationally reconstruct their own agency in order to provide solutions to the inceasingly complex representational problems that the development of civic art posed to them. Furthermore, communication and dialogue with the practitioners of other disciplines, which were also being created and transformed as part and parcel of this process of rationalisation, offered artists models for rethinking their own role, both as practitioners of art and in their relationship to the public that commissioned art. Both of these processes partially disembedded artistic practice and the role of artists from direct social control as new forms of artistic agency and new levels of artistic self-consciousness were developed, particularly in the context of the market situation of the fourth century BC.

Some artists did produce work which could lend itself to purely formal readings, in which the artist's technical accomplishment was, or could be, the

primary focus and meaning of the work, but much of this lent itself easily to assimilation to the dominant institutional frames. Further, there is little evidence to suggest the development either of the new social settings for the consumption of art or of new circuits through which art might circulate, which played such a crucial role in the much more marked autonomisation of art in Renaissance Italy and imperial China. In the former case, in addition to responding favourably to artists' claims to higher status on the supposed model of classical antiquity, the humanists also played a major role in the development of private art collections and the commissioning of works specifically intended for such collections, and consequently not subject to the traditional religious and moral constraints associated with church and public art.[250] In the case of imperial China, the literati artists withdrew from the production of monumental art for public contexts, such as wall paintings in temples or palaces, in favour of restricted production of small-scale paintings circulated in private amongst the literati artists themselves.[251] The dominant role of public art in monumental formats amongst the elite artists of classical Greece restricted such developments there.[252] Although intellectuals and philosophers may have purchased or commissioned works of art, such little evidence as we have suggests that they were used in traditional ways, for votive or funerary purposes.[253] Rather than developing new contexts for the consumption of art or new more specifically aesthetic criteria for the evaluation of visual art, philosophers simply gave new, rational, grounds for traditional moral and ethical criteria for the judgement of art. Aristotle recognised that we might take pleasure in paintings of trivial or unpleasant objects, like animals and dead things, but explained this only through the intellectual pleasure of recognition and learning, of which it represented a relatively low form.[254] In evaluating the qualities of different painters, his judgements are no different from the politically conventional judgements that were characteristic of popular poets like Aristophanes almost a century earlier, praising the morally elevating character painting of Polygnotos, whilst condemning the trivial caricatures and morally degrading pornography of Pauson.[255] In reaffirming the modes of judgement that were characteristic of the dominant institutionalisation of art in the

[250] Hauser (1962) 34–40; Burke (1986) 108. [251] Levenson (1957), Cahill (1994) 113–48.
[252] Even ostensibly private sculpture like funerary monuments was strongly oriented to the public sphere. Most art produced for the private sphere – painted pottery for example – was of a relatively low status, proportionate to the privileging of the public sphere and political life by the Greek state.
[253] Diog. Laert. v.15–16; Frischer (1982).
[254] Arist. *Poet.* 1448b1–13; cf. Fronto, *Ep.* 1.7.4 on Apelles' painting giving value to worthless subjects, such as monkeys and wolves; Moreno (1979b) 502.
[255] Arist. *Pol.* 1340a38; Ar. *Ach.* 854; *Thesm.* 948; *Plut.* 602.

classical city, philosophers such as Plato and Aristotle were following the lead of at least some amongst the foremost artists, who should not be seen as a wholly coherent group, undivided amongst themselves in the promotion of artistic rationalisation. The fourth-century painter Nikias, in particular, seems to have played a somewhat conservative role. Nikias criticised the development of new subjects in painting, such as birds and flowers, on the grounds of their triviality, and advocated instead traditional subjects such as naval battles and cavalry engagements, which had a greater inherent dignity and afforded the artist more scope in developing varied figural compositions.[256] Between the tensions amongst artists themselves, and those between artists and other cultural specialists, specifically aesthetic or artistic values were never able to trump political ones. Even in the third century, when practices of collecting and connoisseurship were being developed (see chapter 5), the Sikyonian politician Aratos, on liberating his city from tyranny, insisted that the figure of the former tyrant Aristratos in a painting by the fourth-century painter Melanthios be erased, notwithstanding the fame of the painter and the quality of the painting.[257]

Cultural rationalisation was an uneven process in classical Greece, and a hierarchical one. The relationships with other cultural specialists and access to the new cultural resources which facilitated artistic rationalisation ultimately also proved to be a significant constraint on artists. The mutual interaction between artists and wise men such as doctors and sophists, and the direct intellectual exchange it promoted, characteristic of the fifth century, seems to have slackened somewhat during the course of the fourth century, along with sculptors' interest in reproducing the more peripheral signs of medical knowledge.[258] Visual artists had taken what they needed in order to reconstruct their own practice of design, and boundaries hardened as the cultural disciplines became increasingly institutionalised. In fourth-century Hippocratic treatises it is a topos that artists' knowledge of the human body is merely superficial, amounting to nothing more than observation and manual reproduction of bodily signs, bereft of the theoretical insight that allowed doctors to understand and explain in causal terms the relationship of underlying bodily structures and psychic dispositions to surface symptoms.[259] Aristotle concedes that there is a rational dimension to art – and is even prepared to concede to those who reflect on that dimension through theoretical writing, such as Polykleitos, the status of

[256] Demetrios, *On Style* 76. [257] Plut. *Arat.* 13.
[258] The more peripheral signs of medical knowledge, for example, representation of cephalic and saphenous veins, disappear – Metraux (1995) 49.
[259] *On the Art* 12; *Regimen* I.21; with Metraux (1995) 59–60, 97.

an educated man, *mousikos anēr*; but such theorisation and the status that goes with it are seen to be a secondary (if more elevated) sideline to art, rather than an intrinsic and necessary component as it seems to have been for Pamphilos and in the later European academies.[260] Sculpture and painting share in the rational, conceptual component that is characteristic of all *technai*, but they are not set apart from other *technai* by virtue of that component, as they were to be in the Renaissance – a claim that was then given institutional basis in the Florentine academy.

The status of artists was enhanced, though it remained lower than that of other cultural specialists such as doctors, philosophers and orators. Sculptors' and painters' agency was significantly transformed by processes of rationalisation but primarily in relation to their performance of a traditional role linked to the provision of adequate expressive symbolism for established religious and civic purposes. Some artists produced autonomous works which challenged the prevailing institutional definitions of the functions of art, and the accepted role of artists, but this was, in the end, a marginal phenomenon. Caught between traditional definitions of the role and function of art which dominated patterns of patronage, and scepticism about the specific value of visual art on the part of the dominant cultural elites, classical Greek artists were unable to redefine the established institution of art and achieve a breakthrough to autonomy comparable to that realised in the post-medieval West.

[260] Settis (1973).

REASONABLE WAYS OF LOOKING AT PICTURES:
HIGH CULTURE IN HELLENISTIC GREECE
AND THE ROMAN EMPIRE

INTRODUCTION: ART AS AN AUTONOMOUS PROVINCE
OF MEANING

'Did you not see as you came in', he said, 'the most beautiful statue of a man set up in the hall, the work of Demetrios, the maker of portrait statues?' 'Are you talking about the discus thrower,' I replied, 'the one bent over according to the position for the throw – his head turned back towards the hand which holds the discus, the opposite knee slightly bent – looking as though he is about to spring up with the throw?' 'Not that one,' he said, 'since that is one of the works of Myron, the discus thrower that you mention. Nor am I speaking of the one beside him, that beautiful statue of a man binding his head with a fillet (*ton diadoumenon*), for that is a work of Polykleitos. And forget about those to the right of the entrance, modelled by Kritios and Nesiotes, the Tyrannicides; but if you notice the one beside the flowing fountain, the one with the fat paunch, balding, left half-naked by the hang of his cloak, with some of the hair of his beard wind-blown and with protruding veins, the very image of a real man, he is the one I am speaking of; he is thought to be Pellichos, the Corinthian general.'[1]

The setting of the second-century AD satirist Lucian's tall tales of statues with magical properties of movement and healing – popular superstitions here as elsewhere ridiculed by the rationalist intellectual – is a familiar one in the literature of the late Hellenistic and early imperial Roman periods. A hall or peristyle garden in a private house, or a marginally 'public' more specifically cultural space such as a lecture hall, is decorated with sculptures and paintings (or copies thereof) by classical artists – Demetrios, Polykleitos, Myron, Kritios and Nesiotes all flourished in the fifth or early fourth centuries BC. Here, these works of art are taken out of their original contexts: civic agoras in the case of honorific portraits such as the Tyrannicides, or a sanctuary, like that of Zeus at Olympia, where major athletic festivals were held, in the case of athlete statues such as the Diskobolos and the Diadoumenos.[2] In this new setting, they are valued as much or even more as the works of great artists than they are valued in terms of the pragmatic social and cultural effects that such objects realised in their original social context, as discussed in chapters 2 and 3.

[1] Lucian, *Philops.* 18. [2] Cf. Philostr. *Imag*; Lucian, *The Hall* esp. 21–32.

The immediate epigraphic framing of statues in these new contexts, neatly emblematises the changing status of the artist vis-à-vis the person represented in the construction of the viewing experience. The anonymisation of the athlete statues mentioned by Lucian's narrator could hardly stand in greater contrast to their original function of commemorating the *kleos* of victors. The new centrality of the artist is epigraphically indicated and accomplished on a series of first-century BC/AD statue bases found in Rome that bore classical or early Hellenistic originals expropriated from Greece (by then conquered), or conceivably copies of classical originals. In some cases the artist alone is named in a formulation – OPUS·BRYAXIDIS, OPUS·PRAXITELIS, and such like[3] – that binds object and artist in a closer relationship, through the possessive genitive, than the more conventional *epoiei* of classical Greek artists' signatures (or *fecit* in contemporary Roman artists' signatures). In others, inscribed in Greek rather than Latin but also located in Rome, the person represented is named – generally a famous man, often a cultural figure such as an orator or philosopher – and the artist's 'signature' as maker is added underneath, but given equal status with the name of the subject represented. Examples are a set of five bases from the Villa Matthaei in Rome (figure 5.1),[4] and a more recently discovered group of late Republican bases from Ostia (figure 5.2).[5]

These inscriptions insert the image in a quite different realm of meaning from the pragmatic social contexts of exchange, benefaction and social prestige that we saw in chapters 3 and 4. They point towards a cultural heritage that transcended the particularistic communities of specific cities, namely the heritage of literature, philosophy and, on an apparently equal footing, the arts of sculpture and painting. A base like that of Zevi, no. 1

Plato, the poet of the Old Comedy, Lysikles made it.

ΠΛΑΤΩΝ Ο ΤΗΣ ΑΡΧΑΙΑΣ
ΚΩΜΩΔΙΑΣ ΠΟΙΗΤΗΣ
ΛΥΣΙΚΛΗΣ ΕΠΟΙΕΙ.

removes the portrait from the kind of social relationship it might have been used to construct in classical Athens. It is valued equally as a representation of a great cultural figure, Plato the comic poet, and as the work of the (otherwise unattested but presumably classical) artist Lysikles. Perhaps the neatest example of this shifting frame occurs with the statue of Pythokles from Olympia. We looked at this base in the last chapter (see figure 4.1 on p. 154) and noted the relative marginality of the artist Polykleitos' signature at the back left-hand corner of the upper surface of the base, whereas the athlete's name frames the

[3] *CIL* VI.2.10039–43. [4] *IGB* 481–5. [5] Zevi (1969/70).

ΔΙΩΝ ΦΙΛΟΣΟΦΟΣ ΕΦΕΣΙΟΣ
ΣΘΕΝΝΙΣ ΕΠΟΙΕΙ

Δίων φιλόσοφος Ἐφέσιος.
Σθέννις ἐποίει.

ΤΙΜΟΘΕΟΣ ΑΘΗΝ....
ΠΟΛΥΚΡ......

Ṭιμόθεος Ἀθην[αῖος].
Πολυκρ[άτης ἐποίει].

ΥΠΕΡΙΔΗΣ ΡΗΤΩΡ
ΤΕΥΣΙΑΛΗΣ ΕΠΟΙΕΙ

Ὑπερίδης ῥήτωρ.
[Ζ]ευ[ξ]ιά[δ]ης ἐποίει.

ΛΥΣΙΣ ΜΙΛΗΣΙΑ
ΔΗΜΟΚΡΙΤΟΣ ΕΠΟΙΕΙ

Λυσὶς Μιλησία.
Δημόκριτος ἐποίει.

...ΠΟΣ ΙΠΠΑΣΟΥ ΠΕΛΟΠΟΝ...
ΚΑΛΑΜΙΣ ΕΠΟΙΕΙ

- - - πος Ἱππάσου Πελοπον - - -
Κάλαμις ἐποίει.

Figure 5.1 Statue bases from the Villa Matthaei, Rome; after *IGB* 481–5.

statue from the privileged viewing position in front of the base. At the turn of
the first century BC/AD the statue was removed and replaced with another statue
(conceivably a copy, if we assume the original fixing holes were damaged),
probably facing to the original right side of the base. A new inscription was
cut on the top surface of the base at its new front. At the end of the nineteenth
century a base for the removed original (or a copy of it) was found in Rome with
an inscription (figure 5.3) which again removes the statue from its pragmatic
Olympian context and celebrates it as much as the work of the artist Polykleitos
as for being a representation of the athlete Pythokles. Just as performing a Bach
mass in a concert hall is an act of a rather different order from performing it as
part of divine service in a church,[6] so setting up a statue in this way, and of
course viewing it, is an act of a rather different order from the case when the

[6] Parsons (1951) 411.

Figure 5.2 Bases for portrait statues by Lysikles, Phradmon and Phyromachos; from Ostia, *c.* first century BC. Photo: Archivio Fotographico della Soprintendenza per i beni archeologici di Ostia.

statues were originally set up and viewed in their civic or specifically religious contexts.

Disembedded from their original social contexts, how were these images to be read in their new frames? Such collections of 'pictures so beautiful and varied', characterised by 'the exactness of their technique (τῆς γὰρ τέχνης τὸ ἀκριβές)' and their 'antiquarian interest', 'call for a cultivated spectator (πεπαιδευμένων θεατῶν δεόμενον)', Lucian tells us.[7] The components of this

[7] *The Hall* 21.

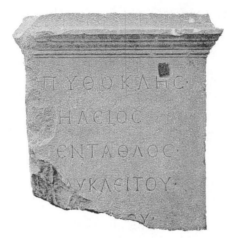

Figure 5.3 Base for statue of Pythokles by Polykleitos, from Rome, *c.* first century AD.
Photo: after *Bulletino Communale* (1891), tav. x.1.

sophisticated culture of viewing, available to be deployed in such specifically artistic contexts as those represented by Lucian and Philostratos, in order to engage with real pictures, must be reconstructed from a variety of sources. These include the remnants of ancient art history writing in the first-century AD Roman Pliny the Elder's encyclopaedic *Natural History*, in addition to a wide array of not specifically aesthetic texts in which elite Greeks and Romans deploy or evoke elements of a socially and culturally distinctive ethos of viewing.

This elite culture of viewing was characterised by an extensive formal aesthetic vocabulary, a knowledge of classical artists' names and of the history of classical (fifth- and fourth-century) art, what Pierre Bourdieu, speaking of modern western high culture, characterises as the indicators of the development of specifically artistic competence.[8] Mastery of these cultural tools made it possible to name and apprehend stylistic differences. Dionysios of Halikarnassos, for example, characterises a set of wall paintings as follows:

The paintings on the walls were both *very precise in their lines* and also pleasing *in their mixture of colours*, which had a *brightness* completely free of what is called tawdriness.

αἱ ἐντοίχιοι γραφαὶ ταῖς τε γραμμαῖς πάνυ ἀκριβεῖς ἦσαν καὶ τοῖς μίγμασιν ἡδεῖαι, παντὸς ἀπηλλαγμένον ἔχουσαι τοῦ καλουμένου ῥώπου τὸ ἀνθηρόν.[9]

[8] Bourdieu (1968) 594–6, 604; (1987) 204. [9] Dion. Hal. *Ant. Rom.* XVI.3.6.

These concepts allowed viewers to make explicit the variable aesthetic bases on which artistic meaning was constructed, and through which different aesthetic effects were achieved:

There are some old paintings which are worked in simple colours (χρώμασι μὲν εἰργασμέναι ἁπλῶς) without any subtle blending of tints (οὐδεμίαν ἐν τοῖς μίγμασιν ἔχουσαι ποικιλίαν), but precise in their outline (ἀκριβεῖς δὲ ταῖς γραμμαῖς) and thereby possessing great charm (πολὺ τὸ χαρίεν ἐν ταύταις ἔχουσαι); whereas the later paintings are less well drawn (εὔγραμμοι μὲν ἧττον), but are more elaborately worked (ἐξειργασμέναι δὲ μᾶλλον), having a subtle interplay of light and shade (σκιᾷ τε καὶ φωτὶ ποικιλλόμεναι); and they are effective because of the many nuances of colour that they contain (καὶ ἐν τῶι πλήθει τῶν μιγμάτων τὴν ἰσχὺν ἔχουσαν).[10]

The mastery of these cultural tools allows the viewer to divide the inherited universe of representations and order it in time as manifesting the accomplishments of individual artists in the elaboration of an artistic tradition, set apart from the realm of everyday life, rather than reading forms implicitly in order to construct an extra-artistic order of social or religious meaning. The portrait of Miltiades on the painting of the battle of Marathon, in the *Stoa Poikile* at Athens, for example, which in the classical period was incorporated in political discourse by orators like Aeschines in terms of political prestige and civic memory,[11] is now read art historically in terms of the development of the specifically aesthetic means of artistic representation:

Indeed Panainos, the brother of Pheidias, painted the battle of the Athenians against the Persians which took place at Marathon; by that time the use of colours had gained so much ground and the art had reached such a level of perfection that he is said to have painted actual portraits of the leaders (*iconicos duces pinxisse*) in the battle, Miltiades, Kallimachos and Kynageiros on the Athenian side, Datis and Artaphernes on the barbarian side.[12]

The personal styles of artists are clearly recognised and explicitly distinguished, and the correct attribution of works to painters and sculptors becomes a preoccupation of informed viewers and of art history writing.[13] These verbal and visual skills are developed and applied in a practice of attentive looking, characterised by a minute examination of works of visual art 'poring over them minutely and in every detail'[14] and set apart from the hustle and bustle of everyday business, 'since such appreciation is something for those with leisure and requires deep silence in our surroundings'.[15] This interest in art as such was

[10] Dion. Hal. *Isaeus* 4. [11] See ch. 3, p. 136. [12] Pliny, *HN* xxxv.57.
[13] Cic. *De or.* III.7.26; Philo, *On Drunkenness* 89; Dion. Hal. *Dem.* 50, *Dinarchus* 7; Pliny, *HN* xxxvi.28–9; Fronto, *ad Verum Imperatorem* 1.1.
[14] Plut. *Mor.* 470a. [15] Pliny, *HN* xxxvi.27.

associated with the development of a system of related practices and new social roles such as collecting and collectors, dealing and dealers, forging of old masters and forgers, and touristic travelling in order to contemplate such 'visenda' ('must-sees') as Apelles' *Venus Anadyomene* ('Rising from the Sea'), Timomachos' *Medea* or Myron's cow.[16]

Both sociological perspectives on high culture and classicists' analyses of ancient high culture have assumed that in all cultures the development of such practices takes place within the framework of a discourse of 'art loving'.[17] Weber's studies of cultural rationalisation, however, suggest that the patterning of art as a relatively autonomous domain or province of meaning in different cultural traditions may vary across three dimensions – not only by virtue of the social distribution of these practices and the varying degrees to which they are mastered by their practitioners, but also by virtue of the dominant cultural and value patterns which are institutionalised in a society and, on a slightly lower level of cultural generality, by the shape of the cultural practices used to articulate art as a province of meaning. Practices of collecting, connoisseurship and high-cultural viewing consequently function not only to mark status but also to form their practitioners as bearers of a culturally (as well as socially) distinctive *aesthetic ethos*.[18] This chapter analyses the social and cultural conditions that gave rise first to art history writing, and then to the construction of a distinctively Graeco-Roman high culture, which were components of an elite aesthetic ethos. Chapter 6 explores the ways in which the development of art history writing, together with the practices associated with this distinctive high-cultural aesthetic ethos, informed art production in the late Hellenistic world and the early Roman empire. The distinctiveness of the Graeco-Roman pattern of artistic differentiation has two primary dimensions: structural and cultural. First, on a structural level, art becomes disembedded from its traditional political and religious functions only to a very limited, if nevertheless signficant, extent. In so far as it does become differentiated, it is much more closely tied to the lifestyle of a relatively restricted social elite than is modern high culture. Notwithstanding many parallels with the modern world of high culture, there is no structurally autonomous cultural field in which institutions and interests specific to art world participants might have developed. On a cultural level, the

[16] Juv. *Sat.* 3.215–22 – statues by Polykleitos and Euphranor to decorate a private house; Hor. *Sat.* II.3.18–76 on Damasippos, dealer in and collector of old statues; Phaedrus, *Aesop's Fables* VPref. 93 on dealers attributing works to early artists – Praxiteles, Myron, Zeuxis – rather their actual contemporary producers and forging their signatures in order to get a better price. This seems to contradict recent suggestions that ancient viewers/collectors did not distinguish between originals and copies – otherwise there would be no need to forge – contra Bartman (1992) 11–13.

[17] Bourdieu (1984), Di Maggio (1982). [18] Hunter (1992).

rationalist cosmology that was characteristic of Greek intellectual culture, together with associated cultural practices derived from elite rhetorical and philosophical education, engendered an aesthetic ethos that stylised how viewers related to works of art in a quite distinctive way. Through such practices, members of the elite formed themselves as subjects of aesthetic experience significantly different in sensibility and aesthetic orientation from the art lovers of the modern West, whose aesthetic ethos was profoundly shaped by patterns of Christian culture, in secularised form.[19]

COURTS, CULTURAL ORGANISATIONS AND COLLECTING: PERGAMON, ALEXANDRIA AND THE INVENTION OF ART HISTORY

Introduction

Ancient art history writing survives only in somewhat dismembered form. The primary surviving material consists of a set of narrative histories of bronze sculpture, marble sculpture and painting in books XXXIV–XXXVI of the *Natural History*, a kind of encyclopaedia, of the first-century AD Roman writer Pliny the Elder. Occasionally in the course of these books, and more systematically in book I, which summarises the contents and sources of the entire *Natural History*, Pliny makes reference to the Greek art writers on whom he is drawing. In addition, we can gather some sense of the nature and authors of Hellenistic art writing from surviving fragments and attestations of works scattered throughout texts primarily concerned with other matters.[20] Pliny seems to have had access to a number of fourth-century technical treatises – Euphranor's *On Proportion and Colours* as well as the writings of Apelles and Parrhasios, for example.[21] His primary sources for his continuous story of Greek art as the development of the means of artistic representation by individual artists seem to have been Xenokrates, Antigonos and Duris of Samos.[22]

[19] For the Christian background to modern high culture, see chapter 1; for a study including both ancient and modern high culture and art history writing, see Alsop (1981); on the Greek case – perhaps the best short synthesis, though largely derived from Hansen (1971) – 187–208. Like more recent sociological work, Alsop interprets the phenomenon largely in terms of elite status-marking and does not address the specifically rationalist character of Greek high culture. For a more systematic comparative sociological analysis, see Tanner (2005).

[20] Cf., e.g., Diog. Laert. II.15; II.104; Ath. v.210; XIII.605–6. Most of the relevant fragments were collected by Urlichs (1887).

[21] *HN* XXXV.129; *HN* I, s.v. libro xxxv.

[22] On Pliny's sources, see the introductions to the Budé editions of books XXXIV–XXXVI, with full reference to earlier secondary literature. Sellers (1896) is still the best starting point, with Isager (1991).

In this section of the chapter, I wish first (pp. 213–14) briefly to sketch what we know of these three art writers (all near contemporaries writing probably in the third century BC) and their writings. Then, I shall set their writing in the context of the changing social structure and cultural practices of the intellectual field in Hellenistic Greece (pp. 215–19) before looking at the monarchic expropriation of civic art, art collecting and the associated development of new modes of display in Alexandria and Pergamon as contexts which perhaps gave rise to and motivated the extension of intellectual practices already established for litera-ture to the visual arts (pp. 219–27). I shall then further elaborate the courtly context of the new ways of seeing associated with art history writing (pp. 227–33). Lastly, I shall draw together the different strands of the argument by showing the interconnection of Pergamon, collecting, artistic tourism, new modes of display and new modes of response to visual art in a new Hellenistic genre of art writing, the ekphrastic epigram (pp. 233–4).

The art history writers

Xenokrates of Athens was a sculptor, the son of Ergophilos and pupil of Tisikrates or Euthykrates, one of the sons of Lysippos.[23] His own son, Themistokles, also became a sculptor. On the basis of literary and epigraphic testimonia his sculptural activity is dated in the period 280–230 BC and, along-side Antigonos, he was amongst the artists called to work on the monuments at Pergamon which memorialised Attalid victories over the Gauls. According to Pliny he wrote about painting as well as about his own art, sculpture.[24] The range of Xenokrates' writing, extending to other artists' work and other arts than his own, suggests a broader intellectual purpose than the more specific technical treatises of his fourth-century predecessors, which were designed to rationalise their particular artistic practices and the cultural transmission thereof, and thereby to enhance their status. That said, Xenokrates' histories of painting and sculpture were in certain respects continuous with and depen-dent on the cultural innovations, in particular the aesthetic conceptualisations, of the fourth-century artists' technical writings, on which, like Pliny, Xenokrates in all probability drew. His story of art was a technical one, of the solution by particular artists of specific representational problems of painting

[23] My sources for this account of Xenokrates are: *EAA* III.1234 s.v. (Moreno); Picard (1957); Linfert (1978); Pollitt (1974) 74–7; Susemihl (1891) 515–17; Urlichs (1887) 29–32; *RE* IXA.2 1531–2 no. 10. The crucial synthesis is Schweitzer (1932), which reviews almost all the relevant evidence, although his account is embedded in a deeply modernising conception of creative arts. For recent modern summaries of the evidence, largely following Schweitzer, see Rouveret (1995), Settis (1995b).

[24] *HN* XXXIV.83; XXXV.68.

and sculpture in the picturing of the natural world. In painting, for example, Kimon develops foreshortening (*katagrapha*),[25] Apollodoros shading (*skiagraphia*), techniques further developed by Zeuxis, and so on.[26] Correspondingly the concepts that Xenokrates drew on to compare different artists and evaluate their contribution to the development of sculpture and painting were those developed by the artists themselves in their technical writings: *symmetria*, *rhythmos*, line, light, shade and colour.

Duris was born *c.* 340 BC. He was a pupil of Theophrastus *c.* 304–302 BC and at some point after the battle of Ipsos, 301/0, probably at the turn of the century, became tyrant of Samos.[27] He was still living in 262 BC. Duris' attested writings include a number of histories (*On Agathokles, Makedonika*), literary writings (*On Tragedy, On Euripides and Sophocles, Homeric Problems*) and *On Painting* and *On Sculpture*. The range of his writing befits the encyclopaedic codification of knowledge undertaken by Aristotle's Peripatetic successors led by Theophrastus. The titles of the works of Duris on painting and sculpture, the first of a non-professional, perhaps also suggest a changing social-cultural horizon for writing on art, being entitled, in the case of painting, περὶ ζωγραφίας καὶ ζωγράφων, 'On painting and painters',[28] rather than περὶ ζωγραφικῆς (sc. τέχνης), 'On the art of painting', as in the case of professional painter-writers like Melanthios.[29]

A more shadowy figure, or possibly two, is Antigonos.[30] One Antigonos, like Xenokrates, was a sculptor active in the mid third century, attested in literary and epigraphic sources as working on the Gallic anathemata at Pergamon. Like Xenokrates, Antigonos wrote on both painting and sculpture and was used by Pliny as a source. Another Antigonos, from Karystos, studied with the philosopher Menedemos of Eretria, and must be identical with the contemporary homonymous paradoxographical philosopher from the same city. Wilamowitz identified the artist and the philosopher, but the identification is by no means certain and perhaps improbable on chronological grounds.

[25] *HN* xxxv.56. [26] *HN* xxxv.60–1; cf. Plut. *de glor. Ath.* 2 = *Mor.* 346.

[27] On Duris: Susemihl (1891) 1.524, 585–92; Urlichs (1887) 21–9; Linfert (1978); *EAA* III.198; *RE* v 1853–6 (Schwartz); Jacoby, *FGrH* IIA no. 76, 138–58 esp. 147; Müller, *FHG* II. 466–88, esp. 487. Pédech (1989) is the most recent and the fullest monographic treatment.

[28] Diog. Laert. I.38. Following Ms F, with Urlichs (1887) 21, though cf. Ms BP with *zographikes*. For another Hellenistic artist-writer who seems to have switched from a technical to a historical focus see the painter Artemon, writing *peri zographon*, 'On artists', Harpocration s.v. Polygnotos.

[29] Diog. Laert. IV.18; cf. Pédech (1989) 270–3 on the cultural significance of the shift in titles.

[30] On Antigonos: Susemihl (1891) 1.468–75, 519–24; Urlichs (1887) 33–45; *EAA* I.416 (S. Ferri); *RE* I.2421, no. 19 (C. Robert); Wilamowitz (1965); Hansen (1971) 398–402; Pollitt (1974) 77. Andreae (1990) 67–9 casts doubt on the identification. Dorandi (1999) suggests that Andreae's arguments depend on too early a dating of the death of Menedemos and favours Wilamowitz's original identification of artist and philosopher.

The intellectual context of Hellenistic art history writing

The shift in the social and cultural context of art writing – from artists writing as artists and at least ostensibly and primarily for other artists, to intellectuals, some of whom may also happen to be artists, writing for other men of culture – seems to have been permanent. Pasiteles, in a Roman milieu in the late second and early first centuries BC, is the only later artist of whom we know who wrote about art, and then his writing is not oriented to the rationalisation of his own art or rational pedagogic transmission but is a work entitled *nobilia opera in toto orbe*, presumably about famous works of the past (which his own classicising work, designed for the Roman collectors' market, echoed). More common are men like Pliny and Juba of Mauretania, whose interest in art and motivation for writing about it are purely intellectual, not practical. Juba, born *c.* 50 BC, was brought up in Rome after his father, the king of Numidia, had supported the wrong side in one of Rome's civil wars.[31] He was a member of the first emperor Augustus' circle and accompanied him during the war against Antony, before being made client-king of Mauretania in *c.* 25 BC. A prolific writer, Juba produced treatises on geography, history (*Libyca*, *Assyriaca*), natural history, linguistics, drama and theatre, and a work in at least eight books entitled περὶ γραφικῆς καὶ ζωγράφων, of which a few fragments survive.

We hear of no writers after the late fourth and early third centuries who wrote about their art in the same way as Polykleitos, Apelles, and so on – with the possible exceptions of Xenokrates and Antigonos, whose writings seem to have been more intellectual and cultural than practical and pedagogic. That is not to say that artists necessarily stopped writing such theoretical treatises, although Pliny's famous *cessavit deinde ars* ('then art stopped') has been interpreted as saying such.[32] One also hears relatively little about post-classical architectural writers – Hermogenes of Priene being the primary exception – but it is unlikely that Vitruvius was the only Roman-period architect to write about his art.

It seems that an intellectual hierarchy of cultural practices crystallised in the late fourth and early third centuries, excluding the visual arts from the set of practices accorded highest prestige, above all philosophy and rhetoric. This is reflected in the relatively modest claims for rationality made by Vitruvius on behalf of architecture and accorded by Galen to sculpture and painting.[33]

[31] On Juba: *RE* IX 2384–95 no. 2 (Jacoby); Müller, *FHG* III. 465–84; Jacoby, *FGrH* IIIA no. 275; Harpocration s.v. Polygnotos, Parrhasios. Pliny was familiar with at least Juba's scientific writings: *HN* v.16.

[32] *HN* XXXIV.52; Pollitt (1974) 26–8.

[33] Vitr. I.1; Galen *Protreptikos* 14. Discussed in more detail in chapter 6.

Cultural boundaries hardened with the increasing institutionalisation of the intellectual field in the late fourth century and the Hellenistic period. The development of a differentiated intellectual field, on the level of social organisation as well as cultural practices, was marked by the foundation of a permanent philosophical school with buildings and an endowment by Aristotle in his will, and, most importantly, the foundation of specifically cultural institutions, libraries and 'museums', most notably in Pergamon and Alexandria by the Hellenistic monarchs. Even if artists continued to write theoretical treatises further to rationalise their own practices and to facilitate pedagogic transmission, their writings were less likely to circulate amongst a broader intellectual community than had been the case in the relatively fluid situation of the classical period. In such circumstances it would not be at all surprising if artists had ceased to write. Their institutional project for artistic autonomy had failed. There was no 'museum' to support artists producing art for art's sake as there was for scientists, litterateurs and philosophers in the institutions sponsored by the Hellenistic monarchs. Purchases and commissions were still overwhelmingly for various forms of art tightly bound to specific political and religious contexts: portraits, cult statues, and the propaganda projects of the Hellenistic monarchs, largely tied to traditional iconographic languages by virtue of the kings' desire to legitimate themselves in the eyes of a Greek world still primarily organised in terms of more or less autonomous poleis. Artistic training was still predominantly practical and workshop-based. The social motivations for writing that had existed in the fourth century were, therefore, undermined.[34]

Whether or not artists' treatise writing actually stopped in the third century, the social and cultural context for such writing changed, and this may have affected the nature of the writing itself. As the conceivable purpose of art-theoretical writing changed to being more purely professional and pedagogic, less a claim to membership in the highest intellectual community, and as the institutions of the intellectual field crystallised and excluded visual artists, so the writing and reading of the two groups grew increasingly distant from each other. Artists' theoretical writing was progressively less oriented to a wider intellectual community, and intellectuals proper had progressively less reason and inclination to read contemporary artists' theoretical writings. At any rate, the effect seems to have been the closure of the corpus of art-theoretical writing available in intellectual (literary and philosophical) circles in the late fourth and early third centuries BC, immediately prior to the foundation of the Libraries

[34] Contrast the formation of the Academic system in post-Renaissance Italy and Europe often – as in France – with the political and financial support of the princes and monarchs of the newly emerging states, and the place of art writing in it.

and Museums in Alexandria and Pergamon, which events doubtless reinforced that closure.

Two of the major Hellenistic dynasties, the Attalids and the Ptolemies, established institutes of higher learning during the course of the third century BC, the former a library and Athenaeum at Pergamon, the latter a library and Museum at Alexandria, so named after the deity or deities under whose protection the association of scholars in each institution supposedly worked.[35] The kings provided funds for the support of intellectuals such as poets, historians, scientists and scholars of all kinds including, at Pergamon but not Alexandria, philosophers. The libraries aimed to make a comprehensive collection of purchased or laboriously copied manuscripts of the entire Greek literary heritage in the broadest sense, from poetry to medical and, presumably, art-theoretical writing, all of which was to be organised, catalogued and researched by the scholars who worked at these institutions.

Before these foundations, there had only been relatively limited personal libraries, like that of Aristotle at the Lyceum. The vastly increased scale of the collections – estimates for Alexandria range between 100,000 and 700,000 scrolls, whilst the library at Pergamum may have contained some 200,000 scrolls in the first century BC – qualitatively transformed their nature and functioning.[36] Libraries no longer simply contained writings, but themselves generated another level of writing as a means of organising their contents, in addition to further scholarship and literary writing generated as a result of actually reading the books. The poet scholar Kallimachos, working in the library at Alexandria, produced a catalogue for the library, known as the *pinakes* or 'tablets' and itself some 110 volumes. This classified the contents of the library – in effect the archive of written knowledge – by authors, listed alphabetically, genres worked in (oratory, lyric poetry, epic, philosophy, etc.), and individual works.[37] Exactly the same organisational tools – alphabetical lists of painters and sculptors, lists of genres and those who worked in them – are also used in Pliny the Elder's chapters on art history. Amongst the other organisational devices employed by Hellenistic scholars to manage and order their vast written stock of knowledge was the development of successions and canons. Successions, διαδοχαί, of philosophers were essentially 'rosters of pupils and teachers in continuous series'.[38] Amongst those we know to have established such lists of philosophical succession is Antigonos of Karystos.[39] The practice could easily enough be transposed into writing histories of

[35] Pfeiffer (1968) 96–104; Fraser (1972) 323. [36] Hansen (1971) 273–4; Fraser (1972) 328–9.
[37] Kennedy (1989) 202; Pfeiffer (1968) 129; Onians (1979) 69. [38] Fraser (1972) 453.
[39] Fraser (1972) 453 n. 58.

sculpture and painting. Such successions seem to have been an interest of the art writer Antigonos,[40] and are a key organisational tool in Pliny the Elder's chapters on art history.

Like all codifications of an inherited tradition, that of Hellenistic scholarship was selective and evaluative. In part for educational purposes, a drastically reduced list of writers in each genre – three tragedians, for example, and nine lyric poets – were established as classics (Gk: *enkrithentes* – adjudged into the highest rank or class; Lat.: *classici*). Similar lists seem to have been established for other cultural figures – physicians and law-givers for example – and for sculptors and painters.[41] A second-century papyrus, the *Laterculi Alexandrini*, has lists of 'law-givers', 'painters', 'cult-statue makers' (*agalmatopoioi*), 'makers of statues of men' (*andriantopoioi*), and 'inventors'. The law-givers named are Zaleukos, Solon and Lykourgos; the *agalmatopoioi*, Pheidias, Praxiteles and Scopas; the *andriantopoioi*, Myron and Polykleitos.[42]

All traditions are selective, of course. But Greek intellectual culture was particularly predisposed to closure (and the involuted pattern of development that characterises it in the Hellenistic and Roman periods) by virtue of its underlying cosmology, and the way in which the presuppositions embedded in that cosmology shaped accounts of cultural development. This is best exemplified by Aristotle's assumption that any literary genre develops teleologically to reach its natural form – given by the rationality embedded in nature – at which point it stops. The same conception informs the stories of sculpture and painting in Pliny the Elder (see below, pp. 239–46). This contrasts markedly with the radically self-transforming nature of western culture – artistic, literary and scientific – in the post-Renaissance period. Classicism – the respect for naturally given traditional boundaries not to be transgressed – is built into Aristotelian cultural ideology. Much of post-classical Greek and Roman art and literature can be interpreted as an involuted elaboration of cultural patterns within those given boundaries. The Second Sophistic is perhaps the most characteristic expression of this pattern of cultural process. These boundaries were marked out and enforced by the characterisation of perceived transgressions as going against the natural order. This built-in assumption that there is some natural end point for cultural innovation is in sharp contrast to Judaeo-Christian ideas, in their rationalised Protestant form, where the 'naturally given' is not sacred, but is, rather, morally neutral matter to be instrumentally mastered and transformed, *ad infinitum*, with no obvious given or preconceived end point for the process. To be sure, there are many classicist movements in the art, literature

[40] Urlichs (1887) 41. [41] Onians (1979) 61; Marrou (1956) 161. [42] Fraser (1972) 456.

and music of the West (though not, as in antiquity, in science and medicine) in part precisely because much of classical critical theory is built into the heritage of the modern West. These classical elements sit alongside culturally dominant Christianising presuppositions. And it is perhaps hardly coincidental that the major artistic breakthroughs, involving fundamental transformation and reorganisation of expressive forms, as opposed merely to elaboration and adjustment largely within or on the basis of inherited patterns, are often associated with intensified expression of the ideology of creativity – one thinks, for example, of Michelangelo or Beethoven – partly recognising the extraordinary cultural transformation effected by the artist, partly legitimating a change which goes beyond the limits of the previously dominant artistic paradigm and cannot be justified within its framework of aesthetic norms.

Courts, libraries, collecting and display

A number of cultural and social processes, we may conclude, converged to create a closed 'great tradition' of classical Greek art and artists: the failure of the fourth-century artists' institutional project; the crystallisation of differentiated intellectual institutions which excluded artists as practitioners; the separation of subsequent art-theoretical writing from the intellectual tradition codified and reproduced in the Hellenistic museums and libraries; the development of a teleological account of cultural development which placed 'natural' limits on it. Moreover, we have seen how intellectual practices were developed in the context of the organisation of the legacy of written documents in the Hellenistic museums, practices which were eminently suited to extension, and in fact ultimately were extended, to the construction of histories of painting and sculpture alongside those of philosophy and the various genres of literature.

But why should Hellenistic writers have been more disposed to extend these intellectual practices to the visual arts than Aristotle had been disposed to extend his critical practices? In part perhaps the creation of specifically cultural institutions in Pergamon and Alexandria, attached to the royal palaces, and set apart from the cities (which were both, in fact in the case of Alexandria, in practice in the case of Pergamon, new foundations) distanced the intellectuals from the civic mimetic functions of art in traditional poleis, which had so prejudiced (for good socio-cultural reasons) Plato and Aristotle against visual art. In new cities, without as yet much visual art and without art tied to the reproduction of pre-rational cultural traditions as in the cities of old Greece, the visual arts may not have seemed so threatening to intellectuals' own cultural projects. Perhaps just as Aristotle was able to break the connection between

tragedy and the civic context of its reception by reading the text, so both at Alexandria and at Pergamon classical works of art became available for viewing extracted from the original civic and religious contexts in which they made sense as signifiers of extra-artistic meanings. As will be seen, the chronology here is less than clear, and it may well be the case – though I suspect it was not – that art history writing and the concomitant valorisation of classical art as art preceded the expropriation and collection of art by Ptolemy Philadelphos (308–246, founder of the Alexandrian Museum and Library) and Attalos I (269–197, founder of the Pergamene Athenaeum and Library). The precise ordering is not important, and over-precision might in fact be misleading. I am concerned to delineate a number of distinct cultural and social processes which favoured the development of art as an autonomous province of meaning, but were not in isolation or simple mechanical succession adequate causes of such an outcome. Rather they converged in a historically specific configuration in which they interacted to promote the constitution of art as an autonomous province of meaning more strongly than they could have done alone or merely additively. Expropriation of old art by force or purchase and cultural valorisation were complementary and mutually re-enforcing processes, the former giving rise to further writing on art and ultimately the creation of new kinds of viewing context, the latter motivating art collecting.

Classical art and its appropriation in Ptolemaic Alexandria

In Athenaios' *Deipnosophistai*, there is preserved an account by Kallixenos of Rhodes (second century BC) of a procession organised by Ptolemy Philadelphos in Alexandria in about 276 BC. The procession itself can be read as a massive and spectacular demonstration of Ptolemaic power and prosperity.[43] Dionysiac imagery evoked Alexander's triumph in the East and Ptolemaic claims to be heirs to that legacy. A fantastic assortment of wild animals – elephants, Père David deer, Leira and Sanga antelopes, ostriches, parrots, peacocks and gui-neafowl, amongst others – along with tribute bearers and camels carrying such exotica as myrrh, frankincense, saffron, cassia, cinnamon and other spices, signified virtual world dominion, representing, as they did, both the riches of Ptolemaic trade and 'political gifts to the king from rulers of lesser domains, which were the natural habitats of the beasts'.[44] Claims to influence and dominion in the Greek world also were not lacking. One cart in the procession carried a statue group consisting of Ptolemy, alongside Alexander, being

[43] Rice (1983), Pollitt (1986) 280–1. [44] Rice (1983) 86.

crowned by a personification of Corinth, perhaps alluding to the league of Corinth and pan-Hellenic claims to Greek hegemony inherited by Ptolemy from Alexander. This was followed by another cart bearing women who represented cities from Ionia, Asia and the islands that had been under Persian control until Alexander's great expedition. Set somewhat apart from the main viewing station in the stadium and the route of the procession, 'inside the enclosure of the citadel, at a distance from the place where the soldiers, artisans and tourists were entertained', was a vast pavilion, holding some one hundred and thirty couches, each seating three diners.[45] The pavilion was elaborately beautified with decorations thematically integrated with those of the parade – Dionysiac thyrsoi for columns, tableaux from Dionysiac drama, shields and military cloaks with portraits of kings woven into them, pelts of animals 'extraordinary in variety and size': 'Placed beside the pillars which supported the pavilion were figures in marble, one hundred in all, by artists of the first rank; in the intercolumniations were panels by painters of the Sikyonian school, interspersed with a wide variety of the most select images.'[46]

Quite how Ptolemy acquired these Sikyonian paintings is not clear. Conceivably, they were contemporary commissions and thematically integrated with the political programme of the pavilion. But in that case we might expect Kallixenos to have told us something of their programmatic content, as he does for the elements of the procession and other parts of the pavilion. More probably they should be read – fitting the rather unspecific frame in which Kallixenos presents them – analogously to the exotica from the South and the East and the representations of the Greek cities: tokens of Ptolemy's hegemony over Greece and his capacity politically and materially to appropriate its cultural wealth, represented by masterpieces from the leading school of Greek painting, the Sikyonians. The specific content of the paintings is unimportant. In one way or another, relations between Ptolemy and Sikyon were close during this period, and one can easily imagine a number of slightly different scenarios according to which Ptolemy might have acquired Sikyonian paintings as a token of the relationship. Following Ptolemy's expedition to the Peloponnese in 308 BC, Sikyon – as well as Corinth and Megara – was garrisoned by Ptolemaic forces until 303 BC. In the 270s and 260s Sikyon was ruled by a series of tyrants periodically and briefly replaced by elected chief magistrates or *archons*, with at least one of whom, Kleinias, Ptolemy had a relationship of guest-friendship, until Kleinias was assassinated in 264 BC.[47] This relationship was inherited by Kleinias' son, Aratos,

[45] Ath. v.196a. See Winter and Christie (1985) for a recent reconstruction.
[46] Ath. v.196e. [47] Griffin (1982) 78–81.

a child at the time, who was taken away to the safety of Argos. When Aratos grew up, he returned to Sikyon, and soon rose to a position of prominence, partly by virtue of considerable financial support from Ptolemy. In *c*. 250 BC, when unrest arose in Sikyon on the return of exiles who wished to reclaim property now occupied by others, Aratos,

> seeing that his only hope lay in the benevolence of Ptolemy, hastened to sail to Egypt and beg the king to contribute money for the resolution of these disputes ... he found both that the king was naturally well disposed towards him and that he had been effectively courted by means of the drawings and paintings which he had received from Greece. Aratos had not unrefined judgement in these matters (ἐν οἷς κρίσιν ἔχων οὐκ ἄμουσον), and continually collected and acquired works of particular artistic skill and merit, especially by Pamphilos and Melanthios, which he then sent to Ptolemy.[48]

By 250, at any rate, these paintings being acquired by Ptolemy were 'old masters': Pamphilos flourished in the first half of the fourth century and Melanthios was one of his pupils. Both must have been long dead by the time of Aratos' activities.

Classical art and its appropriation in Attalid Pergamon

The somewhat fuller evidence from Pergamon presents a similar picture, although once again the chronology is less than clear.[49] The art collecting of Attalos II (r. 160–138 BC) is well attested in Pliny's *Natural History*. Following the sack of Corinth in 146 BC, Attalos 'bought for 600,000 denarii a picture of Father Liber or Dionysus by Aristeides', a fourth-century painter, only to have it withheld by the Roman general Mummius who, realising from the price offered that it must be a work of some consequence, assigned the painting for dedication in the temple of Ceres at Rome.[50] A series of statue bases inscribed with the names of the artists of the (now lost) statues and *ex Oreou* or *ex Aiginēs* ('from Oreos', 'from Aigina') attests to appropriation of works of art by Attalos I (r. 241–197) from cities captured, garrisoned and incorporated in his kingdom during campaigns in the Aegean in the last decade of the third century (figure 5.4).[51] Amongst these is the base for a statue by the sixth-century Aiginetan sculptor Onatas, the son of Mikon, probably the Apollo also mentioned by Pausanias as being in Pergamon,[52] and the base for a statue by

[48] Plut. *Arat*. 12.
[49] On Attalid collecting, see M. Fränkel (1891); Schober (1951) 37–42; Hansen (1971) index s.v. art collecting, esp. 316–17, 353–5, 367–8. For the broader background of Pergamene Kulturpolitik, see Schalles (1985).
[50] *HN* XXXV.24; cf. XXXV.100; VII.126; Paus. VII.16.8. [51] *IVP* 48–50. [52] Paus. VIII.42.7.

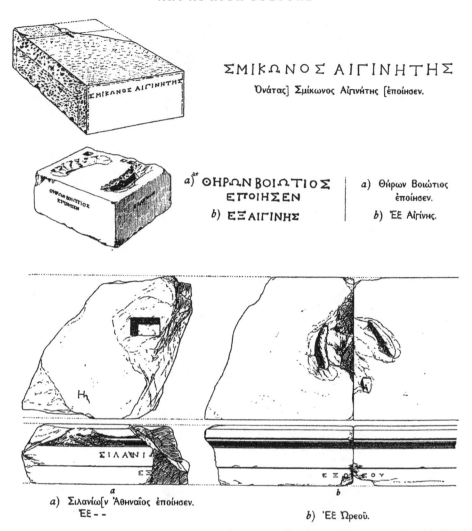

ΣΜΙΚΩΝΟΣ ΑΙΓΙΝΗΤΗΣ

Ὀνάτας] Σμίκωνος Αἰγινήτης [ἐποίησεν.

a)ᵗ ΟΗΡΩΝ ΒΟΙΩΤΙΟΣ
ΕΠΟΙΗΣΕΝ

b) ΕΞ ΑΙΓΙΝΗΣ

a) Θήρων Βοιώτιος
ἐποίησεν.

b) Ἐξ Αἰγίνης.

a) Σιλανίω[ν Ἀθηναῖος ἐποίησεν.
ΕΞ - -

b) Ἐξ Ὠρεοῦ.

Figure 5.4 Statue bases from the sanctuary of Athena Nikephoros, Pergamon, late third/early second century BC – for statues by Onatas, Theron and Silanion, captured as booty from Aigina and Oreos. Drawing: after *Inschriften von Pergamon* (1890), nos. 48–50.

the fourth-century Athenian sculptor Silanion. Another set of statue bases (figure 5.5), probably for what were once honorific portraits, similarly display only the artist's name – amongst them Myron (fifth century), Praxiteles (fourth century) and Xenokrates (possibly/presumably the sculptor/art-writer, so third century).[53] In the absence of the statues themselves it is of course impossible to be certain that the Myron and Praxiteles in question were the classical

[53] *IVP* 135–40.

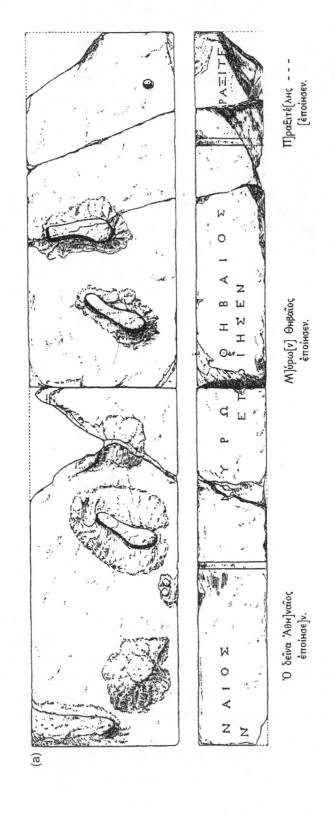

Πραξιτέ[λης - - -
[ἐποίησεν.

Μύρω[ν] Θηβαῖος
ἐποίησεν.

Ὁ δεῖνα Ἀθη]ναῖος
ἐποίησε]ν.

Ξενοκράτη[ς - - -
[ἐποίησεν.

Figure 5.5a and b Statue bases from the sanctuary of Athena Nikephoros, Pergamon, early second century BC, for statues by Myron, Praxiteles and another (*IVP* 135–7), and by Xenokrates (*IVP* 138). Drawings: after *Inschriften von Pergamon* (1890), nos. 135–8.

sculptors, rather than homonymous successors, or indeed that the Xenokrates is the third-century sculptor/art history writer rather than a homonymous predecessor/successor – a far from inconceivable possibility in a society where craft skills were transmitted down family lines, and grandsons were frequently given their grandfather's name. In the light of the literary evidence for other pre-Hellenistic works of art by famous artists demonstrably expropriated from their original context and placed in a new setting in Pergamon, recent scholarship has preferred to assume that the bases were for expropriated classical works of art.[54] Other works by pre-Hellenistic artists to be found at Pergamon, and in all probability acquired by the Attalids in similar fashion to those listed above, include statues of the Graces 'in the chamber of Attalos' by the sixth-century Chiot sculptor Boupalos, a painting of *Ajax Struck by Lightning* by the fifth-century painter Apollodoros, and a *symplegma* (group of intertwined figures)

[54] Carpenter (1954); Pollitt (1986) 166, 311 n. 13; R. R. R. Smith (1991) 156; Hansen (1971) 316–17; Radt (1999) 291–4. Mielsch (1995) prefers to see the bases as being for statues by contemporary artists, as part of an argument against any connection between Pergamon art collecting and art history writing, but ignores both the larger cultural context of collecting and writing at Pergamon, and the specific character of the bases; these thematise the artist alone in a way that is not characteristic of the bases of homonymous contemporary artists practising elsewhere in the Greek world, where signatures remain relatively small and marginal in relation to the text specifying the subject and occasion of a dedication of a statue – cf. Marcadé (1953–7) II.58–62 Myron and II.10–11 Skopas; *IGB* 318–19 Praxiteles; *IGB* 320–1 Leochares.

by the younger Kephisodotos (late fourth or early third century).[55] In addition, the Attalids commissioned copies of great classical works that they were not in a position to acquire, including the *Tyrannicides* by Kritios and Nesiotes, the Pheidian *Athena Parthenos* and possibly the frescoes by Polygnotos in the *leschē* or 'club-house' of the Knidians at Delphi.[56]

Whilst the sanctuary of Athena Nikephoros, 'the bringer of victory' (and her temple), in which these statues were set up, was established by Attalos I, it was substantially reorganised during the reign of Eumenes II, though without changing its character as a monumental celebration of Attalid military victory. The sanctuary was entered through a massive propylon, inscribed on the architrave above the Doric columns of the lower story 'King Eumenes [dedicated this] to Athena Nikephoros' and decorated on the balustrade between the columns of the Ionic upper story with representations of piles of armour, Greek and Gallic, trophies of Attalid victories (figure 5.6).[57] In addition to the specific programme of sculptural decorations which celebrated Attalid victories over the Gauls and were set up in the sanctuary, the expropriated classical sculptures were also on one level dedications to Athena and metonyms of Attalid power vouchsafed by the goddess. In view of this religious context, Zanker has argued that it is difficult to imagine their reception by viewers as pure works of art.[58] Up to a point he is certainly correct, but specifically aesthetic and political/religious readings need not have been mutually exclusive in this ambiguous context; Napoleon's Louvre is perhaps an obvious comparison.[59] The removal of honorific portrait statues, as some of these sculptures are thought to have been, from their original context and from the communal and pragmatic frame of reference in which their original viewers would have interpreted them, would certainly have made their deciphering in their new Pergamene context somewhat problematic. Similarly, for those of the statues which in their original context were votives, commissioned as such, their rededication will have broken the internal relationship between the objects' content and style and the votive action performed in its dedication, such as we saw in chapter 3. In brief, the frame provided by the rededication of these works as votives and metonyms of Attalid victory broke the relationship between the aesthetic structure of the works of art (form and style) and their

[55] Paus. IX.35.6, *HN* XXXV.60, *HN* XXXVI.24. [56] Hansen (1971) 355, 360; M. Fränkel (1891).

[57] On the precinct of Athena and the Attalid victory monuments there, see Hansen (1971) 300–6; Onians (1979) 106–7; Pollitt (1986) 79–89; Webb (1998) – all following the full publication of the excavation in Bohn (1885) and M. Fränkel (1890).

[58] Zanker (1978) 288–9. [59] McClellan (1994) 124–54.

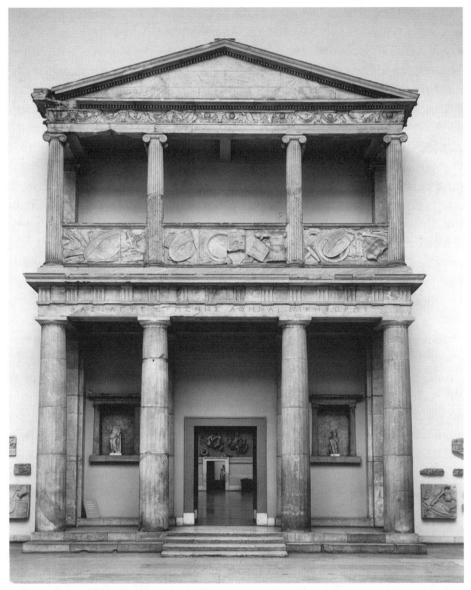

Figure 5.6 Reconstruction of the Propylon to the sanctuary of Athena Nikephoros, Pergamon, *c.* 170 BC. Pergamon Museum, Berlin. Photo: Museum.

expressive meaning. As such it was not fully adequate to their specific aesthetic properties.

The archaeological and historical context strongly suggests a connection of some kind between the way in which these expropriated images were displayed and the development of specifically aesthetic or art-historical modes of viewing.

227

First, two of the artists who worked on Attalos I's victory monument set up in the sanctuary of Athena Nikephoros were Xenokrates and Antigonos, the art history writers. Secondly, immediately adjacent to the sanctuary of Athena, effectively an annex of it, entered through the stoa which surrounds the sanctuary, are the remains of what most scholars identify as the Pergamene library or Athenaeum (figure 5.7).[60] In the main room of this complex, stood a copy, one-third original scale, of the Athena Parthenos of Pheidias (figure 5.8), complete with the elaborate reliefs of its base, once again probably to be dated to Eumenes' reorganisation of the sanctuary. Like the classical statues in the sanctuary, the Athena is removed from the specifically Athenian iconographic programme which tied the statue into communal mythic and religious traditions and removed from the architectural-artistic framing of the statue in the Parthenon, where the exterior frieze positioned the approaching viewing-subject as a votary in a sacrificial procession and thereby encouraged the appropriation of the statue of Athena in a ritual attitude as an epiphany of the goddess herself.[61] The statue of Athena in the Pergamene library does not function as a periodic embodiment of the divine power or personality of Athena, nor does it even point to such a power. Athena is here rather a metaphor, signifying, on the one hand, the role of the library as a place of cultural pursuits and, on the other hand, Pergamon's appropriation of the cultural heritage of Athens, both literary and artistic, above all the writings now preserved in the Pergamene library. If the Athena was not read in specifically religious terms – and in that context she could not be – it is not unreasonable to suppose that the classical statues in the sanctuary of Athena Nikephoros might also have been read in terms articulated on a similar level of cultural generalisation to those presupposed by the Athena as metaphor of intellectual culture. The unusual epigraphic framing of the classical statues exclusively in terms of their artists' identities does point towards a specifically aesthetic/art-historical reading of them, at least by those equipped with the cultural knowledge to accomplish such a reading, and hence to the developing differentiation of art as an autonomous province of meaning from more directly political or religious uses and meanings of art. However, the mere

[60] Mielsch (1995) questions the traditional identification, preferring to see it as a treasury for a display of the goddess's votives. It is reaffirmed (though with new reconstructions of the arrangements of the library) by Knesebech (1995), Hoepfner (1996). The current excavator gave some thought to relocating the library – unconvinced by Hoepfner's reconstruction (Radt 1998, 18–19), but in his recent synthesis retains the traditional identification, in part on the basis of the numerous portrait statues of literary figures dedicated in the sanctuary – Homer, Alkaios, Timotheos, Herodotus (Radt 1999, 165–8).
[61] Cf. Fehr (1979/80), R. Osborne (1987).

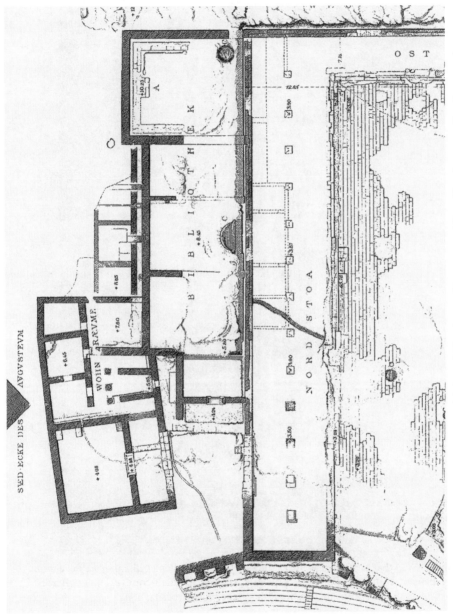

Figure 5.7 Plan of the sanctuary of Athena Nikephoros, Pergamon. After *Altertümer von Pergamon*, vol. II: *Das Heiligtum der Athena Polias Nikephoros*, taf. XL.

Figure 5.8 Athena Parthenos, from the sanctuary of Athena Nikephoros, Pergamon.
Hellenistic copy after Pheidias' Athena Parthenos. Date of copy, *c.* 190 BC. Berlin.
Photo: Bildarchiv Preussischer Kulturbesitz, 2004.

presence of these classical statues as triumphal votives in the sanctuary of Athena Nikephoros also suggests that there was not as yet (or at least, not here) a strong boundary between embedded art, involving a communal frame of reference and everyday institutional knowledge for its interpretation, and autonomous art to be read solely in terms of artists' elaboration of an aesthetic tradition.

In this respect it is interesting that the only two Hellenistic literary representations of viewers deploying a specifically aesthetic mode of viewing are set in the context of religious occasions.[62] In Herodas' fourth mime, written in the third century BC, two 'petit-bourgeois' women, Kynno and Kokkale, whilst waiting for the sacristan's pronouncement on the acceptance of their sacrifice to Asklepios, survey the sculptures and paintings in the cella of the temple. Their first concern is with the identity of the artists who made the statues:

> *Ko*: Goodness, Kynno my dear, what beautiful statues! Who was the master
> who worked this stone, and who is the one who dedicated it?
> *Ky*: The sons of Praxiteles. Do you not see the letters there on the base?
> And it was Euthies, the son of Prexon, who dedicated it.[63]

A little later, Kokkale's naively realist reading of a painting showing an oxen being led to sacrifice ('I would let out a scream of fear, lest the bull do me some mischief: he is so much looking at me askance, Kynno, out of one eye')[64] is supplemented by Kynno's rational aesthetic response in terms of the artist Apelles' artistic mastery, his *aletheia* (truthfulness – a technical term of Greek art criticism) and his virtuosity in the range of subjects he was prepared to paint. Only with this kind of knowledge, Kynno suggests, can one properly appreciate Apelles,

And whoever has looked at his works without gazing in just admiration, may that man be hung up by the foot in the fuller's house.

Aesthetic sophistication collapses into the bathos of vulgar colloquialism, which betrays the gap between Kynno's aesthetic pretensions and her social origins and gives the entire poem its ironic, humorous cast.[65]

In Theokritos' fifteenth Idyll, two similar women, Praxinoe and Gorgo, go to the palace of Ptolemy in Alexandria in order to participate in celebrations of the festival of Adonis. Once inside the palace, they gaze in admiration at the

[62] See Goldhill (1994) 216–23 for a much fuller literary criticism than I have space for here; also Preisshofen (1978), Gelzer (1985).
[63] Herod. *Mimes* 4.20–5. [64] *Mimes* 4.69–71. [65] *Mimes* 4.72–8.

tapestries and statues decorating the room or garden in which the festival is to be celebrated.

> *Go*: Praxinoe, come over here. First take a look at those tapestries, how fine and full of grace (λεπτὰ καῖ ὡς χαρίεντα); you would say they were robes fit for the gods.
> *Pr*: Lady Athena, what weavers must have laboured over them, what artists (*zographoi* – drawers of living things) drew the lines with such precision (ἀκριβέα γράμματ'). So true (ὡς ἔτυμ') to one standing, so true to one turning are the figures, they are alive, not woven. What a clever thing is man.[66]

These few lines are dense with the technical terms of Hellenistic aesthetic discourse: *poikilos* – intricate or subtle; *leptos* – fine; *charieis* – graceful; *etumos* – true; *akribeis* – accurate or precise; *sophos* – clever or intelligent. This representation of urbane aesthetic sophistication is, however, only set up in order to be undercut. The reader is meant to enjoy the piquant incongruity of refined Alexandrian high-cultural criticism coming out of the mouths of low-life characters, provincial immigrants from Syracuse with uncouth Doric accents, an incongruity to which Theokritos explicitly draws attention, through the voice of a man:

Wretched creatures, give your endless twittering a rest – perfect turtle doves; they utterly wear one out with all their broad vowels (*plateiasdoisai*).[67]

Whilst Herodas' life is something of a mystery, Theokritos was a court poet for Ptolemy Philadelphos at Alexandria from about 275 BC, and it is unlikely that the fifteenth Idyll was composed much after the date of the festival to which it refers, which probably took place in about 272 BC. It is certainly interesting that specifically aesthetic modes of viewing were sufficiently familiar at least in courtly and literary circles of the second quarter of the third century BC to be the object of poetic play. However, the literary contexts of these ironic skits on cultures of viewing make it difficult to infer very much more about the broader sociological and cultural context in which this mode of viewing was developing, beyond what we have already learnt from the less problematic, if also less direct and more fragmentary, evidence concerning the development of art history writing and art collecting. Is the collocation of ritual activity and aesthetic viewing a 'reflection' of the limited, hesitant differentiation of art as an autonomous province of meaning, or is it part of the joke? Here, as often, there is an

[66] Theoc. *Id.* 15.78–83. [67] *Id.* 15.87–94.

inverse relationship between the literary merit of the texts and their historical usefulness.

Courts, collecting and cultures of viewing

Thus far we have looked at the beginnings of art history writing, collecting, copying and the emergence of a new epigraphic framing of classical statues, alongside somewhat ambiguous traces of new specifically aesthetic viewing practices. Whilst it makes sense to assume that these practices are interrelated in antiquity as in the modern world, we can demonstrate this connection by looking briefly at a new mode of ekphrastic poetry developed in the Hellenistic period and manifested above all in epigrams. The use of poetry, and specifically epigrams, to construct subject-positions for viewers of works of art was – as we have seen – by no means an innovation of the Hellenistic period.[68] Hellenistic ekphrastic poetry is, however, culturally distinctive in so far as it explicitly thematises the artistic accomplishments of named artists, and it is sociologically distinctive in so far as it characterises the mode of viewing it invokes as *sophos*, 'wise' or 'clever', aligning itself with other elite cultural practices such as philosophy and rhetoric, and distancing itself from 'naive' non self-reflexive viewing.[69] The broader cultural and sociological implications of these epigrams I shall address below (pp. 245–6, 261–4). For the moment, I am concerned only to show the intersection of this new literary activity with the other components of art as an autonomous province of meaning in the Hellenistic world and with cultural activities sponsored by the Hellenistic monarchs. My point is quite simple. The artists and images that are the objects of this mode of writing are characteristically also the objects of the other practices that constitute art as an autonomous province of meaning, namely collecting, copying and artistic tourism (as well as, of course, art history writing).

To start with an example of a late archaic/early classical statue we have already encountered in Attalos' collection at Pergamon, Onatas' statue of Apollo at Pergamon is the subject of an artist-centred epigram by Antipater of Thessalonike, writing in the first century BC.[70] Antipater also wrote an epigram on the *Nekuia* (underworld) by the fourth-century Athenian painter Nikias, a painting which either Ptolemy or Attalos sought unsuccessfully to purchase from the Athenians.[71] Antipater of Sidon, writing in the second

[68] See Tanner (1999) 158–64 and above, pp. 66–7. [69] Preisshofen (1978) 264–8; Goldhill (1994).

[70] *Anth. Pal.* IX.238; Gow–Page, *GP* Antipater of Thessalonike 73, with Gow and Page (1968) II.85–6.

[71] *Anth. Pal.* IX.792; Gow–Page, *GP* Antipater of Thessalonike 85, with Gow and Page (1968) II.86–7 for resolution of the contradictory accounts of Pliny, *HN* XXXV.132 and Plut. *Mor.* 1093e.

century BC, composed an epigram celebrating Praxiteles' Knidian Aphrodite and his Eros at Thespiai.[72] Both statues are the subjects of a number of Hellenistic epigrams in praise of Praxiteles.[73] The Aphrodite of Knidos is named by Pliny as a statue which people undertake great journeys to see, and both statues are named by Cicero as *visenda* ('must-sees') which would not be parted with at any price by the cities which housed them.[74] King Nikomedes of Bithynia is said to have offered to pay off all the Knidians' public debts in exchange for the Aphrodite.[75] The Roman emperor Caligula apparently pinched the Eros from Thespiai, as did Nero (it had been returned in the mean time by Claudius), one of whose court poets, Leonidas of Alexandria, composed an ekphrastic epigram on it.[76]

In addition to epigrams on Myron's cow, a painting of Salmoneus by the fifth-century Thasian Polygnotos and two on Praxiteles' Eros, Geminus (probably C. Terentius Tullius Geminus, suffect consul in 46 AD and subsequently governor of Moesia) wrote an epigram on Lysippos' Herakles, which was eventually used to frame a copy of that statue by being inscribed on its base.[77] Leonidas' and Geminus' contemporary, Antiphilos, wrote an epigram celebrating Timomachos' painting of Medea – listed by Cicero alongside Myron's cow and Praxiteles' Eros amongst the works that cities would not part with at any price[78] – and another on a painting of Perseus and Andromeda, probably by the fourth-century Athenian Nikias. Both paintings may survive in copies of the same period from Pompeii.[79] Both Praxiteles' Eros and his Knidian Aphrodite, and Lysippos' Herakles, have been identified, with varying degrees of confidence, amongst the corpus of Roman copies of Greek sculptures.[80] The earliest textual and material evidence for such relatively close, apparently historically oriented, copying of the art of earlier eras comes from second-century BC Pergamon.[81]

[72] *Anth. Pal.* XVI.167; Gow–Page, *HE* Antipater 44.
[73] *Anth. Pal.* XVI.159–70, 203–6 – one (204) possibly by Praxiteles himself; see above, ch. 4.
[74] *HN* XXXVI.20; Cic. *Verr.* II.4.135. [75] *HN* XXXVI.21; VII.127.
[76] *Anth. Pal.* XVI.206; Page, *FGE* Leonidas 42 with Page (1981) 503, 540; Paus. IX.27.3.
[77] Gow–Page, *GP* Geminus 5–9 with Gow and Page (1968) II.294–5; *IGB* 534. [78] *Verr.* II.4.135.
[79] Gow–Page, *GP* Antiphilos 48–9 with Gow and Page (1968) II.142–3; *Anth. Plan.* 136, 147. On the difficulties of pinning down such identifications, and to some degree questioning the point of the activity, see Schmaltz (1989) and Bergmann (1995). Moreno (2001) gives a rather optimistic assessment of copies of Apelles in Pompeian paintings. Ling (1991) 128–35 offers a balanced discussion, 129 optimistic that we can identify the Perseus and Andromeda after Nikias, and 135 sceptical about picking the right version (if any) for Timomachos' Medea amongst the versions of that theme in Pompeii.
[80] Ajootian (1996) 98–102, 113–16; Edwards (1996) 145–7.
[81] Niemeier (1985) 154–9; M. Fränkel (1891).

A NATURAL HISTORY: PLINY'S STORY OF GREEK ART

Introduction

I now turn from the social and cultural context in which the project of art history writing was formed and accomplished, and in which the associated practices of collecting and display developed, to the cultural patterning of ancient art history writing, as manifested, in somewhat dismembered form, in Pliny the Elder's *Natural History*, books XXXIV–XXXVI. The traditional and still dominant approach, amongst classical art historians, to Pliny's art history writing has been collegial. Assuming that Pliny's fundamental assumptions and purposes in art history writing are the same as theirs, classical art historians regard his text primarily as a resource for writing their own slightly better-informed art history.[82] Pliny's text becomes a topic for analysis only in order to correct supposed errors or to evaluate the depth of his aesthetic sensibility so as to determine whether or not we can trust his judgement. This positivistic approach has at least performed the entirely necessary task of source criticism of Pliny and produced the scholarly commentaries which are an indispensable aid to the study of Pliny, whatever one wishes to do with him.[83] In practice, however, this approach reduces contemporary classical art history writing to a gloss on Pliny, taking for granted as the appropriate intellectual framework precisely the artist-centred account of classical art as the autonomous development of an aesthetic tradition modified by strong artistic personalities which I argued against in chapters 2–4. Such an approach is not so much wrong as sterile, and, in so far as it tends to exclude less 'factual' elements such as Pliny's 'anecdotes' on animals' responses to paintings, gives a misleading account of what was at issue for Pliny and his readers in the story of the development of Greek sculpture and painting.

The question of the accuracy and depth of Pliny's knowledge imperceptibly blends, as in modern art history writing, into evaluative questions concerning Pliny's 'connoisseurship'. Morehouse seeks to determine whether the Romans showed 'appreciation of the real value of art' and whether Pliny was a 'true appreciator of art' – sadly not, he concludes, because 'rhetoric gets the better of Pliny'.[84] Danneu-Lattanzi wishes to evaluate Pliny's 'aesthetic sensibility' and

[82] Coulson (1972), for example, defends Pliny's account of Euphranor's sculptural significance against charges of ignorance and incoherence. Cf. Smith (1991) 8: 'The purpose of this book [on Hellenistic sculpture] is to fill the blank left by Pliny and to show that it was a time of major innovation.'

[83] See Pollitt (1974) 73–81. Sellers (1896) is still the best starting point. More up to date are the Budé commentaries by Bonniec and Gallet de Santerre (1953) (XXXIV), André, Bloch and Rouveret (1981) (XXXVI), and Croisille (1985) (XXXV). Corso (1988) is a useful supplement.

[84] Morehouse (1940).

concludes that Pliny must have known a lot about art, because many of our modern western art concepts are derived from him – a somewhat less than compelling argument.[85] Michel, likewise, tries to discern in which aspects Pliny's art history writing was original, in order to determine his 'personal aesthetic'.[86] Heuzé, relying on the questionable assumption that 'the reactions to works of art have a certain perennial character', attempts to evaluate the quality of Pliny's art criticism. He concludes, on the basis of Pliny's interest in illusionism (which 'impresses the bourgeois, but has nothing to do with art') and his 'bourgeois' taste for anecdote, manifested in stories about animals deceived by works of art, that Pliny was nothing other than a vulgar bourgeois.[87]

More recent scholarship on the *Natural History* as a whole has laid great emphasis on the intellectual background of the entire work, in particular Pliny's Stoicism.[88] Developing this line of research, in this section I aim to put Pliny's story of art back in the context of Greek rationalist cosmology. This helps to make sense of what are, from the perspective of modern preconceptions about art, anomalies in Pliny's story: firstly, its strange structure with the 'end of art' in the early third century BC, and secondly, the role played in the story by such 'anecdotes' as Zeuxis and the grapes. The question of rhetoric and the 'authenticity' of Pliny's aesthetic response, I leave until later (pp. 246–64), where I shall analyse the social and cultural patterning of the deployment of art-historical knowledge by its bearers, as opposed to the underlying codes which structure the narrative and are my immediate concern.[89]

Natural history and art history

Rationalism, Stoicism and natural history

The first book of the *Natural History* is essentially an analytic table of contents. The second book opens with a statement of Pliny's conception of nature and man's place within it. Pliny's cosmology is fundamentally Stoic, with traces of Epicureanism and Platonism.[90] *Natura* is the world-immanent reason that animates and regulates the world. The power of Nature (*naturae potentia*) is

[85] Danneu–Lattanzi (1982). [86] Michel (1987) 59.

[87] Heuzé (1987) 34–6. [88] Beagon (1990); Isager (1991) specifically on the chapters on visual art.

[89] Consequently I am not concerned here with the *HN* as a whole as a particular 'speech act' in its specific historical and political context, that is, as a dedication to Titus as future emperor, future benefactor of mankind and hence potential god. On this dimension of the *HN* and its ramifications for certain of Pliny's preoccupations in his writing on sculpture and painting see Isager (1991) 18–31, 221–9 and Pascucci (1982).

[90] Beaujeu (1948), Gigon (1982), Della Corte (1982), Wallace–Hadrill (1990), Beagon (1990).

what we call god.[91] The anthropomorphic representations of so-called gods, from the Olympians to the personifications of virtues such as Pudicitia (modesty), Clementia (clemency) or Fides (faith) are marks of human weakness (*imbecellitatis humanae*), signs of insufficiently developed reason, and on a level with the 'mad fancies of children' (*puerilium prope deliramentorum*).[92] The 'divine power (*numen*) ... of Nature is diffused throughout the universe, repeatedly bursting out in different ways'. All the components of the universe, therefore, partake of world-immanent divine reason, though some very much more so than others. The sun, for example, is described as follows: 'It is the rational soul (*animum*), more precisely the mind (*mentem*) of the entire world. It should be held to be the ruling principle and divinity of nature ... It regulates according to nature's usage the cycle of the seasons and the recurrent rebirth of the year. It dissipates the gloominess of the sky and even calms the storm clouds of the human mind.'[93] The earth (*terra* – not to be confused with the 'world' *mundus*), also, though on a lower level, participates in the world-immanent divine order, Nature or world-immanent reason, which providentially regulates and orders the *mundus*. The earth therefore stands in its relation to man as part of the divine or sacred order, providentially giving to man innumerable *beneficia* for the enhancement of his life.[94] Even natural poisons are part of the providential order, a gift of earth and nature, providing a painless means of suicide when life hangs heavy upon an individual or a more horrible death threatens.[95]

How do man and his *technai*, or *artes* in Latin, fit into this world-view? Man's relation to Nature is doubly mediated through his higher reason, which sets him apart from animals, and through his sensuous body, which marks his continuity with the animal realm. Ideally his life should be one of rational adaptation to his providential situation in the world, rational enjoyment of the gifts of nature which fulfil his naturally given needs. This rational adaptation to the world is facilitated by the *artes* which are in essence pre-given in the pattern of the processes of nature to the craftsman (*artifex*). Nature, in the course of her natural processes, reveals and teaches the *artes* to man, who in turn learns them by imitating nature.[96] The use of clay for building, for example, is attributed to Toxeus, the son of Uranus, 'the example having been taken from

[91] *HN* II.27. [92] *HN* II 13–17. [93] *HN* II.13. [94] *HN* II.154. [95] *HN* II.154–6.

[96] See André (1978) for the best analysis of the nature of culture in Pliny. On Nature as teacher of the *artes* cf. Cic. *de Leg.* I.26: *artes vero innumerabiles repertae sunt docente natura*, 'innumerable arts have been discovered with Nature as teacher'. On *natura* as *artifex*: *HN* II.166. Isager (1991), unhelpfully, translates *artifex = technitēs* as 'creator'. On *technē* as an imitation of nature in Greek thought, see Schneider (1989) 206–16.

swallows nests'.[97] Men, it follows, 'are not the masters of nature. They are granted the knowledge that Nature wishes to grant them'.[98] The availability of herbs with medicinal properties is only in small part the result of human efforts. Rather, 'That same mother of all things (Nature) has both brought forth these things and shown them to us, and, if we are willing to confess the truth, there is no miracle of life greater than this.'[99] Active instrumental-rational mastery of the natural world – as opposed to theoretical-rational adaptation to the naturally given – is considered deviant, a sacrilegious affront against Nature. If Nature had intended man to make great use of gold, silver and iron she would have placed them accessibly on the surface, rather than hiding them in the depths of the earth.[100] Mining, excavation and extraction transgress the boundaries set by Nature, violating the earth:[101]

For what luxuries (*delicias*), for what abuses (*contumelias*), has nature been made to slave for man. She is hurled into the sea, or she is excavated to allow us to let in channels. At every hour with water, iron, wood, fire, stone, growing crops she is tortured, and much more besides in order to make her serve our luxuriousness (*deliciis*), not our sustenance. And yet, as if to make the sufferings she endures on her upper surfaces and her outer skin seem bearable, we pierce right into her entrails (*penetramus in viscera*), digging out veins of gold and silver and mines of copper and lead ...[102]

Pliny's 'moralising rhetoric' should be taken seriously. The precise definition of what was merely rational completion/perfection of nature and what went against nature was of course subject to social negotiation, and this was shaped by the interests, power and capacities for moral suasion of differing social groups. But the appeal to science was more than a simple rationalisation of traditional Roman morality.[103] In the context of Greek rationalist cosmologies, above all Stoicism, increasingly assimilated at Rome, *scientia* was a primary technology of morality, since it was through understanding the processes of Nature that man not only assimilated himself to the sacred through contact with cosmic reason, but also became able to adjust his attitudes, dispositions and conduct to a rational fit with Nature's providential course. *Scientia* was, for the Stoics as for Plato, a guide to the good life and as such had as real a moral force as traditional social norms. Indeed the reception and elaboration of Greek philosophy in late Republican Rome can only be properly understood in the light of the breakdown of the social order which had supported and been in turn sustained by traditional Roman morality, in the face of massive and speedy

[97] *HN* VII.194. [98] Isager (1991) 34; cf. *HN* VII.143. [99] *HN* XXVII.1–2 in Isager (1991) 41.
[100] *HN* XXXIII.1–4. [101] Cf. André (1978) 11–14; Isager (1991) 52–5. [102] *HN* II.157–8; cf. XXXIII.2–3.
[103] Wallace–Hadrill (1990) 90–2 emphasising the sociological aspects of Pliny's moral discourse.

social and economic differentiation.[104] The more generalised cultural codes elaborated in the Greek world offered a more adequate and flexible means of guiding action in and responding to an increasingly complex social world than the rather rigid social norms of traditional Roman moral culture.

Rationalism, Stoicism and the story of art

How then should we read Pliny's histories of sculpture and painting in the broader cultural context of Greek rationalist cosmology? In what follows I treat Pliny's account as a proxy for ancient art history writing in general, since my interest is in the discourse of ancient art history, not in Pliny's *Natural History* as such. My analysis, that is to say, is framed by the sociological problematic of cultural differentiation rather than by the more concrete philological problematic of Pliny's *Natural History* as a text in its own right. In practice this means that I shall slight some important problems one encounters in reading the chapters on sculpture and painting in Pliny, for example the fact that they 'form part of what is for us an entirely different topic, the taxonomy and technology of metal and stone ...'[105] Whilst it should become clear why art history can find a place in a 'natural history', it is possible to exaggerate the embeddedness of ancient art history writing. (Indeed Pliny himself at certain points in his texts signals a shift in discursive register from the normal way of going on in art-historical discourse to a more technical register and explains that the shift is motivated by the larger purpose of his work as a natural history rather than a history of painting and sculpture *per se*.)

To be sure, the very presence of art history in a 'natural history' suggests that the boundaries between art history and other forms of knowledge were perhaps less strong, and certainly differently configured, than is the case for modern art history. The structure of the history of all the 'arts and sciences' – an opposition actually foreign to Pliny who talks quite happily of the *scientia artium*, since *artes* are merely rational applications of forms of knowledge, *scientia* – is told in terms of *inventiones*, discoveries by man on the basis of the imitative instinct and what Nature freely shows or gives.[106] Pliny tells us, for example, about the history of warships from biremes to ships with forty banks of oars as a series of progressive *inventiones*.[107] There is nevertheless a hierarchy of rationality in

[104] Hopkins (1978) 1–98, esp. 74–96. [105] Gordon (1979) 7. [106] *HN* VII.123, 191–209.
[107] *HN* VII.206–8. *Invenit* should certainly not be translated as 'created', as it sometimes is. Nor, in *inventio*, does the painter or sculptor parallel the divine productive activity of *natura/phusis*. The semantic distinctions are neatly exemplified by the example of poison, to which nature gives birth (*genuit*) but which man discovers (*invenit*) – *HN* XVIII.2.

forms of cultural practice, and whilst painting and sculpture may occupy a considerably lower position than philosophy or rhetoric, they were held to offer a wider field for the play of human reason than, say, shipbuilding or clay-brick making. Consequently, whilst the ancient history of sculpture is in certain respects continuous with that of shipbuilding or brick-making, it is also discontinuous from them in so far as the considerably greater cultural elaboration of the stories of sculpture and painting reorganised the normative ways of viewing and using classical Greek art amongst the elite, whereas the primary relationship of the elite to shipbuilding and brick-making remained a practical, not a theoretical-contemplative, one. The story of art in Pliny's *Natural History* is, in respect of its content, preoccupations and cultural style, broadly continuous with a much more extensive set of cultural practices – from epigram writing to the discursive appropriation of paintings and sculptures in picture galleries and sculpture gardens. Even if Pliny is our only very extensive realisation of it, the discourse of ancient art history was autonomous of the particular setting Pliny gives it in his rather different, wider project of writing natural history.

Another extreme approach best avoided is that of the traditional analytic school, criticised by Gordon, which discounts the rhetorical, epigrammatic and 'anecdotal' components of Pliny's art history writing, in order to recover the 'properly' aesthetic/art-historical components of Pliny as a primary resource in writing a modern scholarly history of sculpture and painting in classical Greece, a history which is effectively an extensive and illustrated gloss on the appropriate sections of the *Natural History*.[108] This tradition is nicely illustrated by the Budé edition of book XXXIV, where, following Schweitzer, the introduction separates out the 'authentic' art-historical tradition of Xenokrates, transmitted by Antigonos and Varro, from the diverse accretions such as epigrams and anecdotes, usually attributed to Duris because he was not a professional artist.[109] Similarly, Pollitt distinguishes 'professional criticism', characterised by its employment of specifically aesthetic categories, from the 'rhetorical criticism' of the not very deeply cultured Greek and Roman elites, and 'popular criticism' which is characterised by a supposedly naive 'non-intellectual' interest in realism and bizarre stories about birds pecking at painted grapes.[110]

The purified story of art thus produced is an account of the development of an artistic tradition through the solution of that tradition's specifically aesthetic problems by individual artists. The art of painting, Pliny tells us, was discovered either at Sikyon or at Corinth:[111]

[108] Gordon (1979) 8. [109] Bonniec and Gallet de Santerre (1953) 70–84; cf. Schweitzer (1932) 47–52.
[110] Pollitt (1974) 9–72, esp. 63, trenchantly criticised by Gordon (1979) 8. [111] *HN* xxxv.15.

But all agree that it was initiated by tracing around a man's shadow with lines ... line drawing was discovered (*inventam linearem*) by Philokles the Egyptian or by Kleanthes the Corinthian ... the first to daub these drawings with colour, made from crushed pottery, as they say, was Ekphantos of Corinth. (16)

[There then follow 'digressions' on who brought painting to Rome, and on pigments, motivated by the wider projects, moral/political and natural historical, of the *Natural History* – as Pliny himself signals: 'Later discoveries – who made them and at what date in time – we shall discuss during our enumeration of the artists, since a prior motive for the work now in hand is to make known the natural properties of colours.']

Eumaros the Athenian was the first to distinguish the male sex from the female sex in painting and dared to imitate every kind of figure, and it was on the basis of his discoveries that Kimon of Kleonai improved. It was Kimon who discovered *katagrapha*, that is, oblique or three-quarter images, and it was he who began to vary the representation of the face, representing some looking backwards, some upwards, others downwards. He distinguished the various components of the limbs, raised the veins to visibility, and furthermore discovered the representation of creases and folds in drapery. (56) ... Polygnotos of Thasos was the first to make many contributions to painting, in so far as it was he who introduced showing the mouth open with the teeth visible, and who varied the appearance of the face from its archaic rigidity (58) ... Parrhasios was born at Ephesos and made many contributions to painting. He was the first to introduce systematic proportions (*symmetria*) to painting; he was the first to represent the lively expressions characteristic of the face, the elegance of the hair and the loveliness of the mouth. He is agreed by the judgement of artists to have won the palm in painting contour lines. (67)

And so on, coming to an end with the painters of the late fourth and early third centuries, Apelles and Protogenes.[112]

The story of sculpture has the same structure, narrating the development of the means of realistic representation, verisimilitude, within the framework of the aesthetic dimensions of symmetry, rhythm and precision (*diligentia*/*akribeia*). Where the painter Apollodoros discovered shading (*skiagraphia*), and thereby opened up the 'gates of art' which Zeuxis entered,[113] Pheidias

is deservedly judged to have opened up the art of statuary (*toreutike*) and to have pointed the way (XXXIV.54) ... Polykleitos is judged to have consummated the science of statuary and to have refined the art of metalwork, just as Pheidias is deemed to have opened up its possibilities. It is the personal invention of Polykleitos to have statues throw their weight on one leg. (56) ... Myron seems to be the first sculptor to have extended the degree of truth to nature; he was more concerned with compositional patterns (*rhythmoi*) in his art than Polykleitos, and more diligent in his proportions (*symmetria*).

And so the story continues until Lysippos, who

is said to have contributed a very great deal to the art of statuary, by modelling the hair in detail, by making the heads smaller than earlier sculptors had, and the bodies more slender

[112] *HN* XXXV.79–108, 111; cf. 135. [113] *HN* XXXV.61.

and lean, as a result of which his statues seemed taller in height. Latin has no name for *symmetria*, which he diligently preserved, changing the four-square figures of the old sculptors through the application of a new and untried system. (65)

Lysippos and his sons and pupils are mentioned, and then the history of sculpture effectively stops, as Pliny had said it would in his introductory comments, '*cessavit deinde ars* – then *ars* stopped' – after the 121st Olympiad, the *floruit* of the sons and pupils of Lysippos, 296–292 BC.[114] After a few words on Praxiteles, Pliny then proceeds to discuss in alphabetical order other sculptors who were important, primarily of the fifth and fourth centuries BC, but who did not play a leading role in the development of sculpture as Pliny told the story.

There are two primary respects in which Pliny's story of sculpture and painting embarrasses modern art historians: the apparent naiveté of its preoccupation with naturalism, and the strange end of art in 292 BC. Both problems are, however, generated by the presuppositions with which the modern reader comes to Pliny's text, namely an art history informed by the conception of artistic creativity and broader Judaeo-Christian cosmology. Both problems disappear when Pliny's story of art is read in terms of the rationalist cosmology that informs the *Natural History*, in particular the conception of Nature as world-immanent divine reason.

There have been various *ad hoc* attempts to explain away *cessavit deinde ars* – 'then art ceased'. The simplest is that Pliny's source, Xenokrates/Antigonos, stopped at this point. In practice, this is what conventional classical art historians assume, and they fill in Pliny's omission by continuing the story of Greek art down to the end of the Hellenistic period, partly relying on remarks Pliny makes about later artists in the context of, for example, his lists of artists in alphabetical order or by genre. The very idea of art stopping, it is assumed, is silly or worse; best ignore it.[115] Alternatively, it is suggested that *cessavit* is an aesthetic not a technical or historical judgement (an odd argument to make about an art-historical text), and should be associated with the influence of neo-Attic artists amongst Roman patrons in the second century BC. The most notable amongst these artists was Pasiteles, to whom the statement that art had revived (*revixit*) in the 156th Olympiad (156–153 BC) is attributed.[116]

In terms of the internal cultural logic of Pliny's art history, however, the fact that *ars* should stop requires no special external explanation. As I have pointed

[114] *HN* XXXIV.52. [115] Andò (1975) 80.
[116] Lawrence (1949), Gros (1978), Preisshofen and Zanker (1970/1), Preisshofen (1978).

out, Plinian art history, consistent with the cosmology of the *Natural History* as a whole and the conception of *ars/technē* implied by that cosmology, simply takes over the biological structure of the history of tragic poetry developed in Aristotle's *Poetics*.[117] There is no need, of course, to assume that Pliny or his sources were 'influenced' by Aristotle, merely that they shared common cosmological commitments which require that histories of *technai/artes* are told in the same terms as the growth of a natural organism to maturity; Aristotle's *Poetics* is merely the first example. In Aristotle, poetry arises, out of an instinct for mimesis and for tune and rhythm, in the form of improvisations. Homer was 'the first to show the main lines' of tragedy and comedy. The elements of tragedy – chorus, actors, metre, diction, and so on – evolved 'as men developed each element that came to light'.[118] Nature herself leads the way, discovering the 'proper metre' for dialogue, namely iambic. The great tragedians – Sophocles, Aeschylus, Euripides – are the human medium through whom tragedy realised its pre-given natural form, at which point it stopped (*epausato* – the Greek for *cessavit*).[119] Clearly tragedies did not cease to be written, as Aristotle, living in Athens, knew perfectly well. Simply all the literary resources required for composing a tragedy had been developed. Fourth-century tragedy was, according to this model, merely the variable recombination of all the given elements. Similarly, according to Plinian art history, the elements of painting and sculpture – line, colour, composition, symmetry, rhythm, and so on – develop until these two *technai* reach their natural form. Then they stop. The complete natural repertoire of representational techniques is held to be available. All that remains is for subsequent sculptors and painters to recombine those elements in appropriate ways in producing further works of art.

The artists are of course the medium of this process whereby the *technai* of sculpture and painting are developed, rather than being the agents or masters of the process. Something of the gap between the presuppositions about artists informing Plinian art history and those informing modern art history writing, where there is a profound tension between the inherited story of naturalism and the idea of the artist as creator, is nicely indicated by the rhetoric of Norman Bryson's critique of Pliny's account (and those of his 'successors' Vasari and Gombrich) as a straightforwardly wrong account of how artistic representation works and changes. 'The history of the image', in this story of art, Bryson complains, 'is written in negative terms ... The painter in this project is passive

[117] Onians (1979) 59–61; Webster (1952) 21–3.
[118] *Poet.* 1449a10–15. [119] *Poet.* 1448b4–1449a31.

before experience. A binary epistemology defines the world as anterior and masterful, and the painter's function before it is as the secondary instrument of stenographic transcription.'[120] Precisely what is objectionable in terms of the Judaeo-Christian and post-Protestant cosmology that informs the structure of the modern art world and the presuppositions of modern art history writing – a passive man and the primacy of the world – is the foundation, positively conceived as the primacy of nature and man's rational adaptation to it, in ancient art history writing. (This perhaps in part explains why the biography of the painter and sculptor never became a genre in antiquity, as one might have expected. The individual painter in antiquity has relatively little significance apart from his place within the evolving tradition of representation, which transcends him and of which he is merely the medium. In the modern West, the individual artist transcends as he transforms the tradition, and makes sense as an object of discourse in his own right. The first art history of the West, Vasari, is of course – in its organisation if not, given its Plinian inheritance, in its entire cultural patterning – a series of lives of great artists who transform a tradition, not, as in Pliny, the story of the development of a tradition in which artists merely play their part.)

Similarly, once seen in context, Pliny's animal stories may be interpreted as an integral component of his story of painting. Pliny records how Zeuxis, in a competition with Parrhasios,

produced a picture of a bunch of grapes, painted with such success that birds flew down to the stage buildings; Parrhasios produced a painted curtain, depicted with such a high degree of verisimilitude (*ita veritate repraesentata*) that Zeuxis, puffed up by the judgement of the birds, eventually demanded that the curtain be drawn back for his own picture to be displayed. Once he realised his error, he conceded the palm with sincere modesty, saying that he had only deceived the birds, whereas Parrhasios had deceived him, an artist.[121]

A similar story tells how Apelles, about to lose through his opponents' intrigue a competition involving the painting of a horse,

had some horses brought in and showed them the pictures by the competitors one by one. They only neighed at the horse painted by Apelles. And because afterwards it always turned out the same way, this was demonstrated to be a sound test of artistic quality.[122]

The secondary literature tends to dismiss these stories as either 'anecdotal' or 'popular criticism' – that is, not having anything to do with serious art history – attributed on entirely preconceived grounds to Duris of Samos rather

[120] Bryson (1983) 6. [121] *HN* xxxv.65. [122] *HN* xxxv.95.

than to Antigonos or Xenokrates as the writers of professional/technical accounts of art.[123] Whereas art historians dismiss these stories as 'popular' and therefore uninteresting when compared with professional art criticism, Gordon valorises them also as being popular, and therefore pointing to how art was really understood by most of the population in the ancient world, in opposition to the (for Gordon) uninteresting 'lucubrations of philosophers and rhetoricians'.[124] These attempts to excise such stories from Pliny's history of art ignore the fact that they were clearly a part of elite discourse on art in the Hellenistic-Roman world. Similar stories are retailed by Strabo, concerning the response of partridges to a painting including one by Protogenes, and Aelian, on Alexander's portrait and his horse – both authors with Stoic leanings and Aelian a former teacher of rhetoric.[125] Moreover such stories also find their place in ekphrastic epigrams – a favourite medium of art-critical response amongst the elite of the Hellenistic and Roman worlds[126] – most notably in the long series of epigrams on Myron's cow.[127] Antipater of Sidon, for example, plays on the theme of the relation between art and nature by having the (bronze) cow address a calf:

Calf, why do you approach my flanks? And why ever do you low? *Technē* did not place any milk in my udders.[128]

Anacreon the Alexandrian picks up the notion of even human beings being taken in by the bronze cow:

Cowherd, pasture your herd far away from here, lest, along with the other cattle, you should drive off Myron's heifer, as if it were alive.[129]

In the modern western tradition, the peak of artistic achievement is marked by originality, the genius which creates 'new forms, ideas and images that exceed all bounds of theoretical or rule governed understanding'.[130] In the tradition of Greek rationalist cosmology, particularly Stoicism, the excellence of human rationality at its best 'is guaranteed by its willing agreement with Nature',[131] and the pinnacle of artistic achievement is correspondingly marked by the perfect adaptation of the work of art to the world-immanent reason of Nature, nicely symbolised by animals, as representatives of Nature, approving the adequacy of a

[123] Pollitt (1974) 63–5 with refs. [124] Gordon (1979) 8.
[125] Strabo XIV.2.5; Ael. *Var. Hist.* II.3. [126] Goldhill (1994), cf. pp. 253–4, 261–4 below. [127] Fuá (1973).
[128] *Anth. Graec.* IX.721. [129] *Anth. Graec.* IX.715.
[130] The classic Kantian formulation of the specificity of aesthetic imagination, discussed in Norris (1989) esp. 153.
[131] Long (1974) 105.

representation of their kind to Nature, and even further by the inability of man, most rational of animals, to distinguish a product of human reason from that of the world-immanent divine reason that is Nature.[132]

REASONABLE WAYS OF LOOKING AT PICTURES

What was the social distribution of this stock of art-historical knowledge, and how was this knowledge used? Recent work in the sociology of culture has argued that the social and cultural construction of art as an autonomous and privileged domain, the elaboration of a normative etiquette of appropriation, and the restriction of the social availability of this mode of cultural experience should be understood in terms of dominant status-groups' needs to monopolise social and cultural honour, to distinguish themselves from subordinate groups and thereby reproduce social hierarchy, in particular in contexts where group boundaries are being threatened with erosion by social change.[133] In this section of the chapter I will look at how art-historical knowledge functioned as a marker of elite status in the Hellenistic and Roman worlds pp. 246–50. I shall show that the normative etiquette of high-cultural artistic appropriation was integrated with rhetorical practices transmitted as a component of the pedagogy of elite education (pp. 250–4). This rhetorical mode of response has led to a questioning, by classical art historians, of whether or not Romans and Greeks of the Roman period, like Lucian, were 'true lovers of art'. Further analysis of the normative discourse on proper modes of relation to visual art, shows that amongst the elite of the Hellenistic and Roman worlds to construe conduct as manifesting a love of art was to define it as deviant, whilst the proper relation to art was controlled, rational response, a pattern regulated by commitment to the religious value placed on cosmic reason (pp. 255–61). This particular cultural shaping of aesthetic response produced a quite distinct aesthetic ethos, one that seems to a modern reader to be over-intellectualised and lacking in sensibility, manifested in and partly constituted by ekphastic epigram writing and speechifying (pp. 261–4).

Paideia and *humanitas*: the culture of distinction in the Graeco-Roman world

In post-classical antiquity, as in the modern West, it was a requirement of elite status, 'to make the effort to acquire, attain and transmit the corpus of know-ledge which goes to make up the necessary condition and ritual accompaniment

[132] Isager (1991) 136–40. [133] Bourdieu (1984), Di Maggio (1982), De Nora (1991).

of learned consumption [of art]'.[134] *Paideia*, or in Latin *humanitas*, was held to be conferred by 'education and training in the liberal arts (*eruditionem institutionemque in bonas artes*)':

Those who sincerely desire and seek after these arts are most fully human (*humanissimi*). For the concern of this type of knowledge and the training given by it (*scientiae cura et disciplina*) have been given to man alone amongst all the animals, and on account of this it is called *humanitas*.[135]

In his *Rerum Humanarum*, Varro picks out as a distinctive sign of *humanitas* literary knowledge of art history, above all of 'Praxiteles, who because of his surpassing art is unknown to no one of any humane culture (*humaniori*)'. Any man of 'some cultivation and education' (*eruditiori doctiorique*), 'knew about Praxiteles both from books and from inquiry (*ex libris et ex historia*)'.[136]

The Roman poet Martial flatters Novius Vindex with two poems on the Herakles Epitrapezios (so-called because of its size, small enough to stand on a table) by Lysippos, the prize of Vindex's art collection.[137] The first poem recalls the prestigious social biography of the statue, owned by Alexander the Great, Hannibal and Sulla, and celebrates that the statue 'has now chosen to be the god of learned (*docti*) Vindex'.[138] The following poem serves as a display of Vindex's humane learning, of both the name of the artist of the Herakles and of Greek:

I recently asked Vindex whose labour and happy toil was Alcides. He laughed, for this is his custom, and with a slight nod of his head, asked 'Surely you, a poet, are not ignorant of Greek? There is an inscription on the statue base which indicates the name.' I read 'Of Lysippos (Λυσίππου)'; I had thought it was by Pheidias.[139]

The 'keen glance of Vindex in recognising the lineaments of an old master and attributing the author of an uninscribed work', recognising the bronzes of Myron, the marks of Praxiteles' chisel, ivories smoothed by the thumb of Pheidias, statues from the furnaces of Polykleitos, 'the lines which from a distance betray old Apelles', marks out a privileged gaze, and 'certainly' an artist of old 'would not prefer to be approved as authentic by any other eyes'.[140] In brief, *paideia*, a cultivated *technē* of viewing, was deemed to be the prerequisite of culturally adequate engagement with a work of sculpture or painting.[141]

The cultural definition of the knowledge of art history as a privileged indicator of *humanitas*, together with the unequal social distribution of that knowledge,

[134] Bourdieu (1971a) 176. [135] Gell. *NA* XIII.17.
[136] Gell. *NA* XIII.17. On *humanitas* and *paideia*, see Marrou (1956) 95–101.
[137] Bartman (1992) 147–52 for a good discussion. [138] Mart. IX.43. [139] Mart. IX.44.
[140] Stat. *Silv.* IV.6.21–30, 106–9.
[141] Epiktetos, *Diss.* II.24.7; Ael. *VH* XIV.47; Plut. *Per. Aphr. Pand.* ap. Stob. *Flor.* lxxxi.34.

gave rise to strategies of cultural pretension on the part of aspirant members of the elite who wished to be recognised as *humaniores*, and their deflation by those who considered themselves the true guardians of *humanitas*. Pliny complains of collectors of Corinthian bronzes who claimed their statues to be the works of the great classical masters:

to me, the majority [of these collectors] seem only to make a pretence of connoisseurship, in order to distinguish themselves from other people, rather than because they have any particularly subtle understanding of these matters.

ac mihi maior pars eorum simulare eam scientiam videtur ad segregandos sese a ceteris magis quam intellegere aliquid ibi subtilius.[142]

According to the orator Quintilian,

the first of the celebrated painters, whose works are worth seeing (*visenda*) not simply for the sake of their antiquity, are said to have been Polygnotos and Aglaophon [first half of the fifth century]. Their simple use of colour still has such enthusiasts (*studiosos*) that they prefer these primitive rudiments of the later art which was to develop over the works of the greatest artists who were to come after them. Their purpose, in my opinion, is an inflated ambition to appear to be possessed of superior connoisseurship (*proprio quodam intelligendi, ut mea opinio est, ambitu*).[143]

In addition to possession of the formal aesthetic vocabulary of art criticism and a knowledge of art history, an adequate, cultivated, response to a work of classical Greek art required knowledge of the iconographic codes and the stories of Greek mythology. In the context of the classical Greek polis, the appropriate iconographic and mythological knowledge – in part common to all the Greeks, in part particular to the individual traditions of specific city states – was inculcated in the entire citizen population by means of traditional oral *paideia*. In the Hellenistic world, and doubly so in the non-Greek parts of it, whether Latin-speaking central Italy or the 'Greek' East, with its numerous indigenous languages, a distance was opened up between some parts of the mythical tradition and its local contexts. In part this was a function of the transformation of the Homeric epics, tragedy, and so on, into literary culture (see. above, pp. 217–18), in part the result of the disembedding of some works of visual art from the particular local contexts in which they originally made sense – like the Athena Parthenos and the Tyrannicides from Athens displayed in copies at Pergamon. The uneven social distribution of such knowledge and the cultural value attributed to it meant that, like art-historical and art-critical knowledge in the modern West, it functioned as cultural capital. The

[142] *HN* xxxiv.6. [143] Quint. xii.10.3.

sophisticated culture of viewing marked elite status, shaped elite identity and enhanced elite cohesiveness against the excessively accelerated entry into membership of the established elite on the part of rising social groups.

The relationship to elite culture of such subordinate social groups may take a number of forms, ranging from rejection to attempted assimilation. Characteristically, however, even in recognising and acknowledging the legitimacy of elite cultural modes, such individuals betray 'the gap between acknowledgement and knowledge' through 'mistaken identifications and false recognitions', marking their cultural baseness in the very act of trying to enter the circle of the aristocracy of culture.[144] Strategies of social and cultural pretension are a theme of Petronius' satyrical portrait of Trimalchio, a member of the status group of freedmen, ex-slaves, whose sometimes fabulous wealth and (as servants of the emperor) considerable power was not – or so at least the senatorial readers of Petronius would like to think – matched by their intellectual culture, their *humanitas*, still the monopoly of the old aristocracy, even if wealth and power was not.[145] The pictures in Trimalchio's atrium or tablinum, representing episodes from Homer's *Iliad* and *Odyssey*, suggest a man of some artistic and literary culture.[146] In the course of a dinner at Trimalchio's house, attended by the 'hero' of the novel Encolpius – a homosexual adventurer of indeterminate status – Trimalchio steers the conversation towards things intellectual – 'one must not forget one's literary pursuits (*philologiam*) even at dinner'.[147] He boasts of his two libraries, one Latin and one Greek, and affects a familiarity with rhetoric.[148] He then starts to display his art-historical culture, first with a disquisition on Corinthian bronze, in which he manages to confuse the sack of Corinth by L. Mummius in 146 BC with the mythical sack of Troy some one thousand years earlier, and Hannibal, the leader of Rome's enemy the Carthaginians in the third century BC.[149] This is followed by a discussion of his silver plate:

I have a zeal (*studiosus sum*) for silver plate. I own about a hundred four-gallon cups engraved with Cassandra killing her sons, and the boys lying there dead, so well done that you would think they were alive ...[150]

[144] Bourdieu (1984) 323.
[145] Slater (1987), Elsner (1993) for recent discussions of the social and cultural significance of art interpretation in Petronius.
[146] *Sat.* 29 – an impression of cultured sophistication instantly undercut because there are also gladiator scenes, as also amongst his collection of silver cups (see below); perhaps the equivalent of having a Royal Worcester dinner service adorned with pictures of football stars like David Beckham, a comparison I owe to Peter Stewart.
[147] *Sat.* 39. [148] *Sat.* 49. [149] *Sat.* 50. [150] *Sat.* 52.

(A confusion of Cassandra the Trojan prophetess with Medea of Colchis who killed her own children to avenge herself on her husband Jason, and a ghastly mangling of the critical topos of naturalism and the boundary between art and life.)

I have a thousand one-handled bowls which one of my patrons left to me: there you can see Daedalus imprisoning Niobe in the Trojan horse.[151]

(Here Trimalchio confuses three unrelated myths: Daedalus and the labyrinth at Knossos; the story of Niobe and her children; the wooden horse of Troy.)

And I have fights between Hermeros and Petraites on my drinking cups – and every one of them a heavy one, for I would not sell my connoisseurship at any price (*meum enim intellegere nulla pecunia vendo*).[152]

Paying greater attention to the weight of the silver than the artistry of the representations, which he possesses neither the literary-mythological nor the art-critical knowledge to understand, Trimalchio represents the antitype of true connoisseurship.

The rhetoric of art criticism

The social prestige to be derived from the consumption of such privileged cultural goods as painting and sculpture is determined not only by the frequency with which such appropriation is practised, or the quantity of cultural knowledge – artists' names, aesthetic categories, and so on – at the disposal of the viewer. It is also determined by the manner in which the practice of appropriation is accomplished and the experience realised therein communicated. The manner of artistic appropriation and its communication is 'the exemplary expression of a certain type of relation to culture'.[153] In the modern West, for example, the scholastic relationship of the late-comer art historian of working-class origins to high culture, whilst probably showing more knowledge than that of the less well-informed aristocrat brought up in a milieu where outstanding works of fine art on the drawing-room wall were taken for granted, may not secure the same profits of cultural distinction, precisely because it will betray its scholastic origins, whilst the aristocrat born into a world of art will enjoy an apparently more natural, easy discursive relationship to high culture. Trimalchio betrays his vulgarity not only by his ignorance, but by the style in which it is communicated – spattered with vulgarisations of elite Latin which are, in the *Cena*, restricted to freedmen.[154]

[151] *Sat.* 52. [152] *Sat.* 52. [153] Bourdieu (1971b) 199, (1974) 17. [154] M. S. Smith (1975) 220–4.

The manner in which one performs a cultural practice is shaped by the conditions in which the capacity to perform that practice was acquired. In the contemporary West, whilst art history and criticism is not generally taught in schools, the education system, particularly secondary and tertiary, is the foremost site in which the cultural capital necessary to adopt a cultivated disposition towards art is transmitted, with variable success according to the social background of pupils and their concomitant capacity or disposition to accept school culture. In particular the teaching of literature inculcates a 'transferable disposition' to admire works of a comparable artistic canon, and an 'equally generalised and transferable aptitude' both to classify the domain of the visual arts according to the categories of artist, genre, school and period, and to apply to paintings and sculpture a critical discernment informed by aesthetic categories and homologous with the practices of literary criticism.[155] The more fully this educational culture is assimilated, and the earlier, the more deeply it is internalised, the greater the ability of the viewer to 'throw off school constraints' and 'to form discerning or so-called "personal" opinions'.[156]

Bourdieu's account of the Kantian critique of aesthetic judgement is rigorously sociological. Privileged family circumstances and favourable educational opportunities enable members of the dominant class to establish a social distance from economic necessity, a distance which is equally inscribed in their cultural dispositions, above all the pure gaze, which refuses any pragmatic reference to the world of everyday life and ordinary experience in favour of self-referential specifically aesthetic interpretation. Bourdieu demonstrates that this apparently distinctive, disinterested disposition is socially conditioned and socially produced by showing that it is one component of a broader habitus – informed by 'negative economic necessities' – which produces the same effects in the most banal practices of everyday life, from the sports people pursue, to the clothes they choose to wear, the careers they follow, the food they eat.[157] In the remainder of this section of this chapter, I shall look at how the pure gaze of the Hellenistic-Roman elite, also clearly rooted in negative economic necessity although within the context of a rather different mode of economic organisation, was shaped on the most general cultural level in accordance with Greek rationalist cosmology, and also, on a slightly lower level of cultural generality, by the cultural practices of rhetoric, which, analogously to the practices of literary criticism learnt in modern schools in Bourdieu's account, constituted a transferable frame for the classification, comparison and evaluation of authors and their works both rhetorical and

[155] Bourdieu (1968) 604; Bourdieu and Darbel (1990) 62. [156] Bourdieu (1968) 605.
[157] Bourdieu (1984) 5–7 and *passim*.

artistic. This gives rise to an aesthetic ethos which is in crucial respects fundamentally different from that of modern high culture, which was rather differently shaped by codes derived from Christian culture built into the western definition of the artist as creator in the Renaissance, and reinforced in the eighteenth-century reconstruction of art history writing and high culture.

Amongst the skills learnt in the earliest stages of oratorical training was the analysis of the style, *lexis*, of the great masters of rhetoric, Demosthenes, Isokrates, Isaios. The *progymnasmata*, preparatory exercises, included the composition and practice of particular kinds of speech – eulogies, reproaches, theses – in particular, for present purposes, *ekphrasis*, or description – for example of the Alexandrian acropolis – and *sunkrisis*, or comparison – for example of the two heroes Achilles and Hector.[158] Each of these rhetorical skills has its reflex in ancient art-critical practices, probably to some degree at least independently generated in art history writing, but nevertheless making art-critical culture more easily appropriated and deployed by those also possessed of rhetorical culture. The mutual transferability of these rhetorical and art-historical schemes was further enhanced by the sharing of at least some critical vocabulary, increasingly marked as the practice of art history writing became the domain of men of literary culture in general rather than of artists.

The principles which informed the recognition and analysis of personal style in the corpus of orators, and hence the correct attribution of works to authors as well as their correct imitation, also informed the analysis of personal styles and the attribution of sculptures and paintings of the great classical masters.[159] The idea of setting two works of art – or conceptually at least two artists – side by side to compare them was familiar also in the ancient world,[160] rooted, however, not in the technology of slide projection but in the rhetorical practice of *sunkrisis*. Comparing the orators Isokrates and Lysias, Dionysios of Halikarnassos invokes sculptural parallels:

For it seems to me that someone would not be wide of the mark if he were to compare the oratory of Isokrates with the *technē* of Polykleitos and Pheidias in respect of grandeur (*to semnon*), technical virtuosity (*to megalotechnon*) and dignity (*to axiomatikon*), whereas one would compare the oratory of Lysias with the *technē* of Kalamis and Kallimachos, on account of its delicacy (*leptotetos*) and grace (*charitos*). For, just as the latter two are more successful than the former in representing the lesser and human subjects, so the former are more skilful when it comes to representing grander and more divine subjects. Similarly with the two orators: Lysias is the cleverer in small subjects, while Isokrates is the more impressive when it comes to grand subjects.[161]

[158] Marrou (1956) 201. [159] Dion. Hal. *Dem.* 50, *Dinarchus* 7. [160] Plut. *Mor.* 243.
[161] Dion. Hal. *Isoc.* 3.

Pliny's art history often takes the form of an extended series of *sunkriseis*: 'Myron was more rhythmic in his art than Polykleitos, and more diligent in the preservation of *symmetria* (proportionality)', and so on.[162] In addition to constructing comparisons of orators on the basis of explicit analogies with comparisons of painters or sculptors,[163] rhetoricians used summary histories of art as a model or parallel for their own histories of rhetoric.[164]

Both painting and sculpture, and the stories connected to the famous classical painters and sculptors were stock subjects for rhetorical declamation and display.[165] Orators were expected to know about famous sculptors and painters, and their more important works of art, in order properly to be able to praise the cities that gave birth to the artists or the cities that possessed their works.[166] Pliny speaks of Timanthes' painting of Iphigenia as 'celebrated by reason of the praises of orators (*oratorum laudibus celebrata*)', and we find the same work discussed in Cicero as a model of propriety (πρέπον/*decor*), and by Quintilian as an example of the pleasing variety achieved by innovative departure from customary usage.[167] Painters and sculptors, paintings and statues, above all from the classical period of Greece, provided the subject matter for a number of different rhetorical exercises. Works of art offered a particularly favourable field for the display of rhetorical skill, most notably as we have already seen, in set piece ekphraseis of particular paintings or sets of paintings decorating a room or a house. In the absence of the painting being described, the power of the word, of *logos*, was demonstrated by the rhetor's capacity to induce a visual impression or visualisation, *phantasia*, of the picture described in his audience, and, in the presence of the picture, rhetorical skill was demonstrated by the orator's ability rationally to shape the hearer/viewer's response to the contours of the picture.[168] This capacity is probably best exemplified, and in more concentrated form, by the related genre of ekphrastic epigrams.

Antiphilos, writing in the first century AD, describes a painting of Perseus and Andromeda, possibly by the fourth-century Athenian painter Nikias, and possibly copied in contemporary (with Antiphilos) paintings in Pompeii.[169] The poem lists one by one the actionless elements of the picture, so the reader

[162] *HN* xxxiv.58. [163] Demetrios, *On Style* 12–14; Dion. Hal. *Isaeus* 4.

[164] Cic. *Brut.* 18.70–1; Quint. xii.10. [165] Austin (1944).

[166] Nesfelrath (1990) 113; Men. Rhet. i.360, ii.392; Aelius Aristeides, *Panathenaicus* 364; Plut. *Mor.* 345–6.

[167] Pliny, *HN* xxxv.73; Cic. *Orat.* 22.74; Quint. ii.13.10–14; Austin (1944).

[168] See Goldhill's (2001b, 157–67) excellent analysis of the cultivated viewer, *pepaideumenos theatēs*, as represented in Lucian's *The Hall*.

[169] *Anth. Plan.* 147; Gow–Page, *GP* Antiphilos 49. On 'copies' see below, pp. 269–70. Philipps (1968) is unduly sceptical about the relationship of the painting in the *Casa dei Dioscuri* to that of Nikias; see Ling (1991) 129. I follow Neutsch's analysis (1938) for the role of the poem in allowing the reader to envisage and respond to the painting.

can visualise the painting for himself, setting up the tension of the mythic narrative: a patch of land (*bolos*); a man with winged sandals, Perseus; a woman bound to a rock, Andromeda; the Gorgon; the sea monster; Kassiope – the same set of distinctive iconographic elements which compose the structure of the possible copies of Nikias' painting in Pompeii. The viewer's gaze is directed to each element, the tense mythic situation set up and then resolved in the last two lines: 'Andromeda, torpid with characteristic (ἠθάδι) numbness, loosens her feet from the crag ...' The somewhat unexpected *ethadi* points back from the picture to the rhetor/viewer's interpretative response, to the import-ance of *ethos* as a topos of art criticism, and to the poet Antiphilos' masterly enactment of an *ethopeia* – or delineation of character – yet another type of rhetorical exercise for which the story of Perseus and Andromeda – offering a heroic suitor, boastful mother and distressed heroine – might, like Niobe and her children, the example normally cited by the handbooks, be a well-suited topic.[170]

Whilst scholars have long been aware of the rhetoricisation of art-historical and art-critical discourse in the Hellenistic-Roman world, its sociological significance has been ignored in favour of a preoccupation with its origins,[171] and its cultural significance has been deemed wholly deleterious to an authentic engagement with art. It is because 'rhetoric gets the better of' Pliny that Morehouse judges him 'not a true lover of art',[172] and doubtless similar considerations underlie Robertson's judgement that Pliny has no 'feeling' for art.[173] According to Valeria Andò, it is only direct knowledge of the monuments and an innate artistic sensibility that 'saves [Lucian's] art criticism from des-cending into purely rhetorical forms'.[174] She judges Lucian's own critical responses irrelevant to a proper understanding of ancient art, because they are 'totally lack[ing] in originality', 'judgements which are bereft of any real critical content because they repeat ... the numerous topoi of the rhetorical tradition'. Such an evaluation of the rhetorical dimensions of ancient art criti-cism and aesthetic response is rooted in our own Romantic conceptions of 'sincerity' in art, and 'authenticity' of response, both ideally characterised by spontaneity and depth of feeling. In the context of Greek rationalism, however, and the norms of aesthetic response developed in the Hellenistic-Roman period, the rhetoricisation of art criticism makes perfect sense as an intrinsic component of an elite culture of viewing. It is to the broader normative discourse on viewing, and the cultural meaning attributed to elite modes of viewing, that I now turn.

[170] Marrou (1956) 201; Spengel, *Rhet.* II.45–6. [171] E.g. Pollitt (1974) 58–62; Rouveret (1989) 451–3.
[172] Morehouse (1940) 34. [173] Robertson (1975) xv. [174] Andò (1975) 19.

The love of art: passion as perversion

One of the more long-standing debates amongst contemporary historians of Roman art has been the question of whether or not the Romans were 'art lovers'. Zanker pictures the Roman aristocracy of the first century AD as 'art lovers' in succession to the Hellenistic princes.[175] According to Gualandi the Romans were 'passionate admirers' and Pompey in particular 'a passionate lover' of Greek art.[176] Others question whether there was a 'true love of art' amongst the Romans.[177] Most recently, Leen has argued that 'nothing suggests that Cicero had a particularly profound knowledge of art or a great love for it. What he says in *Brutus* and elsewhere smacks of the manual; little of it betrays an original mind or specially sensitive insights.'[178] There are two underlying assumptions to this debate. First, loving art is treated as a universal norm, a marker of civilisation, and the failure of Roman practices to accord with these norms is perceived as an indicator of a lack of true civilisation on their part. The second assumption, not usually explicitly stated, is that the Greeks were art lovers from the classical period onwards. As should have been clear, the very idea of a love of art would be anachronistic in classical Greece.[179] Rather than address this issue as an evaluative one, measuring the adequacy of Roman practices to modern norms of art-critical practice, I want to look more closely at the role played by discourse on the love of art in Roman collecting and viewing practices.

In the Hellenistic-Roman world to talk of someone's relationship to sculpture or painting in terms of the language of love was to brand it as deviant. In the Verrine orations, when Cicero wants to cast the worst possible light on Verres' acquisition of statues and paintings whilst governor of the province of Sicily, he talks of him not only as having committed sacrilege by removing cult statues, but as having 'fallen in love – *adamavit*' with the pictures.[180] According

[175] Zanker (1978) 288. [176] Gualandi (1982). [177] Morehouse (1940). [178] Leen (1991) 233.
[179] The semantics of this issue are complex. *Philotechnos* is often translated as 'art loving', as *philosophia* 'love of wisdom'. As I have already argued, the semantic range of *technē* is much wider than that of our 'art'; it never acquires the primary connotation of 'fine art', and in many instances a translation of *philotechnos* as 'art loving' would be absurd (e.g. Plut. *Alex.* 72). The semantic range of Greek words sometimes translated as 'love' – *eros, agapē, philia* – and their (rough) Latin equivalents – *amor, dilectio, amicitia* – do not easily map onto English equivalents. *Philein* perhaps connotes more 'fondness for' and can be used in Stoic writing of rational love, such as one has, for example, for one's children. *Eros* and *amor* are used of irrational, passionate and hence sexual love. Panaetius, for example, warns against falling in love 'a state so disturbed and uncontrolled' – Sandbach (1975) 123–6. Whilst the edges of these semantic fields are often blurred, I think that it is reasonably clear that modern discourse on the love of art is of the irrational/romantic kind: 'I have fallen in love with that painting', and 'a passionate love of art' are perfectly acceptable turns of phrase, whereas to claim to be 'a lover of the Fitzwilliam Museum' for example, as opposed to 'a friend of the museum' would be rather strange.
[180] Cic. *Verr.* II.2.85.

to Horace, when Greece 'fell in love (*amavit*) with workers of marble or ivory and bronze, and a painted picture held her eyes (lit.: face – *vultum*) and mind in suspense', this marked the beginning of the corruption of Greece.[181] Perhaps more telling are two 'anecdotes' in Pliny, concerning the emperor Tiberius. Amongst the statues by Lysippos was the *Apoxyomenos*, a portrait of an athlete scraping himself down with a strigil, set up near the baths of Agrippa. This statue

was marvellously pleasing to the emperor Tiberius. Tiberius, although he had been able to exercise mastery over himself (*imperiosus sui*) at the beginning of his principate, now proved unable to maintain any self-restraint (*non quivit temperare sibi in eo*), and so, after replacing it with a substitute at the baths, transferred the statue into his own bedchamber. But when the obstinacy of the Roman people was such that they created an uproar in the theatre to demand the return of the Apoxyomenos, the emperor, although he had quite fallen in love with the statue (*adamatum*), had to restore it to its place.[182]

In his account of the painter Parrhasios in book XXXV.70, Pliny tells us of a painting of a high priest of Cybele, a castrate, which Tiberius fell in love with (*amavit*) and locked up in his bedroom.[183]

Whilst the reader is left perhaps to imagine what went on with statues behind closed doors, Tiberius is not explicitly said to have performed unspeakable acts with them. Elsewhere the narratives are more explicit. There was a plethora of stories circulating amongst the elite of Hellenistic-Roman antiquity telling of acts of attempted intercourse with statues, some of divinities some not, by viewers who had fallen in love with them. The most famous of these were acts of attempted intercourse with Praxiteles' Aphrodite at Knidos and his Eros at Parion, both of which reputedly showed stains as *vestigia amoris*, 'traces of passion'.[184] According to Isager, these stories are 'most likely an attempt to explain a flaw in the marble'. He instructs us to 'disregard the curiosity value of these two anecdotes', which merely 'illustrate what was generally expected and demanded of great art, realism and truth to Nature'.[185] Gordon interprets the stories as an 'image of total self-pollution',[186] although the texts do not lay any

[181] Hor. *Epist.* II.1.95–6. [182] Pliny, *HN* XXXIV.62.

[183] Gordon (1979, 23) misses the point, I think, when he interprets the story as expressing Pliny's surprise not that Tiberius shuts up the painting in his cubiculum but that Tiberius does not put the painting on public display and thereby increase his symbolic capital amongst the people by demonstrating both taste and largesse with a painting valued at six million sestertii. Rouveret actively ignores both stories on the ground that their 'eroticism is of more interest for the history of mentalités than the history of art' (1989, 439). Cf. Suet. *Tib.* 43–4 on Tiberius' decoration of his cubiculum with lascivious pictures, amongst them Atlanta fellating Meleager by Parrhasios, all in a context of an account of Tiberius' lack of self-control, in particular sexual incontinence.

[184] Pliny, *HN* XXXVI.21–2; Lucian, *Amores* 15. [185] Isager (1991) 153–4. [186] Gordon (1979) 16.

particular emphasis on such a specifically religious interpretation,[187] and in many cases the statues in question are not statues of deities.[188]

Tiberius' misdemeanours are by no means the *ne plus ultra* of ancient art loving, but they are perhaps the most instructive, because of Pliny's gloss on his 'falling in love'. To fall in love with a work of art does not befit an emperor, because it shows him to be not fully in control of himself, not *imperiosus sui*, 'emperor over himself'. The passage recalls Plato's tyrannical man in whose soul *eros* reigns as lord and master.[189] The ability of the emperors to rule over their own passions was 'seen as a guarantee that they will themselves be able to set a limit on the exercise of their political power'.[190] The principle of self-control as a qualification for exercising power applied equally to the elite of the Hellenistic-Roman world in its entirety as the governing class. In the *Stoic Paradoxes*, Cicero argues that it behoves one who claims to 'have carried on great wars, exercised high authority (*magnis imperiis*) and governed great provinces', 'to manifest a spirit worthy of praise (*animum laude dignum*)'. The man 'who is stopped dumb-struck by a picture by Aetion or a statue by Polykleitos (*Aetionis ne tabula te stupidum detinet ...*)', whom Cicero encounters 'gazing in admiration and gushing with exclamations of delight' at such works of art, he judges 'the slave of every foolishness'.[191] Not that Cicero wishes to deny legitimate aesthetic pleasure. 'Those things are delightful,' he agrees with his interlocutor. 'We also have learned eyes (*eruditos oculos*).'

Aristotle argues that pleasures of the eye are intermediate between the sensuous pleasures of the body, and the rational pleasures of the soul, such as fondness for learning, in which one takes pleasure without the body being affected at all, only the intellect (οὐθὲν πάσχοντος τοῦ σώματος, ἀλλὰ μᾶλλον τῆς διανοίας).[192] The intermediate status of the visual arts between the sensory and the rational predisposed them to be a test of rational self-mastery, because there was always the danger of too much or the wrong kind of pleasure, that is, visual pleasure of an almost animal kind 'free of reason' (*vacua rationis*, as Valerius Maximus describes sexual response to the Aphrodite of Knidos) in

[187] With the exception of Val. Max. VIII.11.4. [188] E.g. Ath. XIII.605.

[189] Pl. *Resp.* 574–5; Ferrari (1989) 123; Foucault (1986) 187. [190] Foucault (1988) 89.

[191] Cic. *Paradoxa Stoicorum* 36–8. At first sight a passage in Stat. *Silv.* IV.6 on the Lysippan Herakles Epitrapezios, owned by Vindex, might seem to contradict my account. The passage quoted above on Vindex, keen eye in attribution ends, 'Whenever he puts aside his lyre, this is the means of his relaxation (*illi desidia est*), this passion (or love – *amor*) calls him away from Aeonian caves' (30–1). And Statius himself talks of having fallen in love with the statue (*multo mea cepit amore | pectora*). The *amor*, here should, however, be read ironically not literally, just as Vindex's *desidia*, slothfulness and relaxation from more demanding pursuits, is in fact the *docta disciplina* of connoisseurship. Similarly, Statius' passion for the Herakles is followed by a tremendously learned, controlled and witty critical response, belying the apparent lack of control in his gaze as he initially described it.

[192] *Eth. Nic.* 1117b28–1118a25.

which the proper relationship, genuine rational pleasure, between viewer and work of art breaks down and men engage with statues or paintings in a lascivious, sensuous way to the point of attempted intercourse.[193] On the basis of pleasure in a work of art, the viewer can either move towards the realms of higher reason, judging and responding with the rational, deliberative part of the mind, or sink into subhuman bestiality, responding to sensual pleasure (*voluptas*) with impulses of desire (*cupiditas, epithumia*) aroused in those lower parts of the soul most closely tied to the body, and all too easily allowed to get out from under the control of reason. Natural and proper pleasure in the aesthetic form of the work of art as pointing towards the accomplishments of human reason is displaced by sensuous pleasure, itself already going beyond 'that which agrees with reason', in so far as art should not be a medium of sensual pleasure, a pander to voluptuaries. Excessive impulses (*pleonazousai hormai*) give rise to unnatural and irrational movements in the *psychē* (*para physin kai alogos kinesis psychēs*),[194] and a sexual, rather than an aesthetic, engagement with the work of art.

It is precisely because it distinguishes so neatly between the truly human, the *humaniores*, endowed with higher reason, and the rest of mankind, not so far above the animals, that artistic *intellegere* is a privileged marker of elite status. When Encolpius, in Petronius' *Satyricon*, wanders into a picture gallery in the porticoes of a sanctuary, he starts to enact a strictly aesthetic reading of the paintings:

I came into a marvellous picture-gallery, hung with a most varied range of paintings. For I saw works from the hands of Zeuxis, not yet overcome by the ravages of time, and I scrutinised not without a certain frisson the rough sketches of Protogenes, which rivalled the truth (*veritate*) of Nature herself. But when indeed I came to the work of Apelles which the Greeks call the goddess on one knee (μονόκνημον), I just worshipped it. For with such subtlety (*subtilitate*) were the outlines of the figures defined in the realisation of natural similitude that you might have believed it the very picture of their souls as well.

Encolpius thus invokes the aesthetic vocabulary and critical commonplaces of sophisticated viewing: naturalism, *veritas*, *subtilitas*. So far, so good. But as he progresses further into the gallery, Encolpius encounters mythological paintings of the gods and their loves: Zeus and Ganymede, Hylas the beloved of Herakles being ravished by a nymph, Apollo and Hyacinthus. Encolpius' self-control breaks down. His capacity to sustain aesthetic distance and respond rationally to the paintings as exemplifications of rational artistic *technē* is displaced by an unabashed subjectivism as he identifies with the gods,

[193] Val. Max. VIII.11.4. [194] Galen, *De plac. Hipp. et Plat.* IV.370–1 (Kühn).

interpreting their amorous adventures as an analogue and a moral model for his own less fortunate adventures in homosexual passion:

Amongst these faces of mere painted lovers, I cried out, as if I were in a desert, 'So love touches the gods as well. Jupiter in his celestial abode could not find an object for his love, but he did no one any harm when he came down to earth to practise his transgressions ... All these divinities enjoyed love's embraces free of rivalry. But I have accepted into a relationship with me a friend more hard-hearted than Lykourgos.'[195]

Following this display of passion, it is all too predictable that Encolpius enlists as his moral guide a poet-philosopher Eumolpus whose only pedagogic credentials are self-confessed skills in the techniques of homosexual seduction.[196]

Underlying these, to the modern reader, somewhat bizarre, almost fetishistic, stories of deviant viewing was a specific epistemology of viewing developed in Stoic philosophy, and associated with the concept of *phantasia*.[197] Although Stoic *phantasia* has often erroneously been assimilated to the western conception of creative imagination,[198] recent philosophical scholarship suggests that *phantasia* was not understood (or valued) as an irrational faculty, higher than and opposed to reason. On the contrary, it was a lower faculty, shared with animals, but positively valued in so far as it played a role in the development of human reason.

In Stoic theories of the mind, *phantasia* forms the link between the world of sense experience and the rational faculty of intellect.[199] It refers both to the particular impressions that are formed in the mind through sense experience, and more generally to the *receptive* capacity for the formation of such presentations. *Phantasia* thus presupposes perception of its object, belonging more properly to the object which engenders an impression than to the mind which is impressed.[200] Whilst the experiencing of *phantasiai* and their storage in

[195] Petron. *Sat.* 83.

[196] See Elsner (1993) for a full analysis of these incidents in the context of the *Satyricon* as satire.

[197] Elsner (1993) 34; Slater (1987) 171.

[198] The classic articles developing this viewpoint are those of Schweitzer (1925) 58–60, 95–120, esp. 95–100 specifically on *phantasia*, (1932) 38–9, (1934); followed by Pollitt (1974) 52–4; Watson (1988). For a detailed criticism of this perspective, from which I draw in the following paragraphs, see Tanner (forthcoming). I discuss the place of *phantasia* in the role and agency of post-classical artists in the following chapter. Here I am concerned only with its place in the viewing practices of the Hellenistic-Roman cultural elite.

[199] I follow here the accounts of Sandbach (1975) and Long and Sedley (1987) I.236–59, II.238–59. Aristotle's account of *phantasia* is in *De an.* 427a17–429a10. For a full treatment of Aristotle's concept of the imagination, see Schofield (1979). Schofield here understands imagination in the rather more limited sense of, 'the capacity [of the mind] to present to itself mental images', rather than the unrestricted 'creative imagination' attributed to visual artists in the modern West: 106 on the predominantly passive conception of *phantasia* in Aristotle, as opposed to active imagining; 110, 115 for the suspicion towards *phantasia*, particularly when not subject to proper rational control. For Plato's use of the concept *phantasia*, see Benediktson (2001) 164–8 and Silverman (1991): *phantasia* as a mixture of belief and sensation, mistrusted as an unreliable source of knowledge, based on appearance.

[200] Aetius IV.12.1; Sandbach (1975) 86–7.

memory is one of the bases on which knowledge is built up, they must be integrated with and controlled by reason, *logos*, in order to have cultural value and intellectual validity. *Phantasia* is a faculty shared with animals[201] and not, as such, a reliable guide to knowledge or action, since *phantasiai* may be false. It may serve, moreover, the animal drives of man as much as his higher faculties: sexual appetite, for example, is stimulated through *phantasiai* of desirable sexual objects, and in animals almost invariably gives rise to pursuit of the object, whilst in man such impulses may be controlled through the check of a rational faculty which recognises higher or real goods.[202]

What distinguishes human *phantasia* from animal *phantasia* is that animals are endowed only with *aisthetikē phantasia*, 'aesthetic imagination' or perhaps better 'perceptual visualisation', whereas humans have, in addition to *aisthetikē phantasia*, a capacity for forming rational impressions, *phantasia logikē*.[203] *Phantasia* contributes to the development of reasoning power, in so far as it provides the mind with the perceptions on the basis of which the mind constructs knowledge of the world, by 'translating presentations into discursive sequences' by means of *dianoia eklalitikē*, 'discursive intellect'.[204] This discursive intellect, which translates mere perceptual impressions into objects of conceptual reflection and hence valid knowledge, manifests itself in such distinctively human cognitive operations as the construction of analogies and syntheses, oppositions, transpositions and similitudes: *analogia*, *synthesis*, *enantiosis*, *metathesis*, *homoiotēs*.[205] The capacity to perform such cognitive operations depends on humankind's natural endowment with reasoning power, *logos*.[206]

It is precisely his proclivity to a feelingful response, his sensitivity, insufficiently controlled by reason, that separates Encolpius from the true cultural elite. Knowledge of art is not enough; it must also be rationally displayed. The cultural aristocracy that a proper relationship to art distinguished in the ancient world was not an aristocracy of feeling and imagination but an aristocracy of reason and intellection. It is not their sensitivity, their capacity for deeper feelings, that Hellenistic-Roman connoisseurs boast of, but their *intellegere*, or intellectual understanding.[207] Where Encolpius and Tiberius, like Lucian's

[201] Arist. *De an.* 428a10–14, 20–3 – with some exceptions amongst the lower animals like ants and bees; Imbert (1980) 189; Sext. Emp. *Math.* VIII.275–6.

[202] Sandbach (1975) 60; Cic. *Acad.* II.10.30.

[203] Arist. *De an.* 433b28ff. [204] Diog. Laert. VII.49–53; quotation Imbert (1980) 187.

[205] Diog. Laert. VII.49–53; Sext. Emp. *Math.* VII.274–6, XI.248–3 on *phantasia metabatikē* and *synthetikē*.

[206] Diog. Laert. VII.50.

[207] Quint. II.13.10, XII.10.3; Petron. *Sat.* 52. See Keuls (1978a) 103, (1978b) 129 for further references; Goldhill (2001b) 162 for the physical dimensions of the intellectual pose.

uneducated viewer, are at a loss for words, the techniques and tropes of rhetoric facilitated the verbal display that for a cultivated Greek viewer was the proper accompaniment of critical looking and any act of aesthetic judgement.[208]

A rational sensibility

How then did Greek viewers articulate aesthetic judgements and express their aesthetic pleasure within this rationalist framework? Plutarch provides some kind of answer in the context of a series of dialogues that seek to reconcile Stoic and Platonic rationalism and to respond to Plato's hostile account of mimesis without falling into the Epicureans' unabashed (as Plutarch saw it) affirmation of sensual pleasure.[209] In *Table-Talk* v.1 and *How to Study Poetry*, Plutarch asks how we can take pleasure in representations of anger and pain, whether dramatic or pictorial, but not in seeing people experience those emotions in reality.[210] He cites as examples Silanion's statue of the dying Jocasta (mother of Oedipus, having hanged herself),[211] Timomachos' Medea slaying her children, Theon's Orestes slaying his mother, and other representations of 'unnatural acts (*praxeis atopous*)'.[212] The pleasure of the viewer, and his commendation of the work of art, lies 'not in the action which is the subject of the imitation, but the art (*technē*), in case the subject at hand has been properly (*prosekontōs*) imitated', that is to say, in a way that is 'fitting (*enharmotton*)' and 'proper (*oikeion*)' to the subject at hand.[213]

A more specific sense of how, ideally, a sophisticated viewer might respond to a work of art may be inferred from the considerable number of ekphrastic epigrams preserved in the Greek anthology. These epigrams both represent responses to specific works of art and in turn, as exemplary responses, shaped the aesthetic responsiveness of the elite intellectual community. Epigrams intended to shape viewers' responses to works of art were by no means new, of course. The inscribed epigrams (fundamentally part of an oral rather than a literary culture), which framed classical paintings and statues, pointed towards extra-artistic orders of meaning and shaped the viewer's response to fit a collective civic political and religious culture. Hellenistic and Roman ekphrastic epigrams, by contrast, make thematic the same concerns as those of art history writing, namely the identity of the artist who made the sculpture or painting and

[208] Cf. Lucian, *The Hall* 2, for the silence of the uncultivated viewer; 6, for the cultivated viewer 'judgement lies not in the looking, but a certain reasoned opinion, *logismos*, also accompanies what is seen', with Goldhill's discussion. As Goldhill nicely puts it (2001b, 161), 'the Greek *pepaideumenos* did not stand in awed silence before the sublime'.

[209] Clerc (1915/20) 111; Russell (1989) 302. [210] *Mor.* 673, *Mor.* 14–37. [211] *Mor.* 674. [212] *Mor.* 18.

[213] *Mor.* 18.

the nature of their specifically artistic achievement. 'Who, lawless Colchian, has painted your anger into your portrait?', asks the first line of an epigram by Philip.[214] The cultivated viewer of course knows the answer, Timomachos, and enjoys the ingenious conceits of Philip's poem – 'even in wax a child-killer; for the paintbrush too feels your jealousy beyond bounds towards the objects of your desire' – which cleverly trump the conventional tropes that characterise the series of epigrams on Timomachos' *Medea*.[215] The mythical content of classical images – where once it was used as a means of constructing religious and political identity in the context of the classical polis – is not taken seriously in a religious sense, but used playfully to address art-critical concerns and praise the artist in the context of a literary display of the clever poet's mythological knowledge and intellectual dexterity. Antipater of Sidon, for example, analysing Apelles' *Aphrodite Anadyomene*, plays upon the story of the judgement of Paris as a paradigm of aesthetic judgement:

Behold the labours of Apelles' brush: Kypris just rising from her mother, the sea; how with her hand grasping her hair wet through with water she wrings the foam from her dripping locks. Now Athena and Hera themselves will declare: 'No more with you will we enter the contest of beauty (*morphas*).'[216]

The epigram 'was a field for the exercise of the intellect rather than display of the emotions, and no qualities were more highly prized than ingenious fancy and clever phrasing'.[217] Whilst the epigram is thus a very suitable vehicle for aesthetic response within a rationalist culture of viewing, for the modern reader Hellenistic and Roman ekphrastic epigrams appear somewhat inauthentic or inadequate responses to art, and they have consequently been ignored except as sources of information about lost works of art. Gow, for example, dismisses the epigrams on Myron's cow as 'literary exercises', constituting a 'long and tedious series of couplets',[218] characterised by 'sentiments [which are] commonplace and foolish', concerned as they are with the tropes of naturalism which I have already discussed.[219]

More recently, Goldhill has drawn attention to the agonistic, rationalist and deeply self-reflexive character of such poems, which 'discuss the process of interpretation as it is performed', and has argued that they should be understood as 'the products of *sophoi* in the context of contemporary *sophia*'.[220] Such practices, however, do not so much function to 'police' and 'legislate' the

[214] Gow–Page, *GP* Philip 70. [215] *Anth. Pal.* XVI.135–41. [216] *Anth. Pal.* XVI.178.
[217] Gow and Page (1965) II.592. [218] Gow and Page (1968) II.387.
[219] Gow and Page (1968) II.294–5, 387 – on epigrams by Leonidas, Euenus and Philip.
[220] Goldhill (1994) 210.

viewing subject, as to emancipate him. The normative regulation of viewing and response was by no means an innovation of the Hellenistic period – as we saw in the cases of the controversy surrounding the Alkibiades portraits and the effective enforcement of ritual and religious appropriations of cult statues in the classical Athenian polis. The disembedding of (some) art from such strongly directive verbal, visual and architectural social framings, together with the construction of a culturally differentiated discourse of viewing, greatly enhanced the freedom of response of a viewer possessed of this culture. In classical Greece, viewing and evaluation of portraits or cult statues ritually enacted shared understandings of religious and civic-moral culture; aesthetic response was more embodied than verbally articulated. The response of the cultivated viewer of the Hellenistic and Roman worlds was verbally highly mediated. Thematisation of the artist's contribution to the construction of an image and the mediation of response to the image through words, which made explicit the artistic basis upon which the sculptor or painter had constructed the work being viewed, enhanced the viewer's autonomy, both in relation to other viewers and their responses and in relation to the work of art. It created space in which the visual presentation can become the object of individual critical reflection, avoiding the pathologies of immediate identification and the conflicted, disunified personalities engendered by such a mode of viewing, which Plato so strongly criticised.[221] On the contrary, rational viewing of art was one means whereby the unified sense of self as against the fluctuating vicissitudes of one's social and cultural environment might be culturally constructed and affectively stabilised. It enriched the meaning of the viewing experience and led the viewer away from the purely sensory, uncritical responses to images characteristic of uncultivated viewers and so powerfully criticised as intrinsic to visual art in Plato's *Republic*.

This is nicely illustrated by Antiphilos' account of Timomachos' *Medea*:[222]

When the hand of Timomachos was painting the murderous Medea, dragged back and forth now by jealousy, now by her children, he undertook an immeasurable task in seeking to portray her double character: the one part inclining to rage, the other to pity. He showed both in full. Look at the image. In her threat there dwells a tear, in her compassion wrath. 'The intention is enough,' the wise man said. The blood of the children was appropriate for Medea but not for the hand of Timomachos.

> τὰν ὀλοὰν Μήδειαν ὅτ' ἔγραφε Τιμομάχου χείρ
> ζάλωι καὶ τέκνοις ἀντιμεθελκομέναν,
> μυρίον ἄρατο μόχθον, ἵν' ἤθεα δισσὰ χαράξηι,
> ὧν τὸ μὲν εἰς ὀργὰν νεῦε, τὸ δ' εἰς ἔλεον·

[221] Havelock (1963) 246. [222] Well analysed by Neutsch (1938) and Goldhill (1994) 212–13.

ἄμφω δ'ἐπλήρωσεν. ὅρα τύπον· ἐν γὰρ ἀπειλᾶι
δάκρυον, ἔν δ' ἐλέωι θυμὸς ἀναστρέφεται.
ἀρκεῖ δ' ἀ μέλλησις, ἔφα σοφός· αἶμα δὲ τέκνων
ἔπρεπε Μηδείαι κοὺ χερὶ Τιμομάχου.[223]

The poem takes the form of a critical response to the painting by Timomachos. The first four lines set out the painter's task, invoking the critical vocabulary of characterisation (*ethea, charaxē*). The fifth line asserts the painter's success, focuses the viewer's attention on the image and explains how Timomachos represented Medea's emotional ambivalence. The concluding couplet aestheticises a moral tag, 'the intention is enough' (i.e. intention to commit an ill deed, but here the representation of Medea's intention), and the sophisticated culture of viewing is explicitly invoked, 'said the wise man, the *sophos*', 'the children's blood was fitting (*eprepe*) for Medea but not for the hand of Timomachos'. Crucially the critic and viewer do not fully engage in the mythic narrative or in any sense identify with Medea, thus taking on her psychic contradictions in what Havelock, following Plato, calls the 'pathology of identification'.[224] On the contrary the critic-viewer remains at one with himself, unconflicted, engaging with the myth of Medea solely as the frame for a technical problem of representation to which Timomachos has responded with a rational propriety, articulated once again in the poet-critic's response to Timomachos' painting. It is this rational aesthetic detachment, and a capacity for elaborate verbal articulation of response, which distinguishes the wise, like Antiphilos, from the foolish, like Encolpius. Viewing visual art, by virtue of both its sensuous visual media and its mythological-narrative contents, put at risk the viewing subject's ethical status as a rational being.[225] The *technē* of viewing that was developed in critical and rhetorical discourse was a means of working on the self, subjecting onself to the demands of an aesthetic ethos which composed the viewer as a rational subject of such experiences and demonstrated the rational self-possession proper to his social and political status.

THE RHETORIC OF DISPLAY

Recent work in sociology and the new museology has drawn attention to the importance of the cultural patterning and social organisation of historically specific spatial settings as the sites of the appropriation of symbolic forms. Such

[223] Gow–Page, *GP* Antiphilos 48. [224] Havelock (1963) 207.
[225] Cf. Hunter (1992) 350–4 – with Campbell (1987) 138–60 on the ethics of sensibility – for parallel practices oriented towards a fundamentally different core cultural value.

settings shape the activities which take place within them and may be partially constitutive of the cultural and social meanings generated by practices of appropriation.[226] Bourdieu has shown how the codes of Kabyle culture are embodied by its youth in the form of practical cultural schemata built into the architectural structure of Kabyle houses.[227] Correspondingly, he argues that the conventional architectural structure of art museums, as temples of the Muses, induces both reverence on the part of visitors and a feeling of exclusion or alienation on the part of the culturally dispossessed.[228] Duncan and Wallach have argued that the architecture of the great art museums functions as a script, offering the visitor a ritual walk through a bourgeois history of art, framed in terms of national schools and great individual artists. This culturally patterned ritual performance serves to intensify the attachment of individuals to the state in return for the spiritual wealth the state bestows upon the citizen-viewer.[229] All spaces in which art is displayed are socially and culturally organised in terms of assumptions about the meaning and function of the work of art, the nature of the ideal viewer and the type of experience to be realised in the interaction between displayed art and interpretative gaze.[230]

As we have seen, the spatial and architectural framing of art – whether honorific statues in civic agoras or cult statues in temples – cues certain kinds of knowledge as the appropriate cultural tools for the decipherment of the images in question; it rewards viewing in terms of that set of dispositions and stock of knowledge with a coherent expressive experience and the affirmation of the viewer's expressive identity. In this section of the chapter I wish to examine the new kinds of settings that were developed for the display and appropriation of classical art, which had been detached, by various means, from the kinds of civic and religious context for which it had originally been designed. By synthesising and slightly extending a developing body of research on this subject, I shall show how the social construction and cultural patterning of these new contexts of display – picture-galleries and sculpture-gardens for the most part – rewarded viewing in terms of the rationalist culture of viewing I have described. These settings and their appropriate use thereby served to inculcate a rationalist sensibility, congruent with the cultural patterning of elite philosophical and rhetorical culture.

We have already looked at the somewhat scanty and ambiguous evidence for the development of new contexts of viewing in the Hellenistic-Greek world.

[226] Thompson (1990) 146. [227] Bourdieu (1977) 89–91.
[228] Bourdieu (1984) 30, (1968) 610–11; Bourdieu and Darbel (1990) 51.
[229] Duncan and Wallach (1980). [230] Fyfe (1986); Karp (1991) 11; Alpers (1991).

In order to pursue this problem, we have to turn to Rome and in particular Pompeii, although the evidence here is also somewhat ambiguous, not least because Pompeii was a provincial Italian town, not one of the cosmopolitan centres of the Hellenistic-Roman world. Consequently much of our archaeological evidence for picture-galleries and sculpture-gardens is a somewhat pale reflection, sponsored by local elites and rising groups with social pretensions, like freedmen, of the kinds of installations that men of the senatorial elite at Rome, such as Lucullus in the Republic, or emperors such as Tiberius might have had in their palaces and villas.

In Rome, as in Hellenistic Greece, the appropriation and display of classical Greek art was initially a political and religious, rather than a specifically aesthetic, practice. As Rome expanded into the Greek world during the late third and throughout the second and first centuries BC, statues and paintings were brought back from conquered cities, displayed in victorious generals' triumphs and dedicated in temples or the porticoes of sanctuaries, often themselves built with the proceeds of conquest, in the Campus Martius.[231] The temples and sanctuaries bulging with these works of art became 'a sublimated image that the Roman nation offered itself of its growing power and felicity'.[232] Some scholars have suggested that temples became in effect museums, simply by virtue of the accumulation of works of art in them.[233] Gualandi argues that such temples were 'true and proper museums'.[234] Isager talks of 'temples and colonnades in the Greek style' as 'the proper surroundings for the works of art ... Greek sculpture['s] rightful place' and suggests that 'certain temples ... resembled veritable art museums'.[235] The resemblance, however, is misleading, a false recognition rooted in the architectural iconography of modern museums as temples of the Muses rather than in ancient realities. Although those possessed of the elite culture of viewing could in theory construe the statues and paintings in such contexts in a specifically aesthetic way, neither the gloomy interior of a temple cella nor the rituals that took place in the environs of the temple – animal sacrifice, incense burning, ritual attendance on the statue by garlanding it, and so on – facilitated or supported such a mode of engagement. Moreover, the works selected for display in such public settings were often selected on the basis of some thematic appropriateness to the context in question: Q. Caecilius Metellus rededicated a statue group by Lysippos celebrating Alexander's victories at Granikos, originally dedicated in the sanctuary of Zeus at Dion, in the sanctuary of his Roman counterpart Jupiter Stator.[236] Similarly,

[231] Rouveret (1987) 121–5; Zanker (1978) 288–93. [232] Gros (1976) 156.
[233] Van Buren (1938), Lehmann (1945). [234] Gualandi (1982) 276–7. [235] Isager (1991) 158.
[236] Vell. Pat. I.11.2–5; Hölscher (1994) 878–85, (1989).

a painting of Dionysos and Ariadne by the fourth-century painter Aristeides was placed in the temple of Ceres, Liber (the Roman Dionysos) and Libera in Rome.[237] As such they will have fitted quite adequately within the traditional practices of cultic and votive viewing described in chapter 2.

In the early imperial period some temples may have lost their cultic function and been redesigned for more specifically cultural display,[238] but the development of new specifically artistic modes of display seems to have taken place primarily in private contexts, modelled on the palaces of the Hellenistic kings.[239] Whilst the norm of public display, in religious or political contexts, was still in force in the first century BC (at least in the context of political discourse in the law courts), Verres, the governor of Sicily, was not the only member of the Roman elite who began displaying expropriated Greek art in private contexts.[240] In the *Tusculan Disputations* Cicero talks quite familiarly of the notion of having statues and paintings '*privatim*', as private property, a conception which would scarcely have made sense in the classical polis.[241] Varro tells us, not altogether approvingly, that Cicero's contemporary Lucullus, a former governor of the province of Asia (the western half of modern Turkey), had villas furnished in a 'kingly style (*regie polita*)' with picture-galleries, '*pinakothekai*', which his friends would come to visit and in which, on occasion, they would dine.[242] In the early imperial period, the architect Vitruvius suggests that 'persons of high rank who hold offices and magistracies and whose duty it is to serve the state' should have 'princely entrance courts, lofty atria, and very spacious peristyles', and in addition 'libraries, picture-galleries and basilicas arranged in a similar fashion with the magnificence of public structures, because in their houses public deliberations, private trials and judgements are often transacted'.[243]

What did these *pinakothekai* look like? Picture-galleries with movable classical Greek originals, probably possessed at any time only by those at the peak of the Roman elite – members of the senatorial class like Lucullus and Verres, have not of course survived. What do remain are more modest representations of such

[237] Pliny, *HN* xxxv.25. [238] Rouveret (1987) 128–33.
[239] Cf., however, Kunze (1996) on the relatively limited material evidence for this. [240] Cic. *Verr.* II.4.126.
[241] Cic. *Tusc.* v.35.102. Statues and paintings were monuments for public display; there was of course 'private art' in the form of painted vases, but these functioned as objects for use in a specific practical (symposiastic) setting, with which their themes were often integrated. Being relatively cheap, they did not function as markers of status like collections of paintings or sculptures (though in more precious versions, in gold and silver, of course, they did: but there is little evidence for a distinctively different discourse of connoisseurship for the precious versions of sympotic vases from that for their pottery ones – on the relationship between pottery and precious metals, see Vickers and Gill (1994)). Kunze (1996) 111–13 on the limited, generally cultic, nature of private sculpture (terracottas, occasionally marble statuettes) in private houses before the Hellenistic period.
[242] Varro, *de Agricultura* I.2.10; I.59.2. [243] Vitr. VI.5.2; cf. VI.7.3, VI.3.8; VI.4.2.

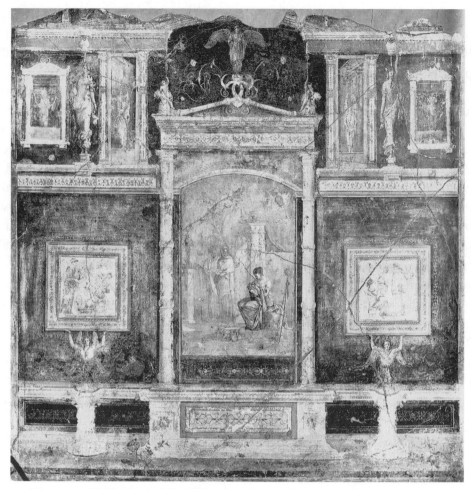

Figure 5.9 'Cubiculum' of the Villa Farnesina, *pinakothekē*. Late first century BC.
Photo: Anderson/Alinari 2937.

galleries used to decorate *cubicula* (bedrooms) and *triclinia* (dining-rooms) in houses of members of the elite in Rome, and, on a more modest scale and in inferior quality, in the Vesuvian cities of Pompeii and Herculaneum.[244] The earliest of these representations of picture-galleries is in the so-called cubiculum of the Villa Farnesina, possibly belonging to Agrippa and Julia, the son-in-law and daughter of the emperor Augustus.[245] This room exploits to the full the illusionistic techniques of the so-called second Pompeian style of wall painting, in order to give viewers the impression that they are in a gallery hung with classical Greek paintings. On the end wall (figure 5.9), a central aedicula, with two fluted

[244] Zanker (1979), Van Buren (1938), Leach (1982).
[245] Bragantini and de Vos (1982) esp. 128–37; Clarke (1991) 52; Leach (1982) 162–4.

268

Figure 5.10 Detail of figure 5.9. White-ground painting. Photo: DAI, Rome. Neg. 77.1380.

columns standing on a projecting and richly ornamented base, frames a large-scale figure-painting of the nymph Leucothea nursing the infant Dionysos, possibly a copy after or imitating a Greek painting of the fourth century BC.[246] On each side of this painting, two smaller white-ground pictures with carefully delineated moulded frames (figure 5.10) are supported by *trompe l'œil* painted statuettes of sirens, standing on half columns projecting from the dado. The style and restricted palette of the paintings recall Athenian white-ground lekythoi of the mid fifth century BC, and the paintings, portraying women with musical instruments, were presumably after or intended to echo Greek art of that period. In the so-called 'House of Livia' on the Palatine, conceivably part of the emperor Augustus' residence and certainly part of an elite domus of roughly

[246] Clarke (1991) 52.

contemporary date with the Farnesina, a similar scheme has large central mythological paintings – of Polyphemus and Galatea, and Argus guiding the nymph Io, the latter possibly a copy after a painting by the fourth-century Athenian painter Nikias – framed by smaller paintings standing on a *trompe l'œil* picture rail, some three-fifths up the height of the wall, and with illusionistically painted shutters (to protect the pictures) represented with their doors open.[247] Such imitation *pinakothekai* are also found in third and fourth style wall-painting decorations in Pompeii and Herculaneum, if in rather more modest schemes. Clarke suggests that the three paintings in oecus 15 of the House of Menander – depicting Perseus in Cepheus' palace, Perseus saving Andromeda and the punishment of Dirce – may have functioned primarily to recall 'well-known paintings by Greek masters', since the paintings are not integrated by any obvious thematic programme, and the representations of Muses floating between the paintings point to the intellectual connotations and possible purpose of the room.[248] Two oeci in the House of the Vettii are decorated as picture-galleries with a painting after or imitating classical Greek models at the focal point of each main wall, one of them – showing the infant Herakles, son of Zeus by a liaison with Alkmene, the wife of Amphitryon, strangling the snakes sent to destroy him by Hera – possibly after an original by Zeuxis.[249]

[247] Rizzo (1936) Tav. A, Tav. I–II; Leach (1982) 159; *EAA* s.v. Nikias. The whole question of copying is somewhat fraught, not least because it is generally embedded in the ideologically loaded questions of the 'originality' of Roman art and whether one can meaningfully study Greek art on the basis of Roman copies rather than 'originals'. It is clear that Greeks and Romans in the Hellenistic-Roman period both made copies and expected them to be read as such, that is as pointing towards, or derived from, or a substitute for an 'original' – if not in precisely those cultural terms. Josephus talks of Herod Agrippa adorning Caesarea Philippi with dedications of portrait statues 'and with replicas (*apotupois*) of ancient sculptures' (*AJ* XX.212). Lucian's ekphrasis of Zeuxis' centaurs is based on a copy (*antigraphos*) in Athens, 'made on the basis of accurate measurement (ἀκριβεῖ τῆι στάθμηι)' from the original, which had since been lost when a ship carrying Sulla's booty from the sack of Athens in 87/6 BC foundered off Cape Malea (Lucian, *Zeuxis* 3). Pliny tells us that Lucullus bought a copy (Lat.: *exemplar*; Gk: *apographon*) of a picture by Pausias (XXXV.125), and Quintilian is also familiar with the practice of making copies of paintings (X.2.7). As aesthetic cultivation and luxury villas in which to acquire and display such cultivation became *de rigeur* amongst a highly competitive Roman elite, and amongst their inferiors who wished to emulate them, the production in Greece of serial copies of statues for export was established, and eventually workshops were set up in Italy itself (P. Zanker 1978, 287; Coarelli 1983).

The evidence indicates that the ancients recognised copies and read them as proxies for the works of the great classical masters, in a manner not entirely dissimilar from the way we read casts, posters or reproductions in books. My argument does not depend on whether the reader would also recognise as copies those paintings and sculptures which I, following other scholars, have suggested might be copies, let alone on agreement that they are copies after the particular named artists. I am not so much interested in the elucidation of individual paintings, sculptures or ensembles at Pompeii or Herculaneum – still less to use these 'copies' to write a history of Greek art. What concerns me here is the articulation of sets of practices of viewing, collecting, copying and display. For the sceptic, the particular images in question can stand as proxies for the kinds of pictures that viewers of the Hellenistic-Roman period would have recognised as copies of works by great classical artists, and in interpreting which they would have deployed the sophisticated culture of viewing I have described.

[248] Clarke (1991) 180–2. [249] Clarke (1991) 223–7; Pliny, *HN* XXXV.63.

How did these schemes depend on and reward the sophisticated culture of viewing that I described in the opening sections of this chapter? By framing each picture as an independent object of visual interest, these picture-galleries encouraged attentive looking. The contrast between the austere linear severe-style imitation fifth-century white-ground panels, with their restricted pallet, and the richer, more modelled central panel in the Farnesina lends itself to precisely the kind of stylistic comparisons, art-historical explanations (of the differences in style) and aesthetic arguments which Quintilian tells us about.[250] In a specifically religious context such as a temple, orally transmitted mythic knowledge was rewarded in so far as the programme of paintings revealed the *aretai* or virtues of the god to whose power the viewer-visitor to the temple was gaining access in his act of worship. The temple of Dionysos in Athens, for example, had representations of Dionysos bringing the drunken Hephaistos back to Athens, the deaths of Pentheus and Lycurgus (mythic kings who had sought to suppress the cult of Dionysos) 'paying the penalty of their insolence', and Dionysos arriving to save Ariadne abandoned by Theseus on Naxos.[251] In a *pinakothekē*, the pragmatic relevance of viewing was suspended, as are the pragmatic cues which might incline the viewer approaching a temple in a sanctuary to adopt a ritual attitude and to link the art displayed with the deity of the temple. In place of the pragmatic mythic-religious and ritual knowledge associated with oral *paideia* and the ritual involvements of a religious setting such as a temple, it was literary-mythological and art-critical knowledge which was at a premium in order to recognise the mythic scenes represented, place them in their broader narrative context and evaluate the appropriateness of the way in which the artist had represented the scene to the story – as we encounter Plutarch and the epigram writers doing (see above, pp. 261–4). Style (and the content of the painting) does not tacitly shape and mediate the relationship and attitude of the viewer as worshipper towards the god. It is rather available for discursive objectification as the theme of the viewing experience in the evaluation of painterly *technē*.

This is not to say that there were no programmes, only that the underlying organisation of the programmes was not religious and they did not lend themselves to religious viewing. In so far as the collections of paintings in such *pinakothekai* are programmatic, they lend themselves to a rhetorical articulation of the relationship between the paintings. The panels of the Room of the Fateful Loves in the House of Jason depict Phaidra and Hippolytos (both killed as the result of the former's love for her stepson Hippolytos), Medea and her

[250] Quint. XII.10.3–13. [251] Paus. I.20.3.

271

children (whom she killed to avenge herself on her unfaithful husband, Jason) and Paris and Helen (who herself survived the consequences of her unfaithfulness to Menelaos, but cost Paris and thousands of Greeks and Trojans their lives). As Richard Brilliant has suggested, the visual interest of the collocation of these three paintings lies less in an underlying theme – such as the dangers of passion, which might have appealed to Stoics and other rationalists – than in the way in which the ensembles 'impose a dialectical tone on thematic representation as if they corresponded visually to the familiar rhetorical practice of *controversiae* or disputations'.[252] In so far as the viewer followed Plutarch's precepts, he was not expected to identify with the protagonists but to discourse upon the possible rhetorically identifiable relationships – similitude, difference, analogy – between the different scenes, to thematise in critical discourse and to take pleasure in the rational formal properties of the painting contributed by the artist, and perhaps to conclude with the kind of epigrammatic evaluation of the cleverness and propriety of the artists in adjusting their mode of representation to the mythic themes in question, as exemplified in rather condensed form by the ekphrastic poems of the Greek anthology, such as Antiphilos' epigram on a painting of Medea. The deeper one's knowledge of myth, the fuller one's critical vocabulary, and the more refined one's rhetorical skill in seeing and manipulating the rhetorical tropes of irony, metonymy, synecdoche, and so on, the richer the viewer's reading could be.[253]

The pleasure generated by such viewing practices was deeply rational, *logikos*. *Logos* mediated the relationship between the viewer and both the mythic content and the aesthetic forms of the painting. *Logos* provided the basis of the self-conscious, self-reflexive criticism of the relationship between form, content and viewer's response. The primacy of the value-pattern of reason in informing this mode of viewing should not, however, be conflated with the cognitive primacy which informs science, the cultural realm which we most readily associate with rationality. On the contrary, high-cultural viewing was primarily expressive in classical antiquity as in the modern world, and indeed the elite culture of viewing in classical antiquity is very expressive, if within a different cultural frame from the depth expressiveness of the modern high-cultural ethos, derived from the cult of sensibility and Romantic aesthetics. The expressive style of the elite culture of viewing in classical antiquity was patterned by the self-consciously manipulated resources of rhetoric to create a rationalist sensibility which took pleasure in the work of art as a manifestation of artistic reason (rather than creative will) and took that pleasure by means of a critical discourse of viewing which laid a

[252] Brilliant (1984) 69. [253] Brilliant (1984) 71–3.

premium on both the supposedly most rational artistic elements of the work of art being viewed and the rationality of the viewer's response.

The same rationalist, rhetorical expressive-style informed the organisation of at least some displays of sculpture, and their viewing, within houses, whether indoors or in sculpture-gardens.[254] The appropriation of art in these contexts thereby shaped the viewer-collector's expressive identity in conformity with conceptions of the rational man formulated in philosophy. Amongst Cicero's letters is a series in which he writes to his friends Atticus and M. Fadius Gallus concerning statues and other pieces of sculpture which he had asked them to purchase for him in Greece for the decoration of his villa in Tusculum. He seeks to decorate a peristyle in his house with statuary which might evoke the atmosphere of the Academy (of Plato and his successors) in Athens, itself set in a public gymnasion, although in Cicero's case this space is privatised and internalised in his house. He asks his friends to acquire '*ornamenta* γυμνασιώδη', ornaments suitable for a gymnasion and '*dignum Academia*' worthy of an Academy.[255] He is delighted with a Hermathena, a double bust of Hermes and Athena, 'exactly the right ornament for my Academy (*ornamentum Academiae proprium meae*) since Hermes is to be found in every gymnasion and Minerva is a signal feature of mine'.[256] A set of Bacchantes, however, he declines as not being worthy of him (*me digna*). Muses 'would have been apposite in a library and concordant with my literary pursuits (*aptum bibliothecae studiisque nostris congruens*). But as for Bacchic women, where is there a place for them in my house?'[257] Whilst clearly integrated with the literary and intellectual activities of Cicero, and with rationalist techniques of self-formation, there is little in Cicero's letters to point to art as an autonomous province of meaning valued in its own right, as opposed to art oriented to evoking the philosophical culture of the elite.

A similar impression is created by the best surviving late Republican sculpture garden, in the Villa dei Papiri at Herculaneum, so named after the scrolls of Epicurean philosophy writing found in its library. This villa has an elaborate programme of sculpture, decorating its peristyle/'gymnasion' and a porticoed garden. Whilst there are 'copies', often somewhat abbreviated in the form of herms, of relatively famous works of classical Greek art – Polykleitos'

[254] There was also, of course, a range of other programmes which informed such displays. Some, unlike Cicero, seem to have preferred Dionysiac themes – even in these cases, however, the tone of such displays often has a highly sublimated, cultivated and intellectual character – designed as they are to evoke literary and sentimental reminiscences, rather than the specifically religious responses they may have evoked in their originally sacred settings in classical Greece. Neudecker (1988) offers a comprehensive study of the range of programmes and their motivations: 50–5 on Dionysiac installations.

[255] Cic. *Att.* I.5, 9. [256] Cic. *Att.* I.4. [257] Cic. *Fam.* VII.23.

Doryphoros, Pheidias' Amazon, Polykleitos' Herakles and a Polykleitan ath-
lete – it is not at all clear that they were intended to be read in a specifically
aesthetic way rather than as an element in a broader programme which evokes
the philosophical and literary culture of the owners of the villa more generally.
The works of classical art are interspersed amongst busts and statues of philo-
sophers (Epikouros, Hermarchos, Zeno), orators (Demosthenes, Aeschines),
poets and poetesses, and Hellenistic kings, as elements in a programme which
articulates and either opposes (Sauron) or resolves the antinomy between
(Pandermalis) the Epicurean view of the good and reasonable life (which in its
most extreme formulation mandated total withdrawal from political life) and the
Stoic ideal that recognised the political roles of warrior and orator as part of the
social duty of the wise man, which, if thrust upon him, he was bound to accept.[258]

It may be a mistake, however, to push too hard the distinction between a
sculpture-garden or decorative scheme indoors evoking the philosophical life and
a sculptural scheme supporting art as an autonomous province of meaning. Both
were articulated at a similar level of cultural generalisation and were elements of
the same range of rationalist techniques of self. Each in different ways functioned
to enhance identification with the cultural patterns of elite rationalism, rather
than with the embedded religious culture of the city states. As Rouveret has
suggested, the 'Academy' of Cicero or the 'Garden of Epikouros' of the owner
of the Villa dei Papiri constituted a setting for high-cultural – philosophical,
literary – rational activity. Further, partly by virtue of their complementarity with
an art of memory learnt by orators and rooted in a sense of the evocativeness of
place, they created the psychological conditions of identification with the masters
of philosophy represented in such decorative schemes and hence the development
of the pupil-proprietor's own rational self.[259]

Such a complementarity does seem to be established in the imperial period.
Conceivably this was a result of the increasingly profound assimilation of Greek
high culture on the part of the Roman elite, and a relaxation of an ambivalence
about Greek art (particularly marked during the Republican period in such
political contexts as the law courts),[260] motivated by a pressing need on the part

[258] See Sauron (1980/1), Pandermalis (1971), Warden and Romano (1994) for programmatic interpreta-
tions; P. Zanker (1995) 203–10 for a broader intellectual interpretation; Neudecker (1988) 107–14
emphasising the aesthetic interests informing parts of the collection.

[259] Rouveret (1989) 324–5.

[260] Cicero seeks to deny any but the most superficial knowledge of Greek art in the Verrines, whether
because such aesthetic affectations were seen as unRoman (as Cicero implies in order to engender
prejudice against Verres), or because they were perceived as an element of specifically elite culture,
distinguishing aristocrats such as Cicero from more ordinary citizens in the jury (Cic. *Verr.* II.4.132;
II.4.4; II.4.5). In his letters and philosophical works, intended for a more restricted audience, he is by no
means so coy.

of the established elite to distinguish themselves culturally from the increasingly wealthy and powerful imperial freedmen. In the second poem of book II of the *Silvae*, Statius describes the villa of Pollius Felix at Surrentum. The description, from the villa's natural setting and its enhancement by Pollius to the description of the individual rooms and their decoration, is designed to evoke the suitability of Pollius' abode to rational – literary, philosophical and rhetorical – pursuits, and the success of Pollius in realising 'the peak of reasonable nature and a disposition of the soul in full agreement with it' as Plutarch would put it.[261] In the course of his description, Statius enumerates the works of art in Pollius' collection. Works of classical masters – paintings by Apelles, an early Pheidias – are valued as such and listed alongside portraits of philosophers, each presumably, in a slightly different way, pointing towards their owner's rational culture and a medium through which that culture is deepened:

What should I relate of the ancient figures in wax and bronze, or what the pigments of Apelles once rejoiced to bring to life, or the hand of Pheidias carved, wondrous nonetheless though Pisa was still empty, or what was commanded to live by the art of Myron or the chisel of Polykleitos; the bronzes from the glowing ashes of Corinth, more precious than gold, the countenances of commanders (*duces*) and seers (*vates*, i.e. poets) and sages (*sapientes*) of old time, whom you are anxious to follow, whom you are sensible of through the whole of your breast, free of worries, always lord of your own heart, in your tranquil virtue?[262]

Later examples also suggest that, as in *pinakothekai*, the pendant was used as a device to organise sculptural displays in terms of 'intellectual and formal values', thus lending them to the kind of rational aesthetic appropriations we have seen in the case of paintings.[263] In a room in an imperial building in Side, for example, a copy of the Ludovisi *Diskobolos* or discus-thrower, possibly to be attributed to the fifth-century sculptor Pythagoras, is displayed alongside a copy of Myron's *Diskobolos*. The former is 'stiff-jointed and frontal – "early" in its conception', the latter 'with a naturalistically modelled anatomy and a pose of considerable complexity, hallmarks of a later era'.[264] Outside their original context and function as memorialisations of athletic victory in one or another of the sanctuaries of the athletic circuit in Greece, it is difficult to interpret the deliberate placing of these two very different treatments of the same subject – a discus thrower – as pendants to each other in the decoration of a indoor room except as a demand for specifically aesthetic and even art-historical appropriation on the part of the viewer, along the lines of Quintilian's, Cicero's or Pliny's accounts of the development of the *technē* of sculpture in the fifth century BC.

[261] Plut. *Mor.* 24e. [262] Stat. *Silv.* II.2.63–72. [263] Bartman (1988), (1991).
[264] Bartman (1988) 222–3.

CONCLUSION

Art history writing, I have argued, was invented in Hellenistic Greece as a result of the intersection of two related social and cultural processes. First, the efforts of classical Greek artists to secure institutional autonomy on the grounds of the rationality of their profession failed, but left a permanent precipitate in the Greek cultural archive in the form of their technical handbooks. Second, the restructuring of the intellectual field, under the influence of the patronage of the Hellenistic monarchs and the creation of the cultural institutions which graced their capitals, gave rise to a project in which the new intellectuals employed in these institutions sought to organise, codify and canonise the Greek literary tradition, including the treatises of the artists of the fourth century. At the same time – possibly under the influence of the invention of art history writing, possibly giving rise to art history writing – the Hellenistic kings expropriated classical statues and paintings from cities which fell under their influence, initially perhaps as a token of their political power, later and in addition as a sign of their place as inheritors of the cultural traditions of classical Greece. These practices were fused in a courtly and princely high culture characterised by art collecting, the creation of new contexts for the display of art, and an etiquette of cultured viewing. In the context of the increased social mobility of the Hellenistic world, the formation of elites transcending the bounds of the poleis, and the conquest of the Hellenistic Greek world by Rome, which became a primary centre of Hellenistic culture, the high culture of the Hellenistic monarchs was adopted as a marker of elite status and cultural distinction. Whilst many of the cultural practices of ancient high culture and their social functions are homologous with those of modern high culture, ancient Graeco-Roman high culture was distinctively patterned on several levels: the narrative structure of the story of art, rhetorics of appropriation, and the settings for the display of art and its cultured viewing. This distinctive patterning was shaped both by the characteristic education of the Graeco-Roman elite and by their commitments to the philosophical ideal of the rational man. In addition to its social functions as a marker of elite status, Graeco-Roman high culture shaped the expressive identities of members of the elite in accordance with the rationalist presuppositions of Greek philosophical culture and thereby helped to sustain that culture.

EPILOGUE: ART AFTER ART HISTORY

INTRODUCTION: COPYING AND CREATION IN POST-CLASSICAL ART

How did the development of art history writing affect the cultural environment of artists, their role, status and agency, and how is this manifested in artistic production? Bernard Schweitzer, followed by many more recent scholars, suggested that the Hellenistic period saw a breakthrough to a conception of the visual artist as the possessor of a special irrational faculty of creative imagination, analogous to (in fact the direct antecedent of) the modern concept of the artist.[1] Others, focusing on artistic production rather than than history of ideas, argued that the failure of fourth-century artists such as Lysippos and Zeuxis to bring to institutional fruition their attempts to secure a radical autonomy for artists entailed a significantly reduced level of artistic innovation in the post-classical Greek world. The vastly expanded market of the Hellenistic-Roman world, and the cultural premium laid on classical art, encouraged artisanal serial production that was organised on an industrial scale, at the expense of an earlier tradition of relatively small workshops responding flexibly to their immediate environments.[2] In the Roman period, official art drew upon the technical capacities and figurative repertoire already established in the classical and early Hellenistic Greek worlds, adapting and transposing models to new purposes, but not introducing any fundamental innovations in techniques, style or repertoire of motifs.[3] As Martin Robertson put it, 'the creative artist as he was known in Greece tends to fade out between the programme organiser and the craftsman'.[4]

More-recent literature has been characterised by a similar ambivalence about the creative character of Hellenistic- and Roman-period Greek art. Some see the

[1] Schweitzer (1925), (1932) 7, (1934); Pollitt (1974) 52–5, 101–2. I discuss the concept of *phantasia* and its implications for artistic agency below. For a detailed critique of Schweitzer, and his successors – particularly Watson – and their tendentious translations of the key texts, see Tanner (forthcoming).
[2] Bianchi Bandinelli (1978) 11–13. [3] Bianchi Bandinelli (1978) 13. [4] Robertson (1975) 605.

Hellenistic period as one of important innovations in both genres and styles,[5] whereas others attribute even such supposedly Hellenistic innovations as baroque style to earlier periods and characterise the Hellenistic period as one of the elaboration and recombination of elements that were largely inherited from the classical period.[6] This debate comes into a particularly sharp focus over the issue of copying in the late Hellenistic and Roman worlds. Scholars concentrating on the social organisation and material techniques of production have argued that they were fundamentally changed from those of the classical polis in order to fit a mass market, following Rome's unification of the Mediterranean in the last two centuries BC. Innovation in production methods – moulds for ceramics, increased division of labour, large teams of sculptors working with drills from different sides of the object, replacing individual or small groups working with chisels, mechanical techniques of copying – took place, whilst a tried and established repertoire of figure scenes (and variants thereon) was relied upon in part as a strategy for ensuring sales of increasingly commodified art forms to increasingly distant consumers.[7] The mass production of 'ideal sculpture', copying Greek models, in order to decorate first the villas of the Roman elite and then to form the statuary programmes of public buildings throughout the Roman empire represents the model case of this 'massification' of art production.[8] Other scholars, focusing on small groups of copies in their original contexts, or series of copies supposedly replicating single Greek prototypes, have emphasised the freedom and creativity of the Roman-period artists in relation to their models. Drawing attention to the variation between each realisation of copies after a single model,[9] and the innovative character of statues composed of elements derived from a number of discrete originals, often from different style periods, some have argued that Roman-period sculptors consciously aimed at emulating and surpassing the classical Greek models on which they based their own new 'creations'.[10] Although, in many respects, an important corrective to a traditional focus which valued what were perceived as 'slavish' copies only as proxies for their Greek originals, this new strand of research sometimes simply inverts the traditional approach, remaining embedded within normative western categories of creativity, partly with the explicit goal of enhancing the status and reputation of Roman sculpture, celebrated as the first neoclassicicism.[11]

[5] R. R. R. Smith (1991), Marszal (1998). [6] Fullerton (1998) 95; Ridgway (1999) 7.
[7] Pfanner (1989), Heilmeyer (1988) 15–20. [8] P. Zanker (1978), Niemeier (1985), Marvin (1989).
[9] See Bartman (1992) 63 on the 'individual character' of each copy. [10] Gazda (1995b) 135.
[11] See Gazda (1995b) 121–9 on the intellectual and cultural context of the development of Kopienkritik; Hallett (1995) for a balanced defence of the method. Cf. Marvin (1989) 40 for the first neoclassicism; Fuchs (1959) 158 for slavish copying.

This final chapter seeks to contribute to this debate by looking at certain aspects of Hellenistic-Roman art production in the light both of the concepts of artistic agency, explored in chapter 4, and of the elaboration of the processes of artistic differentiation and rationalisation manifested in the invention of art history writing, discussed in chapter 5. Artistic agency is realised through a repertoire of artistic forms. A crucial component in that agency, and in determining artists' sense of what it means to be an artist, is the relationship of artists to form and to the repertoire of forms inherited from the past.[12] This relationship to past forms is shaped by artists' 'past-orientation', their attitude towards their inheritance, and the cultural and practical means which reproduce that inheritance, whether in an iterative or a transformative way. Both the attitudes and the artistic practices through which artists engage the inherited repertoire are in turn embedded within and partially shaped by the social setting within which art production takes place, comprising both the artists' relationships to patrons and the practical contexts for which works of art are produced. In what follows, I shall argue that the value placed by elite patrons on the opportunity to exercise and display the *intellegere* characteristic of the high-cultural practices which we saw in chapter 5 intersected with the changing bases of the organisation of artistic production, to give rise to a distinctive structure of artistic agency. This structure of agency had a characteristically rationalist style. Rather than seeking to transform their inherited legacy by creating new styles or new motifs, artists rationally adapt that repertoire to a spectrum of contexts from the more functional to the more purely aesthetic, demonstrating their own capacity as agents through the rational tropes that they deployed in their contextually appropriate selection and adaptation of forms. Like the Roman sculptures it concerns, the novelty of my argument lies less in its individual components or observations than in placing them together, abstracted from their original contexts, into a new whole, where they exemplify a rationalised structure of artistic agency, particularly characteristic of elite Graeco-Roman artistic culture, and with specific social and cultural foundations.

ART AND AGENCY IN POST-CLASSICAL GREECE

The social status and cultural valuation of artists

An examination of the admittedly somewhat fragmentary evidence for the role and status of artists in the Greek world in the post-classical period does little to

[12] In addition to Brain (1989), (1994), I draw here on Bryson's valuable discussion of artistic tradition (1984) especially 1–31, 32–62.

confirm Schweitzer's picture, or that of more recent work suggesting that Roman-period sculptors were perceived as creatively emulating and surpassing their Greek forebears in a way analogous to that in which literary figures such as Vergil were.[13] After the fourth century we encounter no more works of art asserting autonomy in the manner of Zeuxis' centaurs, Praxiteles' Eros or Lysippos' Kairos. The story of art transmitted by Pliny the Elder stops rather abruptly in 296 BC with the statement 'cessavit deinde ars' ('then art came to an end').[14] The subsequent Hellenistic period is a lacuna in Pliny, but for a brief 'revival' in 156 BC, which mentions artists associated with major projects at Pergamon. These, however, are soon forgotten by Pliny and play no further part in the later critical tradition.[15] This lacuna is not peculiar to Pliny but is common to the entire ancient art-critical tradition.[16] The artists whose names are remembered and who are held in high esteem to the point of being celebrated as major contributors to their cities' – usually Athens – cultural greatness (a celebration inconceivable in the classical Greek city) are above all fifth- and fourth-century artists.[17] The anonymity of Hellenistic and Roman artists is particularly striking in light of the fact that the same period gave rise to and saw the flourishing of biography.[18] Where the Roman poet Martial may bring one of his poems as a birthday gift to his friend, a statue – by Pheidias – is presented not by a sculptor but by an art collector.[19] For Columella, there are no Roman artists to be named as successors to Pheidias in the same way as Cicero may be said to have succeeded Demosthenes.[20] The few Roman artists whose names Pliny transmits to us are remembered more as the recipients of imperial patronage than as great artists.[21] Statuary and painting are held by Cicero to be the work of *opifices*, mechanics, not liberal arts.[22] Even if one enjoys a work of art, one should despise the artist as a labourer indifferent to the nobler virtues.[23]

This is not to say that we do not continue to get glimpses of artists who had high social status. As in the classical world, wealthy sculptors and painters might hold civic offices, such as priesthoods, or act as benefactors.[24] But, as with the potters of late archaic Greece, it is only in quite unusual and momentary conjunctures that individual artists emerge to any kind of real prominence

[13] Gazda (1995a), (1995b). [14] *HN* XXXIV.52.
[15] Gros (1978), Preisshofen (1978) 271. [16] Settis (1995a) 46.
[17] Aristid. *Panathenaic Oration* 364; Plut. *Mor.* 345–7; Strabo IX.1.16, XIV.1.25 – Parrhasios and Apelles from Ephesos.
[18] Burford (1972) 205. [19] Mart. x.87.
[20] Columella I.pref.30–1. Similarly, portraits of contemporary Roman literary figures were displayed in villas and libraries, alongside of those of Greek intellectuals and writers: Neudecker (1988) 67, 70.
[21] *HN* XXXV.119–20. [22] Cic. *Orat.* 2.5. [23] Plut. *Per.* 1.4–2.2. [24] Goodlett (1991) 676.

from the civic framework which remained the norm, and these events leave no institutional precipitate. The extraordinary honours accorded to Damophon of Messene, in the first half of the second century, possibly extending to a heroon after his death, all fit into a traditional pattern of honouring civic benefactors.[25] Although they relate to his work in constructing statues for various communities, most notably Messene, they do not honour him as an artist *per se*, but, like Polygnotos in the fifth century, for expending his resources on behalf of the state: not charging for his labour, agreeing to a postponement of the collection of payment due to him, promising to complete work despite the delay of contractors.[26] The brief emergence of individual artists from anonymity, during the second century BC when art *revixit* in Pliny's history, occurs during a period when there was a particularly high level of competition for Greek artists to work on the projects of members of the Roman elite, when classicism received a high ideological valorisation, and when patterns of patron–artist relationship were not yet crystallised.[27]

In the Hellenistic and Roman periods the claims of artists to rationality seem to have been moderated and with them the claim to deference based on a mode of life infused with the value of Reason. Aristotle and Plato had accorded a privileged place amongst practitioners of *technē* to architects, because their contribution to building was purely theoretical, primarily mathematical, a matter of supervising intellectually less well-endowed practitioners of the handicrafts.[28] The claims of the Roman architect Vitruvius are much more modest. He asserts that architects have a share in the *ratio* common to all educated persons and insists that an architect should have a certain amount of philosophical education.[29] The work of the architect involves both *fabrica* (craftsmanship) and *ratiocinatio* (reasoning). Reason, however, is not – as it was for fourth-century painters and sculptors – intrinsic to the pursuit and development of architecture, but an extrinsic aid. Only if he has been instructed by philosophers will the architect be able to understand the works of the great Hellenistic engineers such as Ktesibios and Archimedes.[30] A little philosophy ensures the honesty of the architect and saves him from the temptations of avarice.[31] The activity of architecture as such is 'craftsmanship ... continued and familiar practice which is carried out by the hands'.[32] Theoretical reason is not intrinsic to such practices, but does allow their methodical explanation and justification. The absence of literary culture and theoretical reason does not damage one's work

[25] Cf. Gauthier (1985). [26] Themelis (1994) esp. 25–30. [27] Gros (1983) 433–6.
[28] Pl. *Plt.* 259e; Arist. *Metaph.* 981b30; Vernant (1983) 281–2. [29] Vitr. *De arch.* 1.1.15, 1.1.7.
[30] *De arch.* 1.1.7. [31] *De arch.* 1.1.7. [32] *De arch.* 1.1.1.

as architect as such. It simply means that the architect will not enjoy a prestige proportionate to his accomplishments.[33] Similarly, Galen, in a tract intended to persuade its readers of the honourable status of the medical profession, draws a distinction between 'reasonable and holy (*logikai kai semnai*)' *technai* and banausic *technai*. The former, one may honourably pursue if one does not have sufficient personal wealth to be able to enjoy the leisure necessary to the purely contemplative life of perfect reason. The latter are 'despised because they involve bodily labour and … men call them banausic and manual'. If one pursues one of these *technai* one's soul (*psychē*) will be rendered utterly brutish (*boskematodēs*). Amongst the acceptable *technai* are listed medicine, rhetoric, music, geometry, arithmetic, mathematics, astronomy, grammar and law. Painting and sculpture stand somewhere between these liberal arts and the brutish life of the banausic. If you like, Galen suggests somewhat ambivalently, you may, as some of his contemporaries did, add these to the list of liberal professions, not so much because of their logical and rational components, but because they are the least physical of the manual crafts, and consequently will not let you down in your old age, 'for even if they accomplish their business by means of the hands, at least they do not require the strength of a young man'.[34]

The hints of Galen that sculptors and, probably to a greater extent, painters could at least make some claim to be practitioners of liberal arts, ranking with rationalised professions like medicine, together with the fact that some artists at least continued to enjoy a rhetorical and philosophical education,[35] indicate that had we a treatise by a sculptor or painter, similar to that of the architect Vitruvius, it might make similar modest but real claims to an artistic identity rooted in a philosophical-rhetorical education and rationalised design technology. Such an identity would make the meaning of what it was to be a craftsman/ artist in the post-classical Greek world, and of the the cultural practice of making art, somewhat different from what it was for archaic or classical Greek craftsmen, Egyptian sculptors and painters or late antique and early medieval sculptors and painters, after the eclipse of Greek philosophical-rhetorica paideia.

A suggestive model for how we might wish to think of artistic agency in the post-classical Greek world – one that shows the importance of the degree of rationalisation of artistic design and the relatively high degree of rational culture expected of and attributed to visual artists, in comparison with other craftsmen – is offered by Pierre Gros' sketch of the transformation of

[33] *De arch.* I.I.I. On the limited intellectual pretensions of Vitruvius, see Gros (1983) 446.
[34] Galen, *Protreptikos* 14.
[35] *HN* xxxv.135. Metrodorus, painter and philosopher as tutor for sons of Aemilius Paullus.

architectural agency in the early Roman empire. He points out that the scope
for architectural creativity in the provinces of the early Roman empire was
limited by a number of factors: a fixed typology of urban buildings, the
universal diffusion of the structural schemes and decorative models of
Hellenistic-Roman architecture, and a strong normative sense of appropriate
urban design. Within these constraints, the architect nevertheless played a
creative role, in so far as the inherited schemata required adaptation to the
particular demands of a specific building programme, and the buildings needed
to be aligned to the natural environment in which they were inserted in such a
way as to make the best use of the resources the site offered.[36] Such a practical
structure of artistic agency was sustained on the basis of a specific professional
authority, prestige and autonomy – not that of the autocratic creator of the
modern West, but a real prestige and autonomy nonetheless, rooted in a certain
level of philosophical-rhetorical education and the mastery of rationalised tech-
niques of design. It depended on, and helped to sustain, a distinctive sense of the
architect's vocation: the harmonious insertion of man in his natural environ-
ment through the medium of architectural design rationally adapted to both the
nature of man and the broader natural environment in which he exists, with all
the rich evaluative connotations of 'reason' and 'nature' which go with the
Greek conception of nature as a living organism animated by divine Reason, in
which man participates by virtue of his intellect.[37]

Lacking a Vitruvius to give us an equivalent sense of artists' self-identity in
the Roman period we can only read between the lines of the few testimonia
available to us, such as those of Galen, insisting as they do on the real if limited
rationality of the sculptor and painter. Fragments of literary evidence, however,
and the evidence of the practices of sculptural production in particular, do
suggest that in some domains of art production (notably ideal sculpture and
sarcophagi), oriented towards elite consumers possessed of the aesthetic *paideia*
discussed in the last chapter, a distinctively new structure of artistic agency was
developed.

Phantasia: intellect and the conceptualisation of visual imagination

Schweitzer was right to suggest that the concept of *phantasia* had important
implications for the conceptualisation of artistic invention, and of the

[36] Gros (1983) 445.
[37] Goguey (1978), emphasising the difference between the role of the modern western architect, concen-
trating on the building *per se* as a work of art, and Vitruvius' concentration on the architect as a mediator
of the man–nature relationship.

understanding of the artist's role, but mistaken in interpreting *phantasia* as an irrational creative faculty attributed to visual artists as special culture heroes in the Hellenistic world. The positive value attributed to *phantasia* in Hellenistic philosophy lay less in its non-rational biological basis than in its crucial role in the development of human reasoning, when integrated with specifically human linguistic and conceptual capacities. Animals also shared *aisthetikē phantasia* – perceptual imagination/visualisation, but only human beings were endowed with *phantasia logikē*, the capacity for forming rational presentations. Whilst *aisthetikē phantasia* made available the perceptual experiences on which all knowledge was founded, it was only man's 'discursive intellect' (*dianoia eklalitikē*) that, by 'translating presentations into discursive sequences', consti-tuted such presentations as objects of theoretical reflection.[38] Once transposed into discourse, *logos*, such presentations could be the object of a range of distinctively human cognitive operations through which higher thought was generated: analogy (*analogia*), opposition (*enantiosis*), transposition (*meta-thesis*) and recognition of similitude (*homoiotēs*) amongst them. These operations play a particular role in generating knowledge that cannot depend solely on direct sense perception: for example, the centre of the earth cannot be seen, but it can be conceptualised on the basis of analogy with other spheres; death we cannot experience but can conceptualise through its opposition to life. These operations are defined as types of *phantasia*: *metabatikē phantasia* – 'transitive impression', for example, involves inference fom one sense impression (intel-ligible impression) to a further intelligible impression – for example from physical movement to the concept of space or void. It is thus a process generative of knowledge, and the condition of movement from lower to higher forms of knowledge. 'Imaginative' visualisation is understood in exactly the same terms, as an exercise of the rational faculties of the mind: the centaur is conceived through *synthetikē phantasia*, synthesising the separate impressions of man and horse; the Cyclops by a form of analogy, magnification; whilst the pygmy is conceptualised by its inverse, diminution. It is the capacity for 'making transitions and syntheses' that differentiates rational human beings from ani-mals, permitting active rational adaptation to the providential world, as opposed to the merely passive adaptation of animals:[39]

the structure of our intellect is such that we do not just passively register impressions as perceptible objects act upon us, but we select among them, subtract from them, add to

[38] Imbert (1980), quotation 187. Key texts: Sext. Emp. *Math.* VIII.274–8, XI.249–52; Diog. Laert. VII.49–56.
[39] Imbert (1980) 189, quoting Sext. Emp. *Math.* VIII.288.

them, and put them together to make something out of them, and, indeed, make transitions from some to others, which are somehow connected to them.[40]

It is this rational *phantasia*, rather than some irrational faculty – whether the modern notion of creative imagination or the low faculty of *aisthetikē phantasia* that is shared with animals – which post-classical art writers seem to have in mind when they talk of *phantasia* as 'wiser then mimesis'.[41] In Philostratos' *Life of Apollonios*, Apollonios criticises Egyptian theriomorphic representations of gods, and makes a claim for the authoritativeness of their Greek counterparts, which suggests that they are something more than mere imitations:

Phantasia wrought these works, a wiser craftsman than mimesis; for whilst mimesis crafts what it has seen, *phantasia* also crafts what it has not seen, for it will undertake (*hypothesetai*) its task by reference to reality (*tou ontos*). And often mental disturbance (*ekplexis*) will knock mimesis from its course, but it will not affect *phantasia* at all, for *phantasia* advances imperturbably (*anekplektōs*) towards whatever it has proposed to itself (*hypetheto*). So it is necessary when reflecting on (*enthumethenta*) an idea (*eidos*) of Zeus to envisage him with the heavens, the seasons and the stars, as Pheidias in his times sought to do, and if you intend to craft an image of Athena, you must keep in mind (*ennoein*) armies, cunning skill (*metis*) and *technē*, and how she sprang out of Zeus himself.[42]

What is striking about the language here is how Philostratos echoes the technical philosophical language of intellectual argumentation, at the expense of a degree of clarity in elucidating what he actually understands the artist to be doing. *Hypotithemi* is regularly used in the sense of proposing a subject or task for discussion, or assuming a preliminary or premise for a discussion. *Ekplexis* connotes a mental disturbance or passion, a loss of rational self-control; *anekplektōs*, so secure a level of rational self-possession, that one cannot be emotionally disturbed.[43] *Enthumazein* means simply to think deeply, but an *enthumema* is a technical term of Aristotelian logic, referring to a kind of syllogism drawn from probable premises and described as a figure of thought specifically antithetical to the arousal of emotion.[44] *Phantasia* is conceptualised not as an irrational or inexplicable originative faculty, as in the creative

[40] Epict. *Diss.* 1.6.10; quoted in Imbert (1980) 189–90. Many of these categories are also terms for the operations of rhetoric: *aphaeiresis* – the removal of first or initial components in a sequence (Lausberg 1998, 219); *prosthesis* – addition (Lausberg 1998, 218); *synthesis* – combination or arrangement (Lausberg 1998, 411; Wuellner 1997).

[41] For a critical discussion of conventional treatments of *phantasia*, such as those of Watson (1988; 1994), which assimilate it to the modern conception of irrational artistic imagination, see Tanner (forthcoming). Limitations of space permit only the presentation of a rationalist alternative here.

[42] Philostr. *VA* VI.19.

[43] Cf. Longinus 15.1, where *ekplexis*, emotional effects of amazement on the part of the reader/listener, is recognised as one of the possible objects of poetic writing.

[44] Arist. *Rh.* 1369a20 contrasting with emotion, and 1418a12–15: 'Whenever you wish to arouse an emotion do not use an enthymeme', since each drives out or disables the other.

imagination of artists in the West after the Renaissance, but, blurring Stoic and Platonic ideas, as a rational faculty, constrained by and making reference to *tou ontos*, the world of the cognisable forms. In this respect, what Philostratos seems to have in mind is a kind of knack for translating between the verbal and the visual, and in particular for finding visual allegories of verbal ideas.

Such a capacity was by no means unique to visual artists, but was a central component of the rhetorical and philosophical culture of the elite of the Hellenistic-Roman world.[45] The rhetorical genre of ekphrasis was precisely intended to call up in the hearer's mind a vivid (*enargēs*) visual image or presentation – *phantasia* – produced through the medium of words. What Philostratos seems to be saying is that visual artists draw upon a comparable facility, but then, by virtue of their possession of a particular manual skill, are able to translate the visual impression into a material form as a piece of sculpture. In Philostratos, Apollonios distinguishes between two mimetic faculties.[46] The first makes likenesses (*eikazein*) with the mind alone, for example seeing centaurs and stags in the formation of clouds, by virtue of a natural mimetic faculty which is predisposed to rearrange chance configurations into meaningful forms (*anarhythmizein*). The second mimesis, that of sculpture and painting, builds on this universal natural mimetic instinct through a learned facility in handling brushes and the instruments of sculpture. The higher, more intellectual, dimension of mimesis is part of a shared rational faculty common to all human beings, supplemented in the case of visual artists by a technical capacity for translating visualisations into material form. There is no sense of the visual artist having some kind of special gift, creativity, which sets him apart from other men as a visionary of any kind.[47]

We find exactly the same idea in Dio Chrysostom's account of Pheidias' production of the statue of Zeus at Olympia. Dio, as an orthodox Stoic, conceives God as the living mind or reason at the heart of nature, which, like Plato's Forms but now world immanent rather than transcendent, is only fully comprehensible by the intellect, not by the senses: 'For mind and intelligence in and of themselves no statuary or painter will ever be able to represent; for all men are utterly incapable of observing such attributes with their eyes.' According to Dio, the models Pheidias draws upon are verbal ones, above all

[45] Imbert (1980) esp. 201–3; Diog. Laert. VII.187–8; Cic. *Fin.* II.69.

[46] Philostr. *VA* II.22.

[47] Consequently, there is no inconsistency between these two passages in themselves, or between them and *VA* IV.7, where Pheidias' Zeus is judged inferior to Homer's. The inconsistencies between the passages found by Watson (1988) are largely a function of his wishing to interpret *phantasia* as creative imagination, and it is suggested that consequently poetic and rhetorical *phantasia* are somewhat different, or alternatively that it is simply a lack of 'fairness' on the part of the 'literary man' insisting on the 'relative inferiority of the visual artist' – Watson (1988) 84.

Homer's representations of Zeus, which Pheidias translates into visual form, thus representing an allegory or symbol of true divinity.[48] Dio characterises the force of Homer's description of Zeus as a rhetorical ekphrasis, spoken '*enargōs kai pepoithetōs*', both key terms of rhetorical criticism, referring to the vividness with which words permitted the object of description to be visualised by the hearer of the words, and the conviction that the visualisation carried of reality.[49] The conception of *enargeia* is picked up in the speech of Pheidias, where he emphasises the difficulty faced by the sculptor maintaining the image in his mind (*en tei psychei*) continuously during the long period whilst he works on the sculpture, and the need for an image of great clearness (*enargeia*) and conviction, precisely the kind that a great poet like Homer can provide.[50]

What we would characterise as the creative imagination of the artist is understood in terms of the same kind of facility for transposing words into images, and vice versa, that was characteristic of the rhetorical culture of the elite in the Hellenistic-Roman world.[51] Philostratos approves Pheidias' attempt to evoke images of 'the sky, the seasons, and the stars' on his representation of Zeus, because by these means he creates a visual allegory of the cosmic power of Zeus, which, by operation of *metabatikē phantasia* on the part of of a viewer such as Dio Chrysostom can give rise to more purely rational, discursive reflections.[52] To be sure, the artist participates in the realm of reason, but only in a partial and imperfect way. He is more distant from perfect reason than either the poet or the philosopher. The sculptor lacks the freedom and the facility of the poet, by virtue of the difficulty of the material the sculptor has to work.[53] It is the philosopher who 'by means of reason interprets and proclaims the divine nature most truly and probably most perfectly'.[54]

[48] Dio Chrys. XII.25–6 and 62. The idea that Pheidias modelled his Zeus on Homer was a commonplace of ancient art criticism: cf. Strabo VIII.3.30/354a; Val. Max. III.7.ext.4; Plut. *Aem.* 28. Man, as the most rational of Nature's offspring, was the most suitable vehicle for a visual allegory of God as pure and perfect Reason.

[49] See, for example, G. Zanker (1981). [50] Dio Chrys. XII.71.

[51] See also Dio Chys. XII.75–80, largely concerned with the way different verbal attributes of Zeus, often cult titles, can be given visual form.

[52] Cf. Imbert (1980) 215: 'The autonomy of reason consists in the mastery of the presentations which sustain it.' A reading of the Zeus, like that of Dio, demonstrates such mastery, in contrast to the vulgar popular readings which conflate image and referent and perceive the image as god – criticised by Plutarch, *Mor.* 379c–d (see ch. 2, pp. 48–54) because still current and probably dominant amongst sub-elite viewers. Cf. the lack of mastery displayed by Tiberius and Encolpius in relation to the visual presentations they encounter in classic mythic representations with erotic dimensions, see above, pp. 225–61.

[53] Dio Chrys. XII.68–70.

[54] Dio Chrys. XII.68–70. Cf. Philostr. *VA* IV.7, where Apollonius is represented as disparaging the Pheidian Zeus as a mere visual appearance, fixed in one place, in comparison with the Homeric description of Zeus, which conveys *hyponoia*, a deep allegorical meaning intimating the heavenly world of the Forms, and communicable throughout the world. See Imbert (1980) 184, n. 7 on the unity of the arts and sciences, treated as new forms of perception, in a hierarchy with philosophy at the top, citing Cic. *Acad.* II.31, Plut. *Demetr.* 1.

Phantasia in practice: historicist aesthetics and the rhetoric of art

The development of the concept of *phantasia* thus defined the operation of the visual imagination, and hence the role of the artist, in a very particular way. Artistic imagination, although disembedded from the purely reproductive mimetic culture in which Plato had placed it, remained framed within an epistemological system in which primacy was attributed to the rational intellect and its operations. Art was valued in so far as it could participate in these operations and generate works of art which lent themselves to such intellectual play.[55] This active selection, abstraction and synthesis (as Epiktetos would put it) from the legacy of visual forms inherited from the past, in the production of objects designed to engage a correspondingly *intellectually stylised* response, can be particularly clearly seen in two domains of art production oriented to elite consumers: decorative 'ideal sculpture' and mythological sarcophagi.

Art history writing transformed the environment within which art was produced and viewed, most notably for the cultural elite. The structure of Hellenistic art history created a closed tradition, in which it was held that the entire repertoire of formal devices for the representation of reality had been discovered and that certain canonical models for the representation of gods and men established. Classical art was both distanced from the present and authoritative for it.[56] All that was left for contemporary artists was to make appropriate selections from that canonical repertoire. Such selection could take two forms. On one level, famous works of classical art could be accurately copied, with minimal intentional variation.[57] On another level, a more sophisticated historicist viewing was catered for by eclectic copying.[58] Here the artist selected and abstracted elements from a variety of sources and recomposed them in order to construct a new unitary synthesis, which nevertheless retained traces of its original models, which the art historically informed viewer could recall through an act of *metabasis*, intellectual transfer.

This way of viewing is attested from as early as the first century BC. The author of the *ad Herrenium*, in a discussion of the borrowing of rhetorical exempla from past authorities versus inventing one's own, draws the analogy with the idea of a statue with a 'Myronian head, Praxitelean arms and a Polykleitan chest'.[59]

[55] Cf. Arist. *Poet.* 1448b12–17 on aesthetic pleasure as pleasure in learning, discussed above pp. 197–8.

[56] Settis (1995a), Preisshofen and Zanker (1970/1).

[57] See Marvin (1997) 13–15 on the consistency of the Diadoumenos and Doryphoros replica series, by contrast with the Hermes, Herakles and Diskophoros attributed to Polykleitos by modern scholars, about which she is more skeptical (15–28). See Bartman (1992) for the best study of the range of copying practices.

[58] Preisshofen and Zanker (1970/1). [59] [Cic.] *ad. Herr.* IV.6.9.

In the second century AD a speaker in a dialogue by the rhetorician Lucian constructs a verbal portrait of a mystery woman, in which each element is constructed on the model of a famous work of art.[60] Having established that his interlocutor is a connoisseur of art, who has visited the sanctuary of Aphrodite at Knidos to see the famous statue by Praxiteles, climbed the Akropolis to admire the Sosandra of Kalamis and visited the Gardens outside the walls of Athens to see Alkamenes' Aphrodite, the speaker Lykinos entrusts to Reason or eloquence (*logos*) the project 'to reconfigure (*metakosmein*) the statues, to combine them, and fit them together as harmoniously as he can (*harmozein*), preserving at the same time the composite unity and their variegated character (*poikilian*)'.[61] The procedure is identical with that according to which higher conceptual forms are elaborated on the basis of simple presentations in Stoic *phantasia* theory, and the conceptual vocabulary correspondingly echoed (*metakosmein, suntithenai*). As in Philostratos, the specifically artistic contribution of the artist would consist not so much in this imaginative faculty – shared with all men of some intellectual culture – as in the technical capacity effectively to materialise the new vision.[62]

A body of art produced according to similar principles is characteristic of Hellenistic-Roman art of the first century BC and later, and it is particularly associated with the work of Pasiteles, the author of a classicising treatise on the *Nobilia Opera* of the fifth and fourth centuries BC, and his school. It continues to be produced in ever more refined forms in the first two centuries AD.[63] Two groups exemplify such works. The San Ildefonso group, late first century BC (figure 6.1), combines two statues by artists of widely differing periods and styles: on the left the languid figure of the Apollo Sauroktonos by the fourth-century sculptor Praxiteles (cf. figure 4.8 on p. 189 – the head of Antinous is a second-century replacement of who knows what original); on the right, the more athletic, Polykleitan figure of the Westmacott ephebe (cf. figure 3.7 on p. 118), from the fifth century BC, with the head of the somewhat more mature Doryphoros.[64] Each figure is adjusted towards the norms of the other – the modelling of the Westmacott athlete softened, that of the Sauroktonos strengthened – to create a level of unity whilst maintaining the overall contrast.

[60] Lucian, *Imagines* 1; discussed in Preisshofen and Zanker (1970/1); more recently Maffei (1986), apparently unaware of Preisshofen and Zanker, concentrating on funerary portraiture; cf. Goldhill (2001b) 187–93 for a sophisticated literary-critical treatment of the dialogue, in the context of a wide-ranging consideration of 'cultivated' viewing in the second sophistic.
[61] Lucian, *Imagines* 1.6.
[62] Indeed Lucian suggests that the vision would be preferable in purely verbal form rather than materialised as a sculpted or painted portrait – *Imagines* 1.23.
[63] P. Zanker (1974) is the standard study. [64] P. Zanker (1974) 28–30; Kleiner (1992) 30–1.

Figure 6.1 San Ildefonso Group, late first century BC. Photo: Hirmer 644.1053.

In a slightly earlier group (50–25 BC – figure 6.2), the figure on the left, the Stephanos athlete (so-called after a version signed by Stephanos, the pupil of Pasiteles), combines the posture (distinguishing weight-bearing and free leg, but without a fully articulated contrapposto) and upper body (shoulders pulled

Figure 6.2 'Orestes and Electra', group made up from Stephanos Athlete and
Aphrodite of Fréjus, *c.* 50–25 BC. Photo: Anderson/Alinari 23083.

back, chest protruding) of an early fifth-century severe-style statue, like the
Omphalos Apollo, with late fourth-century Lysippan proportions (small head,
long legs). In turn, the female figure combines the standing posture and drapery
of the late fifth-century Aphrodite of Fréjus (cf. figure 2.15 on p. 78), with a

severe-style (early fifth-century) head (hair-roll, sharp modelling of brow line) and Praxitelean (fourth-century) reliance on an external support in the form of the male figure.[65] In neither case can we identify the subject with much certainty. In the case of the San Ildefonso group, Castor and Pollux, Orestes and Pylades, Hypnos and Thanatos have been suggested; in the case of the Naples group, Orestes and Electra, Perseus and Andromeda; but in neither case with much conviction. More likely it was just a general classical atmosphere that the figures were intended to evoke, and their visual interest was focused purely on their historicising aesthetic qualities: rewarding the connoisseur able to compare and contrast the varying period styles and identify the multiple models which lay behind the images.[66]

A similar pattern of artistic invention is apparent in Roman mythological sarcophagi, albeit that the freedom of art-historical play is constrained by the need to select and adapt models from the repertoire in a way appropriate to the funerary context in which they were to be deployed. It has long been recognised that sarcophagus sculptors worked primarily by recombining motifs inherited from classical and early Hellenistic sources, rather than inventing wholly new formal types.[67] Some sarcophagi give the impression of being little galleries of *nobilia opera*, copying, for example, series of famous types of Herakles statue, after such well-known sculptors as Lysippos.[68] Recently, Michael Koortbojian has shown the extent to which conceptual and rhetorical tropes inform and structure typical patterns of visual invention in the creation of mythological narratives in Roman sarcophagi. Capacities for analogy, abstraction and typological allusion, designed to appeal to the rhetorically educated viewer also structure the combination and elaboration of inherited motifs into new compositions with enriched meanings. Analogies might be formulated between related narrative and moral exempla on the basis of the assimilation of iconographic types, marked by the quotation of a famous classical work of art, stimulating the viewer to the kind of *synkrisis* or comparison that was a regular part of the programme of rhetorical *progymnasmata*.[69] In a sarcophagus that relates the story of the Phaidra and Hippolytos an analogy is drawn with the the myth of Aphrodite and Adonis, by representing Phaidra enthroned, in the same way as Aphrodite, and marking the borrowing of the pose by quoting Skopas' famous sculpture of Pothos, 'Longing', placed at the knee of Phaidra (figure 6.3).

[65] P. Zanker (1974) 49–56; Kleiner (1992) 30–1; Gazda (1995b) 133–5; Tancke and Yfantidis (1989).
[66] P. Zanker (1974) 49–56; Kleiner (1992) 30–1; see Simon (1987) for specific mythological interpretations.
[67] Koch and Sichtermann (1982) 246–52; see Lippold (1935) 262–4 on models for sarcophagi reliefs.
[68] Walker (1990) nos. 15, 64. [69] Marrou (1956) 201.

Figure 6.3 Sarcophagus, Phaidra and Hippolytos. Louvre, Paris. Photo: DAI, Rome. Neg. 72.1327.

The visual parallel creates an 'intellectual correspondence', enriching the meaning of the Phaidra–Hippolytos myth, and its eschatological significance, through comparisons of its similarities to, and differences from, the story of Aphrodite and Adonis. In both cases the heroines of the story are ultimately denied the fulfilment of their love when the beloved refuses to heed their words. Aphrodite, despite her passion for Adonis is unable to save him when he refuses to follow her advice and instead goes on a hunting expedition, which results in his death. Phaidra, when her sexual advances are spurned by her step-son Hippolytos, sets in train by her suicide a chain of events which lead to Theseus' curse on his own son, and Hippolytos' death. In both cases, refusal to heed their lover's words, the rejection directly or indirectly of the call of Aphrodite in favour of the world of virile action represented by the hunt, leads to the death of the hunter hero. Heroic death in acts of exemplary *virtus*, however, also leads to a certain immortality, in the cults which memorialised and mourned the untimely and undeserved deaths of both young men.[70]

Other techniques used to elaborate upon the stock repertoire of types also point towards a rhetorical pattern of invention or artistic habitus. The number of Erotes escorting Selene is multiplied in some later (third-century AD) recensions of the Endymion story. The myth's topographical setting is specified by the addition of geographical personifications, the figure of Mount Latmos, accompanied by an old shepherd who witnesses the scene. The referential context is broadened with the addition of chariot-borne figures of Apollo and Selene in the upper corners of the sarcophagus, specifying the twilight hour at which the encounter occurred, and giving it a cosmic frame. All these extensions of the much simpler visual core of the myth are interpreted by Koortbojian as variant forms of rhetorical *amplificatio*, a technique whereby the orator – or artist – repeated, developed and amplifed the components of a basic core of material in order to communicate the same underlying idea in a more impressive and powerful manner: 'The formerly simple scene of seduction has been transformed into the complex representation of a cosmic event.'[71] Funerary rhetoric itself functioned in a similar way, consoling mourners with learned mythological comparanda, and allusive citations of classic authors – all designed to appeal to an audience of extensive literary erudition.[72] Where one might explain the comparable rhetorical relationship between different pictures in pictorial programmes at Pompeii as a result of the patrons' selection,[73] the patterns of composition in sarcophagi presuppose that such rhetorical dispositions have

[70] Koortbojian (1995) 28–37. [71] Koortbojian (1995) 70–4, quotation 74.
[72] Muller (1994) 91–3, 160–1. [73] Brilliant (1984) 67–80.

been internalised within the practices of design and production of the artists themselves – whether directly, through limited rhetorical education, or mediately through socialisation into the cultural expectations of their customers.

Hellenistic-Roman artistic agency in historical and comparative context

The rhetorical and historicising pattern of artistic invention manifested in ideal-sculpture and sarcophagus production is not merely a function of a period eye of the viewer, let alone the squeezing out of a capacity for artistic invention by technological rationalisation. On the contrary, it represents a distinctively Greek form of artistic agency that mediates between parameters of technique and design, elite intellectual culture, and the social structures of both patronage and aesthetic communication within which artistic form could be effective. It has a technical basis in copying practices, in which casts were used both for ideal sculpture and as iconographic models in sarcophagus production. In particular, the analytical decomposition of complete statues into component parts, as casts, and their recomposition in the creation of copies, lent itself to eclectic and synthetic recombination of the original elements into new wholes within which the component, historically antecedent parts, nevertheless remained recognisable.[74] These patterns of invention align artistic design with elite culture in two respects. First, in building new visual types, and enriching the domain of visual meaning, they deploy the same forms of intellectual *phantasia* as are characteristic of elite philosophical and rhetorical culture in the generation of new ideas: abstraction, analogy, transfer, synthesis. Secondly, they betray the same classicising relationship to the past artistic tradition as characterises the dominant conceptions of cultural history in contemporary elite culture. We have already seen how a form of classicism is built into Aristotle's teleological account of the development of literary genres, each realising a form given in nature, after which further innovation – the discovery of new forms – ceases. Pliny's history of art shares the same set of assumptions, concluding at the end of the fourth century, when all the devices neccesary to the naturalistic depiction of the world of gods and men in painting and in sculpture had been discovered. The pattern of invention in ideal sculpture and mythological sarcophagi works on exactly the same classicising assumptions, ringing the changes on an inherited and largely closed repertoire of visual types and styles.

[74] Maffei (1986) 161–2; on the use of plaster-cast models from, generally toreutic, prototypes in the design of sarcophagus reliefs, see Froning (1980).

Such artistic agency is not free-floating. Rather, it is also shaped by social relations of patronage. Correspondingly, there is a spectrum from relatively pure examples of historicising and aestheticising cultural production to cases where such patterns of artistic invention are more strongly cut across by the specific social demands associated with a particular functional context. *Idealplastik* like the Ildefonso group represents one end of the spectrum. Another comparable example is offered by the second-century AD Spada relief series, probably originally pendants to each other.[75] In each of the reliefs a famous classical sculpture is cited and harmoniously inserted in a new narrative context as one or another mythological hero: the Doryphoros plays Bellerophon, a Meleager of Skopas or his circle represents Amphion, and a Diomedes is copied after Kresilas' statue of the same subject. Such sculptures were intended for private contexts and learned viewers. They had no social function beyond manifesting their owners' *intellegere*, and no cultural function beyond offering objects on which such cultivation might be exercised, and a distinctive ethical-aesthetic subjectivity be constructed.

At the other end of the spectrum, in imperial sculpture, we encounter a similar structure of agency, but inflected by the more specifically political function of the art. As Tonio Hölscher has shown, imperial relief sculpture characteristically abstracts, selects and synthesises formal models from a variety of periods according to the content to be communicated and the ethical connotations which the sculpture is designed to evoke. Thus in the Ara Pacis, the male figures in the processional friezes are based on classical models, the draped females on Hellenistic. In the tableau showing Aeneas – Augustus' ancestor and the progenitor of the Roman race – sacrificing, the landscape elements and Aeneas' assistants are drawn from Hellenistic repertoire, whilst Aeneas himself is represented according to classical iconographic and stylistic models, in order to emphasise his *pietas* and strengthen the visual parallelism with the classicising image of Augustus in the processional frieze.[76]

Funerary sculpture, in particular sarcophagi designed for the elite, probably stands somewhere between these two poles. On the one hand, the imagery is selected and recontextualised in order to generate responses appropriate to a funerary context. On the other hand, there is quite good reason to suppose that such imagery retained a certain autonomy even when recontextualised – just as the learned literary allusions and quotations in funerary rhetoric were expected to be recognised as such, at the same time as their content had more specifically

[75] Muller (1994) 122–5; Kampen (1979).
[76] Hölscher (1987) 46–9; see Pollini (1995) for similar principles informing the design of the Prima Porta Augustus.

emotive consolatory relevance. Of course, where the images do have a specific contextual relevance, it is tempting for 'primitivists' to suggest that they were not recognised as historical quotations at all,[77] and it is difficult in any individual case to demonstrate that they were. But, in addition to the parallels with the pattern of quotation and allusiveness in funerary rhetoric, there is good evidence that such quotation of works was recognised and played with even a little further down the social scale – and *a fortiori* it seems reasonable to assume it in the case of sarcophagi. A relatively modest grave altar of Tiberius Octavius Diadoumenos is decorated with an image of the famous statue of the same name by Polykleitos, a characteristically Roman onomastic visual pun which depends on the contemporary viewer being able to recognise the statue and its name for the joke to work.[78]

By virtue of its self-conscious character and the reflective – self-conscious, and art-historically informed – response expected of the viewer, this kind of repetition goes beyond the practical iteration that is characteristic of any craft tradition.[79] It also differs fundamentally from the repetitions characteristic of classical art and iconography, by virtue of its dependence on a sense of (art-) historical distance.[80] The superficially similar repetition of the imagery of the Tyrannicides – in representations of Theseus and later of the Athenian polemarch Kallimachos at Marathon in the Stoa Poikile paintings and in the frieze of the temple of Athena Nike – is in fact importantly different. In the recycling of the Tyrannicide imagery, it is less the statue than the action that is re-evoked, and in such a way that time and history are mythicised, each event the repetition of an essential and unchanging Athenian *aretē*.[81] Such repetition and response to it was embedded in the bodily practices of mimesis and the conceptual logic of myth, not the abstract distanciating reflections of art history.

The role of the post-classical artist, therefore, seems not to have been one of creation of new forms *per se*, of a struggle to gain mastery over and subdue the recalcitrant material with which he works or radically to transform an inherited tradition and thereby register his individuality (nor was it ever in the Greek

[77] E.g. Fullerton (1997) 439 'little if any evidence that Roman sculptures were ever intended to be understood in this way' – i.e. as copies, imitations, or quotations; (1998) 96 arguing against any 'perceived referentiality' in neo-Attic art.

[78] This is just one of a series of such altars playing such games of quotation and replication, dating from the first two centuries AD – Boschung (1989).

[79] Contra Fullerton (1997), (1998), following the 'primitivist' orientation of Ridgway.

[80] See Settis (1995a) and Niemeier (1985) 15–18 on the distinctive character of theoretically and historically informed Hellenistic and Roman copying in contrast with the reiteration characteristic of classical art, and of course in much Roman-period art production of a more embedded character.

[81] See ch. 4, pp. 184–7.

world).[82] Rather, the artist's relationship to material form and the structure of his role seems to have been as distinctively Stoic as that of Vitruvius as an architect. The artist's role is rationally to adapt a given repertoire of forms and styles to the shifting requirements of patrons, thereby providing the forms through which viewers may rationally mediate their expressive relationships with their changing lifeworld: relationship to self, power, death, and so on – all the characteristic themes of Roman art and iconography.

This structure of agency gave rise to a distinctive pattern of artistic innovation and cultural accumulation. There is certainly innovation here, but on the basis of a fundamental continuity in terms of the inherited repertoire of motifs and types. Innovation and the creation of new meanings takes place by increasing the density of the semantic interconnections within this set of types, elaborating implicit complementarities – a form of 'cultural embroidery'[83] – within an inherited repertoire rather than by generating the new types and new styles which characterised innovation in the classical period.[84] The differences between Hellenistic-Roman and classical artistic agency lie not only in the kind and quality of innovativeness, but in the structure of that agency, and the articulation between art work and socio-cultural world which it implies.

In classical sculpture and painting, the expressive powers of art were accumulated and elaborated on the basis of an increasingly densely networked set of mimetic correspondences between artistic form and bodily practices, whether bodily actions and facial expressions (chapter 3), or ritually marked social roles grounded in patterns of physiological maturation (chapter 2). Hellenistic-Roman art is to a higher degree abstracted from the flow of social life – in

[82] See Baxandall (1985) 53–7, 131 for an emphasis in the artist's registration of their own aesthetic individuality as an essential component of the western tradition after the Renaissance. The 'anxiety of influence' so characteristic in western art cannot have been so pressing at all in the Greek context.

[83] See Archer (1988) 157–8 for a characterisation of the distinctive pattern of cultural invention and accumulation which takes place in a culture that is characterised by elements that stand in a complementary relationship with each other (as opposed to various types of contradictory relationships between the elements of a single cultural system, which tend to give rise to rather different patterns of innovation, seeking to eliminate one or other of the contradictory elements, or to reconcile them – both strategies which involve quite marked reorganisation of a cultural system).

[84] See Koortbojian (1995) 47 on the expansion of connotations through these representational strategies. Koortbojian continues: 'it was by these means that artists freed themselves from the bondage of codified visual programmes for their myths and allowed their powers of invention free rein'. This is surely a valuable corrective to the traditional accounts of the Romans simply slavishly copying inherited models, but freedom is by no means absolute: the particular structure of invention which these rhetorical means allow is also quite constraining, in so far as it does not offer the grounds for a fundamental reordering of the inherited iconograpic or stylistic repertoire that was characteristic of the period following the Greek revolution. Such fundamental change in later Graeco-Roman art is almost certainly generated from without, rather than from within, the classical tradition – as suggested, for example, in Elsner's (1995) account of the transformation in Roman art as in part a response to its changed religious environment, most notably Christianity.

very high degree in the case of historicist works like the Ildefonso, less so in historical reliefs like the Ara Pacis – and more highly culturally mediated.[85] Classical art appealed to an eye embedded in the socialised body of the citizens of a polis. In doing so, it constructed its iconographic repertoire in part on the basis of a practical and scientific understanding of the organic functioning of the human body, both in action and expression, and as it matured over time. Hellenistic-Roman art, at least in its more high-cultural manifestations, appealed to the mind's eye of a highly cultivated intellectual and cultural – as well as social – elite. Although the new elite shared much of the evaluative vocabulary that was characteristic of the classical polis, the ground of that vocabulary had shifted. The military and political elites that were characteristic of the fractious classical Greek poleis had been gradually pacified, first with their displacement as the dominant centres of power by Hellenistic kingdoms, and then through incorporation within the Roman empire. Orderliness (*kosmiotēs*) and good discipline (*eutaxia*) were no longer components of a civic *paideia*, learnt in processes of socialisation into the disciplines of the hoplite phalanx, but of an intellectual *paideia*, inculcated in the philosophical and rhetorical schools.[86] *Eutonia* was less a question of a muscular physiology, demonstrating preparedness for the stresses of hoplite warfare, than a state of mind, a fine-tuning of the soul, which demonstrated the personal good order and rational self-mastery proper to a member of the ruling class that maintained and guaranteed that order in the Roman empire.[87] Correspondingly, the art sponsored by this elite constructed its iconography by reference not to the natural functioning of (socially relevant dimensions of) human physiology, but to a cultural tradition perceived to have an exemplary character, and a set of rational, highly intellectual, techniques: analogy, transposition, and synthesis. These techniques constituted the means by which this inherited tradition could be appropriated, elaborated and extended, within rather limited parameters, to construct new

[85] Cf. Fuchs (1959) 193–4 for highly perceptive remarks along similar lines, even if one need not take his Heideggerian approach so far as to see classical art as authentic, Hellenistic-Roman as inauthentic; Hölscher (1987) 49–50 characterises the difference similarly, as between classical art grounded in 'concrete experience of life and world' and Hellenistic-Roman art in which content is abstracted and form typified.

[86] See Gleason (1995) 54–72 on rhetorical education and the culture of deportment; Panagopoulou (1997) for a wide-ranging study of the evaluative vocabulary of the Greek elite under the Roman empire, and the concept of the cultivated man.

[87] On spiritual *eutonia*, see Galen, *de plac. Hipp. et Plat.* iv.403–4 (Kühn); Long and Sedley (1987) 1.418. Cf. Stob. ii.155, on the good man as 'calm and orderly', defining *kosmiotēs* as 'knowledge (*epistemē*) of fitting activities' and calmness (*hesuchiotēs*) as the 'proper regulation (*eutaxia*) of his soul's and body's natural activities and rests' – Long and Sedley (1987) 1.419. For a splendid evocation of the personal style associated with such *paideia*, see Brown (1992) 35–58. On the changing balance between literate and physical (*gymnastikē*) *paideia*, the 'natural' vocation of the orator for rulership, see Morgan (1999a) 11–24, 227–35.

meanings and meet new expressive needs, generally of a rather refined and highly intellectualist character, on a variety of levels of cultural abstraction.[88]

Although Roman-period artists did, like all human beings, exercise a certain level of agency, indeed in rather sophisticated forms, the extraordinary authority attributed to the exemplary cultural inheritance of the past seems to have minimised the extent to which this agency was acknowledged by the consumers of art, or the individuality of artists' products perceived and valued. In this respect, what has been called Roman neoclassicism differs markedly from the two other 'classicising' traditions shaped by a strong historical self-consciousness grounded in the practice of art history writing, European post-Renaissance classicisms and Chinese painting after the Song dynasty.[89] The past-orientation of European neoclassical painters such as David was a much more 'activistic' one.[90] David engages with tradition in order to trump and surpass it, relegating – for example – baroque and rococo to the status of dead styles, whilst creating paintings intended from their conception to be hung as the next step forward in the progressive series of paintings that characterised the French tradition in the Louvre.[91] This urge to surpass the past, to take tradition forward by creating an original, has been characterised in terms of an 'anxiety of influence', a 'sense of belatedness' which is not so much suppressed in Pliny's *Natural History* as simply never there, in the absence of the radical concept of creativity characteristic of western art history.[92] Certain strands of Chinese painting, in particular that of the literati, are perhaps just as strongly oriented towards their own historical past as post-classical Graeco-Roman art. The development of art history writing in China also gave rise to practices of copying, and to 'classicising', retrospective movements in art production. In striking contrast with the situation of post-classical artists in the Graeco-Roman world, however, there is an explicit critical tradition interpreting contemporary art as emulation of the

[88] Cf. P. Zanker's (1974, 41–2, 117–18) observation on the gradual dissolution of the organic, functionally integrated character of the contrapposto of the classical originals in Roman-period copies and adaptations. I am of course concerned here with a relatively restricted part of the vast corpus of Roman art, namely that most directly indebted to the classical and Hellenistic traditions, and sponsored by a relatively narrow social and cultural elite. Much of the more radical innovation in later Roman art comes from groups and regions that are in certain respects marginal or peripheral to this elite core: see Elsner (1998) 115–43, 205–21.

[89] See Marvin (1989) 40 for the analogy between Roman and European neoclassicism.

[90] Cf. Parsons (1937) on 'instrumental activism' as the dominant value-orientation of western post-Protestant culture.

[91] See Bryson (1984) 1–31 on the problem of tradition in European painting; 32–62 on David taking on and trumping tradition; McClellan (1994) 76–7 on David's major history paintings being specifically designed for a museum context, and in full awareness of the artist's assertion of his place in the history of the French school, as displayed in the visual narrative of a universal survey museum.

[92] See Bryson (1984) 9 on the suppression of the sense of belatedness in Pliny; 37 on the pressures of the sense of belatedness in European classicism.

past, and celebrating the emulative copyist on the same level as the artist of the past whose work he imitates. A seventeenth-century scholar celebrates having seen the painter Wang-Hui's (literary name Shih-ku) 'Imitating Chu-Jan's "Mist Floating on a Distant Peak"', a copy made for the censor Tsai-Weng. 'I would like to congratulate myself privately on encountering three great happy events in one day: I have actually seen the living incarnation of Chu-Jan; I have admired at a distance the cultivated air of Tsai-Weng; and I have come into close contact with Shih-Ku's personal manner.'[93] The passage makes an interesting comparison with Statius' poems on the art-collecting activities of Pollius Felix, whose cultivation is demonstrated by his connoisseurship only of art of the classical past.[94] In no case in the Roman world is such an aesthetically oriented interest in contemporary art and artists seen to confer status on the connoisseur, or the copyist celebrated as the equal of the predecessor he copied.

CONCLUSION: THE ANCIENT SYSTEM OF THE ARTS

Compared with most other cultures in world history, the level of artistic rationalisation achieved within the Greek cultural tradition was very high – but it was also uneven. The particular shape of the process of differentiation was determined both by the evolving social structure of the Greek world, and the patterns of artistic patronage to which that gave rise, and by the culture of rationalism characteristic of the Greek philosophical tradition. The history of the artist in the classical world is one of paradoxes: the same processes of the democratic elaboration of state institutions as facilitated the development of naturalism, together with the enhanced artistic autonomy which the new visual languages afforded artists, also constrained the parameters of patronage, and thereby artistic experimentation, and severely limited the social and cultural esteem enjoyed by artists. The new intellectual culture, which provided tools that were crucial in visual artists' rationalisation of their own practices – medical knowledge of human physiology, mathematics, geometry – and was the basis of artists' claims to professional esteem, also severely limited both the level of cultural esteem that artists might enjoy and the possibility of any breakthrough to strong forms of autonomy. Even when the suspicion of philosophers such as Plato was moderated in later Greek philosophical systems, the

[93] Murck (1976) xv.
[94] See above, p. 275. Settis (1995a) 46 draws attention to the significance of the absence of a critical tradition concerned with contemporary art in the Roman world, comparable to that elaborated for the discussion of classical art.

absolute primacy placed on reason, the culture of *logos*, could never find a place for visual artists on a similarly elevated level to that of philosophers and rhetoricians, let alone above them as special inspired visionaries unconstrained by the limitations of reason. Only after the claims of fourth-century artists to a relatively strong form of autonomy had already failed, did the codification of their technical writings in the more literary form of Hellenistic art history writing give rise to a sense of visual art as an autonomously developing tradition with its own specifically aesthetic problems and a series of linked solutions which constituted its history.

The final outcome of this process of cultural rationalisation was the production of art with a rather purely aesthetic and art-historical orientation, primarily for connoisseurs and collectors. But the scope of the institutionalisation of a relatively autonomous domain of art was much more limited than its modern western counterpart, which developed on the basis of similar processes from the Renaissance to the nineteenth century. Two major factors in limiting that scope were, first, the strongly exemplary status and character of the art of the classical period, and, second, the sense of closure implicit in the artistic tradition as it was defined in Greek art history writing. Both of these features of the Greek tradition militated against the internalisation of a sense of progressive history as a dynamising and productive factor within the ongoing development of an artistic tradition such as characterised later European art.[95]

[95] For an outline of a more systematic comparative sociological approach to the development of high culture and a relatively autonomous institution of art in the Greek world and the modern West, see Tanner (2005), emphasising the role of Judaeo-Christian culture in the Renaissance and later transformation of the Greek art-historical legacy.

REFERENCES

Abrams, M. H. 1989a. 'Art-as-such: the sociology of modern aesthetics', in Abrams, *Doing Things with Texts: Essays in Criticism and Critical Theory*, ed. M. Fischer. New York and London: 135–58.

1989b. 'From Addison to Kant. Modern aesthetics and the exemplary in art', in Abrams, *Doing Things with Texts: Essays in Criticism and Critical Theory*, ed. M. Fischer. New York and London: 159–87.

Adkins, A. W. H. 1960. *Merit and Responsibility: a Study in Greek Values*. Oxford.

Ajootian, A. 1996. 'Praxiteles', in *Personal Styles in Greek Sculpture*, ed. O. Palagia and J. J. Pollitt. Yale Classical Studies 30. Cambridge: 91–129.

Alexiou, M. 1974. *The Ritual Lament in the Greek Tradition*. Cambridge.

Alpers, S. 1991. 'The museum as a way of seeing', in *Exhibiting Cultures: the Poetics and Politics of Museum Display*, ed. I. Karp and S. Lavine. Washington: 25–32.

Alsop, J. 1981. *The Rare Art Traditions: the History of Art Collecting and Linked Phenomena*. New York.

Anderson, J. K. 1963. 'The statue of Chabrias', *AJArch*. 67: 411–13.

Andò, V. 1975. *Luciano, critico d'arte*. Palermo.

André, J. M. 1978. 'Nature et culture chez Pline l'ancien', in *Recherches sur les artes à Rome* ed. J. M. André. Paris: 7–17.

André, J. M., R. Bloch and A. Rouveret (eds.) 1981. *Pline l'Ancien: Histoire naturelle livre XXXV*. Paris.

Andreae, B. 1990. *Phyromachos Probleme. MDAI (R)* Erg. 31. Berlin.

Archer, M. S. 1988. *Culture and Agency: the Place of Culture in Social Theory*. Cambridge.

1995. *Realist Social Theory: the Morphogenetic Approach*. Cambridge.

Austin, A. G. 1944. 'Quintilian on painting and statuary', *CQ* 38: 17–26.

Austin, M. and P. Vidal-Naquet. 1977. *Economic and Social History of Ancient Greece: an Introduction*. Berkeley.

Babb, L. A. 1981. 'Glancing: visual interaction in Hinduism', *Journal of Anthropological Research* 37: 387–401.

Bal, M. and N. Bryson. 1991. 'Semiotics and art history', *Art Bulletin* 73: 174–208.

Barron, J. 1972. 'New light on old walls: the murals of the Theseion', *JHS* 95: 20–45.

Bartman, E. 1988. 'Decor et duplicatio: pendants in Roman sculptural display', *AJArch*. 92: 211–25.

1991. 'Sculptural collecting and display in the private realm', in *Roman Art in the Private Sphere: New Perspectives on the Architecture and the Decor of the Domus, Villa and Insula*, ed. E. K. Gazda. Ann Arbor: 71–88.

1992. *Ancient Sculptural Copies in Miniature*. Leiden.

Baxandall, M. 1985. *Patterns of Intention: on the Historical Explanation of Pictures*. New Haven and London.

Beagon, M. 1990. *Roman Nature: the Thought of Pliny the Elder*. Oxford.

Beard, M. 1993. 'Casts and cast-offs: the origins of the Museum of Classical Archaeology', *PCPS* 39: 1–29.

1999. 'The invention and reinvention of "Group D": an archaeology of the classical tripos, 1879–1984', in *Classics in 19th and 20th Century Cambridge*, ed. C. Stray. Cambridge Philological Society, Supplementary vol. 24: 95–134.

2000. *The Invention of Jane Harrison*. Cambridge, Mass.

Beard, M. and J. Henderson. 2001. *Classical Art from Greece to Rome*. Oxford.

Beaujeu, J. 1948. 'La cosmologie de Pline l'ancien dans ses rapports avec l'histoire des idées', *Rev. Ét. Lat.* 26: 40–2.

Becker, E. (ed.) 1997. *Sir Lawrence Alma-Tadema*. Amsterdam and Liverpool.

Bellah, R. N. 1970a. 'Religious evolution', in *Beyond Belief: Essays on Religion in a Post-Traditional World*. New York: 20–50.

1970b. 'The dynamics of worship', in *Beyond Belief: Essays on Religion in a Post-Traditional World*. New York: 209–15.

1970c. 'The systematic study of religion', in *Beyond Belief: Essays on Religion in a Post-Traditional World*. New York: 260–87.

Benediktson, D. 2001. *Literature and the Visual Arts in Ancient Greece*. Oklahoma.

Bérard, C. 1983a. 'Imagiers et artistes', *Etudes de Lettres* 4: 2–4.

1983b. 'Iconographie – iconologie – iconologique', *Etudes de Lettres* 4: 5–37.

(ed.) 1989. *A City of Images: Iconography and Society in Ancient Greece*. Princeton.

Bergemann, J. 1991. 'Pindar: das Bildnis eines konservativen Dichters', *MDAI (A)* 106: 157–89.

Berger, E. 1970. *Das Basler Arztrelief: studien zum griechischen Grab- und Votiv-Relief um 500 v. Chr. und zur vor Hippokratischen Medizin*. Basel.

1990. 'Zum Kanon des Polyklet', in *Polyklet: der Bildhauer der griechischen Klassik*, ed. H. Beck, P. C. Bol and M. Bückling. Frankfurt: 156–84.

Bergmann, B. 1995. 'Greek masterpieces and Roman recreative fiction', *Harv. Stud.* 97: 79–120.

Bergren, A. 1989. 'The Homeric hymn to Aphrodite', *Cl. Ant.* 8: 1–41.

Bernal, M. 1987. *Black Athena: the Afroasiatic Roots of Classical Civilisation*, vol. I: *The Fabrication of Ancient Greece. 1785–1985*. London.

Bernstein, B. 1971. *Class, Codes and Control*, vol. I: *Theoretical Studies towards a Sociology of Language*. London.

Bevan, E. 1940. *Holy Images: an Inquiry into Idolatry and Image Worship in Ancient Paganism and Christianity*. London.

Beyer, A. 1990. 'Die Orientierung griechischer Tempel – zur Beziehung von Kultbild und Tur', in *Licht und Architecktur*, ed. W-D. Heilmeyer and W. Hoepfner. Berlin: 1–9.

Bianchi Bandinelli, R. 1978. *Dall'Ellenismo al Medioevo*. Rome.

1980 [1957]. 'L'artista nell'antichità classica', reprinted in Coarelli (ed.) 1980a: 51–73.

Bluemel, C. 1969. *Greek Sculptors at Work*. London.

Blunt, A. 1940. *Artistic Theory in Italy: 1450–1660*. Oxford.

Boardman, J. 1978. *Greek Sculpture: the Archaic Period*. London.

1985. *Greek Sculpture: the Classical Period*. London.

1988. 'Classical archaeology: whence and whither?', *Antiquity* 62: 795–7.

1993. 'Introduction', in *The Oxford History of Classical Art*, ed. J. Boardman, Oxford: 1–9.

Bohn, R. (ed.) 1885. *Das Heiligtum der Athena Polias Nikephoros*. Altertümer von Pergamon II. Berlin.

Bohringer, F. 1979. 'Cultes d'athlètes en Grèce classique: propos politiques, discours mythiques', *Revue des Etudes Anciennes* 81: 5–18.

Bonfante, L. 1997. 'Nursing mothers in classical art', in *Women, Sexuality and Gender in Classical Art and Archaeology*, ed. A. O. Koloski-Ostrow and C. L. Lyons. London: 174–96.

Bonniec, H. le and H. Gallet de Santerre (eds.) 1953. *Pline l'Ancien: Histoire naturelle livre XXXIV*. Paris.

Borbein, A. H. 1979. 'Klassische Archäologie in Berlin vom 18. bis zum 20. Jahrhundert', in *Berlin und die Antike*, vol. II, ed. W. Arenhovel and C. Schreiber. Berlin: 99–150.

1986. 'Winckelmann und die klassische Archäologie', in *Johann Joachim Winckelmann, 1717–1768*, ed. T. W. Gaehgtens. Hamburg: 289–300.

1995. 'Die bildende Kunst Athens im 5. und 4. Jhdt v. Chr.', *Die Athenische Demokratie im 4. Jhdt*, ed. K. Eder. Stuttgart: 429–73.

1996. 'Polykleitos', in *Personal Styles in Greek Sculpture*, ed. O. Palagia and J. J. Pollitt. Yale Classical Studies 30. Cambridge: 60–90.

1997. 'La nascita di un' arte "classica"', in *I Greci*, vol. 2.ii: *Una storia greca*, ii, *Definizione*, ed. S. Settis. Turin: 1275–303.

Boschung, D. 1989. 'Nobilia opera. Zur Wirkungsgeschichte griechischer Meisterwerke im kaiserzeitlichen Rom', *AK* 32: 8–16.

Bourdieu, P. 1968. 'Outline of a sociological theory of art perception', *International Social Science Journal* 20: 589–612.

1971a. 'Intellectual field and creative project', in *Knowlege and Control: New Directions for the Sociology of Education*, ed. M. K. D. Young. London: 161–88.

1971b [1967]. 'Systems of education and systems of thought', reprinted in *Knowledge and Control: New Directions for the Sociology of Education*, ed. M. K. D. Young. London: 189–207.

1974. 'Les fractions de la classe dominante et les modes d'appropriation de l'oeuvre d'art', *Information sur les Sciences Sociales* 13: 7–32.

1977. *Outline of a Theory of Practice*. Cambridge.

1984. *Distinction: a Social Critique of the Judgement of Taste*. Cambridge, Mass.

1987. 'The historical genesis of a pure aesthetic', *Journal of Aesthetics and Art Criticism* 46: 201–10.

1992. *The Logic of Practice*. Cambridge.

1996. *The Rules of Art: Genesis and Structure of the Literary Field*. Cambridge.

Bourdieu, P. and A. Darbel. 1990 [1969]. *The Love of Art: European Art Museums and their Public*. Stanford.

Bourriot, F. 1976. *Recherches sur la nature du génos*. Lille.

Bowen, J. 1989. 'Education, ideology and the ruling class', in *Rediscovering Hellenism: the Hellenic Inheritance and the English Imagination*, ed. G. W. Clarke. Cambridge: 161–86.

Bowra, M. 1934. 'Simonides and Scopas', *CP* 29: 230–9.

1970a. 'Xenophanes on the luxury of Colophon', in *On Greek Margins*. Oxford: 109–21.

1970b. 'Asius and the old-fashioned Samians', in *On Greek Margins*. Oxford: 122–33.

Bragantini, I. and M. de Vos. 1982. *Le decorazione della Villa Romana della Farnesina* (= Museo Nazionale Romano. Le Pitture, ii.i). Rome.

Brain, D. 1989. 'Structure and strategy in the production of culture: implications of a post-structuralist perspective for the sociology of culture', *Comparative Social Research* 11: 31–74.

1994. 'Cultural production as society in the making: architecture as an exemplar of the social construction of cultural artifacts', in *The Sociology of Culture: Emerging Theoretical Perspectives*, ed. D. Crane. Oxford: 191–220.

Brancacci, A. 1995. 'Ethos e pathos nella teoria delle arti. Una poetica socratica della pittura e della scultura', *Elenchos* 1: 103–27.

Bremmer, J. 1981. 'Greek Hymns', in *Faith, Hope and Worship*, ed. H. Versnel. Leiden: 193–215.

1999. 'Rationalisation and disenchantment in ancient Greece: Max Weber amongst the Pythagoreans and Orphics', in *From Myth to Reason: Studies in the Development of Greek Thought*, ed. R. Buxton. Oxford: 71–86.

Brilliant, R. 1971. 'On portraits', *Zeitschrift für Asthetik und allgemeine Kunstwissenschaft* 16: 11–26.

1984. *Visual Narratives: Storytelling in Etruscan and Roman Art*. Ithaca and London.

1991. *Portraiture*. London.

Brisson, L. and F. Frontisi-Ducroux. 1992. 'Gods and artisans: Hephaestus, Athena, Daedalus', in *Greek and Egyptian Mythologies*. London: 84–90.

Brown, P. 1992. *Power and Persuasion in Late Antiquity: towards a Christian Empire*. London.

Bruit-Zaidmann, L. and P. Schmitt-Pantel. 1992. *Religion in the Ancient Greek City*. Cambridge.

Bruno, V. 1977. *Form and Colour in Greek Painting*. London.

Bryant, J. M. 1996. *Moral Codes and Social Structure in Ancient Greece: a Sociology of Greek Ethics from Homer to the Epicureans and Stoics*. New York.

Bryson, N. 1983. *Vision and Painting: the Logic of the Gaze*. London.

 1984. *Tradition and Desire: from David to Delacroix*. Cambridge.

 1992. 'Art in context', in *Studies in Historical Change*, ed. R. Cohen. Charlottesville, Va.: 18–42.

Buckler, J. 1972. 'A second look at the monument of Chabrias', *Hesperia* 41: 466–74.

Buitron-Oliver, D. (ed.) 1992. *The Greek Miracle: Classical Sculpture from the Dawn of Democracy, the Fifth Century BC*. Washington.

Bultmann, R. 1956. *Primitive Christianity in its Contemporary Setting*. London.

Burford, A. 1963. 'The builders of the Parthenon', in *Parthenos and Parthenon*, ed. G. T. W. Hooker. Supplement to *Greece and Rome* vol. 10. Oxford: 23–35.

 1972. *Craftsmen in Greek and Roman Society*. Ithaca, N.Y.

Burford-Cooper, A. 1969. *The Greek Temple Builders at Epidauros: a Social and Economic Study of Building in the Asklepian Sanctuary during the Fourth and Early Third Centuries BC*. Liverpool.

Burke, P. 1986. *The Italian Renaissance: Culture and Society in Italy*. Cambridge.

Burkert, W. 1985. *Greek Religion: Archaic and Classical*. Oxford.

 1987. 'Offerings in perspective: surrender, distribution, exchange', in T. Linders and G. Nordquist (eds.) 1987: 43–50.

Burnett, A. P. and C. N. Edmondson. 1961. 'The Chabrias monument in the Athenian agora', *Hesperia* 30: 74–91.

Cahill, J. 1994. *The Painter's Practice: How Artists Lived and Worked in Traditional China*. New York.

Calame, C. 1997 [1977]. *Choruses of Young Women in Ancient Greece: their Morphology, Religious Role and Social Function*. London.

Campbell, C. 1987. *The Romantic Ethic and the Spirit of Modern Consumerism*. Oxford.

Carandini, A. 1980. 'La fatica e l'ingegno', in Coarelli (ed.) 1980a: 155–71.

Carpenter, R. 1954. 'Two postscripts on the Hermes controversy, *AJArch.* 58: 1–12.

 1960. *Greek Sculpture: a Critical Review*. Chicago.

Cartledge, P. 1993. *The Greeks: a Portrait of Self and Other*. Oxford.

Cartledge, P., P. Millett and S. von Reden (eds.) 1998. *Kosmos: Essays on Order, Conflict and Community in Classical Athens*. Cambridge.

Castriota, D. 1992. *Myth, Ethos and Actuality: Official Art in Fifth Century BC Athens*. Madison, Wis.

Catoni, M. 1997. 'Quale arte per il tempo di Platone', in *I Greci,* vol.2.ii: *Una storia greca*, ii, *Definizione*, ed. S. Settis. Turin: 1013–60.

Clarke, J. R. 1991. *The Houses of Roman Italy 100 BC – AD 250: Ritual, Space and Decoration*. Berkeley.

Classen, C. 1990. 'Sweet colours, fragrant songs: sensory models of the Andes and the Amazon', *American Ethnologist* 17: 722–35.

Classen, C. J. 1962. 'The creator in Greek thought from Homer to Plato', *C&M* 23: 1–22.

Clerc, Ch. 1915. *Les théories relatives aux cultes des images chez les auteurs grecs du IIme siècle Après J.C.* Paris.

Coarelli, F. (ed.) 1980a. *Artisti e artigiani in Grecia: Guida storica e critica*. Roma.

1980b. 'Introduzione', in Coarelli (ed.) 1980a: vii–xxx.

1983. 'Il commercio delle opere d'arte in età tardo-repubblicana', *Dialoghi di Archeologia* 2.1: 45–53.

Colomy, P. 1990. 'Revisions and Progress in Differentiation Theory', in *Differentiation Theory and Social Change: Comparative and Historical Perspectives*, ed. P. Colomy and J. Alexander. New York: 465–95.

Connerton, P. 1989. *How Societies Remember*. Cambridge.

Connor, P. 1989. 'Cast-collecting in the nineteenth century: scholarship, aesthetics, connoisseurship', in *Rediscovering Hellenism: the Hellenic Inheritance and the English Imagination*, ed. G. W. Clarke. Cambridge: 187–235.

Connor, W. R. 1970. 'Theseus in classical Athens', in *The Quest for Theseus*, ed. A. G. Ward. London: 143–74.

1971. *The New Politicians of Fifth Century Athens*. Princeton.

1987. 'Tribes, festivals and processions: civic ceremonial and political manipulation in archaic Greece', *JHS* 107: 40–50.

1988. 'Early Greek land warfare and symbolic expression', *P&P* 119: 3–29.

Cooper, F. A. 1968. 'The temple of Apollo at Bassae: new observations on its plan and orientation', *AJArch.* 72: 103–11.

Corbett, P. E. 1965. 'Preliminary sketches in Greek vase-painting', *JHS* 85: 16–26.

1970. 'Greek temples and Greek worshippers: the literary and archaeological evidence', *BICS* 17: 149–58.

Corso, A. 1988. *Gaio Plinio Secondo. Storia naturale v: Mineralogia e storia dell'arte, Libri 33–37*. Traduzione e note di Antonio Corso, Rossana Mugellesi, Gianpero Rosati. Turin.

Coulson, W. D. E. 1972. 'The nature of Pliny's remarks on Euphranor', *CJ* 67: 323–6.

Coulton, J. J. 1983. 'Greek architects and the transmission of design', in *Architecture et societé de l'archaisme grec à la fin de la république romaine*, ed. P. Gros. Paris: 453–70.

Croisille, J.-M. (ed.) 1985. *Pline l'Ancien: Histoire naturelle livre XXXVI*. Paris.

Crowther, N. B. 1985. 'Male beauty contests in Greece: the euandria and the euexia', *L'Antiquité Classique* 54: 285–91.

1991. 'Euexia, eutaxia, philoponia: three contests of the Greek gymnasium', *ZPE* 85: 301–4.

Csapo, E. and M. Miller. 1998. 'Democracy, empire and art: towards a politics of time and narrative', in *Democracy, Empire and the Arts in Fifth Century Athens*, ed. D. Boedeker and K. Raaflaub. Cambridge, Mass.: 87–125.

Danneu-Lattanzi, A. 1982. 'A proposito dei libri sulle arte', in *Plinio il Vecchio sotto il Profilo Storico e Letterario. Atti del Covegno di Como 1979*. Como: 97–107.

Davies, J. K. 1971. *Athenian Propertied Families, 600–300 BC*. Oxford.

1981. *Wealth and the Power of Wealth in Classical Athens*. New York.

1988. 'Religion and the state', *Cambridge Ancient History*, vol. IV.2: 368–88.

Davis, W. 1989. *The Canonical Tradition in Ancient Egyptian Art*. Cambridge.

Day, J. W. 1989. 'Rituals in stone: early Greek grave epigrams and monuments', *JHS* 109: 16–28.

Dean-Jones, L. A. 1991. 'The cultural construction of the female body in classical Greek science', in *Women's History and Ancient History*, ed. S. B. Pomeroy. London: 111–37.

De Lauretis, T. 1983. 'Semiotics and experience', in *Alice Doesn't: Feminism, Semiotics, Cinema*. Bloomington, Ind.: 158–86.

Delivorrias, A. 1968. 'Die Kultstatue der Aphrodite von Daphni', *Antike Plastik* 8: 19–31.

Della Corte, F. 1982. 'Tecnica espositiva e struttura della naturalis historia', in *Plinio il Vecchio sotto il profilo storico e letterario. Atti del Convegno di Como 1979*. Como: 19–39.

De Nora, T. 1991. 'Musical patronage and social change in Beethoven's Vienna', *American Journal of Sociology* 97: 310–46.

Deregowski, J. B. 1989. 'Real and represented space: cross cultural perspectives', *Behavioral and Brain Sciences* 12: 51–119.

De Romilly, J. 1992. *The Great Sophists in Periclean Athens*. Oxford.

Detienne, M. 1979. *Dionysos Slain*. London.

 1994. *The Gardens of Adonis: Spices in Greek Mythology*. Princeton.

 1996 [1976]. *The Masters of Truth in Archaic Greece*. New York.

Detienne, M. and J-P. Vernant. 1978. *Cunning Intelligence in Greek Culture and Society*. Chicago.

Dietrich, B. C. 1985/6. 'Divine concept and iconography in Greek religion', *GB* 12/13: 171–92.

 1986. *Tradition in Greek Religion*. Berlin and New York.

Di Maggio, P. 1982. 'Cultural entrepreneurship in nineteenth century Boston. Pt. 1: The creation of an organizational base for high culture in America'; 'Pt 2: The classification and framing of American art.' *Media, Culture and Society* 4: 33–50; 303–22.

Donlan, W. 1973. 'The origins of the *kalos k'agathos*', *AJPhil.* 94: 365–374.

Donohue, A. A. 1997. 'The Greek images of the gods: considerations on terminology and methodology', *Hephaistos* 15: 31–45.

Dontas, G. 1977. 'Bemerkungen über einige attische Strategenbildnisse der klassischen Zeit', in *Festschrift für Frank Brommer*, ed. U. Höckmann and A. Knig. Mainz: 79–92.

 1982. 'La grande Artémis du Pirée: une œuvre d'Euphranor', *AK* 25: 15–34.

 1986. 'Ho Chalkinos Apollon tou Peiraia', in *Archaische und klassische griechische Plastik*, vol. I, ed. H. Kyrieleis. Mainz: 181–92.

Dorandi, T. 1999. *Antigone de Caryste. Fragments*. Paris.

Dover, K. 1988 [1975]. 'The freedom of the intellectual in Greek society', reprinted in *The Greeks and their Legacy: Collected Papers*, vol. II. Oxford: 135–58.

Drenkahn, R. 1995. 'Artists and artisans in pharaonic Egypt', in *Civilizations of the Ancient Near East*, ed. J. M. Sasson. New York: 331–43.

Drerup, H. 1961. 'Das Themistokles Porträt in Ostia', *Marburger Winckelmann Program*: 21–8.

Duncan, C. and A. Wallach. 1980. 'The universal survey museum,' *Art History* 3: 448–69.

Dyson, S. L. 1989. 'The role of ideology and institutions in shaping classical archaeology', in *Tracing Archaeology's Past: the Historiography of Archaeology*, ed. A. L. Christenson. Carbondale, Ill.: 127–35.

 1998. *Ancient Marbles to American Shores: Classical Archaeology in America*. Philadelphia, Pa.

Eckman, P. 1979. 'About brows: emotions and conversational signals', in *Human Ethology*, ed. M. von Cranach et al. Cambridge: 169–202.

 1998. 'Afterword', in C. Darwin, *The Expression of the Emotions in Man and Animals*. London: 363–93.

Edwards, C. M. 1996. 'Lysippos', in *Personal Styles in Greek Sculpture*, ed. O. Palagia and J. J. Pollitt. Yale Classical Studies 30. Cambridge: 130–53.

Ehrhardt, W. 1997. 'Versuch einer Deutung des Kultbildnes der Nemesis von Rhamnus', *AK* 40/1: 29–39.

Einem, H. von. 1986. 'Winckelmann und die Wissenschaft der Kunstgeschichte', in *Johann Joachim Winckelmann 1717–1768*, ed. T. W. Gaehtgens. Hamburg: 315–26.

Eisenstadt, S. N. 1980. 'Cultural orientations, institutional entrepreneurs and social change: comparative analysis of traditional civilizations', *American Journal of Sociology* 85: 840–69.

 1982. 'The emergence of transcendental visions and the rise of clerics', *European Journal of Sociology* 23: 294–314.

 1990. 'Modes of structural differentiation: elite structure and cultural visions', in *Differentiation Theory and Social Change: Comparative and Historical Perspectives*, ed. J. Alexander and P. Colomy. New York: 19–51.

Ellen, R. 1988. 'Fetishism', *Man* (n.s.) 23: 213–35.

Elsner, J. 1992. 'Pausanias: a Greek pilgrim in the Roman world', *P&P* 135: 3–29.

1993. 'Seductions of art: Encolpius and Eumolpus in a Neronian picture gallery', *PCPS* 39: 30–47.

1995. *Art and the Roman Viewer: the Transformation of Art from the Pagan World to Christianity*. Cambridge.

1998. *Imperial Rome and Christian Triumph: the Art of the Roman Empire AD 100–450*. Oxford.

Emirbayer, M. and A. Mische. 1998. 'What is agency?', *American Journal of Sociology* 103: 962–1023.

Ernst, W. 1993. 'Frames at work: museological imagination and historical discourse in neo-classical Britain', *Art Bulletin* 75: 481–98.

Faraone, C. 1992. *Talismans and Trojan Horses: Guardian Statues in Ancient Greek Myth and Ritual*. Oxford.

Fehr, B. 1979. *Bewegungsweisen und Verhaltensideale: physiognomische Deutungsmöglichkeiten der Bewegungsdarstellung an griechischen Statuen des 5 and 4 Jhs. v. Chr*. Bad Bremstedt.

1979/80. 'Zur religions-politischen Funktion der Athena Parthenos im Rahmen des Delisch-Attischen Seebundes', Pts. 1 and 2. *Hephaistos* 1: 71–91; 2: 113–25.

Ferrari, G. R. F. 1989. 'Plato and poetry', in *The Cambridge History of Literary Criticism*, vol. I: *Classical Criticism*, ed. G. Kennedy. Cambridge: 92–148.

Finley, M. I. 1973 (2nd edn. 1985). *The Ancient Economy*. London.

1985a. *Democracy Ancient and Modern*. London.

1985b. 'Foreword', in *Greek Religion and Society*, ed. P. E. Easterling and J. V. Muir. Cambridge: xii–xx.

Fisher, N. 1998. 'Gymnasia and the democratic values of leisure', in Cartledge, Millett and von Reden (eds.) 1998: 84–104.

Fittschen, K. (ed.) 1988. *Griechische Porträts*. Darmstadt.

Flashar, M. 1992. *Apollon Kitharoidos: statuarische Typen des musischen Apollo*. Vienna.

Foley, H. P. 1996. *The Homeric Hymn to Demeter: Translation, Commentary and Interpretative Essays*. Princeton.

Forrest, W. G. 1966. *The Emergence of Greek Democracy: the Character of Greek Politics 800–400 BC*. London.

Foucault, M. 1986. *The Use of Pleasure. The History of Sexuality*, vol. II. Harmondsworth.

1988. *The Care of the Self. The History of Sexuality*, vol. III. Harmondsworth.

Fowler, B. H. 1983. 'The centaur's smile: Pindar and the archaic aesthetic', in *Ancient Greek Art and Iconography*, ed. W. G. Moon. Madison, Wis.: 159–70.

Fränkel, H. 1975. *Early Greek Poetry and Philosophy: a History of Greek Epic, Lyric and Prose to the Middle of the Fifth Century*. Oxford.

Fränkel, M. (ed.) 1890. *Die Inschriften von Pergamum*. Altertümer von Pergamon VIII. 2 vols. Berlin.

1891. 'Gemälde-sammlungen und Gemälde-forschung in Pergamon', *JDAI* 6: 49–75.

Fraser, P. M. 1972. *Ptolemaic Alexandria*. Oxford.

Frazer, J. G. 1897. *Pausanias' Description of Greece: Translated with a Commentary*. 6 vols. London.

Freedberg, D. 1989. *The Power of Images: Studies in the History and Theory of Response*. Chicago.

Freidson, 1986a. *Professional Powers: a Study of the Institutionalization of Formal Knowledge*. Chicago.

1986b. 'Les professions artistiques comme défi à l'analyse sociologique', *Revue Française de Sociologie* 27: 431–43.

Frel, J. 1981. *Greek Portraits in the J. Paul Getty Museum*. Malibu.

1983. 'Euphronios and his fellows', in *Ancient Greek Art and Iconography*, ed. W. G. Moon. Madison, Wis.: 147–58.

Frischer, B. 1982. *The Sculpted Word: Epicureanism and Philosophical Recruitment in Ancient Greece*. Berkeley.

Froning, H. 1980. 'Die ikonographische Tradition der kaiserzeitlichen mythologischen Sarkophagreliefs', *JDAI* 95: 321–41.

Frontisi-Ducroux. F. 1975. *Dédale: mythologie de l'artisan en Grèce ancienne*. Paris.

Fuá, O. 1973. 'L'idea dell'opera d'arte "vivente" e la bucula di Mirone nell'epigramma greco e latino", *Rivista di Cultura Classica e Medioevale* 15: 49–55.

Fuchs, W. 1959. *Die Vorbilder der neuattischen Reliefs. JDAI*. Erg. 20. Berlin.

Fullerton, M. D. 1997. 'Imitation and intertextuality in Roman art', *JRA* 10: 427–40.

 1998. 'Atticism, classicism and the origins of neo-attic', in *Regional Schools in Hellenistic Sculpture*, ed. O. Palagia and W. Coulson. Oxford: 93–99.

 2000. *Greek Art*. Cambridge.

Furtwängler, A. 1893. *Meisterwerke der griechischen Plastik*. Leipzig.

Fyfe, G. J. 1986. 'Art exhibitions and power during the nineteenth century', in *Power, Action and Belief: a New Sociology of Knowledge?*, ed. J. Law. Sociological Review Monograph 32. London: 20–45.

Garland, R. 1984. 'Religious authority in archaic and classical Athens', *Annual of the British School at Athens* 79: 75–123.

 1990. 'Priests and power in classical Athens', in *Pagan Priests*, ed. M. Beard and J. North. London: 73–91.

 1992. *Introducing New Gods: the Politics of Athenian Religion*. London.

Gauer, W. 1968. 'Die griechische Bildnisse der klassischen Zeit als politische und persönliche Denkmäler', *JDAI* 83: 118–79.

Gauthier, P. 1985. *Les cités grecques et leurs bienfaiteurs*. BCH Suppl. XII. Paris.

Gazda, E. 1995a. 'Roman copies: the unmaking of a modern myth', *JRA* 8: 530–4.

 1995b. 'Roman sculpture and the ethos of emulation', *Harv. Stud.* 97: 121–56.

Gell, A. 1998. *Art and Agency: an Anthropological Theory*. Oxford.

Gelzer, T. 1985. 'Mimus und Kunsttheorie', in *Catalepton – Festschrift Wyss*, ed. C. Schäublin. Basel: 96–116.

Gerber, D. E. 1978. 'The female breast in Greek erotic literature', *Arethusa* 11: 203–12.

Gernet, L. 1981a [1948]. 'The mythical idea of value in Greece', in *The Anthropology of Ancient Greece*. London: 73–111.

 1981b [1938]. 'The nobility in ancient Greece', in *The Anthropology of Ancient Greece*. London: 279–88.

Gernet, L. and A. Boulanger. 1932. *Le génie grec dans la religion*. Paris.

Gigon, O. 1982. 'Pline', in *Plinio il Vecchio sotto il profilo storico e letterario. Atti del Convegno di Como 1979*. Como: 41–59.

Gill, D. W. J. 1991. 'Pots and trade: space-fillers or objets d'art?', *JHS* 111: 29–47.

Giuliani, L. 1986. *Bildnis und Botschaft: hermeneutische Untersuchungen zur Bildnis der römischen Republik*. Frankfurt.

Gladigow, B. 1985/6. 'Präsenz der Bilder, Präsenz der Götter. Kultbilder und Bilder der Götter in der griechischen Religion', *Visible Religion* 4–5: 114–33.

 1990. 'Epiphanie, Statuette, Kultbild. Griechische Gottesvorstellungen im Wechsel von Kontext und Medium', *Visible Religion* 7: 98–121.

Gleason, M. W. 1995. *Making Men: Sophists and Self-Presentation in Ancient Rome*. Princeton.

Goguey, D. 1978. 'La formation de l'architecte: culture et technique', in *Recherches sur les artes à Rome*, ed. J. M. André. Paris: 100–15.

Goldhill, S. 1986. *Reading Greek Tragedy*. Cambridge.

 1990. 'The Great Dionysia and civic ideology', in *Nothing to Do with Dionysos*, ed. J. Winkler and F. Zeitlin. Princeton: 97–129.

1994. 'The naive and the knowing eye: ekphrasis and the culture of viewing in the Hellenistic world', in *Art and Text in Greek Culture*, ed. S. Goldhill and R. Osborne. Cambridge: 197–223.

2001a. 'Introduction: setting an agenda', in *Being Greek under Rome: Cultural Identity, the Second Sophistic and the Development of Empire*, ed. S. Goldhill. Cambridge: 1–25.

2001b. 'The erotic eye: visual stimulation and cultural conflict', in *Being Greek under Rome: Cultural Identity, the Second Sophistic and the Development of Empire*, ed. S. Goldhill. Cambridge: 154–94.

Gombrich, E. H. 1952. 'The Renaissance conception of artistic progress and its consequences', in idem *Norm and Form*. London: 1–10.

1960. *Art and Illusion: a Study in the Psychology of Pictorial Representation*. London.

1972. 'The mask and the face: the perception of physiognomic likeness in life and art', in *Art, Perception and Reality*, ed. E. H. Gombrich, J. Hochberg and M. Black. Baltimore: 1–46.

1982. 'Image and code: scope and limits of conventionalism in pictorial representation', in *The Image and the Eye: Further Studies in the Psychology of Pictorial Representation*. London: 278–98.

1986. *Aby Warburg: an Intellectual Biography*. London.

Gomme, A. W. 1945. *A Historical Commentary on Thucydides*, vol. I. Oxford.

Goodlett, V. 1991. 'Rhodian sculpture workshops', *AJArch* 95: 669–81.

Goody, J. 1993. *The Culture of Flowers*. Cambridge.

Gordon, D. E. and D. E. L. Cunningham. 1962. 'Polykleitos' *Diadoumenos*: measurement and animation', *Art Quarterly*, summer issue: 128–42.

Gordon, R. 1979. 'The real and the imaginary: production and religion in the Greco-Roman world', *Art History* 2: 5–34.

Gow, A. S. F. and D. L. Page. 1965. *The Greek Anthology: Hellenistic Epigrams*. 2 vols. Cambridge.

1968. *The Greek Anthology: the Garland of Philip*. 2 vols. Cambridge.

Griffin, M. 1982. *Sikyon*. Oxford.

Gros, P. 1976. *Aurea templa. Recherches sur l'architecture religieuse de Rome à l'époque d'Auguste*. Rome.

1978. 'Vie et mort de l'art hellenistique selon Vitruve et Pline', *Rev. Ét. Lat.* 56: 289–313.

1983. 'Statut social et rôle culturel des architectes (période héllenistique et augustéenne)', in *Architecture et société de l'archaisme grec à la fin de la république romaine*, ed. P. Gros. Paris: 425–52.

Gross, W. H. 1988 [1969]. 'Quas iconicas vocant: zum Porträtcharakter der Statuen dreimaliger olympischer Sieger', reprinted in *Griechische Porträts*, ed. K. Fittschen. Darmstadt: 359–74.

Gualandi, G. 1982. Plinio e il collezionismo d'arte', in *Plinio il Vecchio sotto il profilo letterario e storico. Atti del Convegno di Como 1979*. Como: 259–98.

Guarducci, M. 1980 [1958]. 'Ancora sull'artista nell'antichità classica', reprinted in Coarelli (ed.) 1980a: 77–95.

Guthrie, W. K. C. 1965. *A History of Greek Philosophy*, vol. II: *the Pre-Socratic Tradition from Parmenides to Democritus*. Cambridge.

Habermas, J. 1984. *The Theory of Communicative Action*, vol. I: *Reason and the Rationalization of Society*. Boston.

1989 [1962]. *The Structural Transformation of the Public Sphere. An Inquiry into a Category of Bourgeois Society*. Cambridge, Mass.

Halliwell, S. 1988. *Plato Republic 10: Translation and Commentary*. Warminster.

1989. 'Aristotle's *Poetics*', in *The Cambridge History of Literary Criticism*, vol. I: *Classical Criticism*, ed. G. Kennedy. Cambridge: 149–83.

Hallett, C. 1995. '*Kopienkritik* and the works of Polykleitos', in *Polykleitos, the Doryphoros and Tradition*, ed. W. G. Moon. Madison, Wisc.: 121–60.

Hansen, E. V. 1971. *The Attalids of Pergamum*. 2nd edn. London.

Harris, D. 1995. *The Treasures of the Parthenon and the Erechtheion*. Oxford.

Harrison, E. B. 1972. 'The south frieze of the Nike temple and the Marathon painting in the painted Stoa', *AJA* 76: 353–78.

 1977. 'Alkamenes' sculptures for the Hephaisteion, Pts I–III'. *AJA* 81: 137–78, 265–87, 411–26.

Harrison, J. E. 1903. *Prolegomena to the Study of Greek Religion*. Cambridge.

 1912. *Themis: a Study of the Social Origins of Greek Religion*. Cambridge.

Haskell, F. 1991. 'Winckelmann et son influence sur les historiens', in *Winckelmann: la naissance de l'histoire de l'art à l'Époque des Lumiers*, ed. E. Pommier. Paris: 83–100.

Hauser, A. 1962. *The Social History of Art*, vol. II: *Renaissance, Mannerism and Baroque*. London.

Hausmann, U. 1960. *Griechische Weihreliefs*. Berlin.

Havelock, C. M. 1995. *The Aphrodite of Knidos and her Successors: a Historical Review of the Female Nude in Greek Art*. Ann Arbor.

Havelock, E. A. 1963. *Preface to Plato*. Cambridge, Mass.

Heilmeyer, W. D. 1988. 'Arte antica e produzione artistica. Lo studio delle officine nell' archeologia classica', *Quaderni Urbinati di Cultura Classica* 28: 7–26.

Heinimann, F. 1975. 'Mass-Gewicht-Zahl', *MH* 32: 183–96.

Henle, J. 1973. *Greek Myths: a Vase-Painter's Notebook*. London.

Herington, C. J. 1955. *Athena Parthenos and Athena Polias: a Study in the Religion of Periclean Athens*. Manchester.

Heuzé, P. 1987. 'Pline "critique d'art"? Les avis contradictoires de Diderot et Falconet', *Helmantica* 38: 29–39.

Himmelmann, N. 1959. *Zur Eigenart des klassischen Götterbildes*. Munich.

 1971. 'Archäologisches zur Probleme der griechischen Sklaverei', *Abhandlungen der Akademie der Wissenschaften* 13. Mainz.

 1979. 'Zur Entlohnung kunstlerischer Tätigkeit in klassischen Bauinschriften', *JDAI* 94: 127–42.

 1989. *Herrscher und Athlet: die Bronzen vom Quirinal*. Bonn.

 1990. *Ideale Nacktheit in der griechischen Kunst. JDAI* Erg. 26. Berlin.

 1994. *Realistische Themen in der griechischen Kunst der archaischen und klassischen Zeit*. Berlin.

 1998. 'The plastic arts in Homeric society', in Himmelmann, *Reading Greek Art*, ed. H. Meyer and W. Childs. Princeton: 25–66.

Hodge, R. and G. Kress. 1988. *Social Semiotics*. Oxford.

Hoepfner, W. 1996. 'Zu griechischen Bibliotheken und Büchershranken', *Archäologischer Anzeiger*: 25–36.

Hölscher, T. 1971. *Ideal und Wirklichkeit in den Bildnissen Alexanders des Grossen*. Heidelberg.

 1973. *Griechische Historienbilder des 5. und 4. Jh*. Wurzburg.

 1974. 'Die Nike der Messenier und Naupaktier in Olympia: Kunst und Geschichte im späten 5 Jahrhundert', *JDAI* 89: 70–111.

 1987. *Römische Bildsprache als semantisches System*. Heidelberg.

 1988 [1975]. 'Die Aufstellung des Perikles-Bildnisses und ihre Bedeutung', reprinted in *Griechische Porträts*, ed. K. Fittschen. Darmstadt: 377–91.

 1989. 'Griechischer Bilder für den römischen Senat', in *Festschrift für Nikolaus Himmelmann*, ed. H-U. Cain, H. Gabelmann and D. Salzmann. Mainz: 327–33.

 1994. 'Hellenistische Kunst und römische Aristokratie' in *Das Wrack: der antike Schiffsfund von Mahdia*, ed. C. Salles. Bonn: 875–87.

Honour, H. 1968. *Neo-Classicism*. Harmondsworth.

Hopkins, K. 1978. *Conquerors and Slaves: Sociological Studies in Roman History*, vol. I. Cambridge.

Hübert, H. and M. Mauss. 1964. *Sacrifice: its Nature and Functions*. Chicago.

Humphreys, S. C. 1978. *Anthropology and the Greeks*. London.

1983. 'Fustel de Coulanges and the Greek genos', *Sociologia del Diritto* 8: 35–44. (Issue ed. R. Treves and entitled *Alle origini della sociologia del diritto*, Milan.)

1993. 'Family tombs and tomb-cult in classical Athens: tradition or traditionalism', in *The Family, Women and Death: Comparative Studies*. Ann Arbor: 79–134.

Hunter, I. 1992. 'Aesthetics and cultural studies', in *Cultural Studies*, ed. L. Grossberg, C. Nelson and C. C. Treichler. London: 347–72.

Hurwitt, J. 1985. *The Art and Culture of Early Greece, 1100–480 BC*. Ithaca, N.Y.

Imbert, C. 1980. 'Stoic logic and Alexandrian poetics', in *Doubt and Dogmatism*, ed. M. Schofield et al. Cambridge: 182–216.

Imhoof-Blumer, F. and P. Gardner. 1885–7. *A Numismatic Commentary on Pausanias*. Reprinted from the *Journal of Hellenic Studies* 1885–7. London.

Irwin, D. (ed.) 1972. *Winckelmann: Writings on Art*. London.

Isager, J. 1991. *Pliny on Art and Society*. London.

Jeffreys, L. 1990. *The Local Scripts of Archaic Greece: a Study of the Origin of the Greek Alphabet and its Development from the Eighth to the Fifth Centuries BC*. Revised edition, with a supplement by A. W. Johnston. Oxford.

Jenkins, I. 1992. *Archaeologists and Aesthetes in the Sculpture Galleries of the British Museum 1800–1939*. London.

1994. *The Parthenon Frieze*. London.

Jones, M. P. 1996. 'Post-human agency: between theoretical traditions', *Sociological Theory* 14: 290–309.

Kahil, L. 1983. 'Mythological repertoire of Brauron', in *Ancient Greek Art and Iconography*, ed. W. G. Moon. Madison, Wisconsin: 231–44.

Kalberg, S. 1980. 'Max Weber's types of rationality: cornerstones for the analysis of rationalization processes in history', *American Journal of Sociology* 85: 1145–79.

1994. *Max Weber's Comparative Historical Sociology*. Cambridge.

Kampen, N. B. 1979. 'Observations on the ancient uses of the Spada reliefs', *L'Antiquité Classique* 48: 582–600.

1981. *Image and Status: Roman Working Women in Ostia*. Berlin.

Karp, I. 1991. 'Culture and Representation', in *Exhibiting Cultures: the Poetics and Politics of Museum Display*, ed. I. Karp and S. Lavine. Washington: 11–24.

Karusos, C. 1961. *Aristodikos: zur Geschichte der spätarchaischen-attischen Plastik und der Grabstatue*. Stuttgart.

1972 [1941]. 'ΠΕΡΙΚΑΛΛΕΣ ΑΓΑΛΜΑ – ΕΞΕΠΟΙΗΣ᾽ ΟΥΚ ΑΔΑΗΣ – Empfindungen und Gedanken der archaischen Griechen um die Kunst', in *Inschriften der Griechen*, ed. G. Pfohl. Darmstadt: 85–152.

Kennedy, G. 1989. 'Hellenistic literary and philosophical scholarship', in *The Cambridge History of Literary Criticism*, vol. I: *Classical Criticism*, ed. G. Kennedy. Cambridge: 200–14.

Keuls, E. C. 1978a. *Plato and Greek Painting*. Leiden.

1978b. 'Rhetoric and Visual Aids in Greece and Rome', in *Communication Arts in the Ancient World*, ed. E. A. Havelock and J. P. Hershell. New York: 121–34.

Kirk, G. S., J. E. Raven and M. Schofield. 1983. *The Presocratic Philosophers*. 2nd edn. Cambridge.

Kleiner, D. 1992. *Roman Sculpture*. New Haven.

Knell, H. 1994. 'Der jungere Tempel des Apollon Patroos auf der Athener Agora,' *JDAI* 109: 217–37.

2000. *Athen im 4. Jahrhundert: eine Stadt verändert ihr Gesicht. Archäologisch-kulturgeschichtliche Betrachtungen.* Darmstadt.

Knesebech, H. W. von dem. 1995. 'Zur Ausstattung und Funktion des Hauptsaales der Bibliothek von Pergamon', *Boreas* 18: 45–56.

Koch, G. and H. Sichtermann. 1982. *Römische Sarkophagi.* Munich.

Kötting, B. 1982. 'Wohlgeruch der Heiligkeit', *J.A.C. Ergannzb.* 9: 168–80.

Kondo, D. 1985. 'The way of tea: a symbolic analysis', *Man* (n.s.) 20: 287–300.

Koortbojian, M. 1995. *Myth, Meaning and Memory on Roman Sarcophagi.* Berkeley.

Kristeller, P. O. 1951/2. 'The modern system of the arts', *Journal of the History of Ideas* 12: 496–527, 13: 17–46. Reprinted in *Renaissance Thought and the Arts.* Princeton. 1990: 163–227.

Krumeich, R. 1997. *Bildnisse griechischer Herrscher und Staatsmänner im 5. Jh. v. Chr.* Munich.

Kubler, G. 1963. *The Shape of Time: Remarks on the History of Things.* London.

Kunze, Ch. 1996. 'Die Skulpturenausstattung hellenistischer Paläste', in *Basileia: die Paläste der hellenistischen Könige*, Internationalen Symposion in Berlin, Dec. 16–20, 1992, ed. W. Hoepfner and G. Brands. Mainz: 109–29.

Kurke, L. 1993. 'The economy of *kudos*', in *Cultural Poetics in Archaic Greece: Cult, Performance, Politics*, ed. C. Dougherty and L. Kurke. Cambridge: 131–63.

Kurtz, D. and J. Boardman. 1970. *Greek Burial Customs.* London.

Lacroix, L. 1949. *Les reproductions des statues sur les monnaies grecques.* Bibliothèque de la Faculté de Philosophie et Lettres de l'Université de Liège 116. Paris.

Lacy, P. de. 1974. 'Plato and the intellectual life of the second century AD', in *Approaches to the Second Sophistic*, ed. G. Bowersock. University Park, Pa.: 4–10.

Lambert, A. 1878. 'The ceremonial use of flowers', *The Nineteenth Century* 4: 457–77.

Lambert, S. 1999. 'The attic genos', *CQ* 49: 484–9.

Lausberg, H. 1998. *Handbook of Literary Rhetoric: a Foundation for Literary Study.* Leiden.

Lauter, H. 1974. *Zur gesellschaftlichen Stellung des bildenden Künstlers in der griechischen Klassik.* Erlanger Forschungen Reihe A: Geisteswissenschaften Band 23. Erlangen.

1980. 'Zur wirtschaftlichen Position der Praxiteles-Familie im spätklassischen Athen', *Archäologischer Anzeiger* 95: 523–31.

Lawrence, A. W. 1949. '*Cessavit ars:* turning points in Hellenistic sculpture', in *Mélanges d'archéologie et d'histoire offerts à Charles Picard* (=*Rev. Arch.* 29–30) II: 581–5.

Layton, R. 1977. 'Naturalism and cutural relativity in art', in *Form in Indigenous Art: Schematisation in the Art of Aboriginal Australia and Prehistoric Europe*, ed. P. J. Ucko. Canberra: 3–43.

1991. *The Anthropology of Art.* Cambridge.

Leach, E. W. 1982. 'Patrons, painters and patterns: the anonymity of Romano-Campanian painting and the transition from the second to the third style', in *Literary and Artistic Patronage in Ancient Rome*, ed. B. K. Gold. Austin, Tex.: 135–73.

Leen, A. 1991. 'Cicero and the rhetoric of art', *AJPhil.* 112: 229–45.

Leftwich, G. 1987. 'Ancient Conceptions of the Body and the Canon of Polykleitos', (PhD Diss.,) Princeton.

1995. 'Polykleitos and Hippokratic medicine', in Moon (ed.) 1995: 38–51.

Lehmann, K. 1945. 'A Roman poet visits a museum', *Hesperia* 14: 259–67.

Levenson, J. R. 1957. 'The amateur ideal in Ming and early Ch'ing society: evidence from painting', in *Chinese Thought and Institutions*, ed. J. K. Fairbank. Chicago: 320–41.

Lidz, C. W. and V. M. Lidz. 1976. 'Piaget's psychology of the intelligence and the theory of action', in *Explorations in General Theory in Social Science*, ed. J. J. Loubser, A. Effrat, R. C. Baum and V. M. Lidz. Philadelphia: 195–239.

Lidz, V. M. 1976. 'General action analysis: introduction', in *Explorations in General Theory in Social Science*, ed. J. J. Loubser, A. Effrat, R. C. Baum and V. M. Lidz. Philaldephia: 124–50.

Linders, T. 1987. 'Gods, gifts, society', in Linders and Nordquist (eds.) 1987: 115–22.

Linders, T. and G. Nordquist (eds.) 1987. *Gifts to the Gods: Proceedings of the Uppsala Symposium, 1985*. Uppsala.

Linfert, A. 1978. 'Pythagoras und Lysipp – Xenocrates und Duris', *Rivista di Archeologia* 2: 23–8.

Ling, R. 1991. *Roman Painting*. Cambridge.

Lippold, G. 1935. 'Review of J. M. C. Toynbee (1934), *The Hadrianic School*', *Gnomon* 11: 258–65.

Littlewood, A. R. 1967. 'The symbolism of the apple in Greek and Roman literature', *Harv. Stud.* 72: 147–81.

Lloyd, G. E. R. 1979. *Magic, Religion and Experience: Studies in the Origin and Development of Greek Science*. Cambridge.

 1987. *Revolutions of Wisdom: Studies in the Claims and Practice of Ancient Greek Science*. Berkeley.

 1990. *Demystifying Mentalities*. Cambridge.

 1991 [1972]. 'The social background of early Greek philosophy and science', in *Problems and Method in Greek Science*. Cambridge: 121–40.

Long, A. A. 1974. *Hellenistic Philosophy*. London.

Long, A. A. and D. N. Sedley. 1987. *The Hellenistic Philosophers*. 2 vols. Cambridge.

Lonsdale, S. H. 1993. *Dance and Ritual Play in Greek Religion*. London.

Loraux, N. 1986. *The Invention of Athens: the Funeral Oration in the Classical City*. Cambridge, Mass.

 1995. *The Experiences of Tiresias*. Princeton.

Lullies, R. and M. Hirmer. 1957. *Greek Sculpture*. London.

McClellan, A. 1984. 'The politics and aesthetics of display: museums in Paris 1750–1800', *Art History* 7: 439–64.

 1994. *Inventing the Louvre: Art, Politics and the Origin of the Modern Museum in 18th Century Paris*. Cambridge.

MacDowell, D. M. 1978. *The Law of Classical Athens*. London.

Maffei, S. 1986. 'Le "Imagines" di Luciano: un "patchwork" di capolavori antichi. Il problema di un metodo combinatorio', *SCO* 26: 147–64.

Malten, L. 1961. *Die Sprache des menschlichen Antlitzes im fruhen Griechentum*. Berlin.

Mangold, M. 1993. *Athena Typen auf attischen Weihreliefs des 5. und 4. Jhs. v. Chr*. Hefte des Archäologischen Seminars der Universität Bern. 2. Beiheft. Bern.

Mannheim, K. 1956. 'The democratization of culture', in *Essays on the Sociology of Culture*. London: 171–246.

Marcadé, J. 1953–7. *Recueil des signatures des sculpteurs grecs*. 2 vols. Paris.

Marchand, S. 1996. *Down from Olympus: Archaeology and Philhellenism in Germany*. Princeton.

Mark, I. S. 1995. 'The lure of philosophy: craft and higher learning in ancient Greece', in Moon (ed.) 1995: 25–37.

Marrou, H. 1956. *A History of Education in Antiquity*. London.

Marszal, J. R. 1998. 'Tradition and innovation in early Pergamene sculpture', in *Regional Schools in Hellenistic Sculpture*, ed. O. Palagia and W. Coulson. Oxford: 117–27.

Marvin, M. 1989. 'Copying in Roman sculpture: the replica series', in *Retaining the Original: Multiple Originals, Copies and Reproductions*, Studies in the History of Art 20. Washington: 29–45.

 1997. 'Roman sculptural reproductions or Polykleitos: the sequel', in *Sculpture and its Reproductions*, ed. E. Ranfft and A. Hughes. London: 7–28.

Mattusch, C. 1988. *Greek Bronze Statuary: from the Beginning through the Fifth Century BC*. Ithaca, N.Y.

315

1996. *Classical Bronzes: the Art and Craft of Greek and Roman Statuary*. Ithaca, N.Y.

Megow, R. 1963. 'Antike Physiognomielehre' *Das Altertum* 9: 213–21.

Meier, C. 1990. *The Greek Discovery of Politics*. Cambridge, Mass.

Merkelbach, R. 1971. 'Gefesselte Götter', *Antaios* 12: 549–65.

Metraux, G. P. R. 1995. *Sculptors and Physicians in Fifth Century Greece*. London.

Metzler, D. 1971. *Porträt und Gesellschaft: über die Entstehung des griechischen Porträts in der Klassik*. Munster.

Meyer, H. 1995. 'A Roman masterpiece: the Minneapolis Doryphoros', in Moon (ed.) 1995: 65–115.

Michel, A. 1987. 'L'esthétique de Pline l'ancien', *Helmantica* 37/8: 55–67.

Mielsch, A. 1995. 'Die Bibliothek und die Kunstsammlung der Könige von Pergamon', *Archäologischer Anzeiger*: 756–79.

Mitchell W. J. T. 1986a. 'What is an image', in *Iconology: Image, Text, Ideology*. Chicago: 7–46.

1986b. 'Pictures and paragraphs: Nelson Goodman and the grammar of difference', in *Iconology: Image, Text, Ideology*. Chicago: 53–74

1986c. 'Nature and convention: Gombrich's illusions', in *Iconology: Image, Text, Ideology*. Chicago: 75–94.

Mitropoulou, E. 1977. *Corpus I: Attic Votive Reliefs of the Sixth and Fifth Centuries BC*. Athens.

Moon, W. G. (ed.) 1995. *Polykleitos, the Doryphoros and Tradition*. Madison, Wis.

Morehouse, A. C. 1940. 'A Roman's view of Greek art', *G&R* 10: 29–35.

Moreno, P. 1979a. 'La conquista dell spazialità pittorica', in *Storia e civiltà dei Greci*, vol. IV, ed. R. Bianchi Bandinelli. Milan: 631–76.

1979b. 'La pittura tra classicità e ellenismo', in *Storia e civiltà dei Greci*, vol. VI, ed. R. Bianchi Bandinelli. Milan: 458–520.

2001. *Apelles: the Alexander Mosaic*. Milan.

Morgan, T. 1999a. *Literate Education in the Hellenistic and Roman Worlds*. Cambridge.

1999b. 'Literate education in classical Athens', *CQ* 49: 46–61.

Morphy, H. 1989. 'From dull to brilliant: the aesthetics of spiritual power among the Yolngu', *Man* (n.s.) 24: 21–40.

Morris, E. 1997. 'Alma-Tadema and the English classical revival', in *Sir Lawrence Alma-Tadema*, ed. E. Becker. Amsterdam and Liverpool: 59–66.

Morris, I. 1992. *Death Ritual and Social Structure in Classical Antiquity*. Cambridge.

1994. 'Archaeologies of Greece' in *Classical Greece: Ancient Histories and Modern Archaeologies*, ed. I. Morris. Cambridge: 8–47.

2000. *Archaeology as Cultural History: Words and Things in Iron Age Greece*. Oxford.

Morris, S. P. 1992. *Daidalos and the Origins of Greek Art*. Princeton.

Moyano, S. 1990. 'Quality vs History: Schinkel's Altes Museum and Prussian Arts Policy', *Art Bulletin* 72: 585–608.

Mullen, W. 1982. *Choreia: Pindar and Dance*. Princeton.

Muller, F. G. J. M. 1994. *The So-called Peleus and Thetis Sarcophagus in the Villa Albani*. Amsterdam.

Murck, C. F. 1976. 'Introduction' in *Artists and Traditions: Uses of the Past in Chinese Culture*, ed. C. F. Murck. Princeton: xi–xxi.

Murray, O. 1991. 'History and reason in the Greek city', *PBSR* 45: 1–13.

1998. 'Introduction', in J. Burckhardt, *The Greeks and Greek Civilization*, ed. O. Murray, trans. S. Stern. London: xi–xliv.

Murray, P. (ed.) 1989. *Genius: the History of an Idea*. Oxford.

Nagy, G. 1989. 'Early Greek views of poets and poetry', in *The Cambridge History of Literary Criticism*, vol. I *Classical Criticism*, ed. G. Kennedy. Cambridge: 1–27.

Nahm, M. C. 1947. 'The theological background of the idea of the artist as creator', *Journal of the History of Ideas* 8: 363–72.

Neer, R. 1995. 'The lion's eye: imitation and uncertainty in Attic red figure', *Representations* 51: 118–53.

 2002. *Style and Politics in Athenian Vase-Painting: The Craft of Democracy ca. 530–460 BC.* Cambridge.

Nesfelrath, H. G. 1990. 'Lucian's introductions', in *Antonine Literature*, ed. D. A. Russell. Oxford: 111–40.

Neudecker, R. 1988. *Die Skulpturenausstattung römischer Villen in Italien.* Mainz.

Neumann, G. 1979. *Probleme des griechischen Weihreliefs.* Tübingen.

Neumer-Pfau, W. 1985/6. 'Die nackte Liebesgöttin: Aphroditestatuen als Verkörperung des Weiblichkeitsideals in der griechisch-hellenistischen Welt', *Visible Religion* 4/5: 205–34.

Neutsch, B. 1938. 'Bildbeschreibungen des Antiphilos von Byzanz', *MDAI (R)* 53: 175–88.

Niemeier, J. P. 1985. *Kopien und Nachahmungen im Hellenismus.* Bonn.

Norris, C. 1989. 'Deconstructing genius: Paul de Man and the critique of Romantic ideology', in *Genius: the History of an Idea*, ed. P. Murray. Oxford: 141–65.

Ober, J. 1989. *Mass and Elite in Democratic Athens: Rhetoric, Ideology and the Power of the People.* Princeton.

O'Dea, T. F. 1966. *The Sociology of Religion.* Englewood Cliffs, N.J.

Onians, J. 1979. *Art and Thought in the Hellenistic Age.* London.

Ortiz, G. 1996. *In Pursuit of the Absolute: the George Ortiz Collection.* Berne.

Osborne, C. 1987. 'The repudiation of representation in Plato's *Republic* and its repercussions', *PCPS* 33: 53–73.

 1997. 'Herakleitos and the rites of established religion', in *What is a God?*, ed. A. Lloyd. London: 35–42.

Osborne, R. 1987 'The viewing and obscuring of the Parthenon frieze', *JHS* 107: 71–84.

 1994a. 'Archaeology, the Salaminioi and the Politics of Sacred Space in Attica', in *Placing the Gods*, ed. S. Alcock and R. Osborne. Oxford: 143–60.

 1994b. 'Framing the centaur: reading fifth century architectural sculpture', in *Art and Text in Greek Culture*, ed. S. Goldhill and R. Osborne. Cambridge: 52–84.

 1994c. 'Looking on – Greek style: does the sculpted girl speak to women too?', in *Classical Greece: Ancient Histories and Modern Archaeologies*, ed. I. Morris. Cambridge: 81–96.

 1996. *Greece in the Making, 1200–479 BC.* London.

Ostwald, M. 1986. *From Popular Sovereignty to the Sovereignty of Law: Law, Society and Politics in Fifth Century Athens.* Berkeley.

Page, D. L. 1981. *Further Greek Epigrams. Epigrams before AD 50 from the Greek Anthology and Other Sources not included in 'Hellenistic Epigrams' or 'The Garland of Philip'.* Cambridge.

Palagia, O. 1992. 'Development of the classical style in Athens in the fifth century', in *The Greek Miracle: Classical Sculpture from the Dawn of Democracy, the Fifth Century BC*, ed. D. Buitron-Oliver. Washington.

 1997. 'Reflections on the Piraeus bronzes', in *Greek Offerings: Essays on Greek Art in Honour of John Boardman*, ed. O. Palagia. Oxford: 177–96.

Panagopoulou, C. 1977. 'Vocabulaire et mentalité dans les Moralia de Plutarque', *DHA* 3: 197–235.

Pandermalis, D. 1969. *Untersuchungen zu den klassischen Strategenköpfen.* (PhD Diss. Freiburg-Breisgau.) Berlin.

 1971. 'Zum Programm der Statuenausstattung in der Villa dei Papiri', *MDAI (A)* 86: 173–209.

Panofsky, E. 1939. *Studies in Iconology: Humanistic Themes in the Art of the Renaissance.* Oxford.

 1968 [1924]. *Idea: a Concept in Art Theory.* New York.

Parke, H. W. 1977. *Festivals of the Athenians.* London.

Parker, R. 1996. *Athenian Religion: a History.* Oxford.

Parsons, T. 1937. *The Structure of Social Action*. New York.

1951. 'Expressive symbols and the social system: the communication of affect', in *The Social System*, New York: 384–427.

1953. 'The theory of symbolism in relation to action', in *Working Papers in the Theory of Action*, ed. T. Parsons, F. Bales and E. Shils. New York: 31–62.

1961. 'Culture and the social system: an introduction', in *Theories of Society*, ed. T. Parsons, E. Shils, K. Naegele and J. Pitts. New York: 963–93.

1964 [1952]. 'The superego and the theory of social systems', reprinted in *Social Structure and Personality*. New York: 17–33.

Pascucci, G. 1982. 'La lettera prefatoria di Plinio alla *Naturalis Historia*', in *Plinio il Vecchio sotto il profilo storico e letterario. Atti del Convegno di Como 1979*. Como: 171–97.

Pears, I. 1988. *The Discovery of Painting: the Growth of Interest in the Arts in England 1680–1768*. New Haven, Conn.

Pédech, P. 1989. *Trois historiens méconnus. Théopompe, Duris, Phylarque*. Paris.

Peschlow-Bindokat, A. 1972. 'Demeter und Persephone in der attischen Kunst', *JDAI* 87: 60–157.

Pfanner, M. 1989. 'Über das Herstellen von Porträts. Ein Beitrag zu Rationalisierungsmassnahmen und Produktionsmechanismen im späten Hellenismus und in der römischen Kaiserzeit', *JDAI* 104: 158–257.

Pfeiffer, R. 1968. *History of Classical Scholarship: from the Beginning to the End of the Hellenistic Age*. Oxford.

Pfister, F. 1938. 'Kairos und Symmetrie', *Würzburger Festgabe H. Bulle = Würzburger Studien zum Altertumswissenschaft* 13: 131–50.

Philipp, H. 1963. *Tektonon Daidala: der bildende Künstler und sein Werk in vorplatonischen Schriftum*. Berlin.

1990. 'Handwerker und bildende Künstler in der griechischen Gesellschaft, von Homerischen Zeit bis zum Ende des 5. Jh. v Chr.', in *Polyklet: der Bildhauer der griechischen Klassik*, ed. H. Beck, P. C. Bol and M. Bückling: Mainz: 79–110.

Philipps, K. M. 1968. 'Perseus and Andromeda', *AJArch*. 72: 1–23.

Picard, Ch. 1957. 'Du Nouveau sur Xenocrates', *RA* 50: 81–2.

Podro, M. 1982. *The Critical Historians of Art*. New Haven.

Polignac, F. de. 1984. *La naissance de la cité grecque: cultes, éspace et société VIIIe–VIIe siècles avant J.C.* Paris.

Pollini, J. 1995. 'The Augustus from Prima Porta and the transformation of the Polykleitan heroic ideal: the rhetoric of art', in Moon (ed.)1995: 262–81.

Pollitt, J.J. 1964. 'Professional art criticism in ancient Greece', *Gazette des Beaux Arts* 64: 317–30.

1972. *Art and Experience in Classical Greece*. Cambridge.

1974. *The Ancient View of Greek Art: Criticism, History and Terminology*. London.

1985. 'Early classical Greek art in a Platonic universe', in *Greek Art: Archaic into Classical*, ed. C. G. Boulter. Leiden: 96–111.

1986. *Art in the Hellenistic Age*. Cambridge.

1995. 'The canon of Polykleitos and other canons', in Moon (ed.) 1995: 19–24.

Potts, A. D. 1978. 'Political attitudes and the rise of historicism in art theory', *Art History* 1: 191–213.

1982. 'Winckelmann's construction of history', *Art History* 5: 377–407.

1994. *Flesh and the Ideal: Winckelmann and the Origins of Art History*. New Haven.

Preisshofen, F. 1974. 'Sokrates im Gespräch mit Parrhasios und Kleiton', in *Studia Platonica: Festschrift für Hermann Gundert zu seinem 65 Geburtstag*. Amsterdam: 21–40.

1978. 'Kunsttheorie und Kunstbetrachtung', in *Le classicisme à Rome*. Fondation Hardt, Entretiens 25. Geneva: 263–82.

1984. 'Zur Theoriebildung', in *Bauplanung und Bautheorie der Antike: Diskussionen zur archäologischen Bauforschung 4*. Berlin: 26–30.

Preisshofen, F. and P. Zanker. 1970/1. 'Reflex einer eklektischen Kunstanschauung beim Auctor *ad Herennium*', *Dialoghi di Archeologia* 4/5: 100–19.

Prettejohn, E. 1996. 'Recreating Rome', in *Imagining Rome: British Artists and Rome in the Nineteenth Century*, ed. M. Liversidge and C. Edwards. London: 125–70.

Pritchett, W. K. 1974. *The Greek State at War*, vol. II. Berkeley.

Radt, W. 1998. 'Recent research in and about Pergamon: a survey, 1987–97', in *Pergamon: Citadel of the Gods*, ed. H. Koester. Harvard Theological Studies 46: 1–40.

1999. *Pergamon: Geschichte und Bauten, Fund und Erforschung einer antiken Metropole*. Cologne.

Randall, J. H. 1953. 'The Erechtheum Workmen', *AJArch.* 57: 199–210.

Raschke, W. J. 1988. 'Images of victory: some new considerations of athletic monuments', in *The Archaeology of the Olympics*, ed. W. Raschke. Madison, Wis.: 38–54.

Raubitschek, A. 1949. *Dedications from the Athenian Akropolis: a Catalogue of the Inscriptions of the Sixth and Fifth Centuries BC*. Cambridge, Mass.

Reed, N. B. 1987. 'The euandria competition at the Panathenaia reconsidered', *Ancient World* 15: 59–64.

Reeder, E. (ed.) 1995. *Pandora: Woman in Classical Greece*. Princeton.

Reinach, A. 1921. *Textes grecs et latins relatifs à l'histoire de la peinture ancienne*. Paris.

Rhodes, P. J. 1981. *A Commentary on the Aristotelian Athenaion Politeia*. Oxford.

Rice, E. E. 1983. *The Grand Procession of Ptolemy Philadelphos*. Oxford.

Richardson, N. J. 1974. *The Homeric Hymn to Demeter*. Oxford.

Richter, G. M. A. 1955. *Greek Portraits: a Study of their Development*. Collection Latomus 20. Bruxelles.

1965. *The Portraits of the Greeks*. 3 vols. London.

1968. *Korai: Archaic Greek Maidens*. London.

1970. *Perspective in Greek and Roman Art*. London.

1984. *Portraits of the Greeks*. Abridged edn., ed. R. R. R. Smith. London.

Ridgway, B. S. 1981. *Fifth Century Styles in Greek Sculpture*. Princeton.

1990. 'Birds, meniskoi and head-attributes in ancient Greece', *AJArch.* 94: 583–612.

1997. *Fourth-Century Styles in Greek Sculpture*. London.

1999. *Hellenistic Styles in Greek Sculpture*, vol. II: *The Styles of c. 200–100 BC*. Madison, Wis.

Rivier, A. 1952. *Une emploi archaique de l'analogie chez Héraclite et Thucydide*. Lausanne.

1956. 'Sur les fragments 34 et 35 de Xénophane', *Rev. Phil.* 30: 36–61.

Rizzo, G. E. 1932. *Prassitele*. Milan.

1936. *Le Pitture della 'Casa di Livia'*. Mon. Ant. Pic. III, iii. Rome.

Robb, K. 1994. *Literacy and Paideia in Ancient Greece*. Oxford.

Robins, G. 1997. *The Art of Ancient Egypt*. London.

Robert, R. 1992. 'Séduction érotique et plaisir ésthetique', *MEFRA* 104: 373–437.

Robertson, M. 1975. *A History of Greek Art*. Cambridge.

Rodenwaldt, G. 1944. 'ΘΕΟΙ ΡΕΙΑ ΖΩΟΝΤΕΣ', *Abhandlungen der Preussischen Akademie der Wissenschaften, 1943, Philosophisch-historische Klasse* 13: 3–24.

Rohde, E. 1965. *Psyche: the Cult of Souls and the Belief in Immortality among the Greeks*. London.

Romano, I. B. 1988. 'Early Greek cult images and cult practices', in *Early Greek Cult Practice – Proceedings of the Fifth International Symposium at the Swedish Institute at Athens, 26–29 June 1986*, ed. R. Hägg, N. Marinatos and G. Nordquist. Stockholm: 127–34.

Roussell, D. 1976. *Tribu et cité: études sur les groupes sociaux dans les cités grecques aux époques archaiques et classiques*. Paris.

Rouveret, A. 1987. ' "Toute la memoire du monde". La notion de collection dans le NH de Pline', *Helmantica* 38: 113–33.

1989. *Histoire et Imaginaire de la Peinture Ancienne – Vè Siècle av. JC – 1er siècle ap. JC.* B.E.F.A.R. no. 274. Rome.

1995. 'Artistes, collectionneurs et antiquaires: l'histoire de l'art dans l'encyclopédie plinienne', in *Histoire de l'histoire de l'art de l'antiquité au xviiie siècle*, ed E. Pommier. Paris: 49–64.

Russell, D. A. 1989. 'Greek criticism of the empire', in *The Cambridge History of Literary Criticism*, vol. 1: *Classical Criticism*, ed. G. A. Kennedy. Cambridge: 297–329.

Said, S. 1987. 'Deux noms de l'image en grec ancien: idole et icône', *CR Acad. Inscr.* April/June: 310–30.

Salomon, N. 1997. 'Making a world of difference: gender asymmetry and the Greek nude', in *Naked Truths: Women, Sexuality and Gender in Classical Art and Archaeology*, ed. A. O. Koloski-Ostrow and C. L. Lyons. London: 197–219.

Sandbach, F. H. 1975. *The Stoics.* London.

Sassi, M. M. 2001. *The Science of Man in Ancient Greece.* Chicago.

Sauron, G. 1980/1. 'Templa serena: à propos de la "Villa des Papyri" d'Herculaneum: contribution à l'étude des comportements aristocratiques romains à la fin de la République', *MEFRA* 92: 277–301.

Schalles, H. J. 1985. *Untersuchungen zur Kulturpolitik der Pergamenischen Herrscher im dritten Jahrhundert v. Chr.* Istanbuler Forschungen 36. Tübingen.

Schapiro, M. 1953. 'Style', in *Anthropology Today*, ed. A. L. Kroeber. Chicago: 287–312.

Scheibler, E. 1979. 'Griechischer Künstlervotive der archaischen Zeit', *Münchner Jahrbuch der bildenden Kunst* 30: 7–25.

Scheid, J. 1986. 'Le flamine de Jupiter, les vestals et le général triomphant: variations romaines sur le thème de la figuration des dieux', *Le Temps de la Réflexion* 7: 213–30.

Schiller, F. 1965 [1795]. *On the Aesthetic Education of Man.* Oxford.

Schluchter, W. 1981. *The Rise of Western Rationalism: Max Weber's Developmental History.* Berkeley.

Schmaltz, B. 1989. 'Theseus der Sieger über den Minotauros', *Archäologischer Anzeiger*: 71–9.

1995. 'Zu den Ephesischen Amazonen', *Archäologischer Anzeiger*: 335–43.

Schmidt, S. 1996. 'Über den Umgang mit Vorbildern. Bildhauerarbeit im 4. Jahrhundert. v. Chr.', *MDAI (A)* 111: 191–223.

Schnapp, A. 1989. 'Eros the hunter', in *A City of Images: Iconography and Society in Ancient Greece*, ed. C. Bérard. Princeton: 71–87.

Schneider, H. 1989. *Das griechische Techneverständnis von den Epen Homers bis zu den Anfängen der technologischen Fachliteratur.* Darmstadt.

Schneider, L. A. 1975. *Zur sozialen Bedeutung der archaischen Korenstatuen.* Hamburg.

Schober, A. 1951. *Die Kunst von Pergamon.* Vienna.

Schofield, M. 1979. 'Aristotle on the imagination', in *Articles on Aristotle*, vol. iv: *Psychology and Aesthetics*, ed. J. Barnes, M. Schofield and R. Sorabji. London: 103–32.

Schutz, A. 1962. 'On multiple realities', in *The Problem of Social Reality. Collected Papers*, vol. i. The Hague: 207–59.

Schweitzer, B. 1925. 'Der bildende Künstler und der Begriff des Kunstlerischen in der Antike', *Neue Heidelberger Jahrbucher* 2: 28–132.

1932. 'Xenocrates von Athen', *Schriften der Königsberger Gelehrten Gesellschaft, Geisteswissenschaftliche Klasse* 9: 1–52.

1934. 'Mimesis und Phantasia', *Philologus* 89: 286–300.

Sellers, E. 1896. *The Elder Pliny's Chapters on the History of Greek Art*, trans. K. Jex Blake, with commentary and historical introduction by E. Sellers. London.

Settis, S. 1973. 'Policleto fra *sophia e mousike*', *Rivista di Filologia Classica* 101: 303–17.

1975. 'Imagini della meditazione, dell'incertezza e del pentimento nell'arte antica', *Prospettiva* 2: 4–18.

1995a. 'Did the ancients have an antiquity? The idea of Renaissance in the history of classical art', in *Language and Images of Renaissance Italy*, ed. A.Brown. London: 27–50.

1995b. 'La conception de l'histoire de l'art chez les Grecs et son influence sur les theoriciens Italiens du Quattrocento', in *Histoire de l'histoire de l'art de l'antiquité au xviiie siècle*, ed. E. Pommier. Paris: 145–60.

1997. 'Pathos und Ethos: Morphologie und Funktion', *Vorträge aus dem Warburg-Haus* 1: 31–73.

Sewell, W. H. Jr. 1992. 'A theory of structure: duality, agency and transformation', *American Journal of Sociology* 98: 1–29.

Shaw, B. D. 1985. 'The divine economy: Stoicism as ideology', *Latomus* 64: 16–54.

Shils, E. 1982a. 'Charisma', in *The Constitution of Society*. Chicago: 110–18.

1982b. 'Deference', in *The Constitution of Society*. Chicago: 143–75.

Siebert, G. 1978. 'Signatures d'artistes, d'artisans et des fabricants dans l'antiquité classique', *Ktema* 3: 111–31.

Silverman, A. 1991. 'Plato on Phantasia', *Cl. Ant.* 2: 123–47.

Simon, E. 1957. 'Beobachtungen zum Apollo Philesios des Kanachos', in *Charites: Festschrift Ernst Langlotz*, ed. K. Schauenburg. Berlin: 38–46.

1987. 'Kriterien zur Deutung "pasitelischer" Gruppen', *JDAI* 102: 291–304.

Sinos, H. 1993. 'Divine selection: epiphany and politics in ancient Greece', in *Cultural Poetics in Archaic Greece: Cult, Performance, Politics*, ed. C. Dougherty and L. Kurke. Cambridge: 73–91.

Slater, N. W. 1987. '"Against interpretation": Petronius and art', *Ramus* 16: 165–76.

Smith, M. S. 1975. *Petronius: Cena Trimalchionis*. Oxford.

Smith, R. R. R. 1988. *Hellenistic Royal Portraits*. Oxford.

1991. *Hellenistic Sculpture*. London.

Sokolowski, F. 1969. *Lois sacrées des cités grecques*. Paris.

Solmsen, F. 1963. 'Nature as craftsman in Greek thought', *Journal of the History of Ideas* 24: 473–96.

Sourvinou-Inwood, C. 1988a. *Studies in Girls' Transitions: Aspects of the Arkteia and Age Representation in Attic Iconography*. Athens.

1988b. 'Further aspects of polis religion', *AION* 10: 259–73.

1989. 'What is polis religion', in *The Greek City*, ed. O. Murray and S. Price. Oxford: 295–322.

1995. 'The grave monument in the archaic age', in *Reading Greek Death: to the End of the Classical Period*. Oxford: 140–297.

Spiro, A. 1990. *Contemplating the Ancients: Aesthetic and Social Issues in Early Chinese Portraiture*. Berkeley.

Spivey, N. 1995. 'Bionic statues', in *The Greek World*, ed. A. Powell. London: 442–59.

Steiner, D. T. 2001. *Images in Mind: Statues in Archaic and Classical Greek Literature and Thought*. Princeton.

Stein-Hölkeskamp, E. 1987. *Adelskultur und Polis Gesellschaft: Studien zum griechischen Adel in archaischer und klassischer Zeit*. Stuttgart.

Stevens, G. P. 1946. 'Architectural studies concerning the Acropolis of Athens', *Hesperia* 15: 74–100.

Stewart, A. 1978a. 'The canon of Polykleitos: a question of evidence', *JHS* 98: 122–31.

1978b. 'Lysippan Studies. 1. The only creator of beauty. 2. Agias and the oil-pourer. 3. Not by Daidalos?', *AJArch.* 82: 163–72, 301–14, 473–82.

1979. *Attika: Studies in Athenian Sculpture of the Hellenistic Age*. Society for the Promotion of Hellenic Studies, Suppl. vol. no. 14. London.

1986. 'When is a kouros not an Apollo? The Tenea "Apollo" revisited', in *Corinthiaca: Studies in Honour of Darrell A. Amyx*, ed. Mario A. del Chiaro. Columbia, Miss.: 54–70.

1990. *Greek Sculpture: an Exploration*. New Haven.

1997. *Art, Desire and the Body in Ancient Greece*. Cambridge.

1998. 'Nuggets: mining the texts again', *AJArch.* 102: 271–82.

Susemihl, F. 1891. *Geschichte der griechischen Literatur in der Alexandinerzeit*, vol. I. Leipzig.

Svenbro, J. 1988. *Phrasikleia: anthropologie de la lécture en Grèce ancienne*. Paris.

1990. 'The "interior voice": on the invention of silent reading', in *Nothing to Do with Dionysos*, ed. J. Winkler and F. Zeitlin. Princeton: 366–84.

Tancke, K. and K. Yfantidis. 1989. 'Beobachtungen zur Rekonstruktion der Orest-Pylades-Gruppe in Schloss Fanaserie', *Archäologischer Anzeiger*: 243–9.

Tanner, J. 1992. 'Art as expressive symbolism: civic portraits in classical Athens', *Cambridge Archaeological Journal* 2: 167–90.

1994. 'Shifting paradigms in classical art history', *Antiquity* 68: 650–5.

1999. 'Culture, social structure and the status of visual artists in classical Greece', *PCPS* 45: 136–75.

2000a. 'The body, expressive culture and social interaction: integrating art history and action theory', in *Talcott Parsons: zur Aktualität eines Theorienprogramms*, ed. H. Staubmann and H. Wenzel. Österreichische Zeitschrift für Soziologie. Sonderband 6. Wiesbaden: 285–324.

2000b. 'Portraits, power and patronage in the late Roman Republic', *JRS* 90: 18–50.

2000c. 'Social structure, cultural rationalisation and aesthetic judgement in classical Greece', in *Word and Image in Ancient Greece*, ed. N. K. Rutter and B. A. Sparkes. Edinburgh Leventis Studies 1. Edinburgh: 183–205.

2001. 'Nature, culture and the body in classical Greek religious art', *World Archaeology* 33: 257–76.

2005. 'Rationalists, fetishists and art lovers: action theory and comparative analysis of high cultural institutions', in *After Parsons: a Theory of Social Action for the Twenty-First Century*, ed. R. C. Fox, V. M. Lidz and H. J. Bershady. New York: 179–207.

forthcoming. 'Creative imagination and the visual artist in the ancient Greek world'.

Taylor, M. W. 1981. *The Tyrant Slayers: the Heroic Image in Fifth Century BC Athenian Art and Politics*. New York.

Themelis, P. 1994. 'Damophon of Messene: new evidence', in *Archaeology in the Peloponnese: New Excavations and Research*, ed. K. A. Sheedy. Oxford: 1–38.

Thompson, J. B. 1990. *Ideology and Modern Culture: Critical Social Theory in the Era of Mass Communication*. Stanford.

Tobin, R. 1975. 'The canon of Polykleitos', *AJArch.* 79: 307–21.

1995. 'The pose of the Doryphoros', in *Polykleitos, the Doryphoros and Tradition*, ed. W. G. Moon. Madison, Wis.: 52–64.

Travlos, J. 1971. *A Pictorial Dictionary of Ancient Athens*. New York.

Troppenburg, E. G. di. 1980. 'Die Innenausstattung der Glypthothek durch Leo v Klenze', in *Glypthothek München 1830–1980*, ed. K. Vierneisel and G. Leinz. Munich: 190–213.

Tsouna, V. 1998. 'Doubts about other minds and the science of physiognomics', *CQ* 48: 175–86.

Urlichs, H. L. 1887. *Über griechische Kunstschriftsteller*. Würzburg.

Van Buren, A. W. 1938. 'Pinacothecae – with especial reference to Pompeii', *Memoirs of the American Academy at Rome* 15: 70–81.

Van Nijf, O. 2001. 'Local heroes: athletics, festivals and elite self-fashioning in the Roman East', in *Being Greek under Rome*, ed. S. Goldhill. Cambridge: 306–34.

Van Straten, F. T. 1974. 'Did the Greeks kneel before their gods?', *BaBesch.* 49: 159–89.

1976. 'Daikrates' dream: a votive relief from Kos and some other *kat' onar* dedications', *BaBesch.* 51: 1–38.

1981. 'Gifts to the gods', in *Faith, Hope and Worship*, ed. H. S. Versnel. Leiden: 65–151.

Vatin, C. 1977. 'Couroi Argiens à Delphes', *Etudes Delphiques*, ed. Ecole française d'Athènes (*BCH* Suppl. 4): 13–22.

1982. 'Monuments votifs de Delphes', *BCH* 106: 509–25.

Verdenius, W. J. 1949. 'κάλλος καὶ μέγεθος', *Mnemosyne* 2: 294–8.

Vernant, J-P. 1982 [1962]. *The Origins of Greek Thought*. London.

1983. *Myth and Thought among the Greeks*. London, Routledge and Kegan-Paul.

1990a. 'Le symbole plastique', in *Figures, Idoles, Masques*. Paris: 17–30.

1990b. 'Figuration et image', *Metis* 5: 225–38.

1991 *Mortals and Immortals – Collected Essays*, ed. Froma Zeitlin. Princeton.

1994. 'Introduction' to M. Detienne, *The Gardens of Adonis: Spices in Greek Mythology*, trans. J. Lloyd. Princeton: vii–xl.

Vickers, M. and D. W. J. Gill. 1994. *Artful Crafts*. Oxford.

Vidal-Naquet, P. 1993. ''1993 Preface', in P. Lévêque and P. Vidal-Naquet, *Cleisthenes the Athenian: an Essay on the Representation of Space and Time in Greek Political Thought from the End of the Sixth Century to the Death of Plato*, Atlantic Highlands, N.J.: xxxi–xxxvi.

von den Hoff, R. 1994. *Philosophenporträts des früh- und hoch Hellenismus*. Munich.

Voutiras, E. 1980. *Studien zu Interpretation und Stil griechischer Porträts des 5. und frühen 4. Jahrhunderts*. Bonn.

Walker, S. 1990. *Catalogue of Roman Sarcophagi in the British Museum*. London.

Wallace, R. W. 1995. 'Speech, song and text, public and private: evolutions in communications media and fora in fourth-century Athens', in *Die athenische Demokratie im 4. Jahrhundert v. Chr*, ed. W. Eder. Stuttgart: 199–224.

Wallace-Hadrill, A. 1990. 'Pliny the Elder and man's unnatural history', *G&R* 37: 80–96.

Warden, P. G. and D. G. Romano. 1994. 'The course of glory: Greek art in a Roman context at the Villa of the Papyri at Herculaneum', *Art History* 17: 228–54.

Watson, G. 1988. *Phantasia in Classical Thought*. Gallway.

1994. 'The concept of "phantasia" from the late Hellenistic period to early Neoplatonism', *ANRW* 36.7: 4765–810.

Webb, P. A. 1998. 'The functions of the sanctuary of Athena and the Pergamon altar (the heroon of Telephos) in the Attalid building program', in *Stephanos: Studies in Honour of B. S. Ridgway*, ed. K. J. Hartswick and M. C. Sturgeon. Philadelphia: 241–54.

Weber, M. 1931 [1904–5]. *The Protestant Ethic and the Spirit of Capitalism*. London.

1946a. 'The social psychology of the world religions', in *From Max Weber: Essays in Sociology*, ed. H. Gerth and C. W. Mills. Oxford: 267–301.

1946b. 'Religious rejections of the world and their directions', in *From Max Weber: Essays in Sociology*, ed. H. Gerth and C. W. Mills. Oxford: 323–59.

1968 [1922]. *Economy and Society: an Outline of Interpretive Sociology*. Berkeley.

Webster, T. B. L. 1939. 'Greek theories of art and literature down to 400 BC', *CQ* 33: 166–79.

1952. 'Plato and Aristotle as critics of Greek art', *Symbolae Osloenses* 29: 8–23.

Wesenberg, B. 1985. 'Kunst und Lohn am Erechtheion', *Archäologischer Anzeiger*: 55–65.

West, M. 1992. *Ancient Greek Music*. Oxford.

Whitehead, D. 1983. 'Competitive outlay and community profit: φιλοτιμία in democratic Athens', *C&M* 34: 55–74.

1993. 'Cardinal values: the language of public approbation in democratic Athens', *C&M* 44: 37–75.

Wilamowitz, U. von. 1965 [1881]. *Antigonos von Karystos*. 2nd edn. Berlin/Zurich.

Williams, D. 1995. 'Potter, painter and purchaser' in *Culture et cité: l'avenement d'athènes à l'époque archaique*, ed. A. Verbanck-Piérard and D. Viviers. Brussels: 139–60.

Williams, F. 1978. *Callimachus' Hymn to Apollo: a Commentary*. Oxford.

Wilson, J. A. 1947. 'The artist of the old kingdom', *Journal of Near Eastern Studies* 6: 231–49.

Winckelmann, J. J. 1881. *The History of Ancient Art*, trans. G. Henry Lodge. London.

Winter, F. E. and A. Christie. 1985. 'The symposium tent of Ptolemy II: a new proposal', *Classical Views* 29: 289–308.

Witkin, R. W. 1995. *Art and Social Structure*. Cambridge.

Wolfel, C. 1990. 'Erwägungen zur kunstlichen Beleuchtung von Skulptur', in *Licht und Architektur*, ed. W-D. Heilmeyer and W. Hoepfner. Tübingen: 43–52.

Wuellner, W. 1997. 'Arrangement', in *Handbook of Classical Rhetoric in the Hellenistic Period, 330 BC – AD 400*, ed. R. E. Porter. Leiden: 51–87.

Yalouris, N. 1986. 'Das archäische Lächeln und die Geleontes', *AK* 29: 3–5.

Younger, J. G. 1997. 'Gender and sexuality in the Parthenon frieze', in *Naked Truths: Women, Sexuality and Gender in Classical Art and Archaeology*, ed. A. O. Koloski-Ostrow and C. L. Lyons. London: 120–53.

Zanker, G. 1981. '*Enargeia* in the criticism of ancient poetry', *Rh. Mus.* 124: 297–311.

Zanker, P. 1974. *Klassisistische Statuen: Studien zur Veränderung des Kunstgeschmacks in der römischen Zeit*. Mainz.

1978. 'Zur Funktion und Bedeutung griechischer Skulptur in der Römerzeit', in *Le classicisme à Rome*. Fondation Hardt. Entretiens 25. Geneva: 283–313.

1979. 'Die Villa als Vorbild des späten Pompejanischen Wohngeschmacks', *JDAI* 94: 460–523.

1995. *The Masks of Sokrates: the Image of the Intellectual in Antiquity*. Berkeley.

Zeitlin, F. 1982. 'Cultic models of the female: rites of Dionysos and Demeter', *Arethusa* 15: 129–57.

1994. 'The artful eye: vision, ekphrasis, and spectacle in Euripidean theatre', in *Art and Text in Greek Culture*, ed. S. Goldhill and R. Osborne. Cambridge: 138–96.

Zeman, J. J. 1977. 'Peirce's theory of signs', in *A Perfusion of Signs*, ed. T. A. Sebeok. Bloomington, Ind.: 22–39.

Zevi, F. 1969/70. 'Iscrizioni con firme di artisti Greci', *Rend. Pont.* 42: 95–116.

Zimmer, G. 1982. *Antike Werkstattbilder*. Berlin.

Zinserling, V. 1965. 'Das attische Grabluxusgestez des frühen 5 Jh.', *Wissenschaftliche Zeitschrift Jena* 14: 29–34.

1975. 'Zum Bedeutungsgehalt des archaischen Kuros', *Eirene* 13: 19–34.

Zolberg, V. L. 1990. *Constructing a Sociology of the Arts*. Cambridge.

INDEX